TREASURES

of the National Gallery of Canada

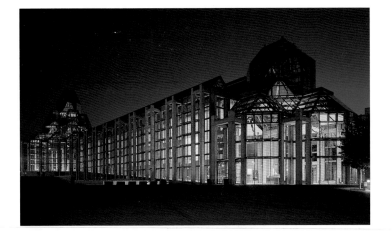

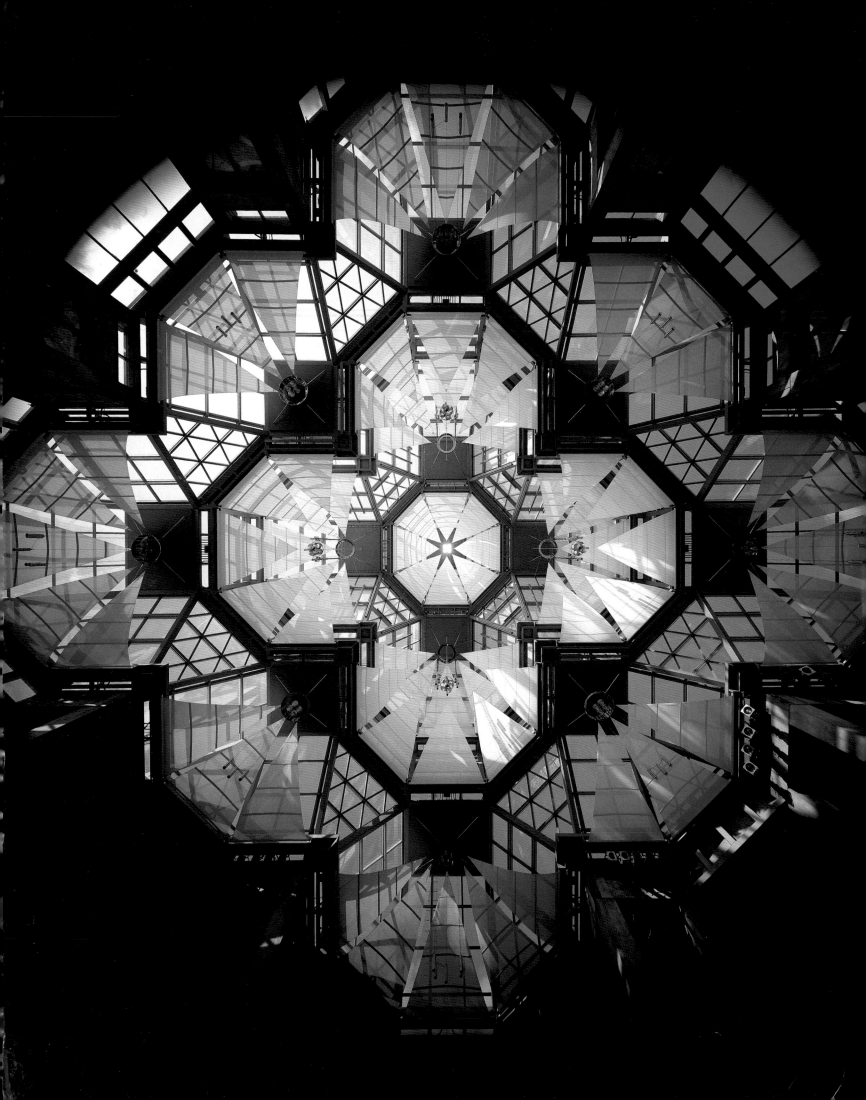

TREASURES

of the National Gallery of Canada

GENERAL EDITOR

David Franklin

NATIONAL GALLERY OF CANADA

IN ASSOCIATION WITH

YALE UNIVERSITY PRESS

Published by the National Gallery of Canada, Ottawa,
in association with Yale University Press, New Haven
and London

NATIONAL GALLERY OF CANADA
Serge Thériault, Chief of Publications
Editing and translation: Usher Caplan, Judith Terry,
Danielle Chaput, Colleen Evans

Designed by Ian Hunt
Printed and bound in Singapore by CS Graphics Ltd.

Cover: Lucius R. O'Brien, *Sunrise on the Saguenay* (detail)

ISBN 0-300-09944-4 (clothbound)
ISBN 0-88884-764-5 (paperbound)

Library of Congress Control Number: 2003107280

All photography by National Gallery of Canada,
except Jana Sterbak, *I Want You to Feel the Way I
Do... (The Dress)*, by Robert Keziere, Vancouver;
Roland Poulin, *Already, the Night Is upon Us, No. 1*,
by Richard-Max Tremblay, Montreal; and pages 1,
6, 8, 10–14, by Timothy Hursley, Little Rock.

Treasures of the National Gallery of Canada has been made possible through the generous support of the Parnassus Foundation; Harrison McCain, C.C., O.N.B.; and patrons of the National Gallery of Canada Foundation's Circle Program and Founding Partners Circle.

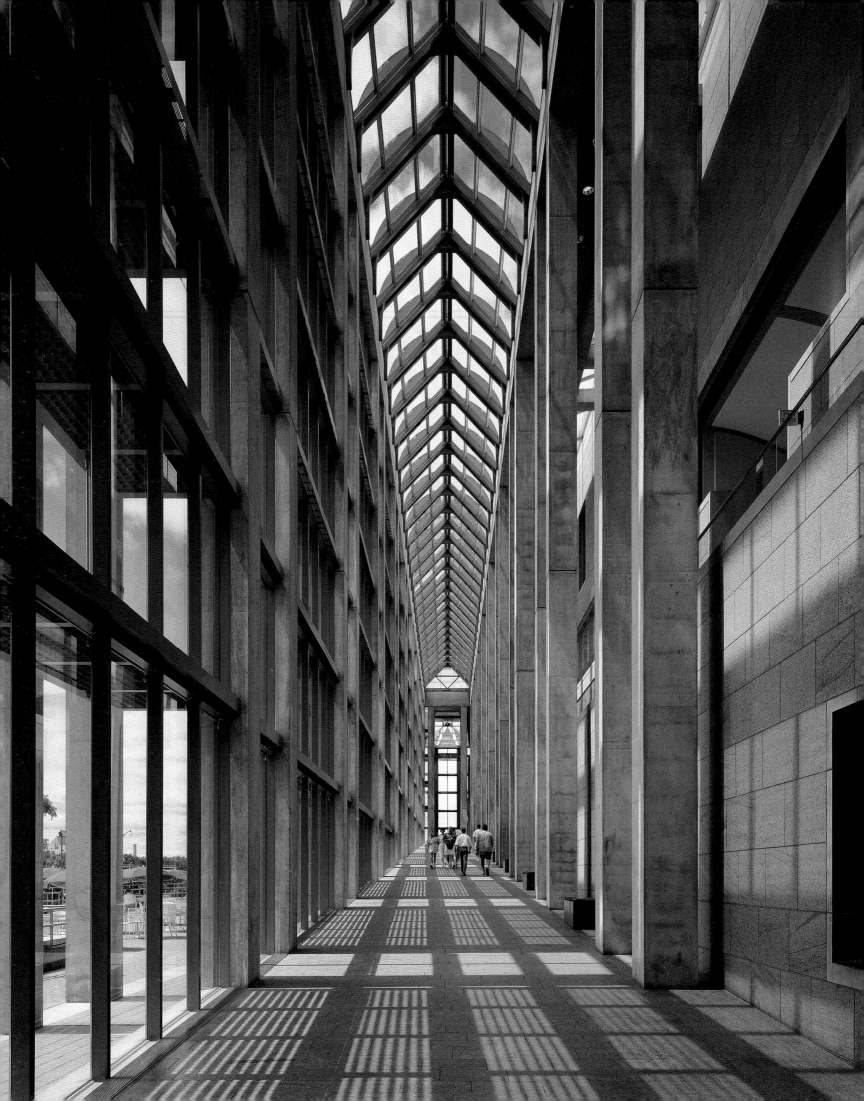

Contents

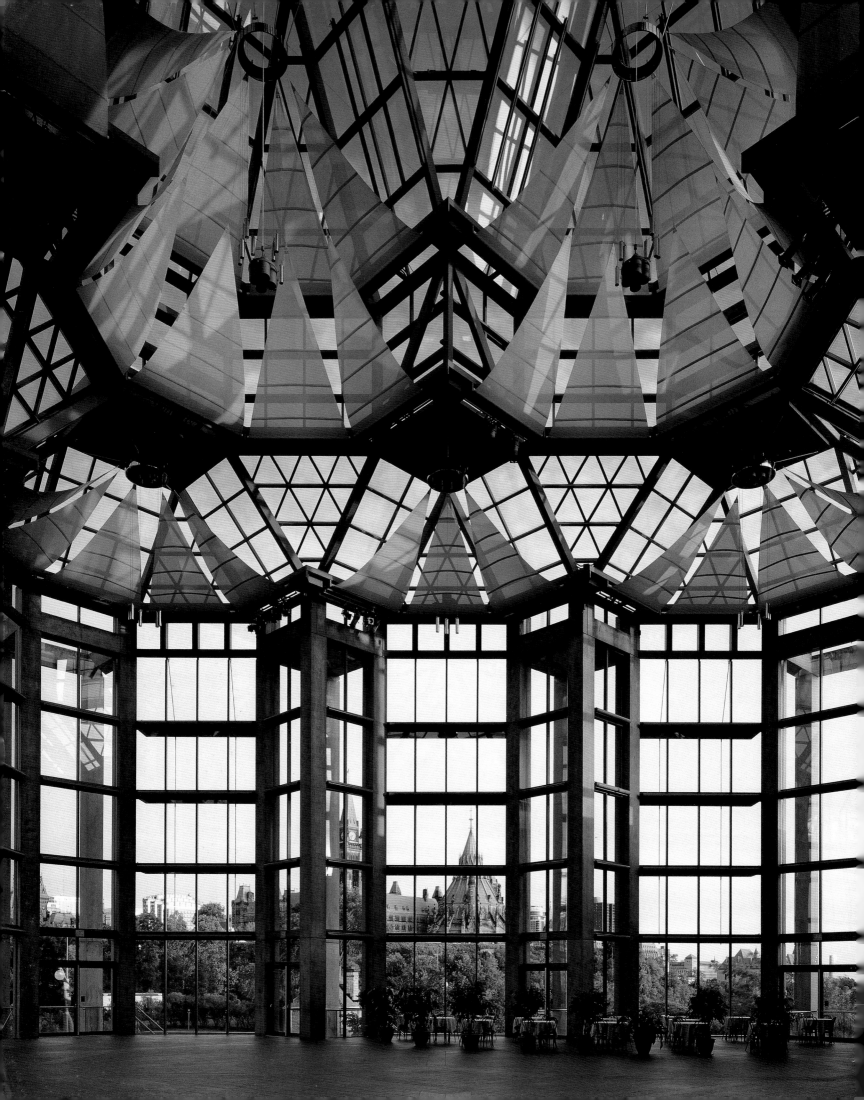

Preface

From its founding in 1880 the National Gallery of Canada has grown to become the largest visual arts museum in the country. The Gallery's outstanding holdings of Canadian art are the direct result of its unwavering commitment to the acquisition of works by living Canadian artists, a commitment that can be traced back virtually to the foundation year of the institution. Indeed, the first major painting acquired by the National Gallery, Lucius O'Brien's *Sunrise on the Saguenay*, entered the collection the very year it was produced. Paintings by some of the artists who would form the Group of Seven – the creators of the first identifiably Canadian style of art – were purchased even before that group was established. As well, it was always assumed that the National Gallery would play an important role in preserving our existing artistic heritage. Thus, for example, five paintings by Paul Kane commissioned by the government in 1851 were transferred to the National Gallery in 1888. Benjamin West's *Death of General Wolfe* of 1770 – a work that continues to exert a vital influence on the Canadian imagination – entered the collection through a similar transfer, by way of the Canadian War Memorials.

The collections of historical European art at the National Gallery of Canada are of the same elevated quality, in prints and drawings as well as in paintings and sculpture. By North American standards, the Gallery has been actively acquiring European treasures for a relatively long time, which accounts in part for the fineness of our holdings. Aided by a special Parliamentary grant, the inspired acquisition in the 1950s of twelve masterpieces from the collection of the Princes of Liechtenstein, including works by Rembrandt and Rubens, was certainly the defining moment in the development of our European paintings collection. The first significant European drawings, including an important example by one of the creators of the Baroque style, Annibale Carracci, were acquired much earlier, in 1911. Two years later, in 1913, prints by masters such as Dürer and Rembrandt were purchased with the intention of formally establishing a print room in the National Gallery. Such is their rarity that virtually none of these prints could possibly be found today outside of public collections. Acquisitions of this nature are indicative of the admirable prescience of the institution's early directors and board members.

Although the Gallery had been collecting contemporary Canadian art from the beginning, relatively few important works by living artists abroad entered the collection until after the Second World War. This lack was partly made up in the 1950s by the selective acquisition of paintings and sculptures by such modern European masters as Picasso, Matisse, Léger, and Giacometti. A further significant step forward was taken in the late 1960s when the Gallery began making a concerted effort to collect contemporary American art. As a result, the collection has notable strengths in Pop Art and Minimalist sculpture and includes a small but important group of Abstract Expressionist paintings. Today, works by such illustrious Canadians as Guido Molinari, Jeff Wall, and Jana Sterbak, to name only a few, take their place in a collection of contemporary art that is truly international, reflecting not only an intensive exchange of ideas with artists beyond our borders but also the more decisive role that our nation has played on the world stage during the post-war period.

Photographs have been part of the National Gallery's exhibition program since 1934. A collection dedicated to the medium was established in 1967, making the Gallery the first museum in Canada to systematically collect photographs as fine art. International in scope, and ranging from the earliest incunabula to contemporary photographic images, this important collection today numbers over 20,000 works. In 1985 the National Film Board's Still Photography Division was transferred to the National Gallery as an affiliate museum, the Canadian Museum of Contemporary Photography, whose mandate is to collect and exhibit the work of contemporary Canadian photographers.

The Gallery's Inuit art collection encompasses the major creative and historical developments of the period since the 1940s. We acquired our first Inuit sculptures in 1956, and we began purchasing prints from the fledgling Cape Dorset studio in the 1960s. Since the mid-1980s this collection has grown significantly, in part through a major gift of works from the Department of Indian Affairs and Northern Development.

The mandate of the National Gallery of Canada clearly states that "the collections are its principal assets." This showcase of some of the pre-eminent objects in our collection bears witness to our passionate belief in these words, and we sincerely hope that it will bring pleasure to a wide audience.

Pierre Théberge, O.C., C.Q.
Director

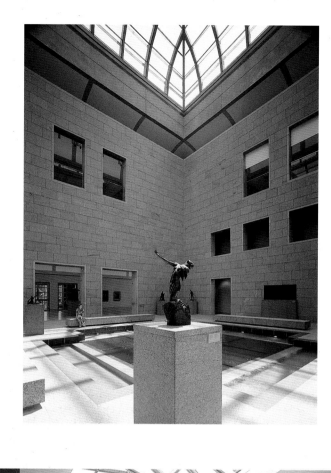

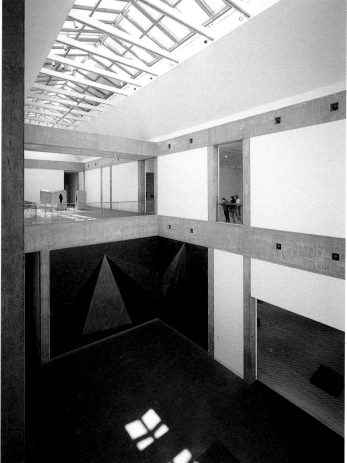

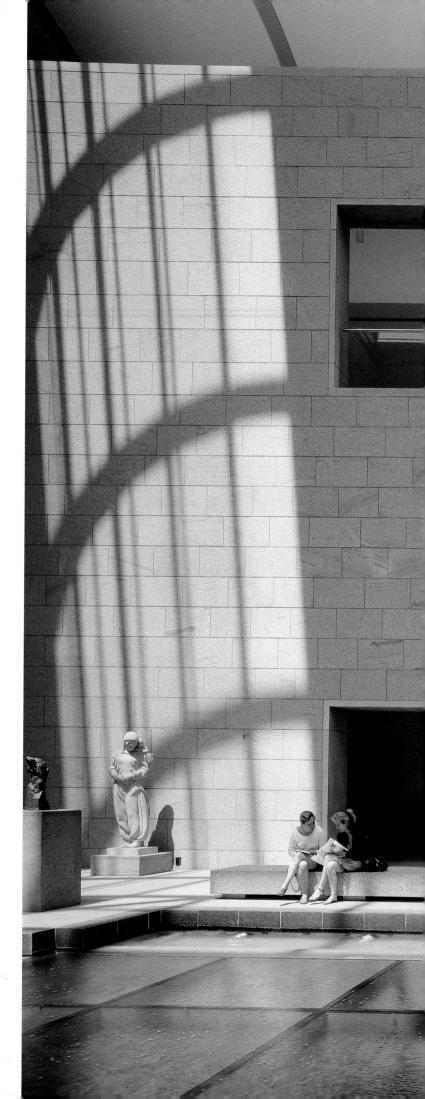

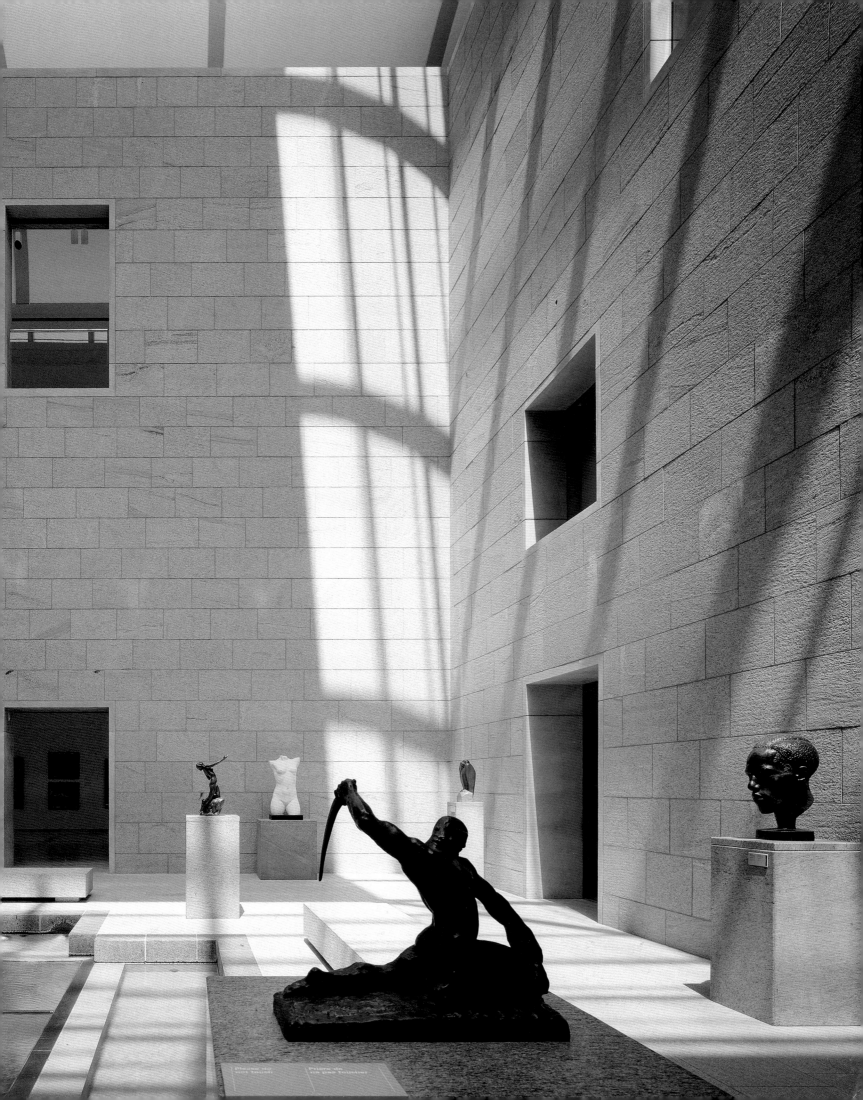

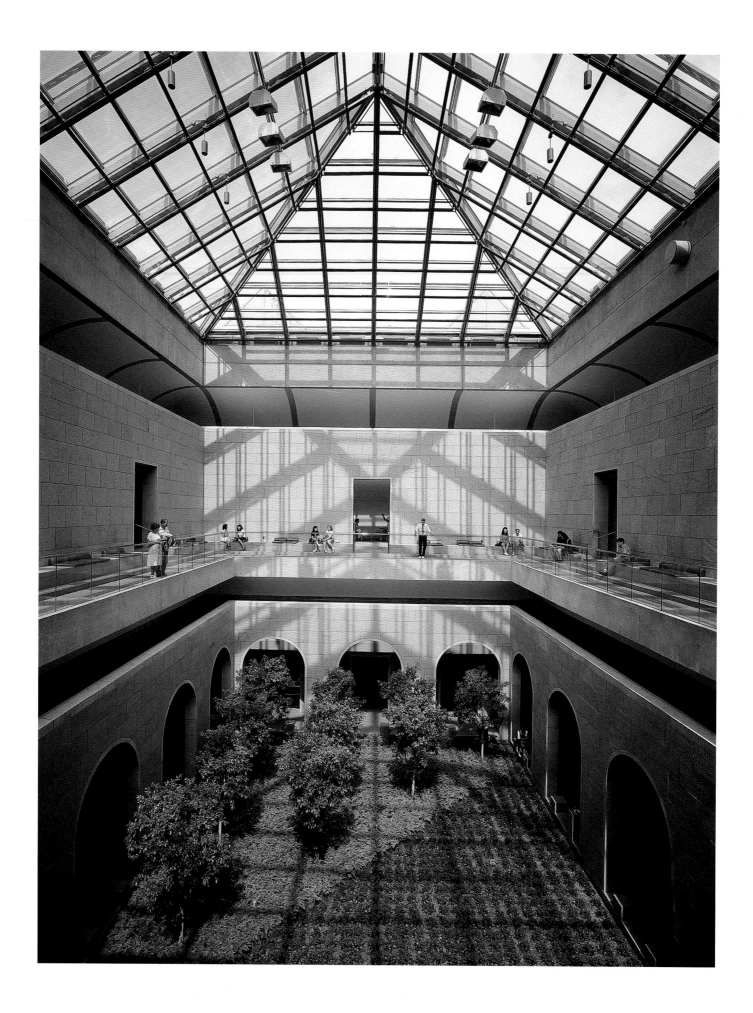

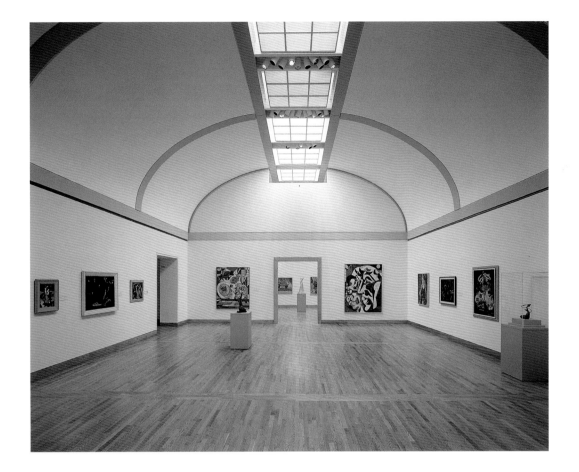

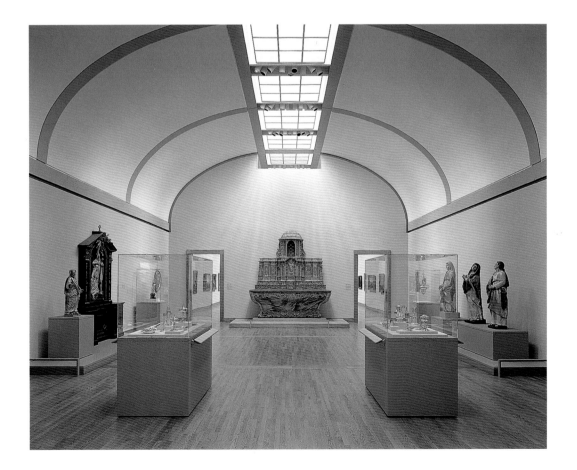

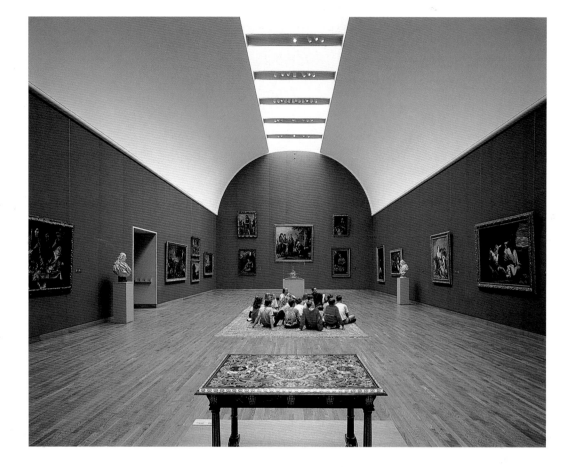

Canadian Art to 1945

Thomas Davies

British, c. 1737–1812

View on the River La Puce near Quebec in Canada

1792
Watercolour over graphite on laid paper, 51.3 × 34.2 cm
Purchased 1954

Thomas Davies was a distinguished officer in the Royal Artillery, a knowledgeable member of the circle of the renowned naturalist Sir Joseph Banks, and a gifted amateur artist who exhibited regularly at the Royal Academy. His military career allowed him to pursue his interests in art and natural history on a broad scale. During his four postings to British North America (primarily to Canada and New York), he spent his leisure time travelling, collecting specimens, and sketching in what was still then a relatively unexplored land.

In a sense, Davies conducted two artistic careers. Professionally, as an officer of the Royal Artillery, he practised the art of topography, a skill he had probably acquired in his late teens while attending the Royal Military Academy at Woolwich. At the same time, he painted landscape watercolours for his own pleasure. His genius lay in his ability to move from the rather restrictive art form of eighteenth-century topography – highly factual renderings of the landscape, used mainly for recording battlefield positions – to that of a landscape artist who could paint watercolours in the fashionable contemporary style known as the Picturesque, with its balanced and atmospheric compositions.

By the 1780s Davies was becoming increasingly interested in natural history, and he produced numerous watercolours of botanical and ornithological specimens. As a result of this activity, which demanded precision of detail in colour, form, and texture, he was simultaneously developing a landscape style uniquely his own. Davies composed his landscapes in a way that reflected prevailing taste, but unlike his contemporaries he employed a rich, opaque palette and meticulous draftsmanship, which enabled him to capture every nuance of a scene. His stylizations of landscape detail also echo his natural history subjects: pine branches are treated like fur, and rushing water like a bird's variegated plumage. The result is a beguiling blend of sophistication and naïveté.

View on the River La Puce was completed in 1792, two years after Davies returned to England from his last posting in Quebec. In this landscape, the artist has depicted some of his fellow officers on an exploratory excursion to the banks of the Sault à La Puce River above Château-Richer, a few miles from Quebec City. In the distance we see the St. Lawrence River and the parish of Sainte-Famille on the Île d'Orléans. This subject is somewhat atypical for Davies's landscapes. Missing are the usual scattering of Aboriginal people and the examples of local flora and fauna – bears, birds, and exotic plants – that the artist clearly took delight in.

Davies was the first British military artist to record the Canadian landscape, and the only one to depict in such detail those qualities that differentiated it from the European landscape. The crystalline light and brilliant foliage of the Canadian autumn so faithfully rendered in this watercolour were not successfully captured again until the mid-nineteenth century.

R.T.

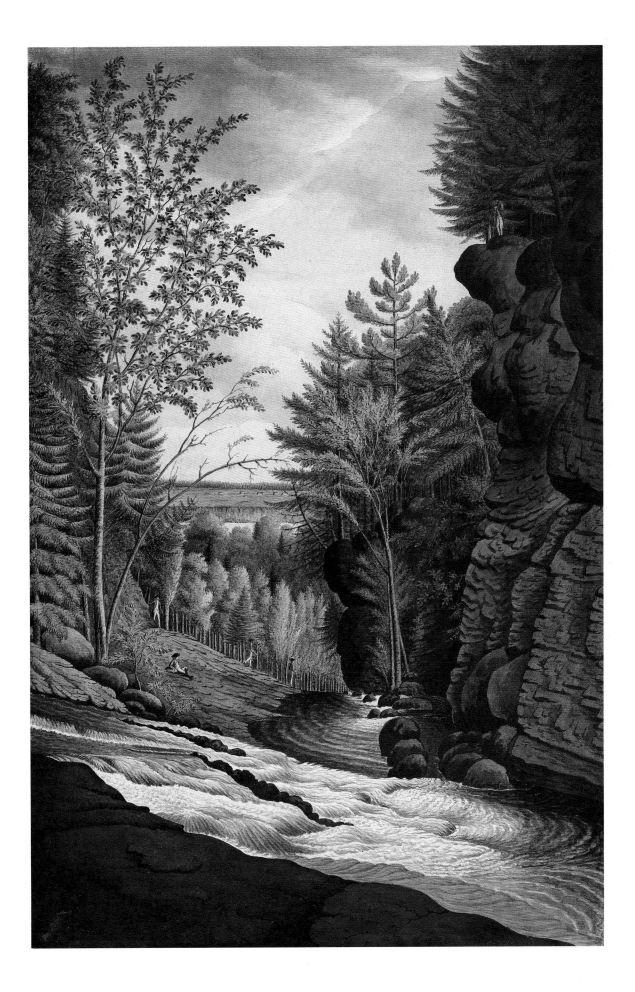

Laurent Amiot

Canadian, 1764–1839

Coffee-pot from the Le Moine Family

c. 1796

Silver and mahogany, 32.9 × 22.2 × 11.8 cm

Gift of Suzy M. Simard, Westmount, Quebec, 1994, in memory of Dr. and Mme Guy Hamel

When this exceptional work became part of the collection of the National Gallery of Canada it focused attention on a fascinating chapter in the history of silver in this country. The piece is the only known example of a silver coffee-pot made in Canada during the pre-industrial era. Its discovery has told us a great deal, not only about the level of refinement attained in certain Quebec homes during the late eighteenth-century – a period when both art and architecture were flourishing – but also about the extraordinary contribution made by its creator to the development of the decorative arts.

Laurent Amiot was one of the finest Canadian silversmiths of his time. Around 1780, after attending school in his native city of Quebec, he apparently became an apprentice in the workshop of his older brother, Jean-Nicolas. In 1782 he set off for Paris to complete his artistic training. By the spring of 1787 he was back in Quebec City, now fully acquainted with all the latest technical and stylistic innovations from the French capital. He set up shop in the same neighbourhood as the city's other silversmiths and embarked on a long and fruitful career, undertaking all sorts of commissions from a wide range of sources – the bourgeoisie, the governor, the Church. Over the next decade Amiot executed a number of consummate works that indicated clearly the path he intended to follow. In the end, his vast oeuvre played a major role in redefining the aesthetic of early nineteenth-century Lower Canada.

This particular coffee-pot was very likely commissioned by Jean-Baptiste Le Moine, a wealthy Quebec City merchant. It remained in the possession of his descendants until it was generously donated to the National Gallery by a member of the family. Apart from its uniqueness, it is remarkable for its elegant design and extremely fine detail. The body of the pot is basically in the shape of an urn, form clearly triumphing over the whimsy that had hitherto dominated silverwork. The piece is nevertheless ornamented with moulding, beading, festoons of foliage, interlacing, and stylized laurel buds, all in keeping with the Neo-classical style. In striking contrast to the monumentality of the pot itself, the powerful curve of the swan-neck spout with its heavy acanthus leaves – echoed in the mahogany handle and the sockets that hold it to the vessel – exudes more than a whiff of the English Rococo. The handle was almost certainly carved by François Baillairgé, who probably also provided the models for the spout, the sockets, and the knob on top of the lid, all of which were cast. Throughout their careers and their lives, these two artists were in frequent contact. Baillairgé, who had made the sign for Amiot's workshop, furnished the silversmith with many lead and wood models over the years, together with numerous knobs and handles for vessels of various kinds.

R.V.

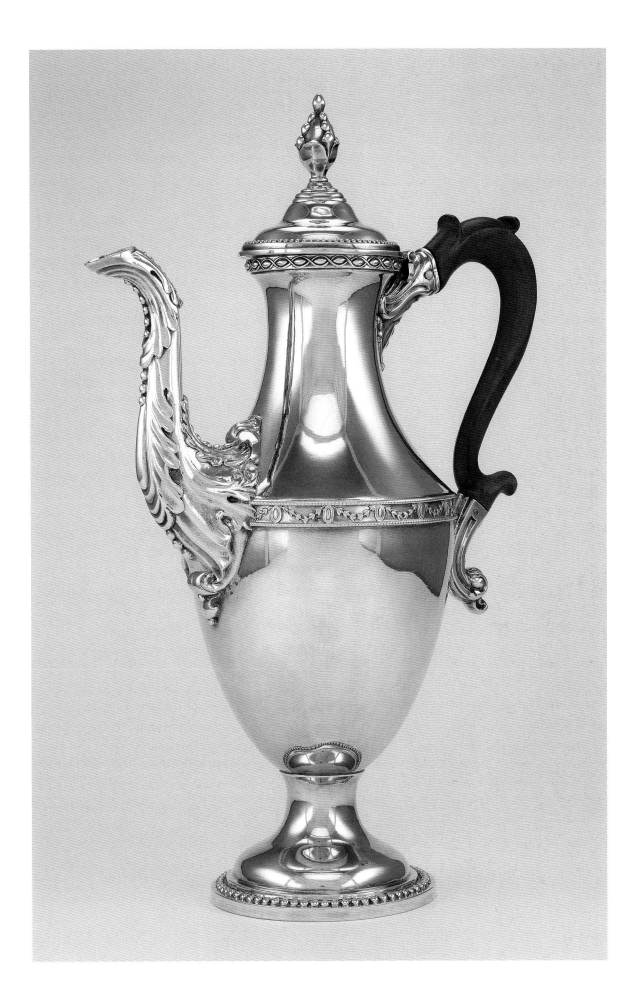

François Baillairgé

Canadian, 1759–1830

The Virgin

1797
Polychromed and gilded white pine,
137.3 × 55 × 47 cm
Purchased 1957

Saint John

1797
Polychromed and gilded white pine,
136.3 × 45 × 41 cm
Purchased 1957

When commissioned by the council of churchwardens of Saint-Jean-Port-Joli to execute a Calvary to adorn their church's main altar screen, François Baillairgé produced an extraordinarily fine group – one of the most accomplished ever made in Quebec. The story of the work began on 20 April 1794; as soon as the contract was signed, Jean Baillairgé informed his son François, who noted the details of the commission in his record book. As the winter of 1797 drew to a close and preparations were being made to install the architectural elements of the altar screen, François Baillairgé got to work, choosing as his subject a specific verse from the Gospel of Saint John (19:26): "When Jesus therefore saw his mother, and the disciple standing by, whom he loved, he saith unto his mother, Woman, behold thy son!"

The coherence of the composition reflects Baillairgé's great skill as a designer. Rather than create an archetypical image, he opted to represent a particular moment in the tragedy of the Crucifixion. In forming the tableau-like ensemble (the central *Christ on the Cross* can still be seen at the church of Saint-Jean-Port-Joli), he paid special attention to the positioning of his subjects, emphasizing the theatricality of the situation. Much more than simply anecdotal, the presence of the two figures at the foot of the cross has the effect of focusing attention on the deeper significance of the drama. The artist has allowed himself to dwell on the expressive character of each of the actors, which the structure of the composition serves to reinforce. The head of the dying Christ, tilted to the right as his gaze meets that of the Virgin, initiates a dynamic. Following the direction suggested by Mary's clasped hands, the viewer's eye is drawn naturally towards Saint John, whose pose leads us back once again to the central figure. Thus, by employing a traditional device based on the postural correspondence between pendant figures, the sculptor has subtly integrated the different protagonists into the scene. This virtual link has the simultaneous effect of reinforcing the sense of immediacy and of heightening the dramatic tension of this terrible moment.

Baillairgé composed his sculptures with enormous care. We sense here the quality of the design, especially in the sinuous curves of the Virgin's cloak. In the female figure the main power is in the outline, but in the *Saint John* the lines are more broken and the dynamic focus is in the region of the right wrist – point of origin of the principal lines and volumes. The placing of a centrifugal and a centripetal figure on either side of a central axis creates an extraordinary intensity. In both the *Virgin* and the *Saint John*, the drapery is rendered with a masterly skill that contributes to the eloquence of the whole. The white gowns have been vigorously carved, the necklines stand out crisply, every crease catches the light. While underscoring the physical presence of the bodies they envelop, the cloaks fall into broad, bold pleats that part to create lively effects of light and shade. And the handling of their surfaces is, again, remarkably sensitive: they appear almost hammered, faceted – never flat.

R.V.

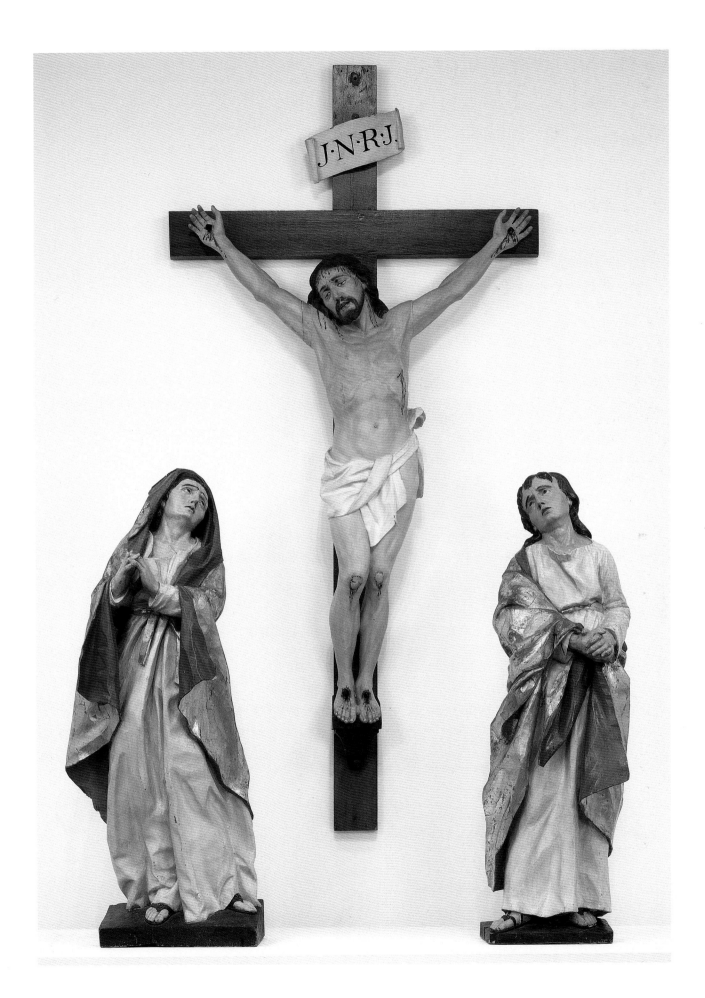

William Berczy

German/Canadian, 1744–1813

The Woolsey Family

1809
Oil on canvas, 59.9 × 86.5 cm
Gift of Major Edgar C. Woolsey, Ottawa, 1952

William Berczy, baptized Johann Albrecht Ulrich Moll on 10 December 1744 in Wallerstein (now in Bavaria), arrived in Upper Canada in 1794 by way of the United States. He had already received a sound artistic training at the Hof-Academie in Vienna and worked as an artist in several European countries, but it was in Canada that he would produce his mature work.

From July 1808 to July 1809 Berczy was in Quebec City, and this year is actually the best documented of those he spent in Lower Canada. Quebec was at the time the colony's most populous city, home to numerous government administrators, politicians, and merchants. Berczy's correspondence with his wife, who had remained behind in Montreal, indicates just how busy he was during this period: as well as doing some picture restoration, he painted at least eight miniatures, one watercolour portrait, and four oil paintings. These commissions were almost certainly unanticipated, for it is generally agreed that Berczy moved temporarily to Quebec City with the specific purpose of painting *The Woolsey Family*.

As we learn from the almost monthly progress reports he sent to his wife (herself an amateur artist), Berczy devoted considerable care to the conception and execution of this remarkable family portrait. He started, in the best academic tradition, by making studies of the eight figures, which he then transferred to the canvas – the same technique he had employed several years earlier in Italy when executing a family portrait for the Archduke of Tuscany. The composition is solid and well constructed, with the various figures presented in a hierarchic, frieze-like arrangement: the father, standing at the rear, dominates the scene, while the mother, her relatives, and the children succeed each other in the mid-ground, and the dog stands alone in the foreground.

Berczy has made use here of the device employed frequently in Neo-classical painting of picturing the models in an interior space. In this instance, the view seen through the window indicates that it is the drawing room of the family home on the Côte du Palais. This type of work, known as a "conversation piece," was already popular in Europe but hitherto untried in Canadian painting. The architecture of the room and the furniture add character to the scene, as well as serving to unify its various elements. The colours, with green and blue predominating, are rather cool, and the finish is smooth. The composition, the palette, and the manner in which the paint has been applied all combine to make this one of the finest examples of Canadian Neo-classical painting.

R.V.

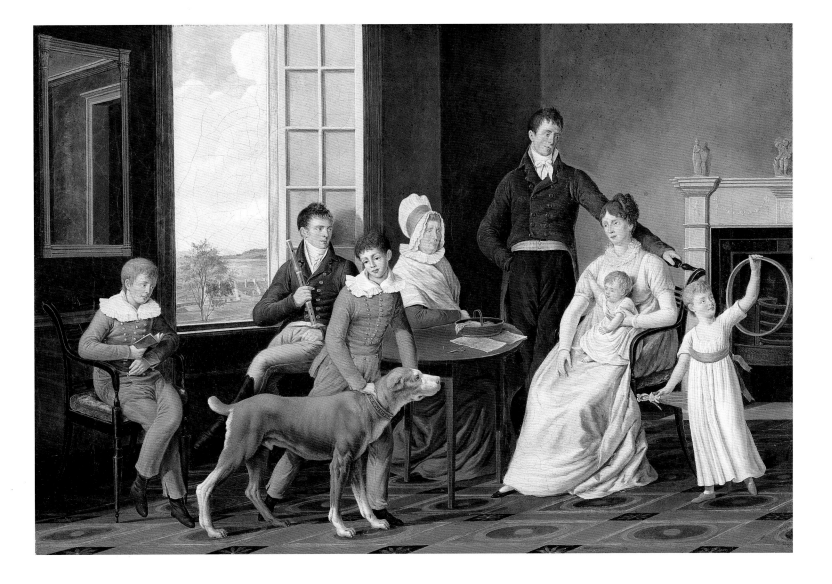

Robert Field

British, c. 1769–1819

Lieutenant Provo William Parry Wallis, R.N.

1813
Oil on canvas, 76.2 × 63.5 cm
Purchased 1950

In May 1808, recently arrived in Halifax, the painter, miniaturist, and watercolourist Robert Field set up a studio in the King Street building that housed the bookstore of Alexander Morrison. Born in England around 1769, Field had attended classes at London's Royal Academy Schools in 1790. He emigrated to the United States in 1794, and worked in a number of East Coast cities, including Philadelphia, New York, Washington, Baltimore, and Boston. He quickly became active in the local artistic communities and even helped found the National College of Painting, Sculpture, and Engraving in Philadelphia in 1795. It was quite common for portraitists at the time to move from city to city, and so it would have been quite natural for Field, like many other painters, to eventually travel north in search of new clients.

It proved to be a good move. Within a year of his arrival in Canada, Field had painted oil portraits of Sir George Prevost, the incumbent lieutenant governor, Sir John Wentworth, his predecessor, and Sir Alexander Croke, judge for the Vice-Admiralty Court of Nova Scotia (together with one of Lady Croke), as well as a miniature on ivory of Richard John Uniacke. Clearly, Halifax society lent the artist its wholehearted support. In the fall of 1816, Field departed for Jamaica, where he died in 1819.

The subject of this portrait, better known to history as Sir Provo Wallis, possessed all the qualities to inspire a painter. The work was probably executed shortly after Wallis's triumphant return to Halifax on 6 June 1813, following a bloody episode in the War of 1812 during which the H.M.S. *Shannon*, under his command, captured the American frigate *Chesapeake*. The sitter's biographer describes him as a young man of striking looks – "tall and well-proportioned, brave, amiable, and good-tempered." And the youthful officer pictured by Field is indeed handsome. The figure of the twenty-two-year-old Wallis, placed boldly in the foreground, occupies most of the picture surface. Positioned at a slight angle, he is dressed in his naval uniform, to which the gold epaulette lends a touch of military elegance. Field evidently took pleasure in rendering the details and decoration of the garments. The sensuality and beauty of the face is conveyed with great sensitivity, and the sitter's steady gaze imbues the composition with a sense of assurance and conviction. The dramatically cloudy background, against which the officer is proudly profiled, conjures both his recent naval victory and the ardour of his youth.

R.V.

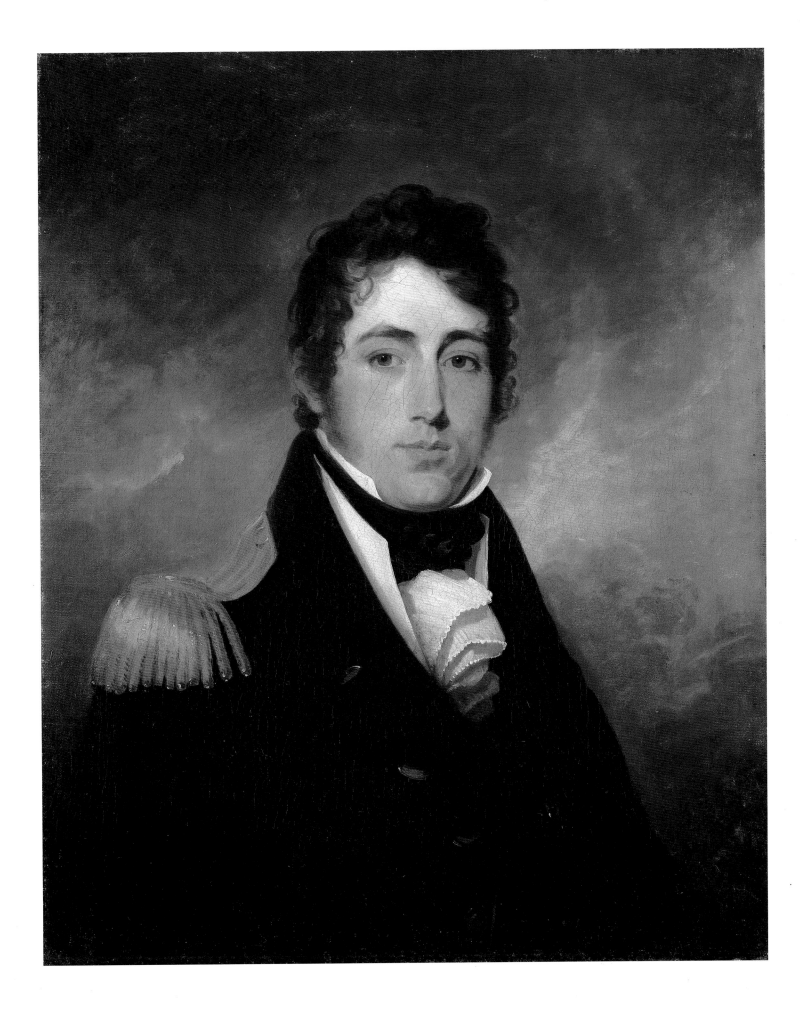

Antoine Plamondon

Canadian, 1804–1895

Sister Saint-Alphonse

1841
Oil on canvas, 90.6 × 72 cm
Purchased 1937

Émilie Pelletier was the eldest daughter of Pierre Pelletier, a Quebec City merchant, and his wife Marie Madeleine Morin. Born in 1816, she became a novice at the convent run by the hospitallers attached to the Hôpital Général de Québec in April 1838. On 15 October 1839 she took her vows as a choir sister, under the name of Sister Émilie Pelletier, *dite* de Saint-Alphonse de Liguori. She was immediately put in charge of teaching English and deportment to the institution's boarders. A competent musician, she occasionally played the organ in the convent's church. She died while still a young woman, in February 1846.

This portrait was acquired in 1937 from the wife of the model's great-nephew. The work was commissioned by Pierre Pelletier, Sister Saint-Alphonse's father, two years after she took her vows. Antoine Plamondon was at that time Quebec City's leading portraitist, and his encounter with the young nun resulted in one of the most accomplished works of nineteenth-century Canadian painting.

Earlier Quebec portrait painters had sought above all to convey the social status of their sitters. Plamondon, true to his European training, strove rather to capture their personality. Some ten years before this work was executed, the artist had studied in Paris – notably under Paulin Guérin, a disciple of Jacques Louis David. While in Europe, he developed a particular approach to the model based on Neo-classical principles. *Sister Saint-Alphonse* represents the culmination of a full decade of pictorial explorations.

The picture's scope and complexity is remarkable if we compare it to the painter's previous work. Here, Plamondon has employed a number of devices to ensure that the young woman's personality shines out from every corner of the canvas. The subtly balanced composition is built around an isosceles triangle. The model is seated in the mid-ground, at a slight angle. A light source located behind her defines the surrounding space and creates a sense of depth. In addition to this muted lighting, which brings out the volumes with great delicacy, there is around the outer edges of the painting a reddish glow that gives the work an almost supernatural feel. To maintain a sense of unity Plamondon has employed a palette of dark colours and halftones, carefully selected and meticulously applied. With a minimum of means, he has created a wide range of effects. The contrast between the veil of flowing black muslin and the immaculately starched wimple serves to focus attention on the face – the need to emphasize the human face is something the artist would remark on more than once in his writings. In this instance, Plamondon has brilliantly captured both the young woman's finely aristocratic features and the penetrating gaze that reflects an intense inner life.

R.V.

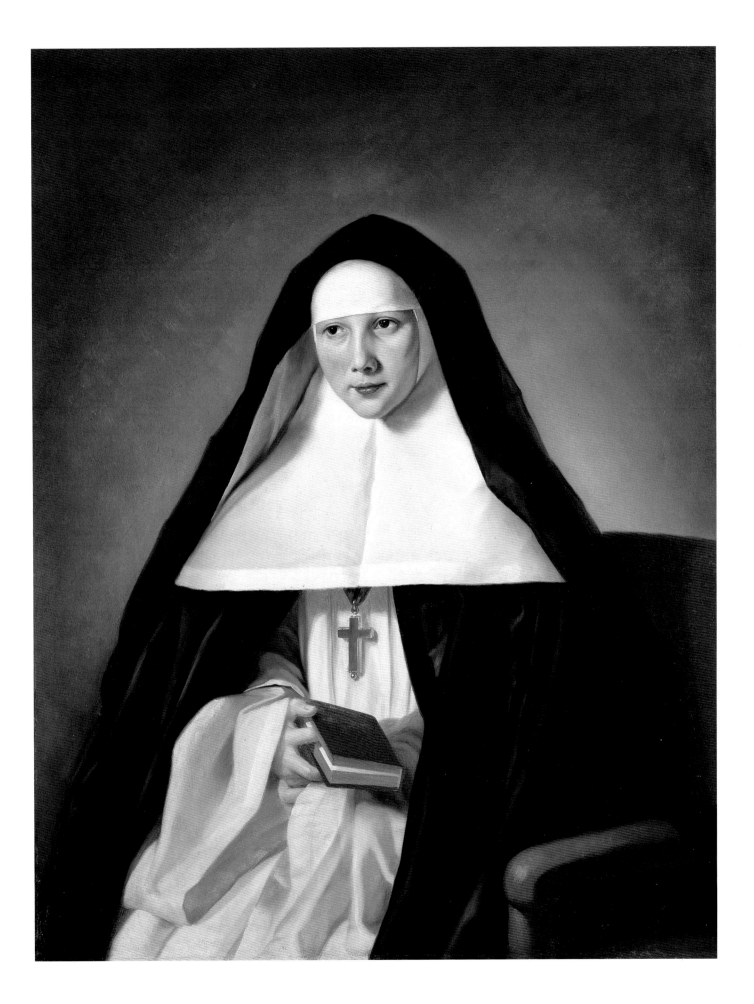

Paul Kane

Canadian, 1810–1871

Interior of a Clallam Winter Lodge, Vancouver Island

c. 1851–1856

Oil on canvas, 47 × 77 cm

Transfer from the Parliament of Canada, 1955

During his trip to London in 1843, Paul Kane visited the famous "Indian Gallery" of the American artist George Catlin. Inspired by this experience, Kane returned to Toronto in 1845 determined to assemble as many visual records as he could of the Aboriginal peoples of British North America, whose life and culture were being threatened by European colonization. With this as his goal, he set off in May 1846 on a two-and-a-half-year trip that would take him from the Great Lakes all the way to the Pacific. Throughout this difficult voyage, conducted on foot, on horseback, and by canoe, Kane portrayed numerous individuals and captured vivid scenes of villages, encampments, buffalo hunts, fishing expeditions, and ceremonies of various kinds. The hundreds of sketches he made on the trip provided him with a wealth of material for the series of paintings he executed in his studio after his return to Toronto in October 1848. During his adventure, the Hudson's Bay Company had provided Kane with transportation, hospitality at its posts, and a degree of protection in what amounted at the time to foreign territory. This enabled him to gather the largest nineteenth-century collection of images of Canada's Northwest. His work is of inestimable historical, ethnological, and topographical value.

It was in the spring of 1847 that Kane visited Vancouver Island. In April or May, he left Fort Victoria by canoe to visit a Clallam village. This marvellous scene shows us the interior of one of the great cedar bark lodges that the Clallam erected for protection during the winter months. Up to a hundred residents could be housed in such a structure. In the centre foreground, a group of people forming a circle are engaged in some type of communal activity; three individuals on the right-hand side are resting, and others towards the back are absorbed in handwork. Here and there, several figures appear to be looking directly at the viewer. The dimness all around lends a certain drama to the scene – the only significant source of light is the opening in the rear wall. The two holes in the roof add an anecdotal touch, for they are a sign that it is springtime and the building will soon no longer be needed. Should we regard this image as an accurate depiction of the various activities that would have taken place in such a dwelling, or rather as a sort of catalogue of the different functions of its various inhabitants? The painting's composition tends to indicate that it is an ingenious collage, in which fidelity to the subject may have given way to aesthetic considerations.

R.V.

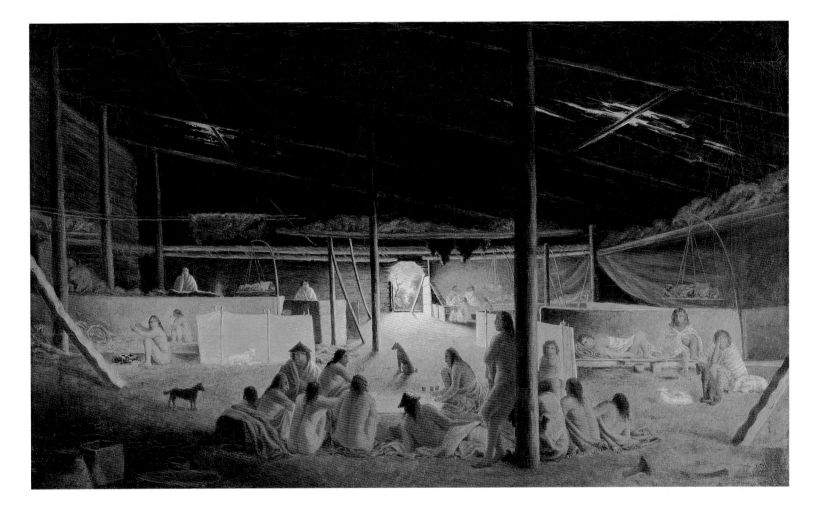

Cornelius Krieghoff

Canadian, 1815–1872

The Passing Storm, Saint-Ferréol

1854
Oil on canvas, 39 × 50.2 cm
Purchased 1963

Cornelius Krieghoff was born in Amsterdam and died in Chicago, but he spent much of his life in Canada, which is where the major part of his artistic career took place. Although he owed his fame to the popularity of his many works featuring French-Canadian peasants and Aboriginal people, he also had a strong interest in landscape. Even a cursory survey of his work is sufficient to establish that he was attracted to this genre virtually throughout his career. Indeed, in 1855 he applied to the government for a grant to execute a "panorama and a series of oil paintings representing Canada and including views of the main cities and the most important sites along the St. Lawrence and its tributaries, the Ottawa, the Saint-Maurice, the Richelieu, the Saint-François, and the Saguenay, right up to the Great Lakes." Advertisements from the period even indicate that a good many of these pictures were already completed. *The Passing Storm, Saint-Ferréol* may have been intended as part of this series. Krieghoff's penchant for landscape was no doubt reinforced by his move to Quebec City, where he drew considerable inspiration from the surrounding countryside.

This small painting is one of Krieghoff's first depicting a waterfall. Somewhat atypically, the artist made it a pure landscape, with no trace of a human presence. The picture's excellent condition allows us to appreciate the fine technique he had developed. Especially noteworthy is the nuanced handling of the rocks, which successfully combines literal description with expressive form. Krieghoff clearly took great pains to convey to the viewer the full range of the scene's many textures: notice, for example, the tree trunk lying diagonally at the lower right, caught in the turbulent water. If we stand back a little, we see that the composition is based on an alternation of dark and light that serves both a representational and an expressive function. This, plus the subtlety and complexity of the chromatic harmonies – essentially variations of brown, green, and red – means that any topographical interest the work may possess is eclipsed by our enjoyment of its colours, shapes, and textures. What we have here is an apparently spontaneous but in fact skilfully orchestrated composition that reveals all the mastery and sensitivity of an artist at the height of his career. Few of Krieghoff's paintings embody such strong emotion. He does not simply *show* us the approaching storm: he makes us *feel* it.

R.V.

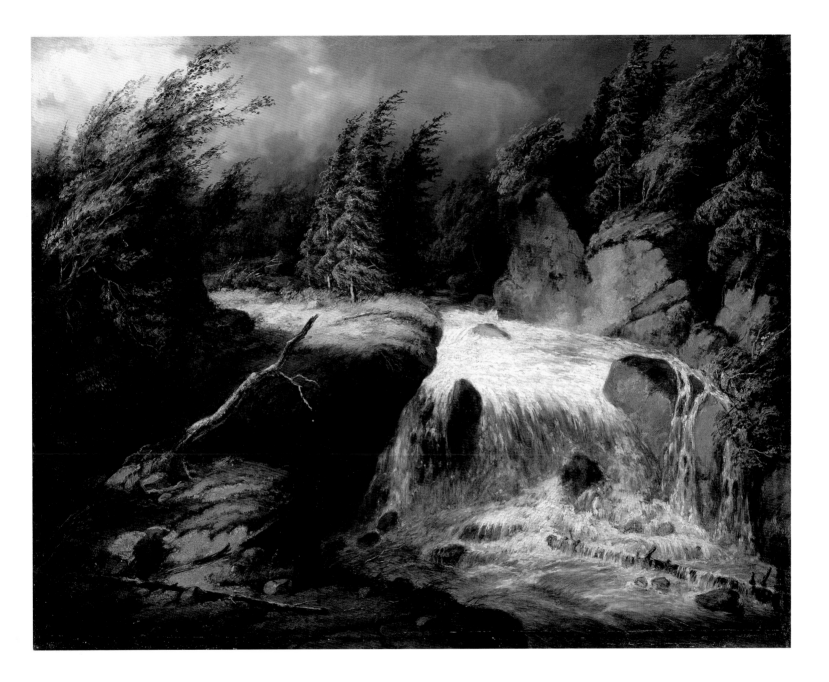

Lucius R. O'Brien

Canadian, 1832–1899

Sunrise on the Saguenay

1880

Oil on canvas, 90 × 127 cm

Royal Canadian Academy of Arts diploma work, deposited by the artist, Toronto, 1880

In March 1880 the Government of Canada created a National Gallery from the works donated by the charter members of the newly founded Royal Canadian Academy of Arts. As a condition of nomination and subsequent election to the Academy, each architect, designer, sculptor, and painter candidate was required to donate a diploma work giving evidence of his or her talents. One of the most prominent works in this core collection was *Sunrise on the Saguenay* by the Academy's first president, Lucius O'Brien.

The son of a former naval and army officer, O'Brien originally trained and worked as a civil engineer. By the early 1870s he had left the profession and embarked on a successful new career as a landscape painter. A man of high social standing and proven administrative abilities (he had served as vice-president of the Ontario Society of Artists since 1874), O'Brien was well chosen by the Governor General, the Marquis of Lorne, and his wife, Princess Louise, to direct the affairs of the nascent Academy.

In the wake of the rapid development of the railways in the 1850s, and especially after Confederation in 1867, artists explored Canada's various regions, capturing the expansive diversity of the new nation. O'Brien painted in his native Ontario, in Quebec, and in New Brunswick, working in watercolour until the mid-1870s and then also in oil. A refined draftsman with a subtle colour sense, he created paintings that are characterized by a gentle reserve and deliberation. In the summer of 1879 he visited Quebec City, most likely to attend the inauguration by the Governor General of the newly completed Dufferin Terrace, and then possibly travelled up the St. Lawrence and the Saguenay as far as Capes Trinity and Eternity, a popular spot with tourists and summer residents since the 1850s.

From this trip came *Sunrise on the Saguenay*, which was included in the Canadian Academy's inaugural exhibition in March 1880. Here the three faces of Cape Trinity rise from the waters of the Saguenay River on Eternity Bay. On the foreground beach, rocks, foliage, and a dead tree painted in jewel-like colours stand out against the glowing morning light, which casts a pink and yellow-green haze over the river and soaring cliffs. "The heights seem made for ever and abide" – these evocative words from the Marquis of Lorne's poem "Guido and Lita" were quoted by O'Brien in the caption for another of his paintings, *Capes Trinity and Eternity*, also included in the first Academy exhibition. The morning breezes have not yet risen, and all is calm. The only movement is the slow rhythm of the diminutive rowers, the distant steamboat, and the gliding gulls. O'Brien's world is serene, with no trace of turbulence – the manifestation of a divine presence and order in nature.

C.H.

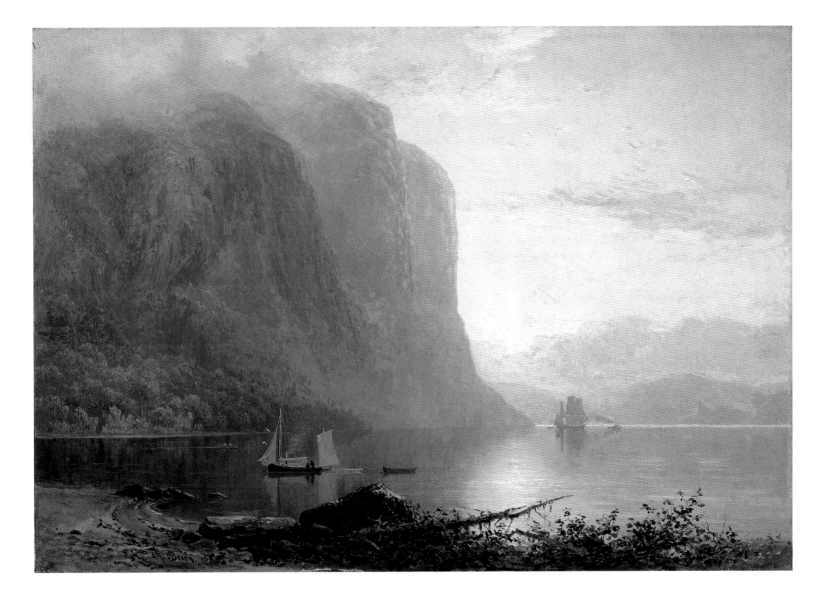

Robert Harris

Canadian, 1849–1919

A Meeting of the School Trustees

1885

Oil on canvas, 102.2 × 126.5 cm

Purchased 1886

Born in Wales, Robert Harris was brought to Prince Edward Island as a young child. After studying in Boston, London, and Paris, he settled in Montreal. By the turn of the century he had become Canada's leading portrait painter, though he is now best known for his *Meeting of the Delegates of British North America to Settle the Terms of Confederation, Quebec, October 1864*, painted in 1883–1884. Commonly referred to as *The Fathers of Confederation*, this large work was lost in the fire that destroyed the Parliament Buildings in Ottawa in 1916; a full-scale drawing of it is in the National Gallery of Canada's collection.

The art of the past always served as a great inspiration for Harris, and during his frequent trips to Europe he took detailed notes on the technique and composition of the paintings he saw. For *Meeting of the Delegates* he had studied the works of Raphael in the Vatican. During the summer of 1885, while on his honeymoon, he visited museums in Belgium and the Netherlands, carefully analyzing and copying paintings by Rembrandt and Franz Hals that he would translate into his *Meeting of the School Trustees*.

The work was inspired by the Government of Canada's call for paintings illustrative of the country's scenery and way of life, to be included in the 1886 Colonial and Indian Exhibition in London. It was first shown in Ottawa, in February 1886, under the title *Meeting of the Trustees of a Back Settlement School, Canada – The Teacher Talking Them Over*. The painting's subject is based on Harris's memories of his youth in Prince Edward Island, though the identification of the school and the teacher on the papers at the lower left, "Roll Pine Creek School – Kate Henderson Teacher," is an invention. "Pine Creek" was in fact Long Creek, near where Harris's uncle Joseph Stretch – the model for the trustee on the left – had a farm; the identity of "Kate Henderson" remains unknown. As with other Canadian artists of his generation who had been raised in farming communities but lived their adult lives in an expanding and rapidly changing urban environment, Harris's choice of rural subjects evoked a disappearing way of life. The presence of the artist's own name carved into the pupil's desk lends an added poignancy to this remembrance of youth.

The standing teacher, modelled by Harris's wife, Elizabeth Putnam, is the dominant figure. As in the seventeenth-century group portraits by Rembrandt and Hals that Harris had studied, she is silhouetted against the light that emerges from the window to her left. The dark interior on the right also helps to focus attention on the teacher as she addresses the seated male trustees, who listen in various attitudes of attentiveness and sympathy to the points she is making. The palette is muted and without high contrasts; the use of simple colouring, predominantly brown and grey, was another lesson Harris had learned during his European travels.

C.H.

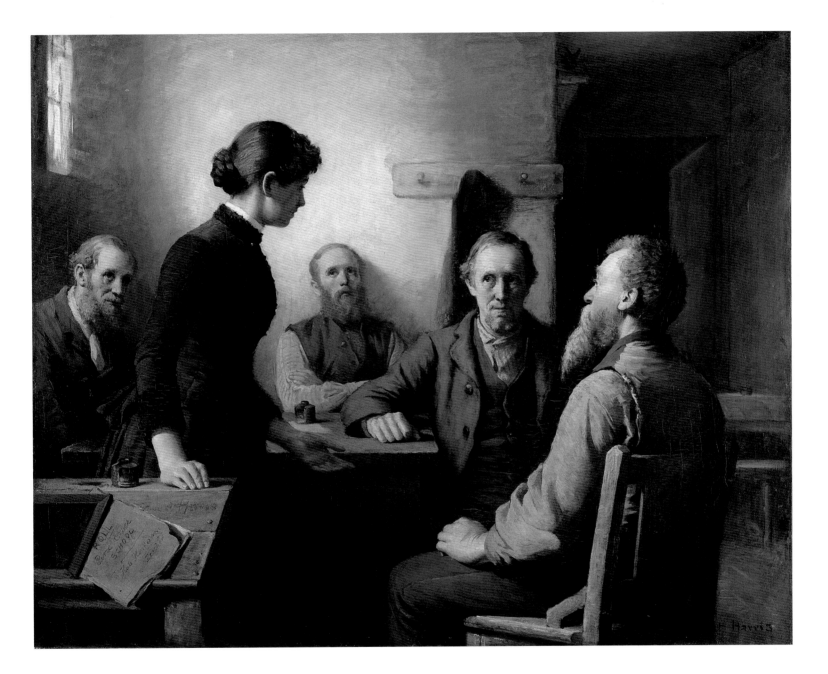

Farquhar McGillivray Knowles

Canadian, 1859–1932

Are you ready, lads?

1891

Watercolour over graphite on wove paper, 69.2 × 129.5 cm

Purchased 1982

During the late 1880s and early 1890s, when many of his fellow artists travelled to the Rockies for their summer sketching trips, Farquhar McGillivray Knowles resisted the temptation to join them, having already found his creative inspiration in the coastal villages along the banks of the St. Lawrence River in Quebec. Knowles had been painting the region since 1883 and submitting his watercolours, with modest success, to the annual exhibitions of the Ontario Society of Artists and the Royal Canadian Academy. During the summer of 1890 he concentrated on the fishing village of Percé, situated on the Gaspé Peninsula. Conscious, perhaps, of the need to compete with the thrilling views of the Rockies that were certain to be entered in the exhibitions of 1891, Knowles produced three large, highly dramatic watercolours. *Are you ready, lads?* is the most striking of them.

To comply with his family's wishes, Knowles briefly pursued a military career before following his own desire to become an artist. He received his early artistic training in Toronto under John A. Fraser, most likely while employed by the studio of Notman & Fraser to tint and compose photographic group portraits. With its brilliant colours, *Are you ready, lads?* owes much to Fraser's influence, and its subject recalls the latter's 1881 canvas *Morning on the Beach at Percé* (now in the Toronto Public Library's collection). Knowles's emphasis on the figures of the fishermen pulling their nets onto the beach suggests that his work at the photographic firm – renowned for its painted composite group portraits – also left its mark. Another influence may have been the widely published work of the English artist Stanhope Forbes and other members of the Newlyn School, whose paintings depicted life in the quaint Cornish fishing village where the artists' colony was situated.

Upon his return to Toronto from his Gaspé sketching trip in 1890, Knowles began to promote his new work as never before. In October he put on an exhibition in his studio that earned him complimentary reviews in the press. The following February he held an open house to preview his entries in the upcoming society exhibitions. Favourably impressed, one critic described Knowles as "working a quiet revolution in Canadian art." *Are you ready, lads?* and its companion pieces, *Gathering Kelp* and *At Gaspé* – both of which are also in the National Gallery of Canada's collection – were highlights of the Royal Canadian Academy exhibition in March and the Ontario Society of Artists exhibition in May. All three works are on a scale comparable to large academic paintings. *Are you ready, lads?* was singled out for its colourful and complex composition, as well as its concentration of figural work, unusual among the abundance of landscape watercolours on view. Unfortunately, Knowles's success in achieving critical acclaim did not translate into sales.

In November 1891, Knowles put a large collection of his watercolours up for sale at auction in order to finance a trip to England and France. In all probability, *Are you ready, lads?* was sold at that time. And, fittingly, one of the places where Knowles went to sketch on the trip was Newlyn, in Cornwall.

R.T.

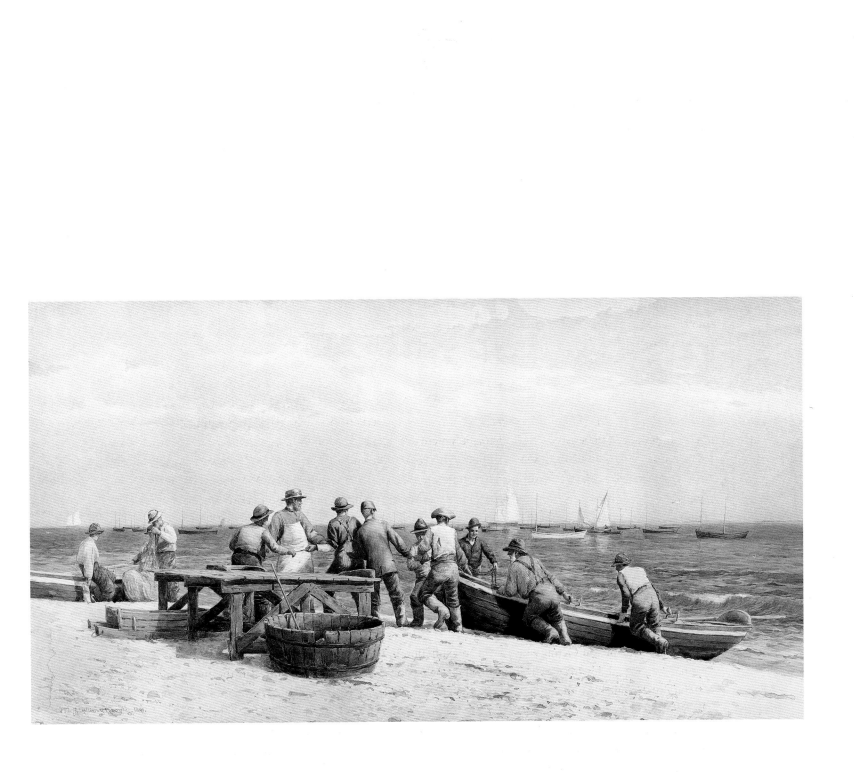

Ozias Leduc

Canadian, 1864–1955

The Young Student

1894
Oil on canvas, 36.7 × 46.7 cm
Purchased 1974

A young man dressed in a plain cotton shirt, a vest, and a cap is studying a page of a magazine. In his right hand he holds a pencil to take notes or – a possibility suggested by the watercolour brushes in the glass – to copy the illustration. The intimacy of this everyday subject is enhanced by the confined space and the simplicity of the interior, with its plain wooden chair, green table covering, and neutral background, all of which are bathed in a soft, natural light. The concentration with which the student examines the magazine is effectively conveyed by the power of his gaze. The dual message seems to be that in art, sight is of the essence, and that assiduous study is the best means to develop one's potential.

And what is the young man reading so attentively? The spine of one of the books reveals it to be a catalogue of the art salon held annually by the Parisian Société Nationale des Beaux-Arts, and the magazine is probably an art periodical. The model was the artist's brother, Honorius Leduc, but the painting is an evocation of Ozias Leduc's own youth and his early ambition to become a professional artist even though he was far from the art centres of Europe and had no direct access to the works of the world's great artists, past and present. (It was not until 1897 that he finally had the means to visit Paris.)

Leduc was born in Saint-Hilaire, southeast of Montreal, and he remained in this small village most of his life, working as a decorator of church interiors. It was in the mid-1880s that he began to exhibit easel paintings, including portraits, genre scenes, and still-lifes. *The Young Student* is in part a still-life whose elements – the books, pencil, and brushes – evoke the world of art and learning. At the same time, however, it is a "genre" scene, a scene from daily life. On a preparatory drawing of 1892 for another painting in the National Gallery's collection, *Boy with Bread*, which depicts a young man playing a harmonica while seated before a table bearing an empty bowl and a crust of bread, Leduc inscribed the Latin expression "multum in parvo" – much in little – affirming the spiritual enrichment of the arts despite the relative poverty of the material environment. Like the Dutch artists of the seventeenth century, Leduc found in the small details of his immediate surroundings all that was necessary to express his deepest values and ideas.

C.H.

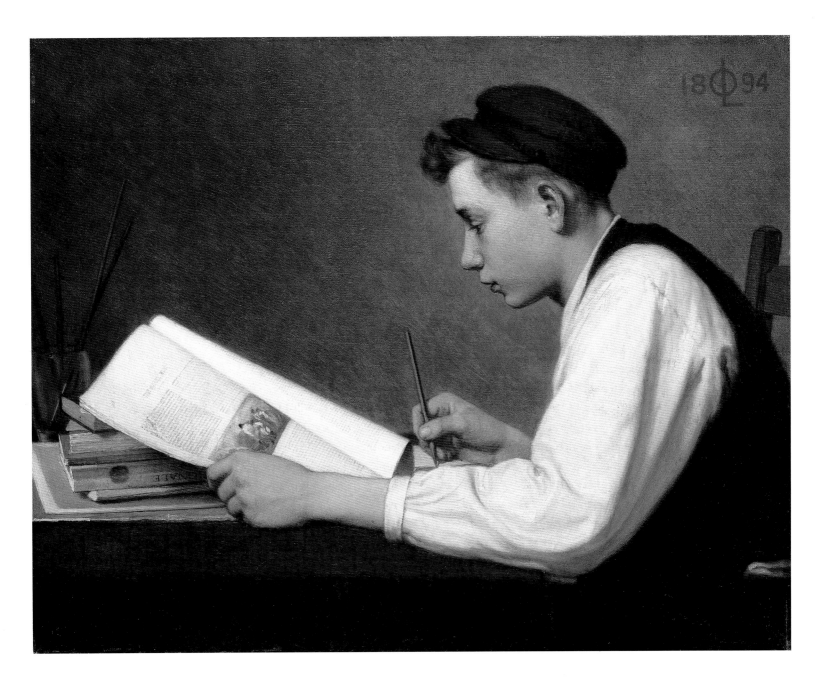

Marc-Aurèle de Foy Suzor-Coté

Canadian, 1869–1937

Winter Landscape

1909

Oil on canvas, 72.2 × 94.4 cm

Gift of Arthur S. Hardy, Ottawa, 1943

The son of a notary, Théophile Côté, and of Cécile-Adéline Suzor, Marc-Aurèle Suzor-Coté (he would later add his maternal grandmother's family name, de Foy) was born in the Quebec village of Arthabaska, southeast of Trois-Rivières, and would find in the environment of his native region much of the inspiration for his later paintings. He worked first as a church decorator, but in 1891 left for Paris, where he studied with some of the leading academic painters of the day. Over the next two decades he would move regularly between Paris, Montreal, and his native Arthabaska.

A sculptor as well as a painter and draftsman, Suzor-Coté was an artist of great technical skill who applied his talents to a variety of subjects that included still-lifes, portraits, and history and genre scenes, as well as landscapes. Starting around 1900, the theme of a winter stream coursing between snow-covered banks was one he would return to frequently, interpreting it with an increasingly Impressionist palette and touch. While the rushing waters evoke the change of seasons and thus the passage of time and of life, their prime subject is the colour and light of the Canadian winter – a subject ignored by the preceding generation of artists but revived by students of the French Impressionists. The dazzle of whites, blues, and pinks is superbly treated in this work, which is most assuredly the finest of Suzor-Coté's winter landscapes.

The painting depicts a bend in the Nicolet River where it traverses a settled and modified landscape near the village of Arthabaska. Evidence of human activity can be seen in the fence on the far bank, the pollarded willows, and the bridge glimpsed in the middle distance. The artist has made extensive use of a palette knife in applying the paint, creating a roughly textured, dry, and very tense surface that enhances the effect of the clear winter light and unifies the composition. While the background recedes into a perspectival space, the foreground is painted as if viewed from above. This results in a flattening of the image reminiscent of Japanese prints and Art Nouveau designs, an effect reinforced by the diagonal flow of the water and the sinuous line of the riverbank.

Winter Landscape was formerly in the collection of Senator Arthur Hardy, from Brockville, Ontario, whose wife was the daughter of Senator G. T. Fulford, an associate of Prime Minister Sir Wilfrid Laurier. Laurier, who had been the mayor of Arthabaska and served as its representative in the House of Commons, was a great supporter of local artists, including Suzor-Coté and the sculptor Alfred Laliberté. It was most probably with Sir Wilfrid's encouragement that Hardy purchased this painting around 1912.

C.H.

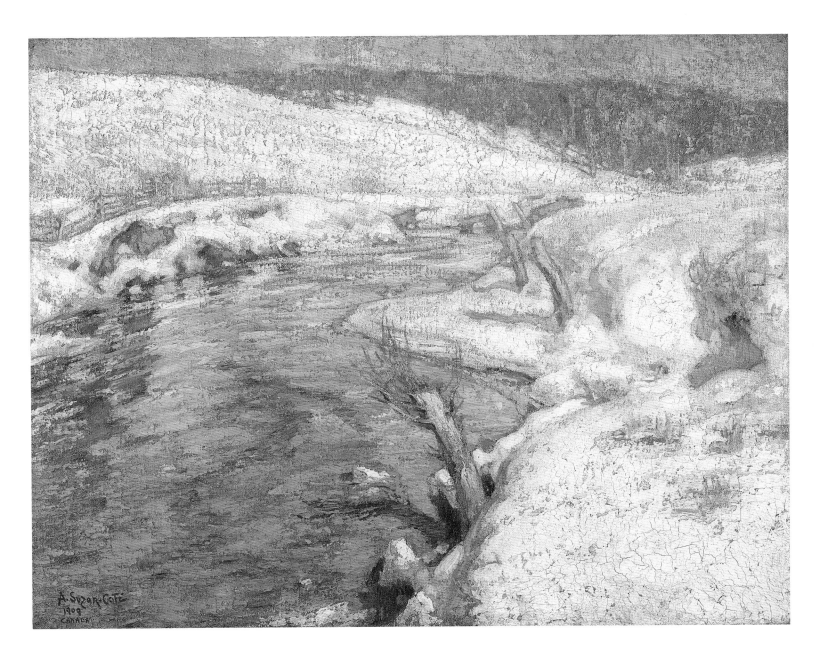

Louis-Philippe Hébert

Canadian, 1850–1917

Le Moyne de Sainte-Hélène

1910
Bronze, 50.9 × 53 × 25.1 cm
Purchased 1992

Louis-Philippe Hébert, who was born on a farm near the village of Sainte-Sophie d'Halifax in the Bois-Francs region of Quebec, began his career as a carver of wood sculptures for churches. His first commemorative monument was the one dedicated to Charles-Michel de Salaberry, produced in 1880–1881 for the town of Chambly, Quebec; this was followed by the monument to Sir George-Étienne Cartier for Parliament Hill, in Ottawa, which Hébert worked on between 1882 and 1885. These two monuments launched his career as a sculptor in bronze. In 1886 he travelled to Paris to perfect his art and to execute a number of commissions for the facade of the Quebec legislature. By the turn of the century he had become Canada's leading sculptor, and today his monuments can be found across the country – from Halifax, Nova Scotia, and Saint John, New Brunswick, to Calgary, Alberta, and New Westminster, British Columbia.

Hébert maintained a lifelong interest in the history of New France, whose narrative and heroic content provided an imagery for French identity in North America. As a youth, he had been an avid reader of the accounts of the Jesuit missionaries to New France, and the 1886 commission for the Quebec legislative building reinforced this earlier preoccupation. From the 1890s on, Hébert realized a number of smaller sculptures, in plaster, terracotta, and bronze, that were inspired by his readings of both literature and history and that dramatized the lives and struggles of the country's first settlers.

The event depicted in *Le Moyne de Sainte-Hélène* occurred on 16 October 1690. The American-born British admiral Sir William Phips had laid siege to Quebec and demanded the surrender of the city, eliciting the famous retort by Governor Louis de Buade, Comte de Frontenac: "I have no reply to make to your general other than from the mouths of my cannon." A shot brought down Phips's mast and along with it the British flag; according to the historian François-Xavier Garneau, some brave Canadians swam out under fire and seized it as a trophy. Soon after, the British ships returned to Boston in defeat.

Hébert first conceived this image in 1901 in a terracotta he called *À la nage*, borrowing the title of a poetic account of the event by his close friend Louis Fréchette in the 1887 book *La Légende d'un peuple*. The sculpture was enlarged and cast under the same title in 1910. Hébert later had three bronzes cast in Paris under a new title, *Le Moyne de Sainte-Hélène*, in accordance with Fréchette's erroneous identification of the principal hero as Jacques Le Moyne de Sainte-Hélène.

Executed relatively late in Hébert's career, this is nonetheless one of the artist's finest historical compositions and has an exceptionally rich patina. The broken mast from Phips's ship floats uselessly on the waves, serving as a support for the beautifully sculpted nude figure of Le Moyne de Sainte-Hélène. Like a heroic Neptune, he rises from the water, holding the flag up in defiance of the English forces and inspiring his fellow Canadians with the roar of his taunts.

C.H.

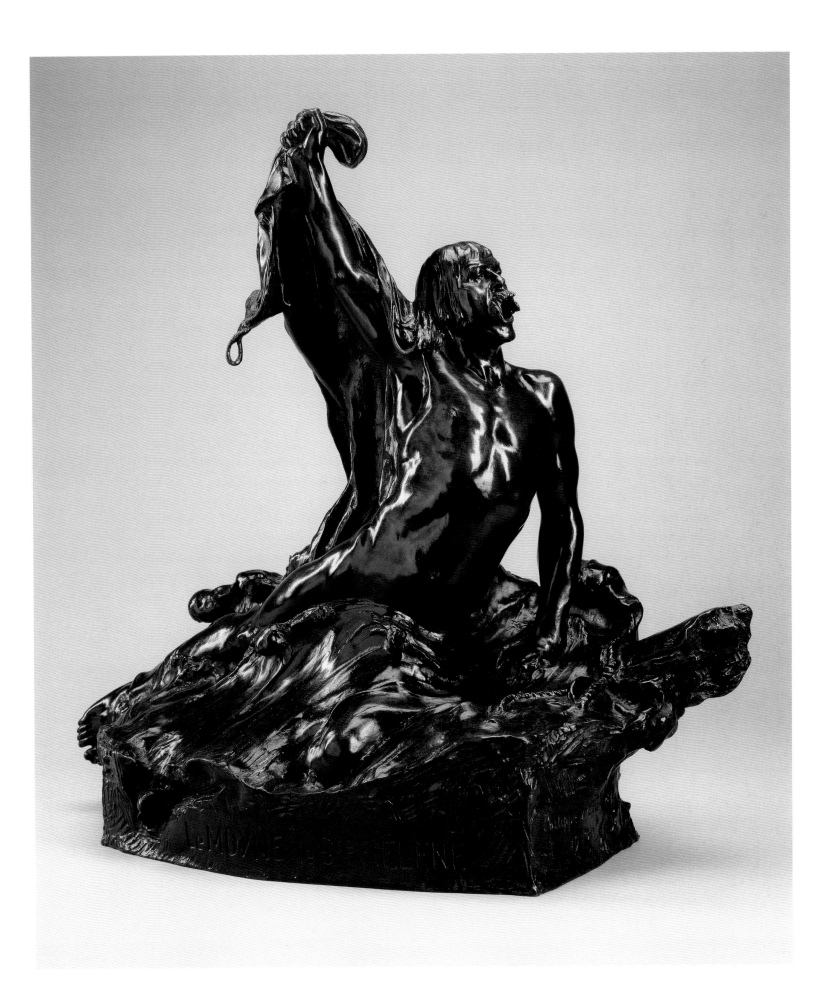

Emily Carr

Canadian, 1871–1945

The Welcome Man

1913
Oil on paperboard, 95.3 × 64.8 cm
Gift of Bryan Adams, December 2000

Although Emily Carr had studied art as a young woman in California, England, and France, it was not until 1912, at the age of forty, that she produced her first mature paintings. As she became increasingly aware of the crisis facing the Aboriginal peoples in British Columbia, who were oppressed by legislation and the Christian churches, decimated by disease, and witnesses to the destruction or removal of their cultural heritage, Carr resolved to paint their houses and totem poles in the communities and landscapes in which they originated. In the summer of 1912 she travelled north from Vancouver to Alert Bay, visited the Kwakwaka'wakw (Kwakiutl) villages of Tsadzis'nukwame', 'Mi'mkwamlis, Kalugwis, and Gwa'yasdam's, and then travelled up the Skeena River and over to Haida Gwai, also known as the Queen Charlotte Islands. The trip took six weeks in all, and by September Carr was back in her Vancouver studio. Most of the studies painted on this trip – single poles, houses and their interiors, street scenes, and panoramic views of villages, both occupied and abandoned – were in watercolour, which she translated into oil in the high-keyed palette she had learned in France. In April 1913 she organized an exhibition of some two hundred of her paintings at Dominion Hall in Vancouver, but sales were few. In addition, the economic recession that began that year was exacerbated by the outbreak of war in 1914. Running a boarding house and a kennel for her livelihood, Carr was forced to give up painting completely until the early 1920s.

Carr inscribed the name of the village of Karlukwees (Kalugwis) on this painting, but the scholar Peter Macnair has identified the subject as a potlatch figure in the nearby village of 'Mi'mkwamlis. Its arm outstretched in the gesture of an orator, the sculpture – presumably erected to welcome guests – is placed in the foreground, filling the frame. Its dark form is silhouetted against the blue and purple mountains and small islets in the distance, and the sky and water are bathed in the yellow light of the setting sun. As in Carr's paintings from 1912, the trees and foreground shore are rendered in short, rapid strokes that break up the form and create a lively surface. However, the dramatic effect of the painting is heightened by the bold simplicity and relatively unmodulated treatment of the silhouetted figure.

Dated 1913, and possibly painted just before the April exhibition, this work represents the culmination of the first period of Carr's career. It is also linked directly to her second period, beginning in 1928, when she painted new canvases from her pre-war studies. Around 1930, Carr reinterpreted *The Welcome Man* in *Silhouette No. 2*, now in the collection of the Vancouver Art Gallery. In that work the issues explored in the earlier painting are resolved in an even more three-dimensional and angular treatment of figure, shore, and mountains.

Contemporary interest in feminism, Aboriginal and colonial history, ecology, modernism, and nationalism has led to a growing recognition of Carr as one of the most compelling and important Canadian artists of the first half of the twentieth century. Her art, as evidenced by the superb *Welcome Man*, was a process of constant growth: through repeated analysis and experimentation, she continually sought the appropriate means to articulate her changing perceptions.

C.H.

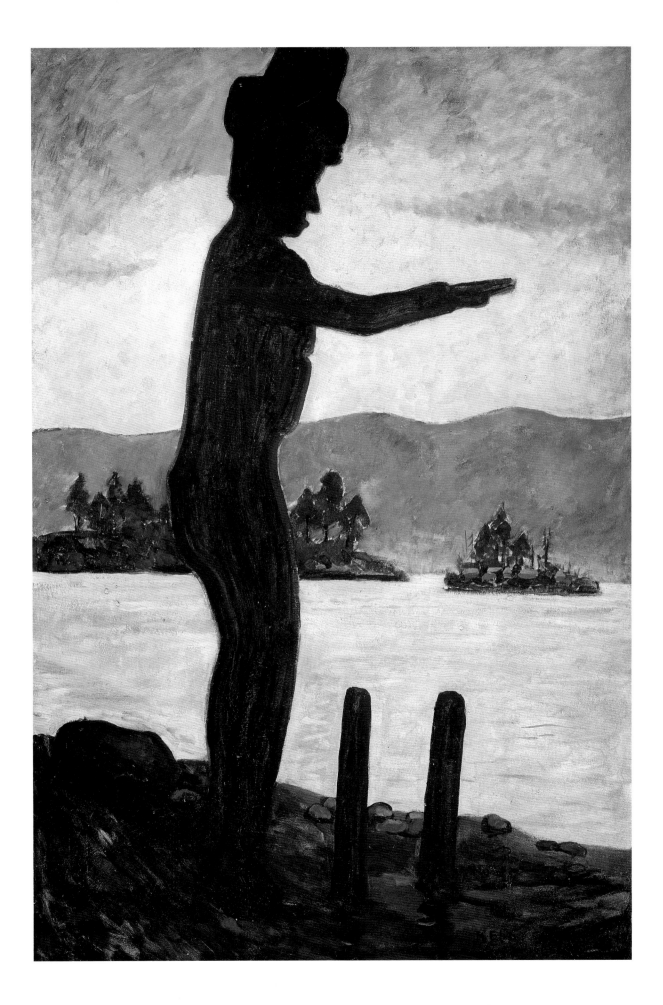

James Wilson Morrice

Canadian, 1865–1924

Café el Pasaje, Havana

c. 1915–1919
Oil on canvas, 65.8 × 67.5 cm
Gift of G. Blair Laing, Toronto, 1989

In 1890, soon after having completed his bar exams to practise law in Ontario, the Montreal-born James Wilson Morrice left for Paris to take up a career as an artist. The French capital remained his home for the rest of his life, although he travelled and painted in Brittany and Normandy, Italy, Spain, and North Africa. Throughout the years he maintained contact with Canadian artists, sending his paintings to exhibitions in Montreal and Toronto and contributing to the furtherance of modern art in Canada. Working within an aesthetic defined by Gauguin and the Nabi painters Pierre Bonnard and Édouard Vuillard, he would become the first Canadian artist to achieve an international reputation.

In December 1914 Morrice returned to Montreal to join his family for Christmas. Both his parents died within the month, and he decided to leave the country to travel. During the two preceding winters he had painted in Tangiers with Henri Matisse, but travel was uncertain during the early months of the First World War. At the suggestion of the son of the railroad magnate Sir William Van Horne, who had been responsible for the construction of a railway in Cuba after the Spanish-American War and who owned an imposing residence there at Camagüey, Morrice visited the island, spending most of his time in Havana and Santiago de Cuba. After a short visit to Jamaica, he was back by mid-April 1915 in Paris.

The scholar John O'Brian has aptly associated Morrice's lifestyle and art with Baudelaire's concept of the "flâneur," described by the poet as someone who wanders through the modern city "amid the ebb and flow of movement" yet "remains hidden from the world." Whether in Paris, Venice, or Tangiers, cafés always offered Morrice the perfect vantage point from which to observe and sketch the passing scene, which he invariably animated with a slow and silent rhythm. In *Café el Pasaje, Havana*, a lone drinker wearing a sombrero inhabits the shaded interior. Only the tops of the tables are fully visible, their legs being merely suggested by a loose network of thin black lines and the same scratching of the paint with which the artist also reinforced the outlines of the shutters, chairs, and railing. From the foreground through to the middle ground, repeated verticals define the interior and exterior spaces and frame the three figures – wearing North African rather than Cuban dress – on the sun-filled street. Beyond, the delicate yellow hue of the trees, enlivened with touches of green and orange, contrasts with the thickly painted blue sky. "Bright colour is what I want," Morrice had written to a friend on his departure for Morocco, and the southern light would continue to enthral him for years to come.

Café el Pasaje, Havana, the finest Morrice in the collection of the National Gallery of Canada, is one of eighty-three paintings by the artist donated in 1989 by the noted Toronto art dealer G. Blair Laing.

C.H.

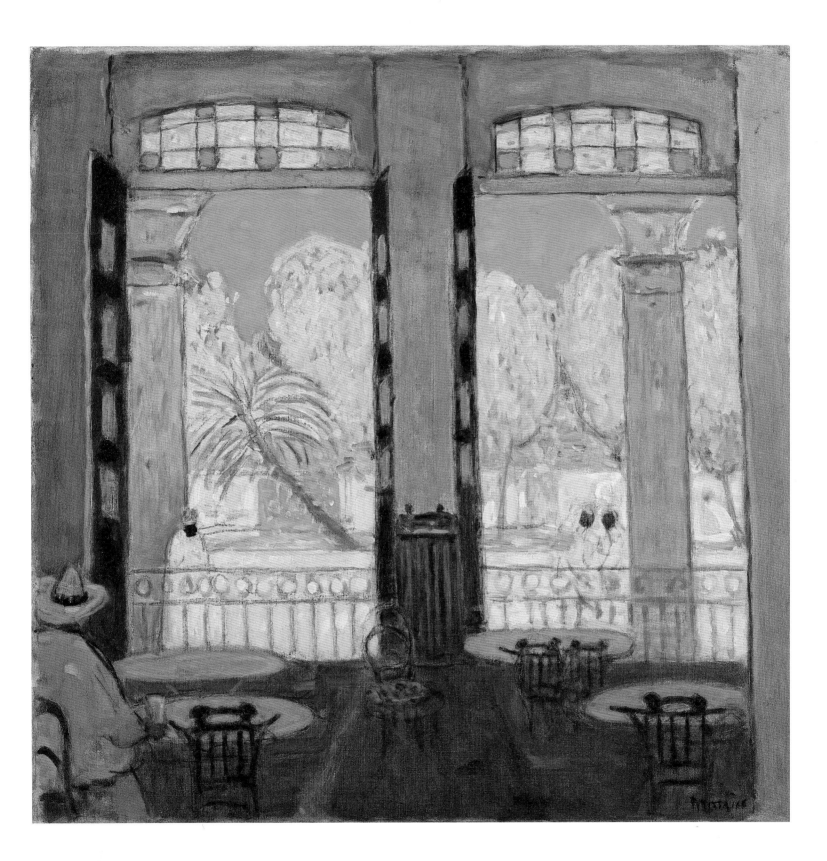

Tom Thomson

Canadian, 1877-1917

The Jack Pine

1916–1917
Oil on canvas, 127.9 × 139.8 cm
Purchased 1918

Tom Thomson has become a mythic figure in Canadian art. His tragic death by drowning in 1917 after a brief but stellar career has intrigued the public for decades. Yet Thomson's life is no less fascinating than the myth, for his paintings and drawings up to 1912 are conventional and show no hint of the superb artist he was to become within the short span of five years.

Encouraged by the artists with whom he worked as a commercial designer at Grip Limited in Toronto, Thomson only began painting seriously around 1912. That year, he made his first major canoe trip in northern Ontario and visited Algonquin Park, which became the stage on which his art and life would be played out over the next five years. Following the example of his colleagues, Thomson painted his oil sketches on paper-board or wood panels, translating selected works into larger canvases in his Toronto studio during the winter. From low-keyed, almost sombre studies of open water and distant shores, his painting evolved at a remarkable pace as he explored the landscape and studied the varying lights and colours of spring and autumn.

The Jack Pine was painted during the winter of 1916–1917. The original study, an oil sketch now in the Weir Foundation at RiverBrink in Queenston, Ontario, was painted in the north of Algonquin Park, most probably at Lake Cauchon, in the spring of 1916, on a standard horizontal board measuring 8½ by 10½ inches (whereas the finished canvas is almost square). The linear tracery of the tree has a graphic quality, reflecting Thomson's training as a designer, yet the painting also exemplifies his superb talents as a colourist. Thomson first drew the outlines of the hills, tree, and foreground in the vermilion paint that glows around the edges of the forms. The sky and water are painted in broad bands, as are the details of the foreground. Dominating the canvas is the jack pine. Its red branches – many devoid of needles, others supporting abstractly rendered khaki-green clumps – are silhouetted against the subtle yellows, greens, and pinks of the sky. The tree is set to the right of centre, against a background of blue-black hills still showing traces of snow, painted in mauve and turquoise. Together, the square format, the horizontal bands of paint, and the almost triangular form of the tree, echoed in the rounded hills, create a sense of repose and meditation that is enhanced by the soft evening light. In this painting Thomson has resolved the formal problems that preoccupied him in all his earlier works and achieved a perfect synthesis of his love for the northern landscape, his sensitivity to its colours, and his talent as a designer.

C.H.

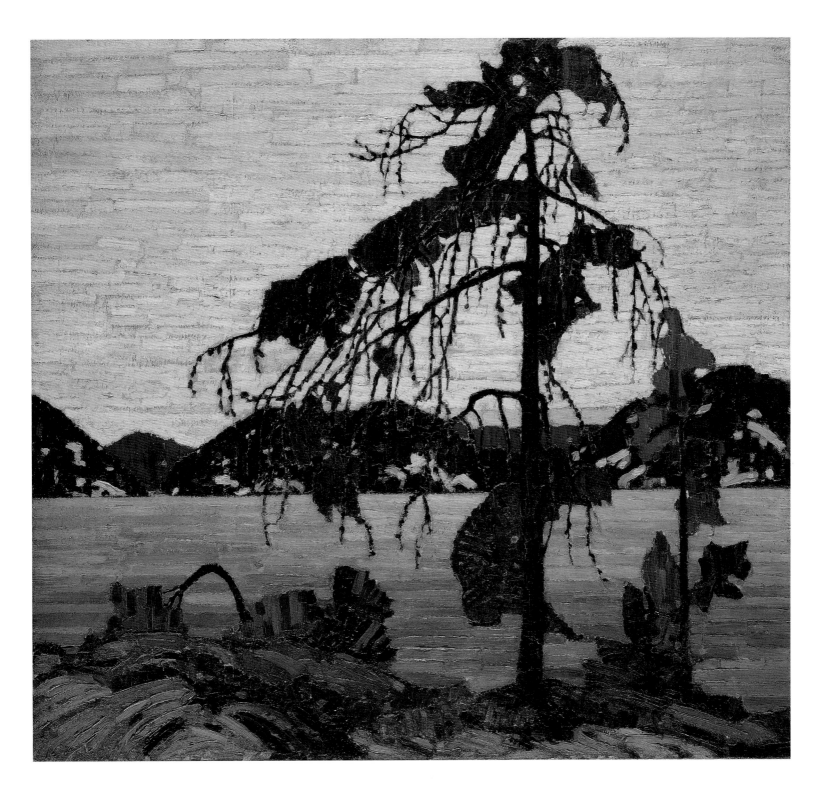

Lawren S. Harris

Canadian, 1885–1970

Decorative Landscape

1917
Oil on canvas, 122.5 × 131.7 cm
Purchased 1992

Spruce trees, painted in a rich, electric blue over a dark maroon highlighted in green, crown waves of purple and blue rocks whose colours are echoed in the hills that can be glimpsed in the distance. Horizontal strokes of a deep yolk-yellow, rising to a brighter though equally intense citron, touched with pale turquoise, set off the brilliant blue trees. Subtly incorporated into the sky are shafts of sunlight that extend diagonally towards the upper corners of the canvas. Virtually square, the painting is a tranquil image, almost one of devotion.

Decorative Landscape is the most extreme of a series of winter landscapes that Lawren Harris began in 1914 after seeing an exhibition of Scandinavian art in Buffalo, New York, in January 1913. Having studied in Germany from 1904 to 1907, Harris returned in 1908 to Toronto, where he drew and painted houses on the city's older residential streets. He went on sketching trips in Quebec and Ontario, producing landscapes in muted, sombre colours. The Scandinavian exhibition triggered a radical break from his earlier work and provided him with the means to treat subjects that he and his fellow artists saw as characteristic of northern climes. Over the next six years, finding his subjects in the valleys north of the city, he experimented with brighter colours and bolder brushwork, arranging screens of snow-bound trees in flattened compositions across the foreground and allowing only a glimpse of open space and distant hills. Harris's earlier canvases were painted in more naturalistic and Impressionist palettes of whites, blues, and pinks, but for *Decorative Landscape* he adopted a non-naturalistic palette of purples, blues, and yellows, probably stimulated by the writings of the American Synchromists, who explored the relationship of colour, emotion, and form. Unlike his American contemporaries, however, Harris did not create an abstraction but structured nature in a decorative and mystical image that recalls the work of the early nineteenth-century German artist Caspar David Friedrich, whose paintings he had undoubtedly seen in Berlin. Nonetheless, the formal power of the work is considerable: there is a subtle tension between the linearity in the trees and sky and the volcanic energy of the rocks. While the influence of Harris's work on Tom Thomson is well known, it could be argued that this painting owes much to Thomson's last canvases, executed during the winter of 1916–1917, including *The Jack Pine*.

Decorative Landscape was exhibited only once during the artist's lifetime, in the spring of 1917. It was received then with dismay and some consternation, and labelled variously as "a garish poster," "an experiment in colour," "a curious and arresting design," and "decorative in the extreme." That summer Thomson drowned, and the following spring Harris suffered a collapse, resigned his commission in the army, and made his first trip to the Algoma region of Ontario. A new phase of his career had commenced, and this most radical painting was put aside; it was not included in either of his retrospective exhibitions, and was sold only after 1963. The intensity of colour contrasts, the boldness of the richly brushed foreground, the tension of the composition, and the rays of light emanating from behind the trees show Harris pushing colour, decorative form, and symbolism further than in any of his works prior to 1919. Together with Thomson's *Jack Pine*, this painting marks the high point of the first period in the work of those artists who would become known in 1920 as the Group of Seven.

C.H.

David B. Milne

Canadian, 1882–1953

Pink Reflections, Bishop's Pond

1920

Watercolour over graphite on wove paper, 37.7 × 54.7 cm

Gift from the Douglas M. Duncan Collection, 1970

Excelling as a painter, watercolourist, printmaker, and theorist, David Milne holds a pre-eminent place in the pantheon of Canadian artists. His reputation rests not simply on his mastery of each individual discipline, but also on the way he resolved certain aesthetic problems through an intelligent, reciprocal dialogue between various media. The result was a body of work of astonishingly high quality that displays a clear and logical progression over a five-decade career.

One of the problems that Milne kept coming back to throughout his career was how best to depict reflections. His interest in reflections centred mainly on the challenge of rendering similar forms and colours in different textures – that is, the actual scene and its watery reflection. Milne's earliest efforts on this theme date from 1906 to 1908 and show only a rudimentary understanding of the problem, which he handled in conventional ways. By 1916, he was producing watercolours like *Reflections (Bishop's Pond)*, also in the collection of the National Gallery of Canada. In that work, his approach was to use a grey wash to mute the reflection's colours, while effectively sidestepping the whole matter by offering two differently composed views of the scene – tree trunks surrounding the pond and leafy treetops mirrored in it.

In 1920, Milne returned to the same pond and once again tried his hand at capturing its reflections. But in the four years since he had last attempted to depict the scene, much had happened to mature him and completely change his style of painting and his thinking about art. The new type of scenery he had encountered while serving as a war artist on the Western Front had totally altered his creative work: his war watercolours were rendered in dry, nervous lines of thick pigment, limited to four or five colours. Upon his return home, he began reading the works of Clive Bell, Roger Fry, John Ruskin, and Henry David Thoreau. Out of this mixture of modernist formal analysis and Victorian philosophical responses to nature, he developed a unique and highly personal artistic vision. In essence, while Milne saw nature as the true inspiration for his art, he felt that its translation onto paper or canvas could be articulated as a series of specific aesthetic concerns. Now he was in a position to address the reflections at Bishop's Pond in a more insightful and original manner.

Looking at the view across the pond, Milne noted in his painting journal the "unusual whiteness of the dead tree" and its contrast to the blackness of the tree next to it. This became the central focus that anchors the composition of *Pink Reflections, Bishop's Pond*. Turning to the problem of textures, Milne pursued his preoccupation with contrast by treating the distant shore and its reflection as the same composition but as aesthetic opposites. The forested shoreline, compacted into the upper third of the composition, is rendered by a concentrated tangle of scratchy brushstrokes of dense colour surrounded by black. In the foreground, the reflection includes not only the far shore trees, now elongated, but also the unseen hill behind and a wedge of open sky. To create the visual impression of the reflection, Milne drew open, ragged lines in both colour and black, surrounded by the white of the paper, washing them over afterwards with clear water to soften the brittleness of the brushwork and create a velvety overall effect.

In his journal Milne declared this watercolour to be "the best drawing I have made using this texture idea." His continuing exploration of reflections would lead finally to his invention of the multiple-plate colour drypoint.

<div align="right">R.T.</div>

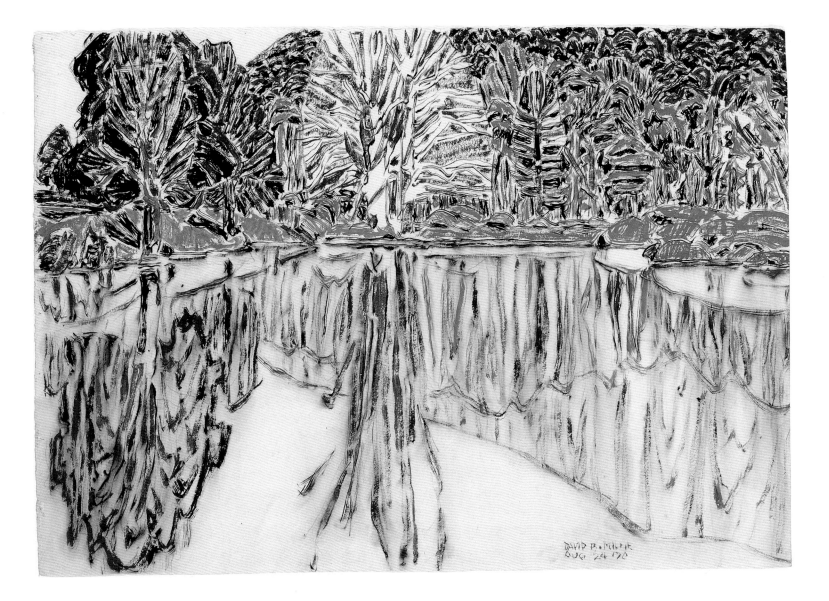

Clarence A. Gagnon

Canadian, 1881–1942

Village in the Laurentian Mountains

1925
Oil on canvas, 89.2 × 130.7 cm
Purchased 1927

Born in Sainte-Rose on Île Jésus, north of the island of Montreal, Clarence Gagnon studied at the school run by the Art Association of Montreal (now the Montreal Museum of Fine Arts). Like other artists of his time, he painted on the Lower St. Lawrence near Quebec City, but in 1903 he ventured further afield, travelling downriver to Baie-Saint-Paul in the county of Charlevoix. Gagnon was delighted with this somewhat isolated region whose inhabitants had retained a distinctive folk culture, manifested in their music, textiles, and architecture. The lives of these people were closely linked to the land, and Gagnon would make them and the Charlevoix landscape a subject of his art for years to come.

In 1904 Gagnon left for Paris to further his studies, quickly earning a reputation as a printmaker of mostly European subjects. From 1910 he began exhibiting his Quebec canvases in France and Canada, and soon became known also as a painter of snow. While the dominant characteristics of Gagnon's art were defined during this pre-war period, his palette would continue to change: over time, his paintings of Charlevoix would evolve, moving from a muted, atmospheric treatment to an approach that displayed increasing sensitivity to the specific qualities of the light and colour of this unique region.

During the subsequent two decades Gagnon travelled regularly between Paris and Montreal, spending time in Charlevoix on each visit to Canada. From 1921 to 1924 he lived in Baie-Saint-Paul – his most extended period in Charlevoix – with his second wife, Lucile Rodier. In December 1924 a law requiring foreigners to be resident in their French property forced Gagnon to return to Paris, where he would remain for the next twelve years.

Gagnon painted *Village in the Laurentian Mountains* in Paris in the spring of 1925 and exhibited it with other Canadian paintings at the second *British Empire Exhibition*, held at Wembley, England, that summer. The picture shows a curving road winding through the village of Saint-Urbain, on the Gouffre River above Baie-Saint-Paul. The street is lined with wooden sidewalks, and sleighs provide the only means of transportation. The church occupies a place of distinction amid the gaily painted houses, with their characteristic peaked and mansard roofs. Beyond the shadowed valley the high peaks of Mont du Lac des Cygnes are bathed in light, making them appear closer and more massive than in reality. It was the particular character and landscape of Charlevoix, and Gagnon's own interpretations of them, that attracted countless artists to paint in this region for over half a century. The nostalgia for a simpler, rural way of life that had marked the work of Canadian artists from the late nineteenth century still held great appeal in an era of increasing industrialization and urbanization.

C.H.

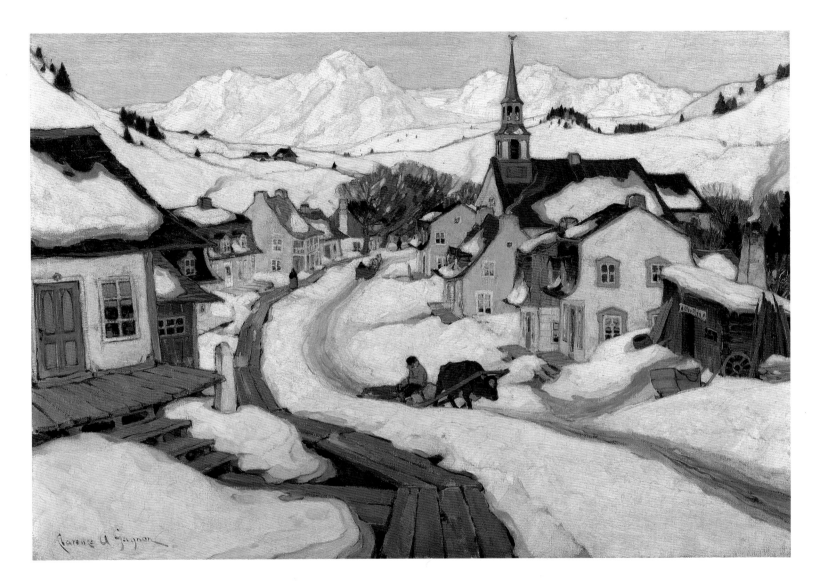

L.L. FitzGerald

Canadian, 1890–1956

Backyards, Water Street

1927
Drypoint on wove paper, sixth state, 34.3 × 30.6 cm, plate 24.2 × 22.9 cm
Purchased 1930

Living his whole life in his native Winnipeg, Lionel LeMoine FitzGerald earned a reputation that was nonetheless far-reaching, and in 1932 he was invited to become the "western" member of the Group of Seven. At a time when Canada was seeking to establish its social and cultural identity, FitzGerald's works exemplified the idea that one's own immediate surroundings could offer worthy subject matter for art. While other members of the Group of Seven sought out dramatic wilderness landscapes, FitzGerald created images of equal intensity by depicting the view from his window, local scenes of Winnipeg, and impressions of the surrounding prairies. In his intimate way, he expressed another vision of Canada. His artistic legacy also includes the contribution he made through his career as teacher and principal at the Winnipeg School of Art, where he encouraged several younger generations of Canadian artists.

Backyards, Water Street presents a not obviously picturesque view of snow-covered backyards as observed from a window of the art college. The jumbled scene of debris, tilting fences, and slanting rooftops is given a coherent order by means of the layered composition and clear delineation of forms. The dark outlines of the chimneys and angular shapes of the garden sheds are laid against the pristine white background in an almost abstract pattern, with relatively little modelling, yet the image solidifies into a clearly legible view. By leaving large areas untouched, FitzGerald conveys the crisp brightness of a cold winter day. The absence of any human presence and the lack of movement combine to evoke the hushed stillness experienced after a snowfall.

In an eloquent personal tribute, the critic Robert Ayre aptly characterized FitzGerald as "The Man Who Looks Out the Window." *Backyards, Water Street* is one of the earliest and best examples of this recurring theme in the artist's work. It is also FitzGerald's largest and most ambitious print, and deservedly his most celebrated. The flexibility of drypoint, where the etching needle is held much like a pencil, allowed him to explore the expressiveness of the print technique without hampering his drawing style. Though FitzGerald generally preferred working in pencil or watercolour, here he has successfully transferred his distinctive vision to another medium, exploiting the velvety drypoint line to create depth and texture. Starting from a finished drawing, squared for transfer, he reworked the image on the plate only slightly, strengthening the composition in subtle ways to achieve this impression, the final state.

In 1930, *Backyards, Water Street* became the first of FitzGerald's prints to enter the National Gallery's collection. Since then, largely through the gift of the Douglas M. Duncan Collection, the Gallery has acquired a comprehensive holding of FitzGerald's work on paper, including the transfer drawing for *Backyards, Water Street* and impressions of each of the six states. The artist himself donated the copper printing plate in 1948 – an indication that he too considered the work to be among his significant achievements.

C.L.

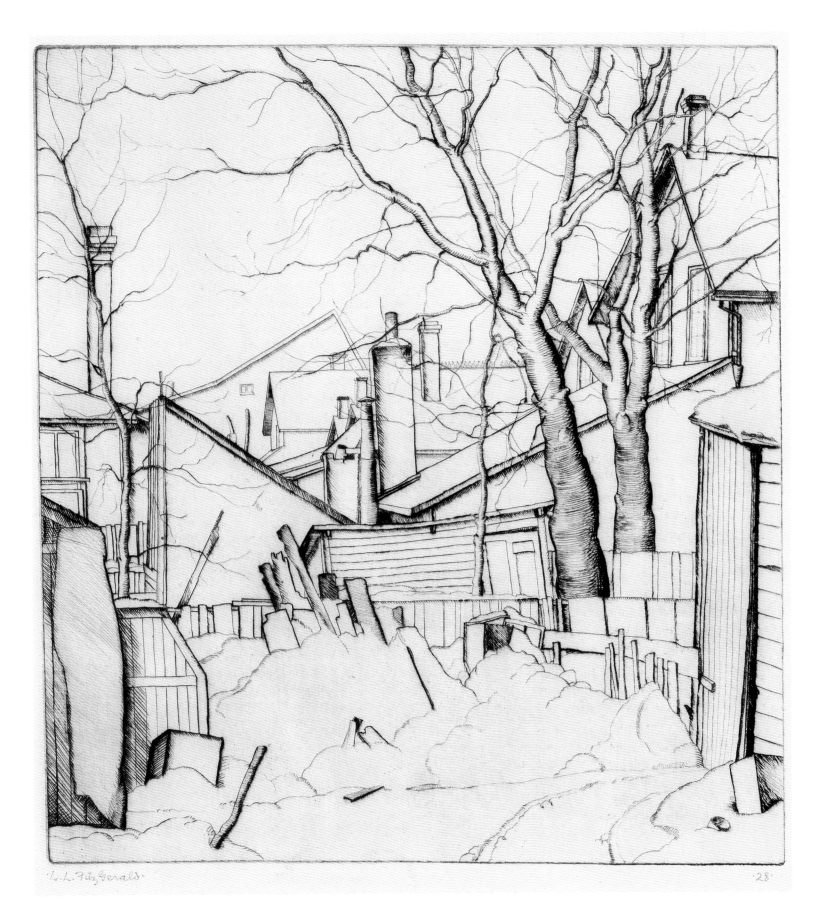

'28

Elizabeth Wyn Wood

Canadian, 1903–1966

Northern Island

1927

Cast tin on black glass base, 22.5 × 71 × 40.5 cm (with base)

Bequest of Mrs. J.P. Barwick (from the Douglas M. Duncan Collection), 1985

Landscape is a subject rarely treated in sculpture. While the configurations of hills and fields, islands and water, and even a passing squall of rain can be flattened and adapted to low relief, landscape is a difficult subject to render in freestanding sculpture. In *Northern Island*, however, Elizabeth Wyn Wood has superbly exploited the sleek lines of a rocky island and its wind-blown tree as they cast their reflections in the black glass.

Wood was born in Orillia, Ontario, and studied at the Ontario College of Art in Toronto from 1921 to 1926. Arthur Lismer and J.E.H. MacDonald, both members of the Group of Seven, were then teaching at the college, and the landscape paintings of the Group were the most modern works being seen in Toronto at that time. The September following her graduation, Wood married one of her teachers, the sculptor Emanuel Hahn, and went to New York for a brief period of study at the Art Students League.

In her early sculptures of heads, torsos, and interlocking figures, Wood had already experimented with non-traditional materials (such as cast tin) and had consistently made the base or support an integral part of the work. Glass, steel, and clean machine-honed lines were omnipresent in the modern decorative arts of the 1920s, and Wood would adapt them to her own ends. In the summer of 1926 she spent two weeks at Hahn's cabin on the Pickerel River in northern Ontario, and while there she made numerous drawings of the small glacial islands and rocks that rise directly from the clear waters.

Northern Island was the first of a number of works – some in the round and some in relief – in which Wood interpreted in three-dimensional form the austere northern landscape so loved by the Group of Seven. The island sits diagonally on the black glass base, leaning to one side as if buffeted by centuries of storms. The wind-blown tree emerges from the cleft between the two faces of the rocky island, split by the receding glaciers. One side is more rounded, almost conical, the other narrower and sleeker, its curves like those of a speeding automobile. Wood cast this work in a number of different materials – brass, brass plated with gold, and bronze – but her first idea was to cast it in tin, creating the dull, low-reflective grey finish seen here.

Elizabeth Wyn Wood was the most advanced sculptor working in Canada in the late 1920s. Her innovative use of materials, her strong sense of design, and her choice of subject matter all played a role in her unique contribution to Canadian art.

C.H.

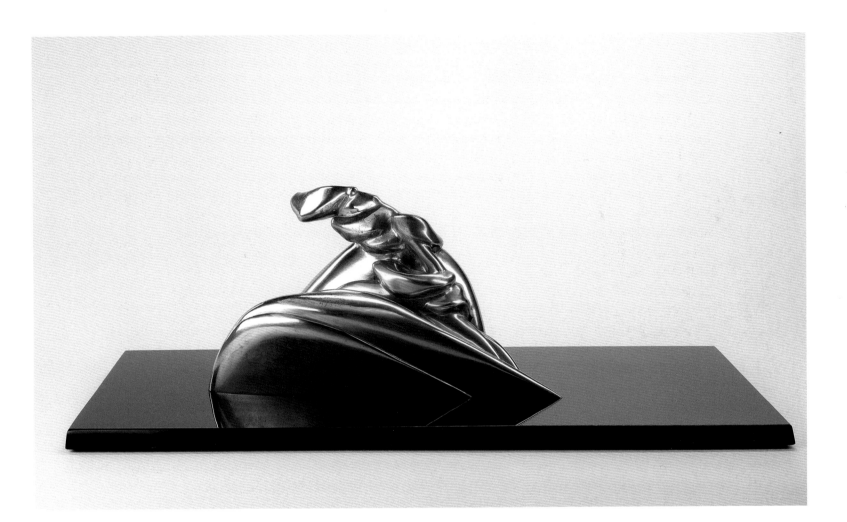

Paraskeva Clark

Canadian, 1898–1986

Petroushka

1937
Oil on canvas, 122.4 × 81.9 cm
Purchased 1976

Paraskeva Plistik was born into a working-class family in St. Petersburg, Russia. She first took evening classes in art at the Petrograd Academy, but after the revolution of 1917 she was able to study full time at the school (renamed the Free State Art Studios) under Kuzma Petrov-Vodkin, who was to have a decisive influence on her painting. Around 1921 she found employment painting sets for the Maly Theatre, where she met her future husband, Oreste Allegri. Newly married and with a young child, the couple planned to join his family in Paris, but on the eve of their departure Allegri drowned. Paraskeva and her son left Russia for Paris, where several years later she met a Canadian, Philip Clark, whom she subsequently married. In 1931, the family arrived in Toronto.

Clark brought to the Toronto art scene a consciousness of the structural and formal traditions of French art derived from Paul Cézanne and the Cubists. Her first Canadian paintings were portraits and still-lifes. However, she could not ignore the political and economic crises brought about by the Depression and the rise of Fascism. Clark was a close friend of Norman Bethune, the Canadian doctor who joined the Loyalist forces in Spain and was to die working with the Communists in China, and she became active in the Canadian League against War and Fascism.

Few Canadian artists expressed their left-leaning political ideals on canvas during the 1930s. Paintings cost time and money, and there was little likelihood that such subjects would sell. Socially committed artists were thus caught in the dilemma of wanting to reach a wide audience and rarely having the opportunity to do so. Some worked in a print medium, or produced magazine illustrations and caricatures, achieving a larger distribution than they could through painting. Murals installed in public buildings would have been the best means to reach a broad public, but no commissions in support of social causes were forthcoming. Nevertheless, some artists did interpret the social and political realities of the time in paintings that were to find their market only much later.

The catalyst for Clark's painting was not a Canadian situation but an American one. In May 1937 the police in Chicago brutally suppressed a strike by steelworkers, and this is the event echoed in Clark's canvas. Part memory, part allegory, the scene is set in the courtyard of the artist's St. Petersburg apartment building, where puppeteers and musicians used to perform for the resident families. But Petroushka, a folk story of suffering humanity, has been reinterpreted here as a political allegory in which the rich industrialist pays the police to beat the worker. Clark stands with her young baby in the background on the left, a witness to the oppression. A man in the foreground raises his fist in the salute of the Popular Front, the European leftist alliance, while the faces and actions of the other spectators reflect varying degrees of concern, anger, and indifference.

<div align="right">C.H.</div>

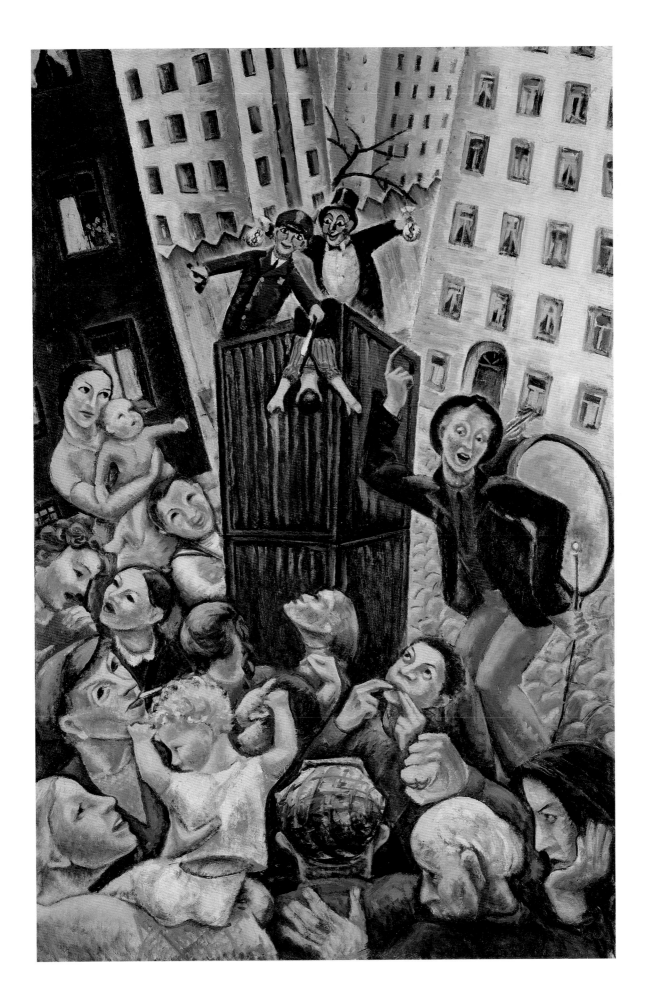

Asian Art

Anonymous
Tibetan, 15th Century

The Protective Deity Rahula

c. 1400
Gilt bronze with gemstone inlay, 33 × 25.3 × 16.7 cm
Gift of Max Tanenbaum, Toronto, 1980

This extraordinary sculpture is a representation of one of the minor deities of the extensive and complex Buddhist pantheon of Tibet. Known by his Sanskrit name, Rahula, or Rahu, he belongs to the class of divinities called in Tibetan "dregs pa." While a few of these protective deities may have originated in India, most are believed to have been adopted from the Bon pantheon. Bon is the second major religious tradition of Tibet, retaining many pre-Buddhist concepts synthesized with ideas borrowed from Buddhism.

The Tibetan Rahula is regarded as the chief of the planetary deities – an association probably derived from India, where he is the eighth member of a group of nine deities led by Surya, the sun god. His elevation to the status of the ruler of the major and minor planetary gods in Tibet is a local gloss. He is also iconographically different from the Indian Rahu. His basic form is more akin to that of the ninth Indian planetary deity, Ketu, who is usually a combination of a human and a serpent. Like the ancient Indian sky god, Indra, he is shown with multiple eyes on his body, representing the thousand eyes with which he can see at once in all directions. In Tibet, Rahula occupies a particularly important place in the pantheon of the rNying ma pa order and is included in the retinue of the important Dharmapala (Defender of the Faith) deity Palden Remati.

Whether this superbly crafted bronze was part of a group or was dedicated in a monastery as an individual piece remains unknown. Its size and workmanship place it in a class of its own, especially since sculptural representations of Rahula are uncommon to begin with. The complex form portrays the deity with a human torso, a serpentine lower body, nine heads, and four arms, all combined deftly and organically into a convincingly credible composition. The back left hand holds a serpent as a noose and the front hand a bow. The bent staff of the banner is still attached to the back right hand, and the front hand once grasped an arrow. The two frontal human heads, with their large eyes and subtly shaped eyebrows, clearly articulate Rahula's angry nature. Above the pyramidal arrangement of human heads is the head of a raven, surmounted by the tiny but active and detailed figure of the wrathful manifestation of Vajrapani, one of the major bodhisattvas and titulary deities.

Crowned and lavishly bejewelled with ornaments inlaid with opals, lapis lazuli, and turquoise, the figure is more majestic than terrifying. The bronze is almost certainly the work of a master sculptor, either a Newar from the Kathmandu Valley in Nepal, whose art was especially valued by Tibetan patrons, or a Tibetan well versed in the Newar aesthetic tradition. The human and reptilian form have been combined into an arresting composition.

P.P.

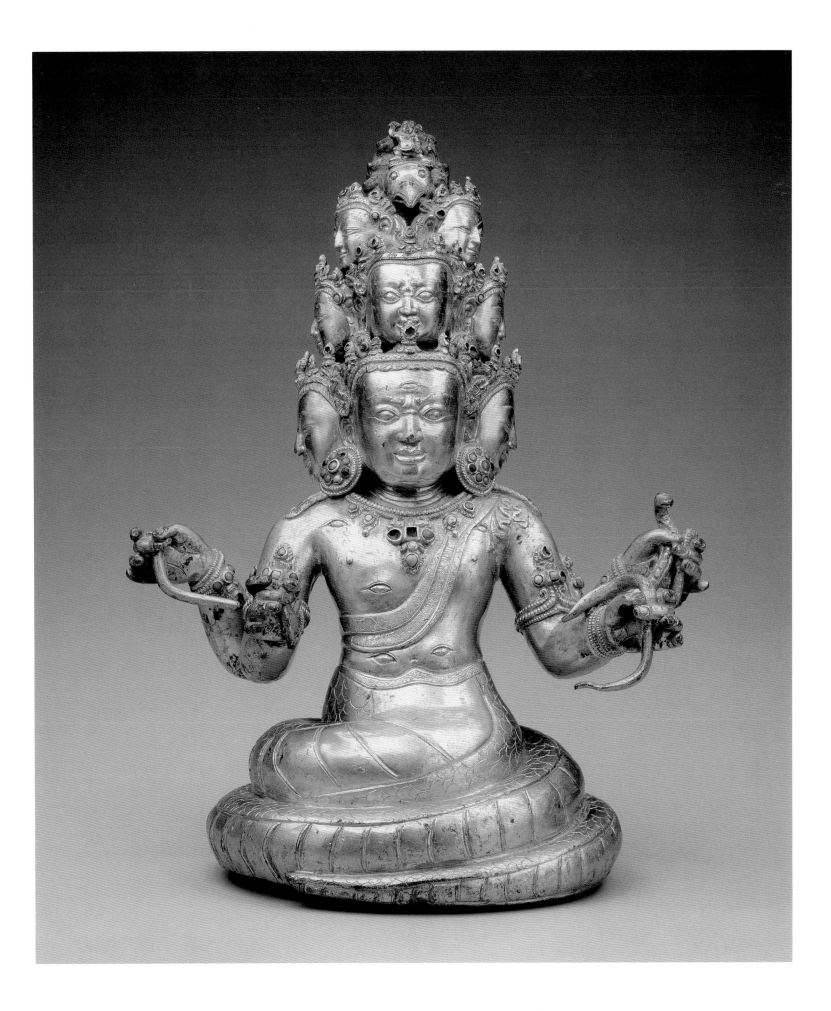

Attributed to **Sur Gujrati**

Indian, active 1590s

King Babur Supervising the Creation of a Garden (folio from a *Baburnama* manuscript)

1590s

Opaque watercolour on paper with gold and coloured ruled borders, 26.5 × 15.9 cm, image 24.8 × 13.3 cm

Gift of Max Tanenbaum, Toronto, 1979

In 1526, at the Battle of Panipat, the central Asian conqueror Babur defeated Ibrahim Lodi, the sultan of Delhi. In the four remaining years of his life he went on to capture most of northern India, laying the ground for what would become the Mughal empire. Besides being a man of arms, Babur was also a distinguished poet and memoirist, and his autobiography, the *Baburnama*, endures as a masterpiece of acute observation and sensitivity.

It was Babur's grandson, the great emperor Akbar, who had the original Chagatai Turkic text of the *Baburnama* translated into Persian and who commissioned the making of several illustrated copies during the last decade of the sixteenth century. Among the artists of the imperial atelier assigned to work on the manuscript was one Sur Gujrati, to whom this picture is attributed. Little is known about him apart from the fact that he came from Gujrat, on the west coast of India. He was apparently valued as a colourist, for most of his known works bear notations indicating that the outlines were rendered by someone else.

A keen naturalist, Babur was extremely fond of formal gardens and lamented their absence in India. Indeed, he was the first to lay out Mughal-style gardens on the subcontinent. One of the earliest gardens he designed, some thirty kilometres north of Bhira on the banks of the Jhelum, in today's Pakistan, was called Bagh-i-safā, the "Garden of Truth." Arriving near Agra, which later was to become a Mughal capital, Babur regretted that the local land was unsuited to agriculture, but having no alternative he laid out "plots of garden … with order and symmetry, with fitting borders and parterres in every corner, and in every border rose and narcissus in perfect arrangement."

Given the rocky background, this picture of a garden being laid out under regal supervision is probably not set near Agra, but it does attest quite graphically to Babur's personal interest in gardens. Under a chenar tree, and shaded by a baldachin, Babur stands in an iconic posture on a pedestal-like slab of rock, inspecting a plant proffered by a gardener. His royal trappings are depicted behind him, carried by servants. Other figures are busy digging, dressing stones, and building a low wall around a water tank, all under the watchful gaze of a supervisor who is leaning on a stick. The insertion of the text panels, done here in a manner that does not disturb the composition, is characteristic of Mughal book illustration.

An example of the mature Mughal style as developed in the imperial atelier, the picture displays a fine combination of naturalistic observation (as demanded by Akbar), technical elements of European pictorialism, and Persian decorative flair, with its brilliant sense of surface patterns. The lighting is uniform, and there is a noteworthy absence of shadows, while saturated patches of intense colour in the textiles contribute to a cheerful, idyllic scene – happy labourers building a paradisal garden on earth!

P.P.

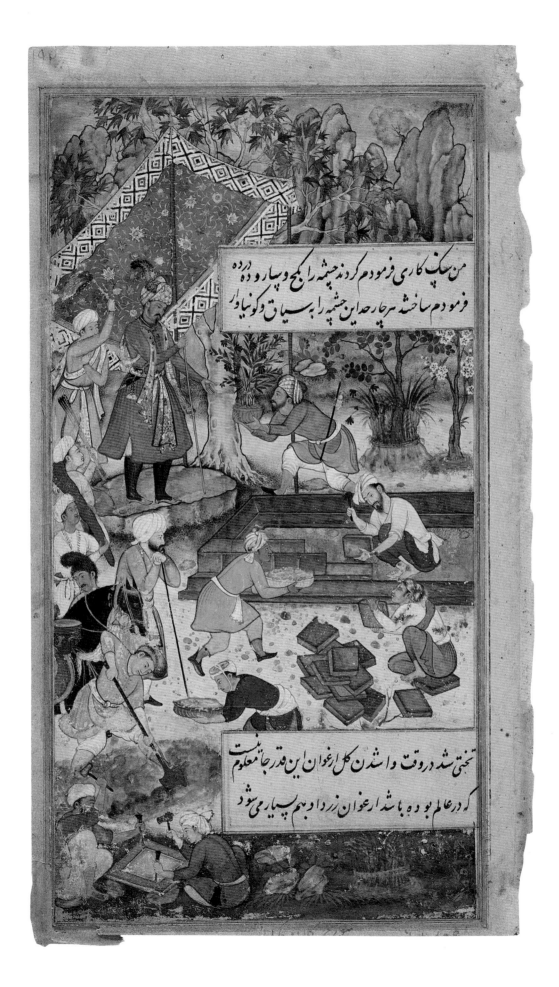

من سنگ کاری فرمودم کردند چشمه را کلنج و پیسار و درده
فرمودم ساخته سرجا حدائن چشمه را بسیاق و کوئیاولر

تجتی شده در وقت واشدن کل ارغوان این قدر جائیست معلوم
که در عالم بوده باشد ارغوان زرد داوبهم بسیار می‌شود

Anonymous
Indian, 17th century

Scene of Dalliance

c. 1650
Ivory, 18.7 × 18.4 cm
Gift of the Bumper Development Corporation, Calgary, 1984

One of the most spectacular Indian artworks in the National Gallery of Canada's collection, this ivory panel succinctly expresses the essence of Indian culture and aesthetics. As is evident from its nail holes, it originally embellished some piece of furniture – very possibly one just like the canopied couch on which the couple here is engaged in lovemaking. Because elephants were plentiful in the subcontinent, ivory was a popular material for use in furniture, especially among the rich. Plaques with such scenes of dalliance were particularly, and appropriately, favoured for loveseats and beds.

This erotically charged scene of a prince and four voluptuous females – one of whom is clearly a dancer – combines iconographic motifs and formal principles that have remained popular with Indian artists since at least the second century B.C. Not only is the theme expressive of unabashed joie de vivre – it is also a vivid portrayal of the Indian belief in the sexual imperative, without which life cannot exist. According to Hindu scriptures, it is desire, or *kāma*, that motivates all existence. The composition also displays the overt sensuality that is characteristic of both human and divine forms in Indian art, and expresses the Indian sculptor's unfettered joy in depicting the female body. The lively figures in this scene perform their acts with effortless ease and measured elegance. Their graceful, naturalistic postures clearly demonstrate the master carver's familiarity with the art of dance. Theoretical texts on art have always asserted that an intimate knowledge of dance is essential for rendering the human body in motion, both in sculpture and painting.

The style of the relief is extremely similar to that of the portrait statues of King Tirumala Nayak (1623–1659) and his consorts as well as the figures in the murals of the Great Temple at Madurai in Tamil Nadu. In fact, the male in this panel so closely resembles statues of the king that we may reasonably assume they represent the same person. Tirumala Nayak, the founder of the Nayak dynasty of Madurai, was not only a great patron of art and architecture but obviously also a bon vivant, as can be seen in this delightfully exuberant image of unrestrained passion.

P.P.

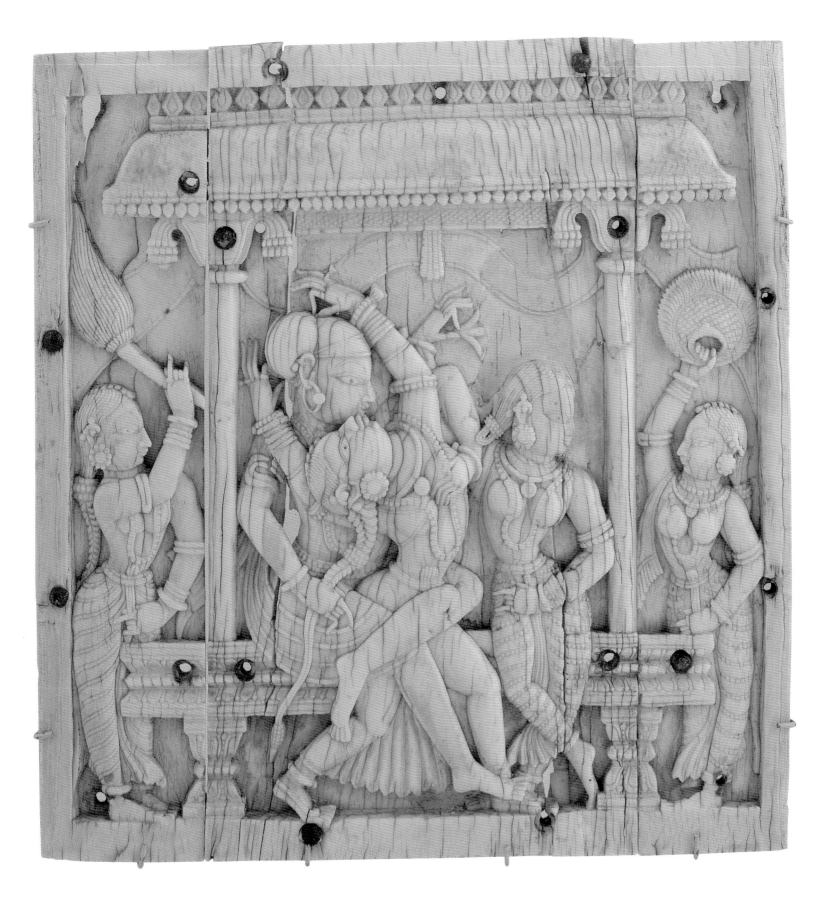

European Art to 1945

Simone Martini

Italian, c. 1284–1344

Saint Catherine of Alexandria

c. 1320–1325
Tempera on wood, 82.2 × 44.5 cm
Purchased 1956

One of the earliest painted images in the National Gallery of Canada's collection, this tranquil portrayal of Saint Catherine contains little to suggest the violence of her legendary death other than the pommel of a sword held in one hand and the martyr's palm in the other. The wheel of her torture is alluded to in the design of the brooch worn on her richly embroidered costume. Its round form is echoed in the larger circle of her decorative halo, signifying sainthood, while a pearl-studded crown denotes her noble birth. Set against a gold background, the undulating contour of the saint's gently inclined head, the graceful silhouette of her figure, and the depiction of her face – with its almond-shaped eyes and long nose – all combine with the subtle gradation of the flesh tones, modelled with fine brush strokes over an underlying green wash, to create a supremely elegant image that still speaks to us across the centuries.

Simone was principal painter in Siena following the death of Duccio di Buoninsegna, but his inventiveness and the exceptional craftsmanship for which his workshop was famous would make him sought-after throughout Italy and at the papal court in Avignon. Soon after completing the multifaceted high altar for the church of Saint Catherine in Pisa, in 1320, he designed no fewer than three altarpiece complexes for the Umbrian town of Orvieto. These were composed of single half-figures of saints grouped on either side of an image of the Virgin and Christ Child, each within a space terminating in a trefoil shape set within a pointed arch. The particular patterns of tooling and punch marks contained in the spandrels between these forms in this fragment of Saint Catherine have caused it to be linked with a Virgin and Child (now in the Opera del Duomo in Orvieto) traditionally associated with the thirteenth-century church of San Francesco and generally thought to be by Simone's brother-in-law, Lippo Memmi. However, there are no documents or other panels among surviving works by either artist that would add weight to the possibility that they collaborated on this commission.

Catherine of Alexandria figures prominently in nearly all of Simone's altarpieces, as well as in his *Maestà* at the Palazzo Pubblico in Siena and his frescoes in the Franciscan basilica at Assisi. Since ours is the only surviving saint associated with the church of San Francesco in Orvieto, opinions vary as to the original appearance of the altarpiece, ranging from a triptych format to a polyptych containing six separate panels of saints. Apart from the usual Franciscan saints, possible contenders for depiction on these panels include Louis of France, whose canonization had taken place in San Francesco just over two decades earlier, in 1297, and Louis of Toulouse, whose own canonization, in 1317, Simone himself had commemorated in a painting for the latter's brother, Robert of Anjou, King of Naples. Louis of Toulouse and Robert's common ancestor, Saint Elizabeth of Hungary, a tertiary Franciscan, may have been among their company, for Simone had already depicted them together in the lower church at Assisi. Various forms of angels in roundels and in the tripartite gable above Lippo's Virgin have also led to the suggestion that the iconography refers to the Franciscan Saint Bonaventure's writings on the hierarchy of the heavenly host.

C.J.

Antonio Pollaiuolo

Italian, 1432–1498

The Battle of the Naked Men

c. 1470
Engraving on laid paper, 41.8 × 61.1 cm, plate 40.5 × 60.9 cm
Purchased 1952

This engraving, the only print irrefutably attributable to the Florentine artist Antonio Pollaiuolo, is extraordinarily ambitious in scale and intellectual purpose. It is also, to the best of our knowledge, the earliest engraving by any Italian artist to carry a full signature (visible at the left, on the tablet hanging from a tree).

The only known impression of the first state of the engraving is in the collection of the Cleveland Museum of Art; all the other impressions are, like this one, of the second state, in which a number of fairly slight alterations are detectable. Technically and expressively it displays considerable maturity, which suggests that at the time of its production the artist was far from inexperienced. The work is striking for the variety of its lines and effects, some of which were evidently the result of improvisation. For example, to produce the zigzag lines with the burin, the artist must have had to manipulate the copper plate a great deal, and the technique of cross-hatching was borrowed from pen and ink drawings.

The print depicts ten nudes, in a sort of horrific ballet, attacking one another with a variety of weapons. Different interpretations of the subject have been advanced, none of them entirely convincing. Most plausible, perhaps, is the suggestion that the figures represent gladiators fighting to the death in commemoration of a deceased hero or dignitary, as was commonly done in the ancient world. Whatever the scene's precise meaning, the concentration on the male nude in active movement and the expression of heightened emotion were clearly important to the artist in conceiving this work. Though not completely accurate, the treatment of the surface anatomy of the nude figures was advanced for its time and more than adequate for the purposes of artistic expression. The audience for this print presumably included sophisticated collectors as well as artists in search of clear and instructive renderings of human anatomy. The impression in the National Gallery of Canada lists on its verso, in a German Renaissance dialect, the inventory of another artist's effects – evidence that it was owned by an artist at an early date and that the print was distributed outside of Italy.

Pollaiuolo's print also attests to the Classical revival that so characterized the Italian Renaissance. In formal terms, this is apparent in the frieze-like treatment of the scene (inspired by the reliefs found on ancient stone sarcophagi) and in the rather stylized rendering of several specific types of active poses. Yet the image has a frightening brutality that goes beyond any Antique example. The remarkable force of this work, which anticipates Leonardo in its uncompromising intensity, was no doubt inspired in large measure by the artist's reading in Classical literature and by his own creative imagination.

D.F.

Piero di Cosimo

Italian, 1462–1522

Vulcan and Aeolus

c. 1490
Oil and tempera on canvas, 155.5 × 166.5 cm
Purchased 1937

This large painting and its pendant at the Wadsworth Atheneum in Hartford, Connecticut, both show an episode from the life of Vulcan, the Roman god of fire. In the Hartford picture, entitled *The Finding of Vulcan on the Island of Lemnos*, the youthful nude figure of Vulcan has just fallen to earth, interrupting the activity of six fancifully clad nymphs gathering flowers. The National Gallery's painting, by contrast, depicts five male nudes and one woman, wrapped in a red mantle, clutching an infant boy. Only two of these figures can be identified with any degree of certainty – Vulcan, working at his anvil, and Aeolus, master of the winds, pumping the bellows to fan the flames. Vulcan, the divine blacksmith who forged tools and weapons for many gods and heroes, has already supplied the builders in the middle distance with a hammer and a saw, and is occupied with making an iron shoe for the horse in the centre of the composition. Other tools are scattered on the ground near his feet. The scene can thus be interpreted as a portrayal of the dawn of civilization, represented by the use of fire and the domestication of animals. Apart from its Classical references, it is also linked to the life and traditions of Piero's native Florence, and to the memory of his father, who was a toolmaker or goldsmith. The stalwart white horse is reminiscent of those painted by Paolo Uccello, active in Florence a few decades earlier, and the prominent giraffe at the right no doubt refers to a famous gift presented to Lorenzo de' Medici by the sultan of Egypt in 1487.

Piero di Cosimo is known for the originality of his imagery and compositions, and indeed there are few representations of Vulcan that pre-date this work. As in the pendant, the scene here is set in a deep landscape. The artist deliberately leads the eye into the distance by repeating on a smaller scale some of the foreground features: the rudimentary wooden structure under which Aeolus is seated is echoed in the construction to the right; the builder raises his hammer in a gesture similar to Vulcan's; a family group much like the one on the right is seated before a dwelling in the left mid-ground; and a distant white horse can just be spotted approaching from the upper left.

It is not known where the two paintings were meant to be installed, but their outdoor settings would have been appropriate for a country villa. Such a location would explain the robust diamond-twill canvas support – which could be easily rolled for transport – and might also be the reason they escaped mention in contemporary literature. The high horizon line in both works (found also in Botticelli's *Primavera* and *Birth of Venus*, made for the Medici villa at Castello) suggests that the viewer's eye is meant to focus on the foreground. The artist's fascination with naturalistic elements may well have been a point of attraction for a possible subsequent owner, the botanist Pier Antonio Micheli, with whose family the pictures remained until the mid-nineteenth century.

C.J.

Albrecht Dürer

German, 1471–1528

Adam and Eve

1504
Engraving on laid paper, with japan paper borders, 24.6 × 19.3 cm
Purchased 1957

The German artist Albrecht Dürer's Latin signature, ostentatiously positioned on a tablet in the upper left of the image, tells us quite clearly that he intended this print for an erudite audience. Its subject is taken from the Book of Genesis. Eve has already disobeyed God's command and plucked fruit from the Tree of Knowledge of Good and Evil, which provides the central axis for the work's highly symmetrical design. Looking towards his mate, Adam reaches out as if ready to accept a fruit from her, while with his other hand he holds onto a branch of the Tree of Life – a hopeful gesture in this context. The serpent, coiled between them, has already bitten into another of the plundered fruits. This is the decisive moment that will inspire God's wrath and lead to the expulsion of humanity's progenitors from the Garden of Eden.

Adam and Eve are surrounded by a plethora of subsidiary details, functioning as commentary to the main theme and giving the image its dense appearance. A parrot – in medieval iconography a symbol of the virgin birth – is perched on the branch held onto by Adam, evoking the purity of Christ's mother, Mary, in contrast to the sinfulness of Eve, who has allowed herself to be tempted by the serpent. The goat perched precariously atop the crag in the upper right corner alludes to Adam and Eve's weakness and the imminence of their Fall. Dürer also explored the subject of Adam and Eve in his paintings, eager to take advantage of the opportunities it afforded to represent nudes of both sexes in their most idealized and unselfconscious manifestation.

From a technical standpoint, this print was, in its time, one of the most ambitious ever produced. In order to replicate the contours and surfaces of the human body, Dürer developed an intricate combined system of dot modelling, cross-hatching, and feather-like curved lines, handled with almost microscopic precision. In his treatment of the protagonists the artist drew upon his theoretical investigations into the rules of figural proportion. The poses are based on those of the celebrated Antique sculptures of Venus and the Apollo Belvedere – commonly accepted models of Classical beauty to which Dürer could apply the results of his research. The figures are presented in a markedly frontalized arrangement and in sharp contrast to the darkened background, as if to focus the viewer's attention on the perfection of their proportions. The extremely static composition did elicit some criticism among the artist's contemporaries. According to Michelangelo, it was Dürer's interest in proportion that led to his excessively rigid treatment of the figures. Nevertheless, the technical mastery and enigmatic details of this image have made it enduringly fascinating.

D.F.

Hans Baldung, called Grien

German, 1484/1485–1545

Eve, the Serpent, and Death

c. 1510–1515
Oil on wood, cradled, 64 × 32.5 cm
Purchased 1972

Baldung, one of the most creative artists of the first half of the sixteenth century, owes his reputation primarily to the dramatic and sensual quality of his imagery and his distinctive interest in the fantastic. Born into an educated and ambitious Swabian family that had settled in Strassburg, he went to Nuremberg in 1503, at the age of eighteen, to study with Dürer. He eventually took charge of Dürer's workshop while the latter was in Venice from 1505 to 1507, and he remained a devoted friend: at his death, a lock of Dürer's hair was found among his belongings. In 1509 Baldung returned permanently to Strassburg, where he joined the artist's guild, opened a workshop, and became the pre-eminent painter of his time.

Baldung's unusual imaginative streak first manifested itself around 1510, when he began working on a series of images of witches, variations on the theme of Death and the Maiden, and his favoured concept of *vanitas*, moral allegories informed by the haunting notions of lust and vanity. After 1517, with the onset of Luther's Reformation, Strassburg became a predominantly Protestant city. Although Baldung did execute an idealized portrait of Luther, his religious affiliations cannot be taken for granted, and there are few documents to clarify the issue. He continued to depict religious subjects alongside themes in which the carnal and the demonic predominated, while also broadening his repertory to include Classical subjects.

Eve, the Serpent, and Death is one of several related compositions inspired by the tragic biblical story of the Fall of Man. While it ostensibly represents but another variation on the Temptation, the richness of metaphor displayed in it, including elements from the secular theme of the Dance of Death, is unique in Baldung's oeuvre. The principal figure, a resplendent and intensely provocative Eve, approaches the Serpent unashamedly, an apple concealed behind her back. With her left hand she ambiguously strokes the Serpent's tail as it curls around the Tree of Knowledge. Standing behind the tree is a figure of Death – a flamboyant mass of rotting flesh – who holds a second apple above Eve's head while grasping her left arm. This attempt to seize her is countered by the Serpent, seen plunging its fangs into Death's forearm. At the centre of the picture, given added focus by Eve's sidelong glance and enigmatic smile, is a knot formed by the Serpent and the hands of the two figures, interlocked as if in some irrevocable pact.

This uncommonly erotic allegorical representation of the Fall, generally considered to be Baldung's most complex work, displays an intricacy of meaning that has long fascinated scholars. For some, the figure of Death is a rare yet profoundly Christian representation of Adam, shown here by Baldung as already corrupted by the Fall. While the presence of Adam would seem to be required by the subject, other commentators have noted the alliance between Eve and the Serpent, the destroyer of Death, and have proposed variant interpretations, based on the writings of Baldung's humanist contemporaries, according to which the Serpent represents not Sin but either Wisdom or Eternity.

M.P.

Lorenzo Lotto
Italian, c. 1480–1556

The Virgin and Child with Saints Roch and Sebastian

c. 1521–1524
Oil on canvas, 81.8 × 108.5 cm
Purchased 1976

Venetian by birth and training, Lotto spent a good part of his career working on the Venetian mainland, in Treviso and Bergamo, and in the Marches, further down the Adriatic coast. If the influence of Bellini and Giorgione can be felt in his altarpiece compositions and in his landscape settings, Lotto was nonetheless a highly individual artist, distinguishable from the mainstream of Venetian Cinquecento painters by the emotional tension in his works – a reflection of his religious conviction – although this is often disguised by a quality of tenderness and a love of descriptive detail.

Such characteristics are present in this picture, which was made for Battista Cucchi, an organist and practising surgeon, during the decade the artist worked in Bergamo. The scene shows the Virgin and Christ Child attended by two saints, Roch and Sebastian, who were commonly invoked as protection against the ever-present threat of the plague. Bergamo was actually overrun by the plague in 1524, but it seems likely that the work was conceived before that date: the bright colours of the Virgin's robes can be seen in earlier paintings by Lotto, and the pattern on the white silk damask of the cushions appears in the 1521 altarpiece for Santo Spirito and even more prominently in *The Mystic Marriage of Saint Catherine*, painted for the artist's landlord, Niccolò Bonghi, in 1523. The witness for the contract for the latter painting was none other than Cucchi himself, who survived the plague and later willed his own picture to the convent of Santa Grata, where he was to be buried. The fact that the convent functioned as a hospital suggests that the work may even have been conceived with this destination in mind.

Although the cushions, with their elaborate tassels and silk, seem to indicate an interest in the material world, they are also part of the tradition of the Madonna of Humility. This religious theme was first introduced in the thirteenth century by the Franciscans, but was then also adopted by the Dominicans, with whom Lotto was closely linked. Both the scale and the intimacy of the scene are in keeping with a picture made for domestic or private use, as opposed to the much larger public altarpieces in which the Virgin is shown enthroned and surrounded by saints, in a formal *sacra conversazione*. Here the prominence of her bare feet and the fact that her figure is noticeably compressed suggest that the painting was meant to be viewed from a low vantage point. On either side of the Virgin, in contraposto poses and cooler tones, are the two half-length saints, Roch leaning back in a swoon and Sebastian bending forward in a manner suggestive of the flagellation episode of Christ's Passion. The Child's feet echo those of the Virgin, and his hands the gestures of Saint Roch. The Virgin's downcast eyes and the elaborate arrangement of her hair are reminiscent of Leonardo, while the pearls, signifying purity and perhaps her role as Queen of Heaven, strike an oddly fashionable note. The interpretation of the theme is thus idiosyncratic and original, but at the same time deeply compelling.

C.J.

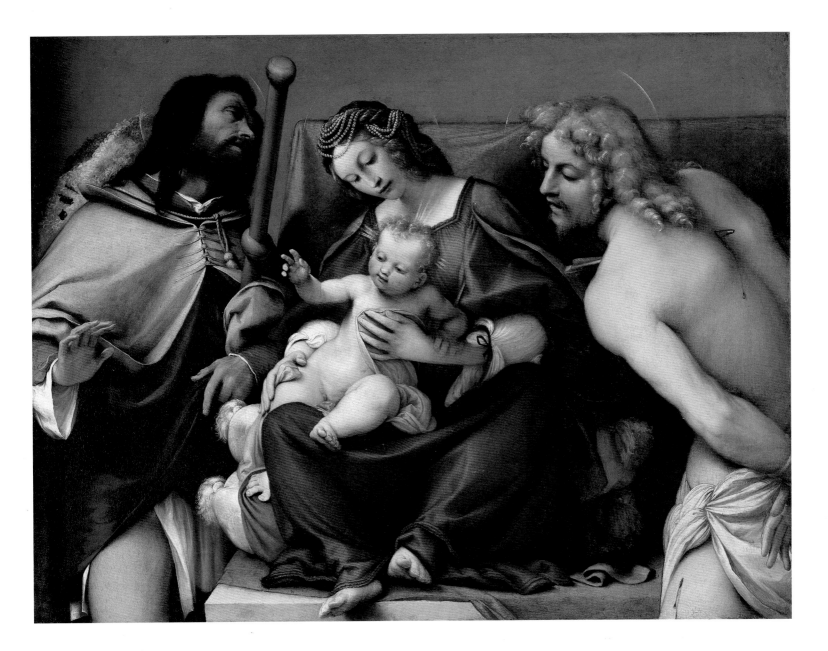

Agnolo di Cosimo, called Bronzino

Italian, 1503–1572

Portrait of a Man

c. 1550–1555
Oil on wood, cradled, 106.7 × 82.5 cm
Purchased 1930

A native of Florence, Bronzino was trained in the workshop of Ridolfo del Ghirlandaio and later became the student and collaborator of Pontormo, the main proponent of Florentine Mannerism and major influence on Bronzino's work. An accomplished fresco painter, he did not turn to portraiture until about 1532, shortly before his return to Florence from Urbino. After 1539, when he contributed decorations for the wedding of Duke Cosimo I de' Medici, he gradually became the dominant artistic personality at the Florentine court, painting fresco decorations, panel paintings, erotically charged allegories, and portraits of the ducal family and Florentine intellectuals and artists in a refined style that epitomized the formal elegance of his milieu.

This portrait is typical of Bronzino's manner at the height of his career, though somewhat unusual in its presentation. The sitter, apparently unwilling to be seen face on, is shown looking away from the viewer. In a typically Mannerist conceit, the lower part of his body points leftward while the torso and head are turned to the right. As always with Bronzino, the representation has been handled effortlessly, with a dispassionate calm, but it is also psychologically rich and informative. This man is a paragon of breeding, the product of manuals for the perfect gentleman, and his composure, as he presents himself to posterity, is absolute. His interest in the arts can be deduced immediately from the Venus that stands on the table next to him, carved no doubt from a rare blue stone. His garments made of fine damask are in the most subdued range of blacks, relieved only by a red silk undercoat. His left hand negligently holds a handkerchief in a gesture that wittily echoes the hand of the Venus above, clasping her drapery.

Pentimenti in the area of the sitter's right hand show the extent to which the artist was ready to emphasize an effect: he evidently reworked the hand in order to further elongate the already remarkably long fingers. And yet, beyond the gravitas and the dazzling show of silks, we glimpse touching intrusions from another reality – the moist, thinning hair and silky beard, the imperfectly aligned eyes, the still-young hands that nonetheless convey a hint of the conspicuous veins age will bring.

The identity of the man remains elusive. It has been suggested that he is the poet Luca Martini, or – far less likely – Lorenzo Cybo, Marquis of Massa and a cousin of Cosimo I de' Medici. The most persistent hypothesis is that the picture portrays Cosimo I de' Medici himself, at the age of about thirty-five, though if this is the case it seems curious that all traces of his identity should have been lost. The man in the painting certainly bears some resemblance to Cosimo and, as scholars have pointed out, wears a cloak made of the same black damask worn by the young Don Garzia de' Medici, one of Cosimo's sons, as his funerary costume.

M.P.

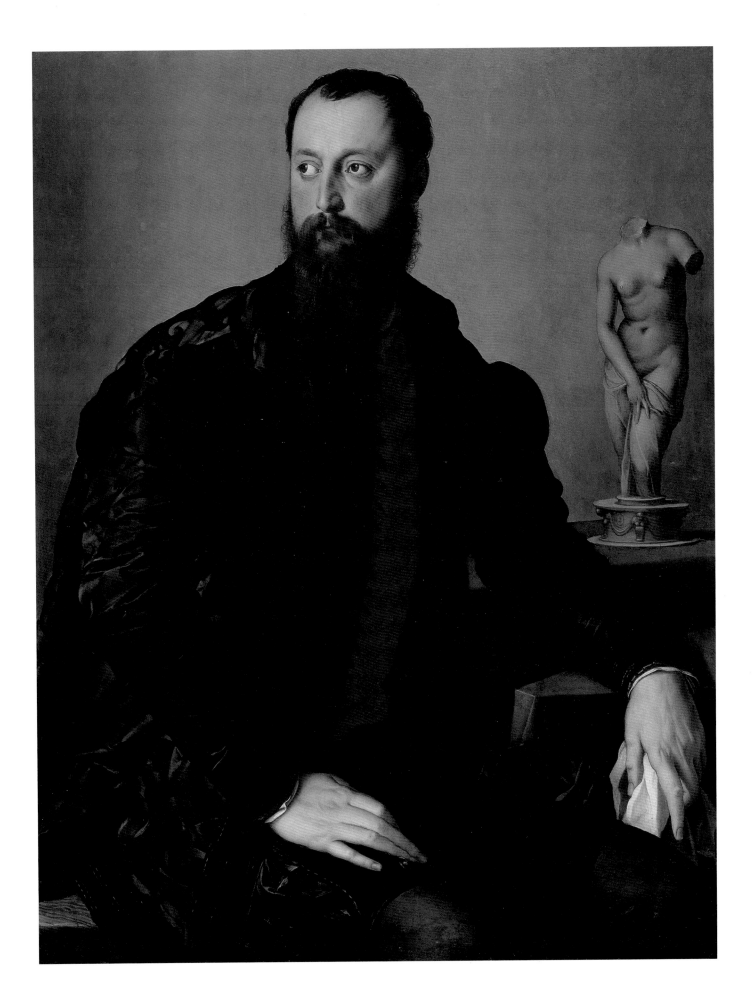

Jacopo da Ponte, called Jacopo Bassano

Italian, c. 1510–1592

The Presentation of the Virgin

1569
Black, white, and coloured chalk on blue laid paper, 52 × 39.7 cm
Purchased 1938

Jacopo Bassano was the most talented member of a family of painters based in the Veneto region of Italy, and this unusually large drawing, executed in a variety of coloured chalks on blue paper, is one of his greatest achievements. In what appears at first to be a study for a painted work, the artist developed an original method of working with coloured chalks that effectively pushed his graphic medium into the realm of painting. The audaciously summary technique is another of Jacopo Bassano's important contributions to the history of drawing. This example is one of the most freely drawn of a large group of studies on religious subjects. The date of 1569, inscribed on the work twice by the artist, is not disputed. Although the condition of the sheet, with its somewhat abraded surface, is not perfect, it is a wonder that such a large working drawing has survived at all.

The subject has been identified as the Presentation of the Virgin in the Temple, and though the image lacks a certain clarity because of the energetic handling, this identification is surely correct. The story of the young Mary's walk up the Temple steps to be greeted by the High Priest is not related in the Gospels but is presented in vernacular texts such as the thirteenth-century *Golden Legend*. Though the subject was a popular one in Venetian art, there is no evidence that Jacopo Bassano ever made a painting on the theme, and so the purpose of this drawing is somewhat mysterious. It and the rest of the series it belongs to, all in coloured chalks on blue paper, were probably made not as preparatory studies for specific commissions but as stock images of commonly painted subjects from the lives of the Virgin and Christ. Around 1570, when these works were executed, Jacopo Bassano was radically reorganizing the family's studio operations so as to make them more efficient. This drawing was almost certainly intended as a prototype for possible commissions on its subject.

The robust application of chalk betrays the hand of an artist searching with considerable impatience for a suitable design. It is perhaps not surprising, therefore, that Jacopo Bassano resorted to a conventional solution for the composition. The markedly vertical design – essentially a parallelogram, with the main subject recessed in the middle ground – was a structure he used for other narrative scenes as well. The figures, which appear notably large and spectral in the impenetrable space, are introduced with powerful, aggressively treated contour lines that provide the framework for the coloured chalks. There is no detail in the drawing, which seems to be formed by the patches of incandescent colour created by the different chalks. Jacopo Bassano's study is a perfect example of the Venetian sensitivity to tone as independent from line.

D.F.

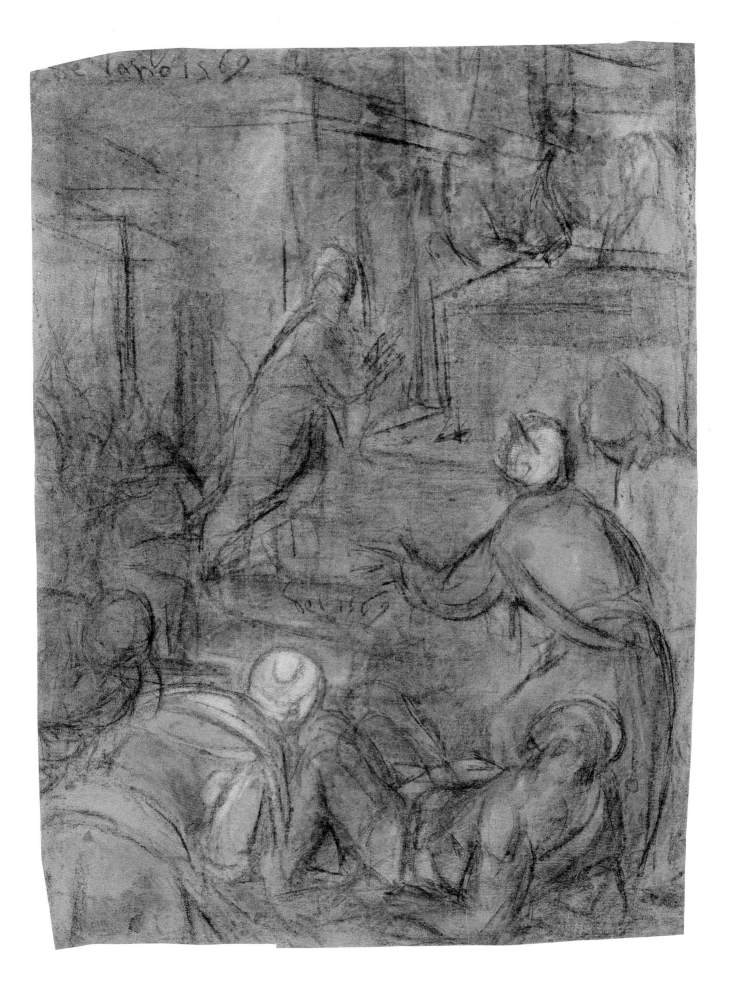

Gian Lorenzo Bernini

Italian, 1598–1680

Maffeo Barberini, Pope Urban VIII

c. 1632
Marble, 94.7 × 68.8 × 34.3 cm (with base)
Purchased 1974

Urban VIII was an ardent patron of the arts. Early in his long papacy he entrusted the responsibility for artistic matters to the young Bernini, who was already noted as a sculptor with an extraordinary facility for working in marble. Bernini rose brilliantly to the occasion, orchestrating the decoration of the recently completed nave of Saint Peter's, erecting the bronze baldacchino beneath its dome that surmounts the tomb of Saint Peter himself, contributing one of the colossal statues that decorate the four niches at the basilica's crossing, and designing the pope's own tomb, which includes a large bronze effigy of the pontiff and marble figures of Charity and Justice.

During the seventeenth century the sculpted bust became a favoured form of portraiture, as it had been in Classical Roman times. Bernini made a substantial contribution in this field, endowing the representations of his sitters with surprisingly lifelike qualities despite the intractability of the marble from which they were carved. Bernini's bust of Urban VIII is one of the great and telling portraits of the age, remarkable both for its psychological penetration and its subtlety of execution. The pose was carefully planned so that the pope looks down at the viewer, with his head turned slightly off the central axis and his eyes a degree further to the left. The effect is to give the subject an aura of quiet authority and keen awareness. The shadows cast by the prominent eyebrows, the faint creases around the eyes and on the forehead, and a perceptible hollowness of the cheeks all contribute to the air of slight fatigue, even introspection, as if the responsibilities of office weighed upon him. The deep cutting of the mustache and beard, about which Urban VIII was said to have been vain, contrasts with the shallow tooling of the stubble on his cheeks. Bernini was at pains to distinguish between the various materials of the pope's costume, bringing out the individual hairs of the fur lining and carefully defining the buttons and the holes through which they pass. The soft folds in the heavy drapery contrast with the crispness of the starched collar. The artist has taken advantage of a vein in the marble to create an impression of light shimmering on the velvet *mozzetta*, or cape.

As Bernini tooled and polished the marble, flaws inherent in the block necessitated production of a second version – the bust of Urban VIII recorded at the Barberini Palace thoughout its history. Although no official documents pertaining to the commission for either portrait have come to light, a contemporary account does refer to a bust being executed while the pontiff was at his summer palace in Castelgandolfo. The fact that here as well as in the second version he is shown in winter attire suggests that Bernini must have begun the portrait earlier in the year.

C.J.

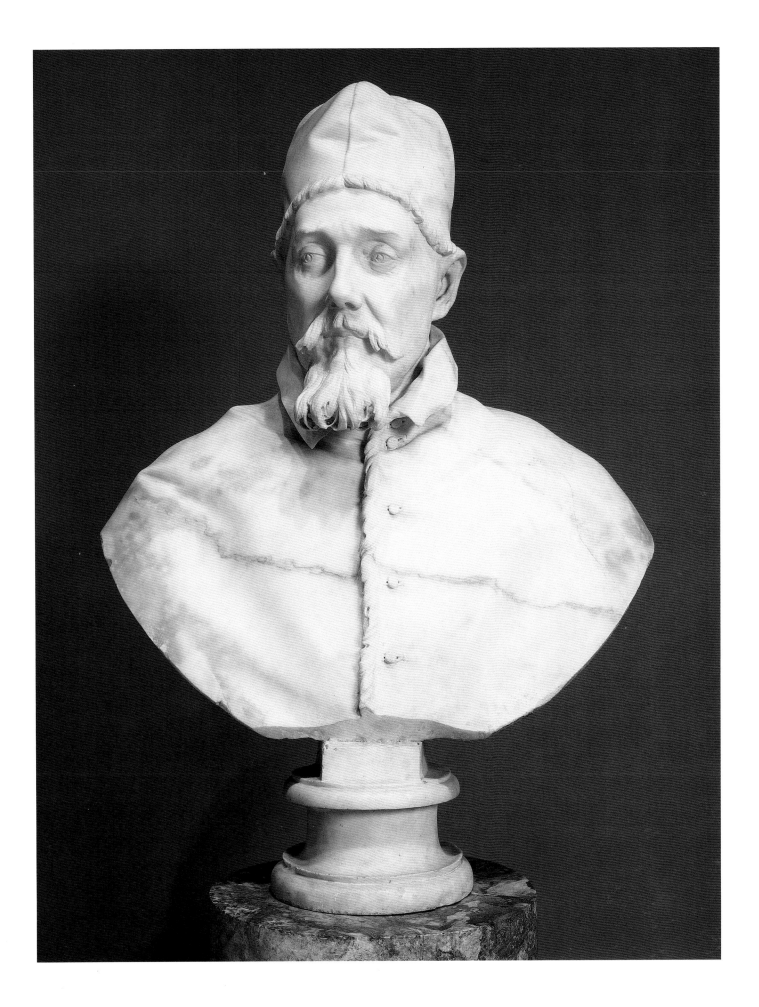

Rembrandt van Rijn

Dutch, 1606–1669

Heroine from the Old Testament (Esther or Bathsheba)

c. 1632–1633
Oil on linen, 109.2 × 94.4 cm
Purchased 1953

Over the years, this richly attired woman has been assigned a variety of names – Saskia (the artist's wife) or Lisbeth (his sister), Judith, Esther, or Bathsheba (all three biblical figures), or simply the "Jewish Bride." Confusion about the subject dates back to the eighteenth century, when the painting was known as *The Jewish Bride*. Considering the woman's lavish apparel and jewellery, the title was probably a reference to an Old Testament character rather than to a contemporary individual. Aside from the depiction of the woman in her dressing room, where she is being assisted by an elderly maid, there is another clue to her identity: the book or document on the table in the background may represent either King David's message to Bathsheba, which would result in their affair (2 Samuel 11:4), or the Persian royal edict against the Jews, leading to Esther's intercession on behalf of her people (Esther 5:1).

Modern scholars tend to identify the figure as the Jewish heroine Esther, shown as she dresses for her audience with Ahasuerus, the Persian king. Ahasuerus had previously dismissed his wife Vashti for disobeying him and had chosen Esther as his new queen, unaware that she was Jewish. Esther now prepares to plead for her people, who are threatened with annihilation in an edict issued by the king's first minister, Haman. The parallels between the biblical story – culminating in the deliverance of the Jews and their triumph over their enemies – and the plight of seventeenth-century Calvinist Holland and its own emancipation from Catholic Spain add weight to the claim that it is Esther who is the subject here. In the United Provinces, the Book of Esther was among the most popular of all Old Testament narratives.

Rembrandt executed this painting around 1632–1633, shortly after he had moved from Leiden to Amsterdam – a period in the artist's development marked by a shift towards more monumental works. Most striking in this picture is the wonderful diffusion of light that defines the entire composition. The plump young woman is seated in the centre of a dimly lit room, her waxy complexion radiant in the soft light. She is clothed in the most luxurious royal garments. Beneath an exquisite russet velvet mantle, its border heavily encrusted with gold, she wears a gauze-like undergarment or skirt glimmering with metal threads. Her stockings are green, and her gold mules are embroidered with gold. Precious jewels adorn her neck, ears, and wrists, and her long hair is crowned with a jewelled gold fillet and pale blue feather. In contrast, the maidservant – an old woman, her face ravaged by time – is soberly attired in dark green with an almost black veil. Her entire figure, with the exception of her right hand holding the comb, is enveloped in shadow.

In addition to the Old Testament references, the *vanitas* theme also reverberates in this work, which is an incidental reminder of the transient loveliness of youth. For Rembrandt, however, the painting's deepest and most personal meaning may have resided in its being a family portrait of his sister or wife and his mother, Cornelia.

S.B.

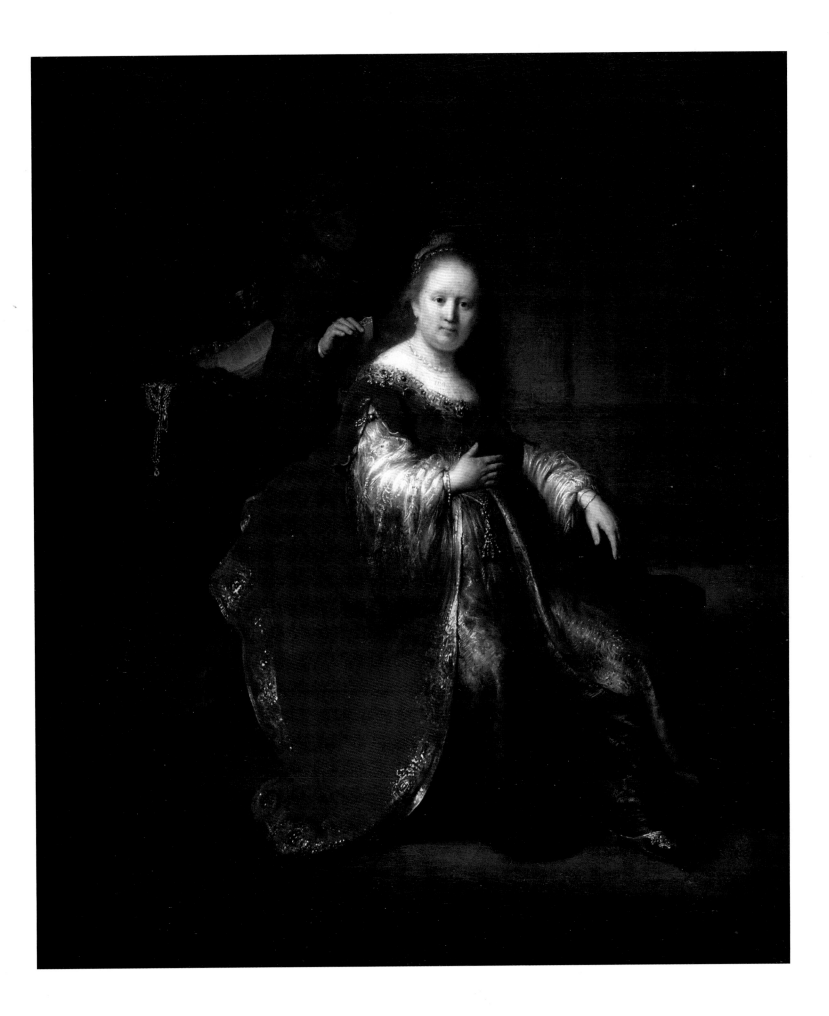

Peter Paul Rubens

Flemish, 1577–1640

A Stormy Landscape

c. 1635–1638
Oil on wood, 29.7 × 42 cm
Gift of Mr. and Mrs. Michal Hornstein, Montreal, 1998

An artist of exceptional creative energy and brilliance, Rubens is chiefly remembered as a painter of large, dynamic, figural compositions. Throughout his career he also demonstrated an interest in landscape, at first in combination with figures illustrating mythological or religious stories or involved in scenes of action such as boar hunts or sheep herding. Initially adopting the turn-of-the-century Flemish preference for a high viewpoint, Rubens tended to crowd the action into the foreground by placing rocks or trees in the mid-ground. The eye would be caught by these natural details and would only occasionally be allowed to stray into the distance. As time progressed, however, Rubens lowered his viewpoint, opening up far-off vistas.

It was during the seventeenth century that landscape painting came into its own as an independent discipline, providing more than just a backdrop to narrative scenes. Before long, differences in climate and topography – and intellectual outlook – gave rise to distinctive northern and southern landscape painting traditions. The flat terrain, cool light, and stormy skies of the Netherlands contrasted with the mountainous, sun-filled landscapes of Italy, where the Classical past, especially around Rome, was ever present. At the turn of the century Rubens left Antwerp and spent eight formative years in Italy, where he not only encountered the Venetian and Bolognese contributions to landscape painting but also, in Rome, came into contact with two northeners active in the genre, Adam Elsheimer and Paul Bril. Following the death of his first wife, in 1626, he again travelled abroad, this time on diplomatic missions to Spain and England. Not only did he study the extensive art collections of their courts, but he also absorbed the particular character of the landscape of each place.

Returning to Flanders in 1630, Rubens remarried and began a new family. Five years later he withdrew to his newly acquired country estate, Het Steen, situated between Malignes and Brussels and immortalized in an expansive landscape today in London's National Gallery. Rubens probably used the vantage point of a tower on this property to make the more intimate oil sketches of the surrounding countryside that characterize his late period. Increasingly personal in feeling, these paintings tend to be devoid of figures: here, for example, only three cows have been allowed to enter the scene. Instead of the traditional reliance on diagonals to lead the eye into the distance, the artist has used aerial perspective to direct our attention across the extensive plain towards the sun emerging from behind the storm clouds.

C.J.

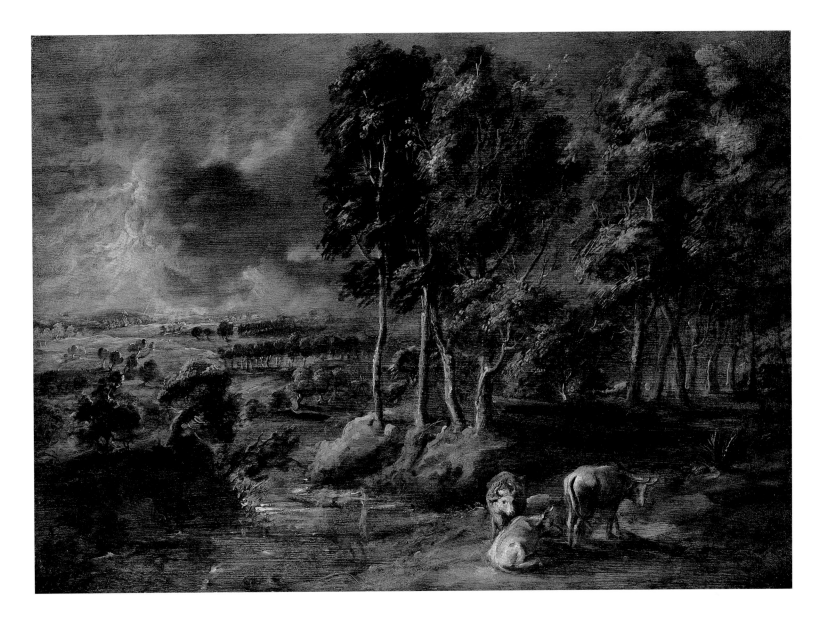

Christoffel Jegher (after Peter Paul Rubens)

Flemish, 1596–c. 1652

Susanna and the Elders

c. 1635

Woodcut on laid paper, 43.7 × 57.5 cm

Purchased 1999

Between 1625 and 1643, the printmaker Christoffel Jegher executed woodcuts of various types for the celebrated publishing house of the Plantin-Moretus press, in Antwerp. Among these were nine woodcuts based on drawings by the great Flemish Baroque master Peter Paul Rubens. While Rubens frequently used printmakers late in his career, Jegher was the only professional maker of woodcuts with whom he collaborated directly, which in itself is eloquent testimony to Jegher's skill and renown.

A trial proof for this print with corrections marked by Rubens indicates that he personally supervised the making of these woodcuts and that Jegher carved and printed the blocks himself. Given this working relationship, it is clear that for Rubens these prints were not mere reproductions but independent works of art that fully translated and broadcast his unique skills as an inventor. The master's drawing for this print no longer survives, though a lost painting by Rubens (known to us only from a copy) showing an earlier treatment of this subject, with a similar design, demonstrates that the print is based on an original composition by the painter and that for the print he added the background area at the left, which includes a formal garden in the Italianate manner. The style of the painting points to Rubens's work of the 1610s, and so the 1630s image developed for the print was partly retrospective.

The popular theme of Susanna and the Elders is derived from the Apocrypha. Susanna, a righteous and God-fearing woman, is menacingly propositioned by two elders of the community who are frequent guests of her husband. They warn that if she refuses them, they will accuse her of taking a young lover and will testify that they have seen her with him. She rebuffs their advances, they denounce her, and she is condemned to death, only to be saved at the last moment when the two elders are caught out by their contradictory lies. The subject was one that obsessed Rubens: he painted at least five different versions of it. Like most other artists, he favoured the terrifying moment in the narrative when its heroine is suddenly accosted and threatened.

The juxtaposition of the female nude with cloaked male figures is an example of how Rubens was inspired by recent Italian art. Distinctive to Rubens himself, however, and characteristic of his art are the dynamic, asymmetrical design, with its massive figures and slanting perspective, and the powerful representation of lasciviousness. Jeghers, for his part, exploits the inherent boldness of the woodcut line with accomplished agility.

D.F.

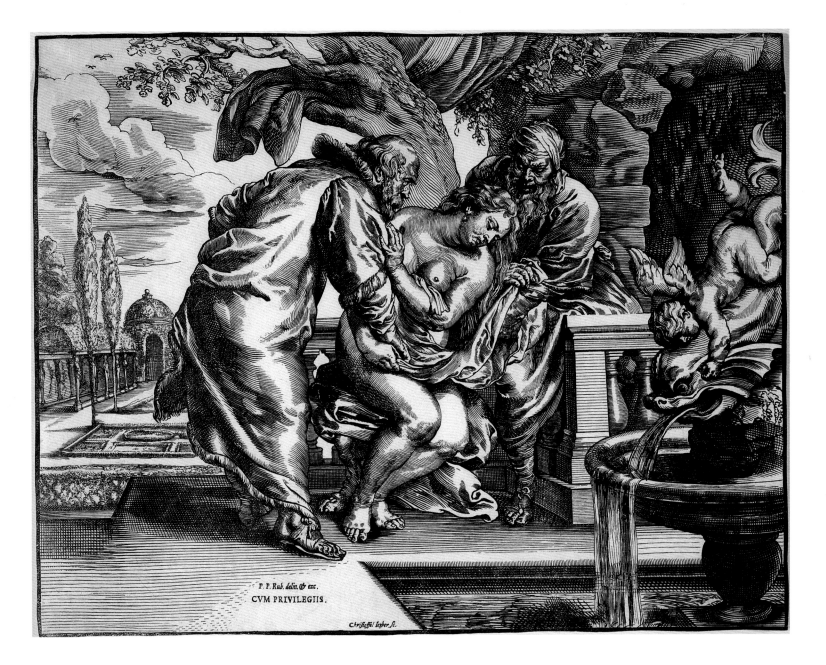

P. P. Rub. delin. & exc.

CVM PRIVILEGIIS.

Christoffel Iegher sc.

Guido Reni

Italian, 1575–1642

Jupiter and Europa

c. 1636
Oil on canvas, 157.5 × 115.3 cm
Purchased 1991

Executed with supreme confidence, Guido Reni's radiantly colourful *Jupiter and Europa* combines the Classical imagery of an earlier period in the artist's career with the technical bravura of his mature years. In the tale of the abduction of Europa, as recounted by the Roman poet Ovid in his *Metamorphoses*, Jupiter disguised himself as a docile white bull in order to seduce Europa, daughter of the king of Tyre, while she played by the seaside with her companions. As they adorned his head with flowers, Europa climbed onto his back. Jupiter then sprang up and carried her across the sea to the island of Crete, where she would bear him three sons. Reni has portrayed Europa at the moment when she becomes aware of her fate, with her gaze directed heavenward.

Jupiter and Europa was painted when Reni was at the height of his powers and in demand at many of the courts of Europe. The work was commissioned by the Duke of Guastalla as a gift for Don Diego Felipe de Guzman, Marqués de Leganés, a patron of Rubens and Van Dyck, who in 1635 was appointed Imperial Governor of Milan. Earlier, Reni had made a larger, horizontal picture of this subject (known to us through a copy by one of his pupils) containing additional figures but with Europa already in a similar pose. The success of *Jupiter and Europa* is reflected in the fact that in 1640, a few years after it had been executed, the artist made a painting for the king of Poland that essentially repeated the single figure of Europa in isolation. Employing cooler colours in the graceful delineation of her form – now represented in full length – Reni sacrificed some of the drama of the story that is achieved in this picture through the warmer tonality and the way in which the swelling forms crowd the edge of the canvas.

Guido Reni was born in Bologna, seat of the oldest university in Europe and a papal state, whose particular response to the Council of Trent had been the encouragment of a vigorous painting style with which to depict Catholic dogma. The Carracci academy in Bologna, where Reni trained, was at the centre of this movement, and the teaching there was grounded in a return to the principles of the Renaissance and a sound observation of the natural world. However, it was Reni's exposure to Classical sculpture during his years in Rome, as foremost painter at the Borghese court, and the time he spent making copies of, among other things, the figures of the Niobids in the Medici collection, that most strongly informed this noble image of Europa.

C.J.

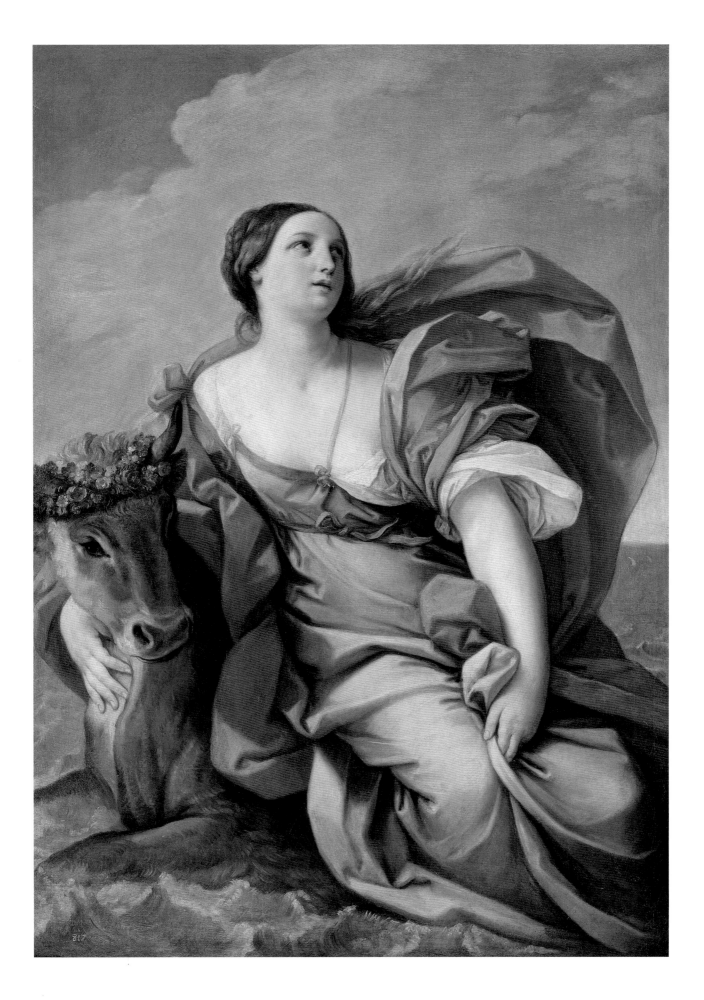

Rembrandt van Rijn

Dutch, 1606–1669

The Three Trees

1643
Etching with drypoint and engraving on laid paper, 21.8 × 28.7 cm, plate 20.8 × 28 cm
Purchased 1939

This is the largest and most celebrated of Rembrandt's landscape prints, executed with remarkable assurance in a complex mixed technique that combines etching with drypoint and engraving. Signed and dated 1643, and known in only one state, it was created by the artist in Amsterdam at the end of the period of his greatest professional and personal success. The print is basically an etching, but the lines of the lower foreground have been strengthened with the engraver's burin, and drypoint has been used to superimpose the rain like a curtain on the sky. A shadow or half-tone on the left side of the print, visible in the dark cloud, was probably produced by burnishing the copper plate on which it was drawn. Rembrandt's penchant for emotionally expressive and formally powerful images led him to experiment with different printmaking techniques in a manner quite unprecedented in the history of the medium.

Although this landscape seems, at first glance, to represent a subject of only casual significance, it is in fact suffused with meaning. The strong contrasts of light and shade are familiar from the artist's painted work, and there is the same sense of high drama as in his history paintings. The print features a striking image of three trees arranged off-centre on a low hill in the right half of the sheet. The panorama is sufficiently naturalistic to have been identified as a view outside Amsterdam, which is just visible on the distant horizon, across the low plain. But the main image of the trees silhouetted against a light sky is probably a dramatic invention of Rembrandt's, who was always willing to sacrifice verisimilitude for the sake of an expressive design. The trees appear calculated to awaken in the viewer thoughts of Calvary, with its three crosses, and perhaps also of the Trinity. At the same time, there are a number of banal reminders of daily life – an artist sketching, a fisherman with a female companion, a pair of lovers partially concealed by the vegetation in the lower right corner. These diminutive figures are set in marked contrast to the awesome scale and force of nature represented by the turbulent sky, which seems almost to mock human concerns. The way the wind and rain are buffeting the leaves suggests the start or end of a storm, reinforcing the dark mood created by the trees' evocation of Christ's Passion. It is conceivable that this brooding image was intended as a memorial to the artist's wife, Saskia, who had died the previous year.

D.F.

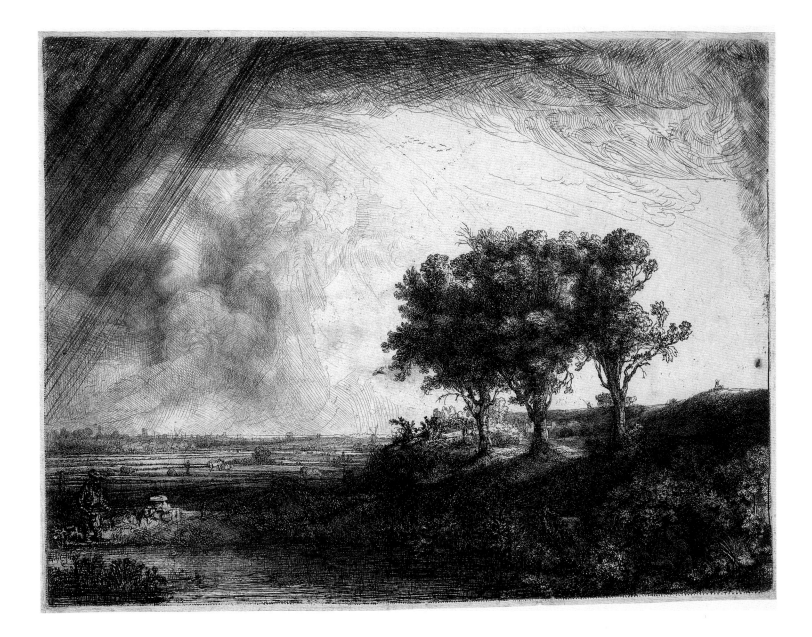

Jean Siméon Chardin

French, 1699–1779

The Governess

1739
Oil on canvas, 46.7 × 37.5 cm
Purchased 1956

Born in Paris into a family of artisans, Chardin spent his entire life in his native city. He was apprenticed to Pierre-Jacques Cazes, a history painter, but soon revealed a talent for still-life painting, the lowest of the four genres in the hierarchy laid down by the Académie Royale. Nevertheless, his remarkable skill as an observer of nature led to an early recognition of his ability. In 1724 he was admitted to the Académie de Saint-Luc as a master, and in 1728 he was simultaneously *agréé* and *reçu* into the Académie Royale, a testimony to his uncommon status.

In 1733, at the height of his success as a still-life painter, Chardin unexpectedly took a major turn and began exhibiting genre scenes. He started with kitchen subjects, and by the end of the decade was painting diverse scenes from everyday life that are almost invariably imbued with a mood of domestic calm undisturbed by the world outside. The extreme simplicity of his art, combined with his unparalleled sense of harmony, led Denis Diderot, the premier critic of the age, to call him "the great magician of mute compositions." As Chardin's prestige grew within the Académie, the wide distribution of engravings after his paintings also ensured him a European following. Contemporary and later critics agreed that he possessed a supreme gift for infusing truth into everyday objects and events, thus elevating them beyond their ordinary significance.

Chardin painted *The Governess* in 1739, apparently for a French collector. When shown at the Salon, however, it was purchased by the Austrian ambassador to France, Prince Joseph-Wenzel of Liechtenstein, who eventually became the owner of a celebrated set of four such paintings by the artist. The success of the work was evidently anticipated, as an engraving was published as soon as the painting went on view.

The scene is in fact utterly simple and devoid of overt anecdote. In an elegant if austere interior a young boy is about to leave for school, no doubt for the first time. His governess gently leans towards him to impart her final instructions while brushing his hat. The dialogue, we surmise, has so far been silent, conducted in the universal language of gestures. Intimidated by the prospect before him, the boy, eyes lowered, stands dutifully clasping his school book under his arm. Behind him, on the floor, are the now relinquished amusements of his childhood – a shuttlecock and racket, a few playing cards. Beyond is a half-open door, leading to the unknown future for which he is being groomed.

M.P.

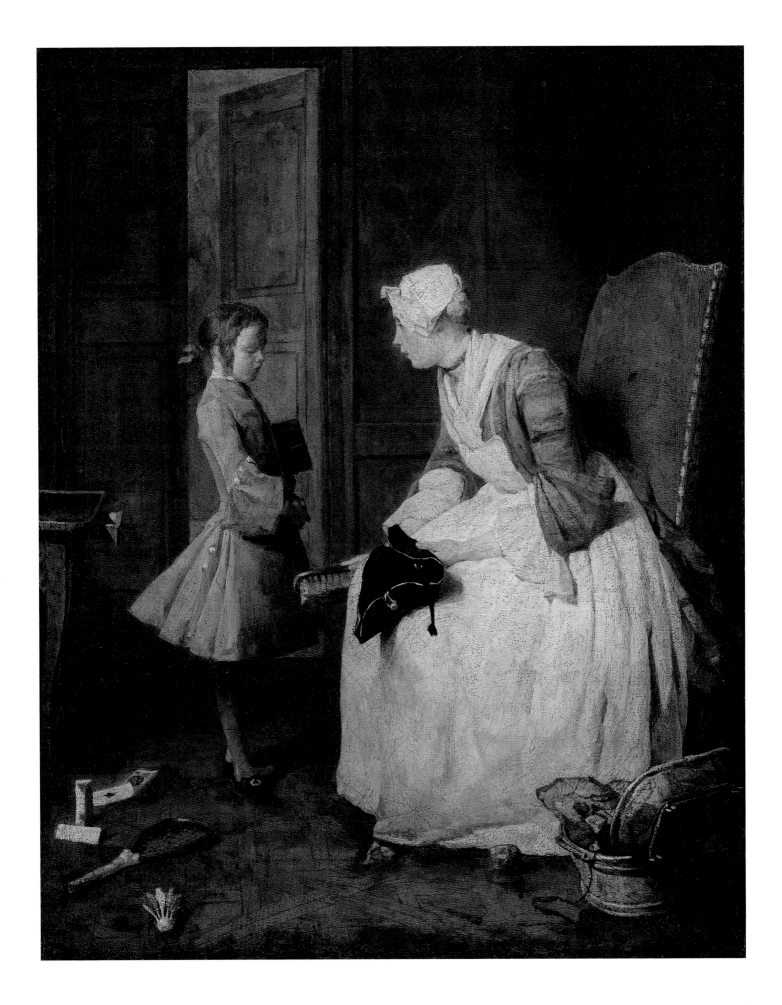

Hubert Robert

French, 1733–1808

Garden of an Italian Villa

1764
Oil on canvas, 93.5 × 133 cm
Purchased 1998

In 1754, when he arrived in Rome in the entourage of the new French ambassador, the Comte de Stainville, the young Hubert Robert had the advantage of a classical education unusual in an artist. This had been the result of a long relationship with the Choiseul-Stainville family, his patrons, who now obtained for him the privilege of entering the Académie de France as a student without having competed for the Prix de Rome. Robert's new environment proved more seductive than anticipated, and he remained in Italy on his own for the next eleven years, absorbing everything Rome had to offer. His feel for the city was shaped by a fascination with ruins, an interest in architecture, and a keen admiration for two artists, Giovanni Paolo Panini (his teacher of perspective), and Giovanni Battista Piranesi. On his return to France in 1765 Robert's career was already launched. He exhibited regularly at the Salon and became well known for his lively and original reinterpretations of Antiquity, which attracted patrons as far away as Russia. His depictions of Rome are variations on an imaginary yet recognizable place, showing permutations of actual monuments in fictitious, idealized settings certain to enchant an enlightened age that had assimilated the past and now valued it in its romantically ruined state.

Although he was never an architect, Robert's interest in buildings led to a series of appointments that culminated in 1795, when he became the curator of the Louvre and redesigned the Grande Galerie. Robert was probably even more fascinated by landscape architecture. In this respect, as an artist who sought to translate a pictorial vision into a fact of nature, he was Monet's only true predecessor. Beginning in the 1770s, he created a series of memorable landscape designs, including the Bains d'Apollon at Versailles and the parks at Méréville and Ermenonville, which are faithful reflections – to Robert's English critics too faithful – of his art.

Garden of an Italian Villa, painted the year before Robert left Rome, is the masterpiece of his Italian period. Typically, the landscape is imaginary, though it contains identifiable elements. One almost hesitates to break the spell and reveal that the central flight of steps and the villa on the right are echoes of Michelangelo's urban design for the Capitol in Rome, here rendered as if reclaimed by nature. A famous sphinx from the Villa Borghese that had earlier attracted Poussin has been positioned at the head of the staircase, which ascends under the shelter of an arch of dishevelled trees Robert had observed in France. The dark clouds, the wind-blown vegetation, and the imminent storm create an irresistibly kinetic mood that in fact overshadows the antiquarian details. Amidst the picturesque, life continues: a lady accompanied by a cleric points out some interesting feature, and a laundress goes about her business, while in the left foreground a man carrying a wooden stake attends to the ongoing and likely endless repairs.

M.P.

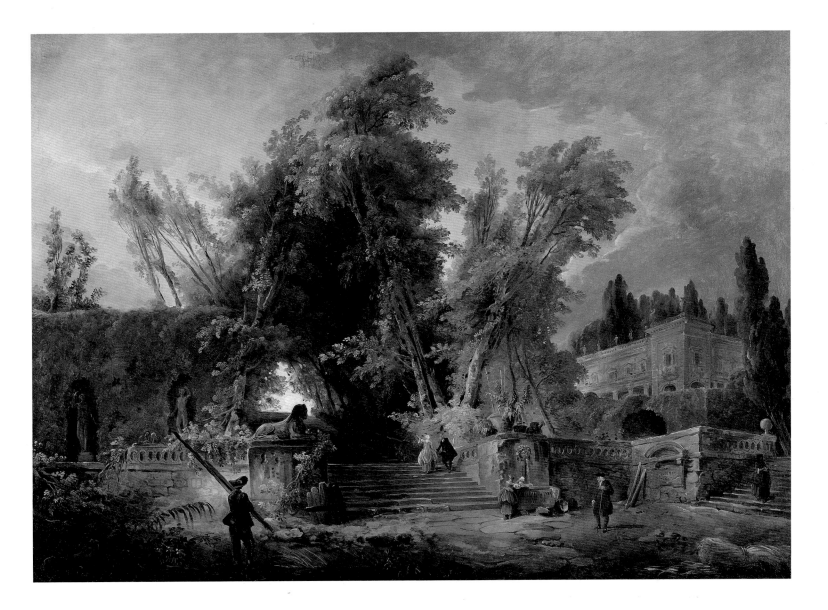

Benjamin West

American/British, 1738–1820

The Death of General Wolfe

1770

Oil on canvas, 152.6 × 214.5 cm

Transfer from the Canadian War Memorials, 1921 (Gift of the 2nd Duke of Westminster, Eaton Hall, Cheshire, 1918)

Officially, the death of General James Wolfe in 1759 at the Battle of the Plains of Abraham was to be commemorated with a monument in Westminster Abbey. However, this project was unexpectedly overshadowed by the enterprising action of a young American painter, Benjamin West. Born in Springfield, Pennsylvania, and largely self-taught, West had travelled to Rome in 1760, where he moved in circles in which new Neo-classical doctrines were taking shape. Full of zeal and a sense of artistic mission, he planned to return to America in 1763 but stopped in London and ended up remaining there for the rest of his life. He quickly attracted patrons, chief among them the Earl of Grosvenor, who commissioned from him a number of history paintings, including two depicting heroic deaths in battle.

It remains unclear whether Lord Grosvenor also commissioned *The Death of General Wolfe*, but he certainly purchased it as soon as it was exhibited at the Royal Academy in 1770. The picture, which had been the unqualified sensation of the exhibition, propelled West into the forefront of British painting as a rival to Sir Joshua Reynolds, the President of the Royal Academy, whom he eventually succeeded in office. West was commissioned to copy the picture several times and eventually became rather obsessive about what was, undeniably, a milestone in Neo-classical painting. A contemporary, James Northcote, reported: "You could not be with him for five minutes at any time without his alluding to the subject: whatever else was mentioned, he always brought it round to that. He thought Wolfe owed all his fame to the picture: It was he who had immortalized Wolfe, not Wolfe who had immortalized him."

One of the lessons that West had learned from Reynolds was the importance of citing Classical precedent when painting in the grand style. For his depiction of the General's death, West adapted the traditional formula used for the Lamentation of Christ. It is a highly effective device, but the artist's true innovation was to show the protagonists in contemporary uniforms, thus creating a modern Passion scene acted out under the silent gaze of a North American Indian. West represented Wolfe not as he died but as, ideally, he should have died, surrounded by Captain Hervey Smyth (his aide-de-camp), John Adair (his doctor), General Robert Monckton, Major Isaac Barré, Colonel George Williamson, and Captain Hugh Debbeig – none of whom was actually with him during his last moments.

The extraordinary popularity of the engravings made from the painting gave West's composition a life of its own and a credibility quite divorced from the artifice that had informed it. Indeed, in the centuries that followed, historians debated the painting's accuracy and argued about the identity of the figures it portrays, treating it as if it were an objective historical record in a way that West himself could hardly have imagined.

M.P.

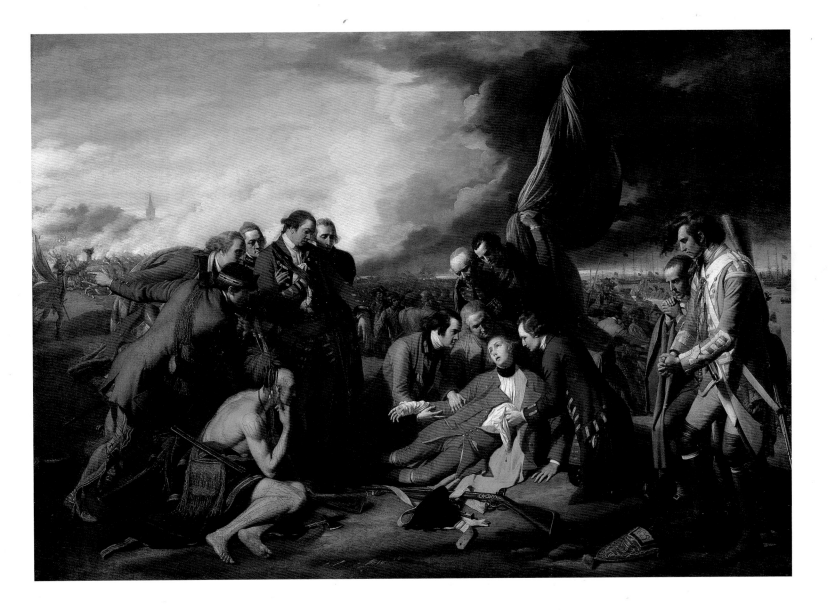

Giovanni Domenico Tiepolo

Italian, 1727–1804

An Encounter during a Country Walk

c. 1791

Pen and brown ink with brown wash over black chalk on laid paper, 28.8 × 41.7 cm

Gift of Mrs. Samuel Bronfman, O.B.E., Westmount, Quebec, 1973, in honour of her late husband, Mr. Samuel Bronfman, C.C., LL.D.

Domenico Tiepolo was the eldest son of a more famous father, Giovanni Battista Tiepolo, but he established himself early on as a major painter and printmaker in his own right. Late in his career he concentrated on the production of the finished drawings in pen and ink and brown wash that constitute his most original achievement. This drawing, which is signed by the artist in the lower left corner, is from a large group of about sixty such sheets representing different vignettes of contemporary Venetian life, some observed but some no doubt invented. These elaborately handled drawings, most in a horizontal format, appear to have been made as ends in themselves rather than as studies for paintings or prints. Several are dated 1791, and this can be taken as an approximate date for the drawing seen here. With this group of images recording the follies of his Venetian contemporaries, Domenico helped create a market for finished drawings. About a decade later he produced another well-known series, comparable in formal arrangement, based on the legend of the *commedia dell'arte* character Punchinello.

In an excellent state of preservation, *Encounter during a Country Walk* is one of the most significant drawings in the National Gallery's collection, owing to its large scale and elaborate technique, but also its charming subject matter, which treats a contemporary theme in a gently satirical spirit. The amusing excesses of aristocratic manners and costume are the target here. A flamboyantly bowing gentleman takes advantage of a chance encounter to confront three ladies on a country road, while their two footmen standing to the side laugh mockingly at his affected gesture. One of them glances directly at the viewer, as if sharing the joke with us. Humour of a pointed but not excessively biting kind is conveyed by the obsequious gesture of the faceless gallant and by the attire of the women, who seem over-dressed for the country setting. The artist also appears to be making a visual pun on the theme of the three Graces, the handmaids of Venus, by his choice of three women as the object of the man's attentions.

The drawing is a quintessential example of the liberal approach of Venetian artists to composition, evident in the splendidly relaxed arrangement of figures, and of their predilection for light and atmosphere, achieved here by the introduction of subtle washes of a warm golden-brown ink. In fact, two different inks were used in this drawing to maximize the pictorial potential of the final image. It is surprising to discover that the design was prepared in detail in a black chalk underdrawing, for the work's emphasis is on shimmering light effects rather than line, and its tonality is so bright as to suggest that the forms were drawn in full sunlight.

D.F.

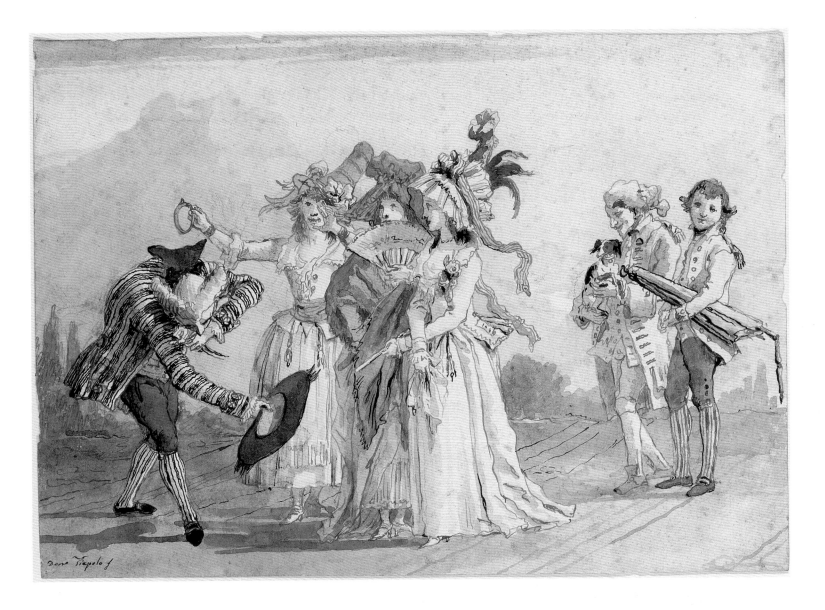

Jacques Louis David

French, 1748–1825

Presumed Portrait of Jean-Baptiste Robert Lindet

1795

Pen and black ink with brush and grey wash over traces of black chalk on laid paper, 19 cm diameter
Purchased 1995

This signed portrait drawing is one of a group that Jacques Louis David produced under the most difficult circumstances, while in prison. It is associated with the artist's second incarceration, which occurred in 1795 (he had been imprisoned the previous year as a member of the Committee of Public Safety headed by Robespierre), and it belongs to a set of medallion portraits of his fellow Jacobin inmates. Eight of these portraits survive, all sharing the same format and technique. Although the identification remains controversial, this sheet is thought to represent Jean-Baptiste Robert Lindet, who, though less loyal than David to Robespierre, was imprisoned with the artist in Paris. During the Terror, Lindet was a radical lawyer and activist, and it was he who composed the legal indictment that was used in the trial of 1792 to accuse the king of crimes against the state. Whoever the drawing represents, the face was presumably done from life, and the emotional intensity of the work may derive from the fearful predicament of both artist and subject, who were no doubt imagining their imminent deaths on the guillotine. Despite the inauspicious circumstances of their production, the drawings in this group were intended as finished works rather than studies towards another end. In fact, their function was to serve as visual memorials, should those involved have met their deaths.

David used all the technical and art historical means at his disposal to transmit a feeling of permanence through this drawing. The roundel format, with the face in strict profile and the figure truncated to half-length, had been commonly used for portrait engravings since the seventeenth century, and so it was a venerable type. This archaizing approach, based on ancient Roman coins, medals, and portrait busts, was revived for Neo-classical commemorative portraiture, beginning in the 1770s. As a student in Rome between 1775 and 1780 David had filled numerous sketchbooks with studies after Antique art and thus would have been familiar with the sources for this format.

Appropriately, the handling of the pen and ink drawing is tightly controlled, with some brushwork applied over a detailed underdrawing in black chalk. The artist also used black chalk to strengthen the contours that separate the figure from the ground and thus enhance the sense of relief. Despite the small size of the sheet, the drawing has a firmly structured design. Within this almost architectonic framework, however, inspired action is suggested by the raised head, the alert pose, the disordered arrangement of the costume, and the fact that the subject's arms break the plane of the somewhat flattened torso. The sitter's bare head and upward gaze are suggestive of an exalting, quasi-religious vision, possibly inspired by the passions and precariousness of the Republican cause.

D.F.

Antonio Canova

Italian, 1757–1822

Dancer

1822
Marble, 176 × 60 × 69 cm
Purchased 1968

The Canova *Dancer* in the National Gallery of Canada's collection is a second version of a celebrated marble commissioned in 1802 by the future Empress Josephine but not delivered until 1812. Canova was easily the most sought-after artist in Europe at the time, and it was not unusual for his patrons to wait several years for their commissions. Born at Possagno, near Treviso, and raised by his grandfather, a stonecutter, Canova had apprenticed in Venice, where he precociously set up a studio in 1774. A visit to Rome in 1779 converted him to Neo-classical theory. He settled in Rome permanently in 1781 and soon began attracting important patrons. The French invasion of Italy in 1797 caused him to leave the city, but he returned in 1799. In 1802 he accepted Napoleon's invitation to visit Paris, where he undertook a number of portraits of the imperial family. After Napoleon's fall in 1815 he returned to Paris to recover the art treasures looted from the Vatican, and he subsequently visited London to see the Elgin Marbles.

Among the visitors to Canova's Rome studio in 1802 was Sir Simon Clarke, a well-known English collector with a Jamaican fortune. At that time, Clarke asked for replicas of two figures Canova was working on – a *Creugas* and a *Damoxenos* destined for the Vatican as replacements for Antique works removed by Napoleon. However, Canova's many commitments prevented him from fulfilling his pledge to Clarke, and indeed the Vatican *Damoxenos* itself was not finished until 1806. In 1812, ten years after the original understanding, Clarke raised the question of his marbles and indicated that he would prefer female figures. By now Canova was besieged with commissions and all he could offer was a sculpture already under way, a *Terpsichore*, which was finally delivered and exhibited in London to great acclaim in 1817. In July 1818, Clarke reminded Canova that a second marble was still due him, and in time Canova proposed a replica of Empress Josephine's *Dancer*. Clarke had a temple built in his gardens at Oak Hill, north of London, especially to house the statue. But it was not until April 1822 that Lady Augusta Murray reported seeing Canova give the finishing touches to Clarke's *Dancer*, and the work only arrived in England in October of that year, a few days after Canova's death.

Viewed frontally, the sculpture is a technical tour de force, for it creates the impression that the dancer is hovering above the ground, in defiance of gravity. Only the views from the side and back reveal that the weight of the marble figure is supported by a carved tree trunk. The idea was loosely derived from a Hellenistic *Dancing Maenad* in Rome, but has been considerably reinterpreted in Canova's distinctive idiom. When the first version of the *Dancer* was shown in Paris in 1812 there was some confusion regarding the subject, and it was widely believed that the sculpture represented a muse. On reading this in the press, Canova reacted with indignation, pointing out that his statue did not represent a mythological subject, which would have required a more severe treatment, but simply a dancer of flesh and blood. After Canova's death, the *Dancer* became one of the most copied sculptures of the nineteenth century and was frequently paired with another of his works, the *Dancer with Her Finger Touching Her Chin*.

M.P.

Julius Schnorr von Carolsfeld

German, 1794–1872

Life Study of a Female Nude

c. 1825–1826

Graphite with brown wash on wove paper, 38.1 × 24.3 cm

Purchased 1977

Julius Schnorr von Carolsfeld was one of a group of German artists known as the Nazarenes, whose nucleus had been formed in Vienna in 1809 by a handful of disillusioned students opposed to the traditional strictures of academic training. Originally calling themselves the Brotherhood of Saint Luke, they took up residence in Rome, where they adopted an austere, quasi-religious manner of life. Their central mission was to seek divine truth through the evidence of the natural world, and their style tended towards uncompromising purity, as witness the drawing seen here. The Nazarenes shared a nostalgia for the artistic and literary traditions of the German and Italian Renaissance, as well as a passion for Italy in general – especially Rome, where this work was executed.

The drawing is a preparatory study for a figure in a historical fresco depicting the army of Charlemagne defending Paris, as related in Ariosto's *Orlando Furioso*. Ordered by the Marchese Carlo Massimo in 1817 for the Casino Massimo, a small palace located near the church of San Giovanni in Laterano, in Rome, the fresco was part of a group commission obtained by the Nazarenes to decorate four rooms with scenes from works by the great Italian writers Petrarch, Dante, Tasso, and Ariosto. Schnorr was responsible for the frescoes on three walls of the Ariosto room. The scene to which the drawing relates shows the Christian army being rallied by Charlemagne and his paladins against the Saracen king Agramante. Schnorr's initial designs were completed by 1823, but he made some late changes to the fresco around 1825 that involved the production of this new drawing. The decoration was finally completed in 1826.

The study represents a female nude leaning forward, her hands resting on a bench or low table. In the finished work the model is transformed into a girl looking down from a balcony, with her hands on the ledge, alarmed at the commotion caused by the soldiers and crowds below. The pose of the painted figure, reminiscent of examples in Raphael's Vatican Stanze, is tauter than that of the woman in this profoundly sober and affecting study. In formal terms, the drawing displays a crisp, linear style of exquisite austerity not lacking in sensuousness. After establishing the powerfully three-dimensional form, Schnorr superimposed the marvellously delicate hatching and then introduced a brown wash for subtle emphasis to various areas. Raphael and Dürer constitute the poles of influence on Nazarene artists like Schnorr, though the deceptive simplicity of this image also evokes Ingres. The drawing is typical of the Nazarene style, which is distinguished by an accurate and direct observation of nature – in this case the human body.

D.F.

Jean-Baptiste Camille Corot

French, 1796–1875

The Bridge at Narni

1827
Oil on canvas, 68 × 94.6 cm
Purchased 1939

After studying briefly with two minor artists, Achille Michallon and Jean-Victor Bertin, Corot began painting landscapes at Fontainebleau and Ville d'Avray, near Paris. In 1825 he travelled to Italy, remaining there until the summer of 1828. During this first, and longest, of his three visits to that country, he spent several days at Narni, a small hill-town situated about seventy kilometres north of Rome, at a point where the Nera narrows before flowing into the Tiber. The Neo-classical painter Pierre-Henri de Valenciennes, whose followers included Corot's two teachers, had encouraged artists to go to Narni to see and document its antiquities. Among the town's ancient edifices were the ruins of a magnificent Roman bridge constructed by the Emperor Augustus. Rising thirty metres above and stretching over a hundred and twenty metres across the Nera, the Ponte Augusto had formed part of the Via Flaminia. Corot was inspired by the natural beauty of the site and made several plein-air studies of the river and bridge, including a preparatory drawing that is also in the National Gallery of Canada and an oil sketch now in the Louvre. The finished painting seen here was executed in the artist's studio and was exhibited at the Salon of 1827 together with its pendant, *The Roman Campagna* (Kunsthaus, Zurich), an evening scene that complemented this morning view.

The Bridge at Narni exemplifies Corot's "beau idéal," transmuting the spontaneousness of the keenly observed oil sketch into a classically balanced work of the imagination. Most remarkable is the masterful handling of light, which defines and animates each part of the composition. Throughout, there is a freshness of colour and a luminosity that instil into the landscape a liveliness characteristic of the artist's early work. Presented as a pastoral scene, the composition also betrays Corot's indebtedness to the masters of the historical landscape – Claude Lorrain and Nicolas Poussin and their eighteenth-century successors in France, including Pierre-Henri de Valenciennes. The theme of recollection, which defines Corot's later "souvenirs," has already emerged, though it remains tempered by the artist's loyalty to the realist landscape tradition.

Corot, who failed to find a buyer for this canvas at the Salon of 1827, kept the picture, and it remained hanging in his bedroom until his death in 1875. Included in the artist's estate sale of that same year, the work was eventually acquired by the National Gallery of Canada in 1939.

S.B.

Samuel Palmer

British, 1805–1881

Oak Trees, Lullingstone Park

1828
Pen and brown ink and wash, with graphite, watercolour, gouache, and opaque white on wove paper,
29.5 × 46.8 cm
Purchased 1937

This magnificent drawing by one of the greatest exponents of Romanticism depicts a pair of oak trees in Lullingstone Park, near Shoreham, in Kent, England. This ancient wood was a magical place for Samuel Palmer, who made sketches there over a number of years. The drawing's asymmetrical composition is dominated by a large oak in the foreground spreading its enormous, lichen-covered branches, while a second tree placed in perspective behind it establishes a dramatic movement into space. Only upon closer examination of the background do we realize that this intensely luminous scene has been portrayed under cloudy conditions. The sheet was commissioned by the naturalist painter John Linnell, a pivotal figure in Palmer's life and the person responsible for introducing him to the artist who most decisively influenced his style – William Blake.

The drawing reflects the powerful tension between the artist's quest for scientific naturalism and his deeply mystical experience of nature. Above all, it seems to be suffused with an indefinable spirituality born of an Old Testament sensibility. The visionary and almost anthropomorphic quality of the representation was fully intended by Palmer, who wrote about these venerable oaks at Lullingstone sympathetically, in human terms, and said that they reminded him of the poetry of Milton.

The artist's technique here is complex. Pen and ink, watercolour, and gouache have been skilfully combined to create a construction as intensely original as it is lavish. Palmer's obsession with the wide variety of textures present in the natural world inspired him to develop a unique system of graphic marks that was calculated to evoke as full a range as possible. Commissioned by Linnell, the drawing was obviously made as an end in itself. In fact, with its brilliant greens and yellows, it is more like a painting than a drawing. Linnell's hope that Palmer would start producing the sort of tidy naturalist sketch that was commercially popular at the time – and thus earn some money – was clearly misplaced.

Remarkably, for a work that appears today so representative of the English landscape tradition, this drawing was apparently rejected for exhibition by the Royal Academy in 1829.

D.F.

J.M.W. Turner

British, 1775–1851

Mercury and Argus

before 1836
Oil on canvas, 151.8 × 111.8 cm
Purchased 1951

According to Classical mythology, Io, the daughter of Inachus, was beloved by Jupiter, who changed her into a white heifer in order to protect her from the jealousy of his wife Juno. Aware of the stratagem, Juno placed her under the guard of Argus, who had a hundred eyes. Undeterred, Jupiter commanded Mercury to lull Argus to sleep with the sound of his flute, cut off his head, and free Io. There is evidence that Turner intended to paint a picture of this subject, derived from Ovid's *Metamorphoses*, as early as 1805, but the work was not actually executed until the artist was at the height of his career, in the 1830s.

Turner showed very early the signs of an uncommon talent. The son of a London barber, he studied at the Royal Academy schools, began exhibiting at the age of fifteen, and by 1802 had become the youngest Royal Academician on record. His study of Poussin and more especially of Claude Lorrain, whom he venerated, led to an interest in history painting and a new, radically romantic conception of nature, which conferred on him a good measure of celebrity but also established him as a controversial figure. The Royal Academy nevertheless stood by him, and he exhibited regularly, taught, lectured, and wrote poetry, all the while maintaining an independent stand. After his first visit to Italy in 1819 there was a shift in his style – not only in his chromatic scales and the increasingly intense effects of light, but also in the exceptional freedom of his technique.

The great collector H.A.J. Munro of Novar remarked to a friend that *Mercury and Argus* was loosely inspired by scenery Turner had observed on the coast of Ross-shire, near Munro's house. If this was the source, Turner largely transformed it, through memories of Italy, into a poetical depiction of Classical antiquity as distilled by a visionary imagination. He has set the subject in a landscape vibrant with light, where the parts form a unified whole under the magic brilliance of the sun.

When Turner exhibited the painting in 1836 the reviews were unanimously hostile and included complaints about the yellowish tints and "the horrid glare" that would have undoubtedly blinded both Mercury and Argus. Most of the critics also accused Turner of having betrayed nature. Yet it was the very "truth to nature" in Turner's art that prompted John Ruskin to repeatedly praise this picture in his *Modern Painters*, which in turn contributed to the fame that *Mercury and Argus* ultimately enjoyed. In 1857, on seeing it at the Manchester Art Treasures exhibition, Sophia Hawthorne noted the "transcendent skies, waters & groups of flower-like colours, like jewels heaped in different parts, & atmospheres that seemed to simmer with songs of birds, of brooks & waterfalls – sometimes dim with golden mist, as when the sun shines on dust – sometimes clear as topaz opening upon us the actual heavens."

M.P.

Camille Pissarro and Edgar Degas
French, 1830–1903 / 1834–1917

Twilight with Haystacks

1879

Aquatint with etching and drypoint in reddish-brown ink on laid paper, 13.3 × 20.1 cm (irregular), plate 10.4 × 18 cm

Purchased 1973

Evoking a wide range of atmospheric effects, *Twilight with Haystacks* is the quintessential print of the Impressionist period. Of all the the Impressionists, Camille Pissarro was the one most attracted to printmaking (he produced nearly two hundred examples) and the only member of the group to concentrate especially on landscape prints. Generally speaking, he seems to have been less interested in the commercial potential of the medium than in its possibilities as an additional avenue for personal expression, independent of painting. This partly accounts for the sometimes radically experimental techniques he employed, as in *Twilight with Haystacks*, which was made during his most creative period of involvement with printmaking. The work belongs to a series of related images all datable to 1879, based on the fact that one of them, now in the Bibliothèque Nationale in Paris, was printed on a wedding invitation of that year. Pissarro's innovations were inspired by his occasional collaborator, Edgar Degas, who encouraged him to try unconventional approaches and to deliberately retain in the final work the accidents and imperfections that resulted. This print was one such collaboration. Degas worked on several versions, exploring how different colours can influence the way in which light is perceived. In addition to this reddish brown impression, he also created others in red, green, ultramarine, and black.

This particular print was executed using a complex mixed technique. The image itself – two figures walking past a pair of haystacks away from the viewer along a path that winds into the background – has been created through a combination of aquatint and etching. Some acid was added directly to parts of the sky, to heighten the transparency of the thin clouds. The more precise lines were added only in the third and final state, seen in this impression. The objects and shadows remain fixed throughout the set of prints, but the various coloured inks overlaying the image suggest different times of day and particular climatic and atmospheric conditions – in this case, a late afternoon flooded with the last rays of sunlight. The extraordinary drama of light and shade certainly takes precedence over literal description in this print, which anticipates by a decade Monet's famous series of paintings of haystacks and no doubt influenced them.

D.F.

nº 9 Épreuve d'artiste C. Pissarro
 cuivre · triphasente brun rouge
 imp. par E. Delâtre

 D. 23

Edgar Degas

French, 1834–1917

At the Café-concert

c. 1884
Oil on canvas, 65.8 × 46.7 cm
Gift of the Saidye Bronfman Foundation, 1995

There can be little doubt that *Au café-concert* was originally conceived as a portrait. The pose (used by Degas for portraits on several occasions), the composition, and the specificity of the physiognomy all suggest that this is the case. Degas's unconventional approach to portrait painting forms one of the more fascinating chapters in modern art.

The fashionably dressed sitter, presumably a habituée of Parisian nightlife, is shown in her usual surroundings – the café-concert. Firmly ensconced in her seat, perhaps during an intermission, she leans back, confident of the impression she is creating. Her intelligent eyes seem to be surveying the spectacle in the house rather than the stage. Illumination is reflected off her from two unseen sources – the glow of the stage and auditorium all around, and probably a gas light above her head. A second female figure, whose upper body is cut off by the canvas edge, stands to the right (the artist's signature appears in green on her left arm). This individual, who holds a bouquet in her hands, is sketched with the most summary of strokes. The seated woman is resplendent and at ease in her extravagant evening dress. She holds a closed fan in her gloved right hand – an invaluable fashion accessory for such occasions – and with her left she clasps the edge of her shawl or cloak. The pink chiffon gown with close-fitting bodice and full skirt is embellished with black bows at the shoulders. Her jewellery consists of earrings and a velvet and rhinestone choker. The most striking part of her outfit is the marvellously coloured shawl, almost too ostentatious for a sophisticated patron of the arts. It hints at someone used to attracting attention, a woman of the beau monde. But just who she is and what her story might be is left to the viewer's imagination.

When Degas's friend Edmond Duranty, in his manifesto *La Nouvelle Peinture*, described the character traits of the modern individual, he was referring in part to Degas's portraits. That a person's surroundings, dress, and comportment could reveal their inner self was a commonplace idea in the literature and art of the time, and the subjects Degas dealt with became standard currency, appearing in novels and operas as well as paintings.

In the mid-1880s, Degas's art underwent a significant change in style and subject matter. He began to simplify his compositions by reducing the pictorial space and adjusting the viewpoint to eye-level. He continued to crop his scenes, so that the figures began to completely dominate the shallow space of the picture. The human form took on a new prominence as Degas focused on scenes involving young working women – especially dancers, milliners, laundresses, prostitutes, and café-concert singers. In these pictures, the artist established a sense of intimacy with his subject: one senses that the woman in *At the Café-concert*, with her distinctive facial characteristics and peculiar expression, may well have been someone Degas knew.

S.B.

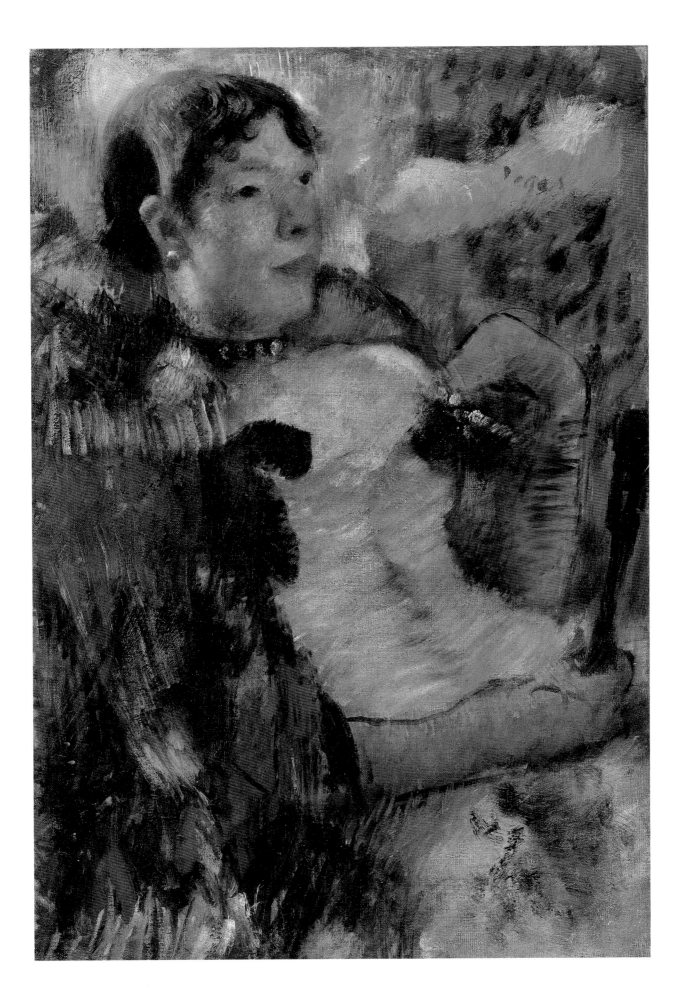

Claude Monet

French, 1840–1926

Jean-Pierre Hoschedé and Michel Monet on the Banks of the Epte

c. 1887–1890
Oil on canvas, 76 × 96.5 cm
Gift of the Saidye Bronfman Foundation, 1995

Born in Paris, Monet spent the very early years of his life in the city of Le Havre, on the Normandy coast. In 1878 he moved from Paris to the village of Vétheuil. His search for a comfortable home for his large family ultimately brought him, in 1883, to the village of Giverny, about eighty kilometres northwest of Paris. Though he would continue to travel in search of new subjects (Venice and London, the Normandy coast, the Côte d'Azur), it was here that he would establish his residence for the rest of his life and find inspiration for nearly two-thirds of his paintings.

The now famous gardens that Monet created at Giverny have become a shrine to Impressionism and one of the most visited sites in France. The property – a house and some two acres of land – was ideally located near the spot where the River Epte joins the Seine. To the east, along the meandering Epte, Monet kept his four boats, the largest of which he used as a floating studio. Poppies and wheatstacks abounded in the fields to the north; close by the house, to the south, were the flower and water-lily gardens. Monet purchased the property in 1891, and later acquired additional land, including the Île aux Orties, so that his domain extended into the Seine.

It was at Giverny, between 1883 and 1890, that Monet produced his last landscapes with figures. Most of these works remained in his possession, probably for sentimental reasons, until his death. Depicted here are Michel, his second son from his marriage to Camille (she had died in 1879), and Jean-Pierre, the son of his second wife, Alice Hoschedé (whom he was to formally marry in 1892). The boys, inseparable during much of their childhood, are shown together among the poplars lining the bank of the Epte. Monet has pictured a bright morning, with long shadows trailing across the ground, and it is a powerfully evocative vision: the effect is that of a sunny day in March, the warm air thick with the feeling of spring even before the trees have burst into leaf. The background, shrouded in mist and defined almost exclusively in terms of colour, is rendered in a wide range of pale pinks and lavender, heightened with touches of blue. The result is both diaphanous and refined, a sort of rich radiance that acts as a foil for the trees in the foreground, rendered freely in broad brushstrokes, with variations of impasto.

S.B.

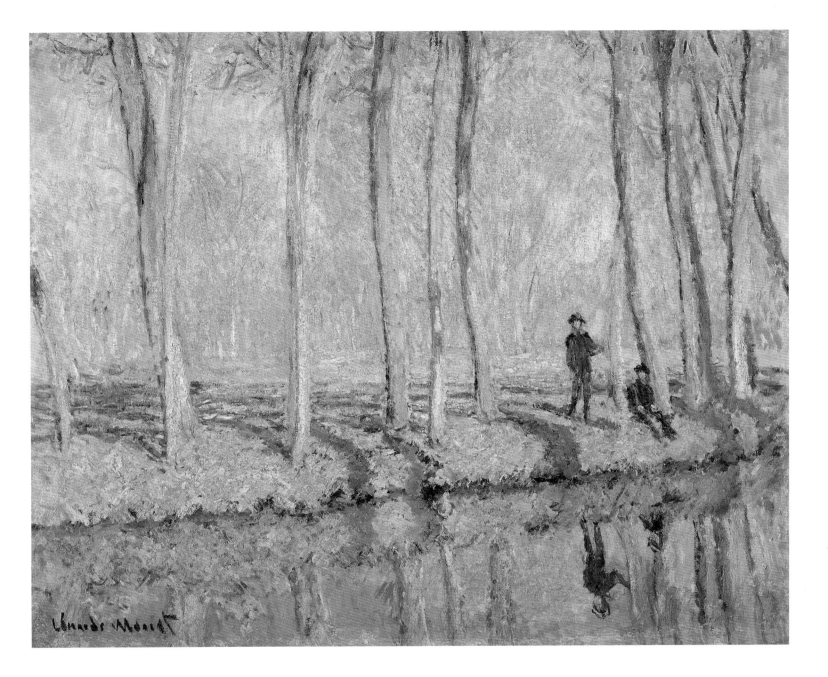

Vincent van Gogh

Dutch, 1853–1890

Iris

1889
Oil on thinned cardboard, mounted on canvas, 62.2 × 48.3 cm
Purchased 1954

In March 1886, following a ten-year absence, van Gogh left Antwerp and returned to Paris, taking up residence with his brother Theo, an art dealer, and enrolling at the Atelier Cormon. He came into immediate contact with the art of the Impressionists, arriving in time to see the group's eighth and final exhibition. In February 1888, after two years in the French capital, van Gogh departed for Arles, in Provence, where he was joined by Paul Gauguin the following October. Both his health and his relationship with Gauguin soon deteriorated (it was at this time that van Gogh mutilated his ear), and his existence seemed increasingly precarious. His brother encouraged him to seek medical care, and in May 1889 he admitted himself voluntarily to the mental institution of Saint-Paul-de-Mausole in Saint-Rémy-de-Provence, some twenty-four kilometres north of Arles. Within a few days of his arrival, van Gogh informed his brother that he was working on paintings of "some violet irises and a lilac bush, two subjects taken from the garden." From his second-floor window he could look directly down onto the unkempt garden, full of flowers and grass, that provided the first subjects for his painting of this period.

In this transcription of a corner of the garden, van Gogh has concentrated on a clump of irises – one stem is in bloom and two buds are about to burst open – against a ground dotted with marigolds. This thematic choice, although dictated by circumstance, also betrays the artist's interest in Japanese *kacho-e*, woodblock prints of flowers and birds. Here, van Gogh was painting to the full extent of his power. The brushstrokes are broad, the oil paint viscous, creamy, thick. Rendered in vigorous, dabbing strokes and a high, unmediated hue, the flowers are almost palpable. Three years earlier, in Paris, van Gogh had produced some fifty canvases on floral themes (two of which are also in the National Gallery's collection). In this vibrant composition he has abandoned their darker pigments, except for the black used to outline the forms.

Paintings such as this seem to have set van Gogh on the road to renewed health, and after some weeks he was able to leave the garden to paint the surrounding cornfields, wheat fields, olive groves, and cypresses that have become the legendary motifs of his art. But it was during the crucial weeks of confinement that he focused on the garden and its irises. Van Gogh's letters often refer to flowers as a metaphor for human emotion and experience. Irises are the symbol of gratitude and of hope, and it was their presence that provided the impetus for his recovery. It was a recovery that would last barely a year, but it produced some of the greatest paintings of the nineteenth century.

S.B.

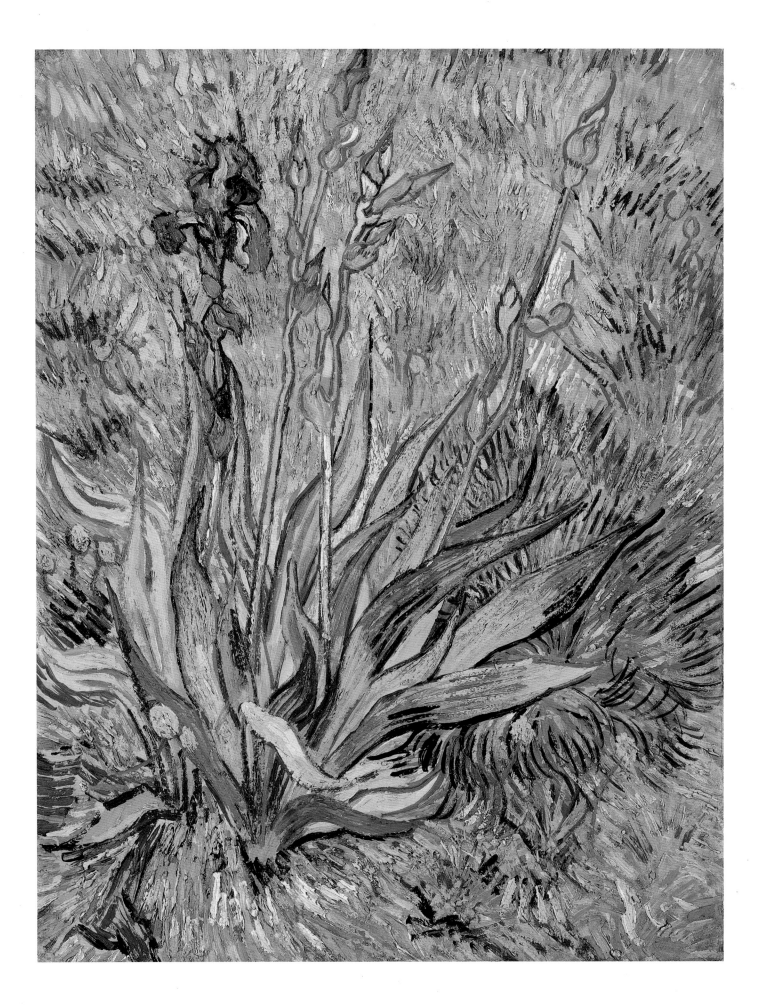

Paul Gauguin

French, 1848–1903

Portrait of Meyer de Haan

1889–1890
Carved oak with touches of colour, 58.4 × 29.8 × 22.8 cm
Purchased 1968

The heir of a prosperous Dutch family, Jacob Meyer de Haan decided relatively early in life to follow his true vocation and become a painter. In the autumn of 1888, at the age of thirty-six, he left his share of the family business to his brothers in exchange for an annuity and went to Paris in the hope that his compatriot Theo van Gogh, who was living there, would advise him on a course to follow. An attempt to study with Camille Pissarro failed, but in August 1889 he visited Paul Gauguin at Le Pouldu in Brittany and eventually joined him there in the autumn. From then on he called himself Gauguin's student, though he was more: he acted as his patron, paying the rent and purchasing works from him. Gauguin was clearly fascinated by the sweet-natured, diminutive hunchback, perhaps recognizing in him something of his own past struggles between a conventional career and painting.

At Le Pouldu the two artists lodged at the inn owned by Marie Henry and rented a studio in the villa of Dr. Mauduit. In Gauguin's company de Haan made enormous progress, and when Paul Sérusier visited them in October he found that they had begun painting murals in the inn's dining room. The decoration was carried out largely in late 1889, and the most interesting part of the scheme was the wall that included the fireplace. There, on the doors of two cupboards, Gauguin painted a self-portrait and a portrait of de Haan, while his monumental carved head of de Haan was set on the mantlepiece.

The *Portrait of Meyer de Haan*, Gauguin's largest sculpture, must have been executed over a period that extended into 1890. De Haan, whom Gauguin portrayed in several paintings as an intensely spiritual (and later malevolent) presence, is shown frontally, in a brooding mood – a favourite motif of Gauguin's. The head, with eyes half-closed, rests on one hand, the symbolic personification of thought. Gauguin had been practising wood-carving since about 1880, and in this instance he took full advantage of the qualities of the wood, exploiting the roughness of the surface and retaining the shape of the log. Behind and above the head he carved stylized roosters that have been assumed to have a significance, perhaps erotic, but may simply be a play on the name Haan, which means "rooster" in Dutch.

In the spring of 1890 Gauguin was planning to leave France and was counting on de Haan to help finance a voyage to Madagascar. By July he thought he might go to Tahiti instead, accompanied by de Haan. But as time passed, Gauguin developed an unexplained animosity towards his friend, perhaps because of the fact that Marie Henry had rejected Gauguin's advances and grown fond of de Haan, now the master at Le Pouldu. When it emerged that Marie was expecting de Haan's child, his family cut off his allowance. Gauguin himself saw de Haan a last time at the dinner held in his honour on 23 March 1891, prior to his departure, alone, for Tahiti. De Haan returned shortly afterwards to Holland, where he died in 1895.

M.P.

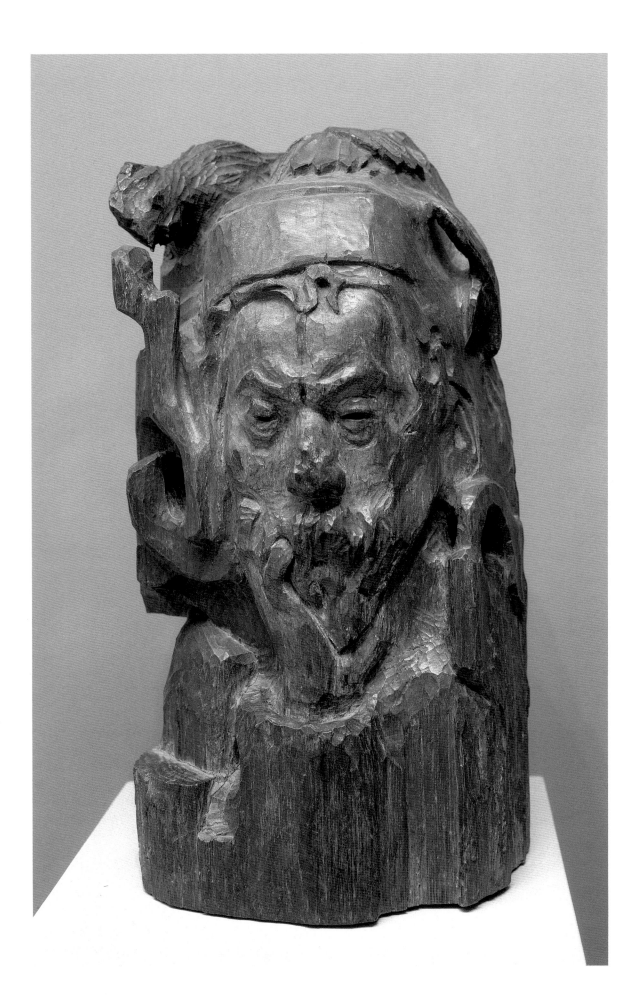

Paul Cézanne

French, 1839–1906

Portrait of a Peasant

c. 1900
Oil on canvas, 92.7 × 73.7 cm
Purchased 1950

"More than anything," wrote Cézanne, "I love the look of people who've grown old without changing their ways, abandoning themselves to the laws of time. I hate the efforts of those who resist these laws." Cézanne rarely set out, in his portraits, to convey the social status or temperament of his models, but the personality of the sitter nevertheless often shines through. In this instance, he has depicted his subject as a somewhat earnest, almost deferential figure sitting and reflecting quietly. With his legs neatly crossed and large hands clasped awkwardly on his lap, the man seems remarkably compliant to the demands of the artist. He is probably a workman, since most of Cézanne's portraits from the late 1890s and early 1900s picture peasants and gardeners from around the family estate of Jas de Bouffan. The man's features are rough-hewn and his expression slightly reserved. For the occasion, he has evidently dressed with some care – he wears a topcoat, vest, cravat, and hat. As is typical with Cézanne, the face and hands are not very worked up. Indeed, despite what probably amounted to several posing sessions (Ambroise Vollard is known to have sat over a hundred times for a single portrait), the composition retains a rather sketchy character. The juxtaposition of the unpretentious setting and the imposing, almost monumental figure gives this portrait an unusually poignant quality.

In the early 1890s Cézanne's palette had lightened and brightened, resulting in soft, luminous colourings composed of shades of warm greys, blue-greys, orange-browns, and yellow-tans. Then, in the latter part of the decade, there was a move towards stronger, darker, almost mysterious tonalities. In this portrait, vivid contrasts of light and dark have surfaced: the blues are more shadowy, and a rich brown has deepened the golds and greys. Now entering what has been called his "synthesis" period, which continued to the end of the century, Cézanne shifted his attention to mass and structure. There is a foreshadowing of Cubism in the breaking down of pictorial elements and the reworking of the picture plane. By this stage in his development, the artist was also downplaying the Impressionist preoccupation with momentary effects of colour and light in favour of more structured compositions and chromatic harmonies.

The artist's father, Louis-Auguste Cézanne, a wealthy banker, had purchased Jas de Bouffan – a former residence of the governor of Provence, situated two kilometres west of Aix-en-Provence – in 1859. From its garden, the fifteen-hectare estate had an uninterrupted view to the east of Mont Sainte-Victoire, the subject of many of Cézanne's late landscapes. The Baroque manor was the artist's refuge for over forty years. Even after the family sold the estate in 1899, Cézanne continued to live in the area, taking a flat in nearby Aix.

S.B.

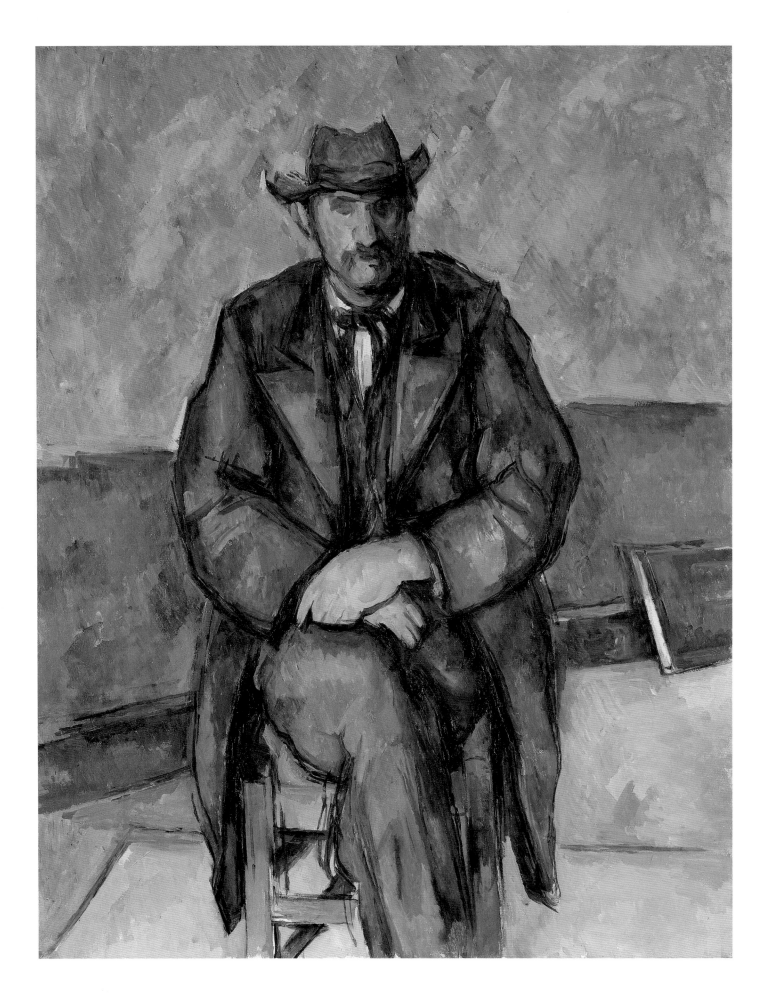

Gustav Klimt

Austrian, 1862–1918

Hope I

1903
Oil on canvas, 189.2 × 67 cm
Purchased 1970

In its forthright portrayal of pregnancy, *Hope I* singles out a motif that appeared originally as part of the entwined tangle of bodies in Klimt's ceiling painting *Medicine*, executed for the Great Hall of the University of Vienna and first exhibited at the Vienna Secession in March 1901. In his work for the ceiling paintings for the university, Klimt challenged conventional views on the most profound questions concerning the origins of life, knowledge, and morality. Where nineteenth-century science insisted on rational explanations for all biological phenomena, Klimt could see only enduring mystery and he asserted the authority of the artist to unravel life's truths in dreamlike allegory. The painting's title in German, *Die Hoffnung*, contains a play on words: allegorically, Hope is one of the Seven Virtues, but there is also a hint of the German expression referring to pregnancy, "in guter Hoffnung."

Preliminary studies for this painting show that Klimt initially thought of *Hope I* as a couple glimpsed in an affectionate moment of contemplation, the man standing with his arm around the shoulders of his pregnant mate. In the final painting, however, the artist replaced the male companion with a skeletal figure of Death wearing a diaphanous blue cape. Encircling the woman and Death is the massive tail of a dark sea monster, a serpentine variation of Typhon, one of the "Hostile Powers" threatening humanity in Klimt's *Beethoven Frieze* of 1902. In the frieze three evil Gorgons stand beside Typhon; the features of one of them reappear in the upper right corner of *Hope I*, in a figure now wearing a long cape richly ornamented with gold arabesques. In the background, beside this Gorgon figure, are two other grotesque heads also derived from the *Beethoven Frieze*, where they represent Sickness and Madness.

The inclusion of these deathly faces only heightens the unsettling effect of the woman's brazen nakedness and her steady, unashamed gaze. Such an image flagrantly contravened standards of propriety in turn-of-the-century Vienna – and indeed it continues to disturb us even today. Interviewed in his studio in 1903, while preparing *Hope I* for inclusion in his first Secession retrospective, Klimt said of the painting: "Everything is ugly: she is, and what she sees is – only within her is there beauty growing, hope. And her eyes say that." Klimt's intention to exhibit *Hope I* threatened to provoke a public scandal, and a few weeks before the opening he was persuaded by the Minister of Culture, Baron von Hartel, to withdraw the painting, lest the loan of the three university paintings, *Philosophy*, *Medicine*, and *Jurisprudence*, be refused by the Ministry.

If *Hope I* stands in one respect for freedom of expression, it also resonates with a sense of spiritual calm. Soon after Klimt withdrew the painting from his 1903 retrospective it was purchased by Fritz Waerndorfer, a wealthy patron of the Secession, in whose home the art critic Ludwig Hevesi first noted this aspect of the work, during a visit in 1905:

> The young woman walks along in the holiness of her condition, threatened on all sides by appalling grimaces,
> by life's grotesque and lascivious demons … but these threats do not frighten her. She walks unperturbed
> along the path of these terrors, made pure and undefilable by the "hope" entrusted to her womb.

Yet even hung as part of Waerndorfer's private collection, *Hope I* remained hidden behind the closed doors of a specially made frame, "to keep away profane eyes."

J.C.

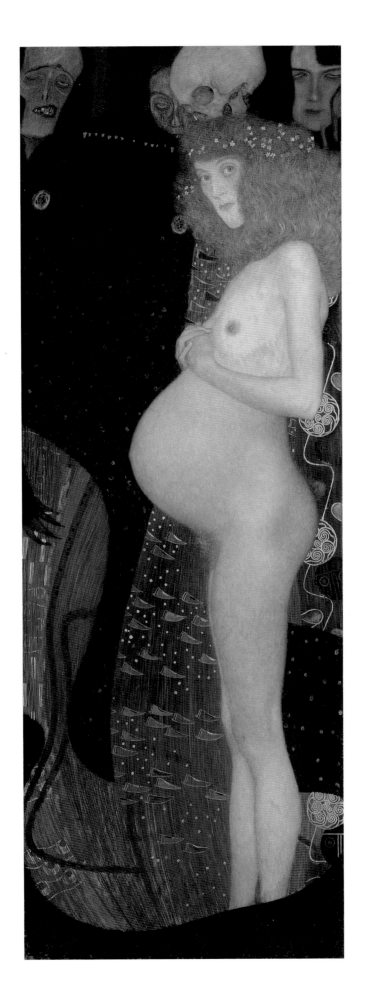

Fernand Léger

French, 1881–1955

The Mechanic

1920
Oil on canvas, 116 × 88.8 cm
Purchased 1966

This is Léger's most fully resolved treatment of the subject of the mechanic, a man at home in the world of machines that characterized the twentieth century. A symbol of the future for Léger, he is shown at rest, smoking a cigarette in front of an abstract, architectural scaffolding painted in black and white with crisp, bright touches of colour. In contrast to the flat, geometric background, the monumental figure of the mechanic is modelled in relief, with particular attention paid to the broad shoulders, muscular arms, sleek hair, and carefully groomed mustache. The static pose and simplified volumes give his body a sense of machine-like precision and equilibrium, while the tattoo, the two rings, and the jaunty angle of the hand holding the cigarette convey the self-confidence of the working man. In spite of the modern atmosphere of the painting, *The Mechanic* is in many ways a traditional portrait, in which the subject is identified by his attributes and the setting in which the artist has placed him: the smokestacks, chutes, and conveyor belts of the factory are suggested by dotted lines, diagonals, and pipe-like circular forms with which Léger breaks up the vertical and horizontal grid of the abstract background. However, in contrast to his friend Henri Rousseau's 1891 portrait of Pierre Loti, whose pose is echoed in *The Mechanic*, the subject remains an anonymous modern type rather than an individual.

The ordered clarity of *The Mechanic* reflects the classicizing tendency of French art after the Great War. Léger's own experiences – he served as an infantryman and a stretcher-bearer – left him with a profound admiration for the power and violence of the machinery of war but also for the human qualities of his fellow soldiers, and he resolved to translate these feelings into paint when the fighting ended. The mechanic was the peace-time counterpart of the soldier, and in earlier treatments of the subject from 1918 Léger shows him as an adjunct to a dynamic montage of machine parts. But in 1920 Léger moved beyond the fragmented dissonance of his post-war compositions of mechanical elements in search of the eternal spirit that linked the art of the present moment with that of the past. The Assyrian and Egyptian galleries of the Louvre, closed during the war, had reopened the previous year, and the stiff, frontal pose of the mechanic with his head in profile owes something to the frozen dignity of ancient relief carvings. A more general influence on Léger and his contemporaries was the call to renew ties with the traditions of French art, particularly those emphasizing visual order, that greeted the reopening of the Louvre's remaining galleries in 1920. Léger's response to this "call to order" can be seen in the architectural stability of *The Mechanic* and the crisp delineation of its forms, and above all in the new prominence given the human figure.

The Mechanic is a heroic figure. No longer dominated by the machine as in the earlier pictures, he is the centre of the composition, framed by the mechanical world of which he is master. The painting gives forceful expression to Léger's belief in the power of pictorial contrasts to embody the modern world. The monumental solidity of the figure poised against the geometric syncopation of the background – accentuated by contrasts of vivid colour and flesh tones – gives *The Mechanic* a vital yet timeless modernity that reflects Léger's optimism and confidence in his own times.

D.N.

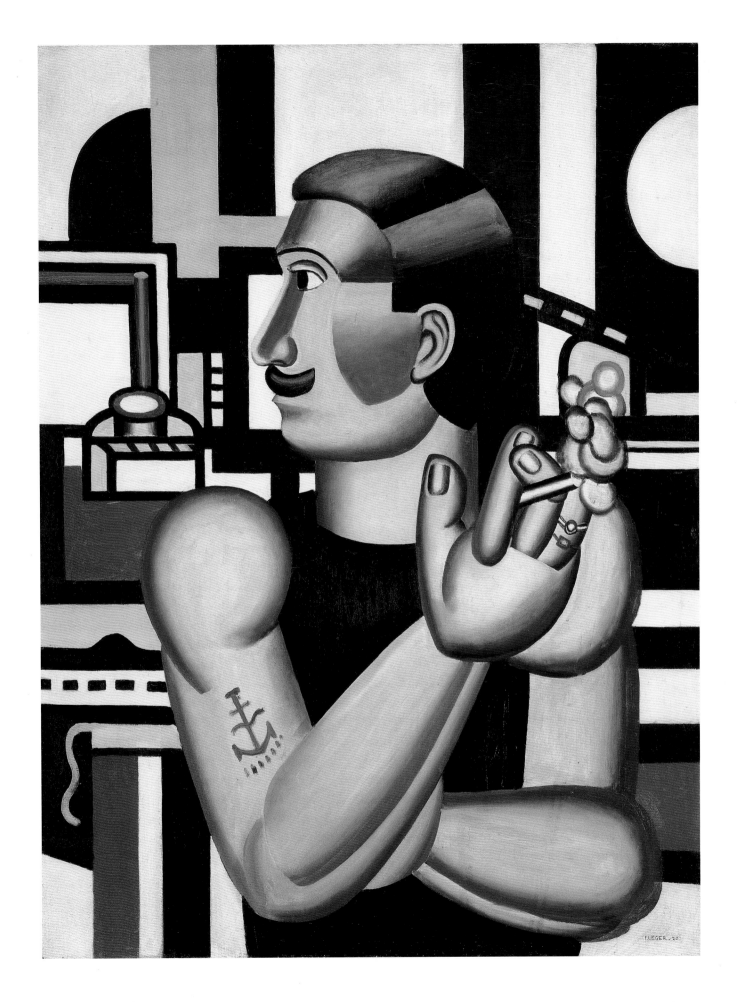

El Lissitzky

Russian, 1890–1941

Proun 8 Stellungen (8-Position Proun)

c. 1923

Oil and gouache with metal foil on canvas, 139.3 × 139.3 cm diagonal

Purchased 1973

El Lissitzky was an artist of many talents. Trained as an engineer and architect, he devoted himself to the cause of Jewish cultural nationalism early in his career, and later distinguished himself as an innovator in typography and exhibition design. In 1919, while teaching architecture and graphic arts in Vitebsk at the invitation of Marc Chagall, he met Kazimir Malevich, who advocated an abstract style he called Suprematism. Lissitzky quickly absorbed the idealistic message of Malevich's Suprematist theories and radically non-objective painting, which he understood as a call for a new world order. As both a painter and an architect, he could see the architectonic possibilities of the new style. Over the course of the following six years he embarked on a series of transitional, two-dimensional projects that he described as way stations between painting and architecture. He called these compositions Prouns – an acronym in Russian meaning "Projects for the Affirmation of the New" – and claimed that they allowed him, in effect, to treat the canvas or board as a building site.

The basic features of the Prouns can be discerned in *8-Position Proun*, made in 1923 while Lissitzky was living in Hannover. The horizon line has been abolished and – as the title suggests – there is no top, no bottom, and no single orientation point from which to view the composition. Instead, forms seem to float in a contradictory spatial arrangement, some apparently parallel to the picture plane, others projecting forward. Intersecting linear elements add to a sense of changing angles of vision, as if the whole composition were in motion, with the viewer circling imaginatively round it. Unlike Malevich, who used flat planes of bright colour or black and white on a white ground to depict infinite cosmic space, Lissitzky employed colours and collage to evoke the building materials of the modern city, its utilitarian metal-and-concrete surfaces. However, while many early Prouns suggest aerial views of plausible architectural structures, here Lissitzky has used simple geometric forms like building blocks to convey the utopian possibility of a new world in which space would be radically transformed.

As the Prouns – perhaps influenced by his graphic design work – became increasingly abstract and removed from architecture, Lissitzky looked for more direct ways to translate his ideas into three dimensions. While still in Germany, he designed a Proun Room for the Great Berlin Art Exhibition of 1923, in which abstract mural reliefs were placed so as to direct the visitor's movement through the space. Three years later, after returning to Moscow, he accepted commissions from the Dresden International Art Exhibition and the Hannover Museum to design exhibition spaces that would emphasize movement and flexibility. Other projects that he proposed in the Soviet Union included a speaker's rostrum, a cinema, and a "horizontal skyscraper." While some of these projects clearly were not practical, they reflected Lissitzky's wish to devote his skills to addressing the needs of a modern Socialist society. The Prouns proved to be (as he had predicted) a temporary stopping point in the development of his art. His ideas eventually found full expression in creative experiments with photography and in design and architectural work that produced innovative solutions to practical problems of communication and urban living.

D.N.

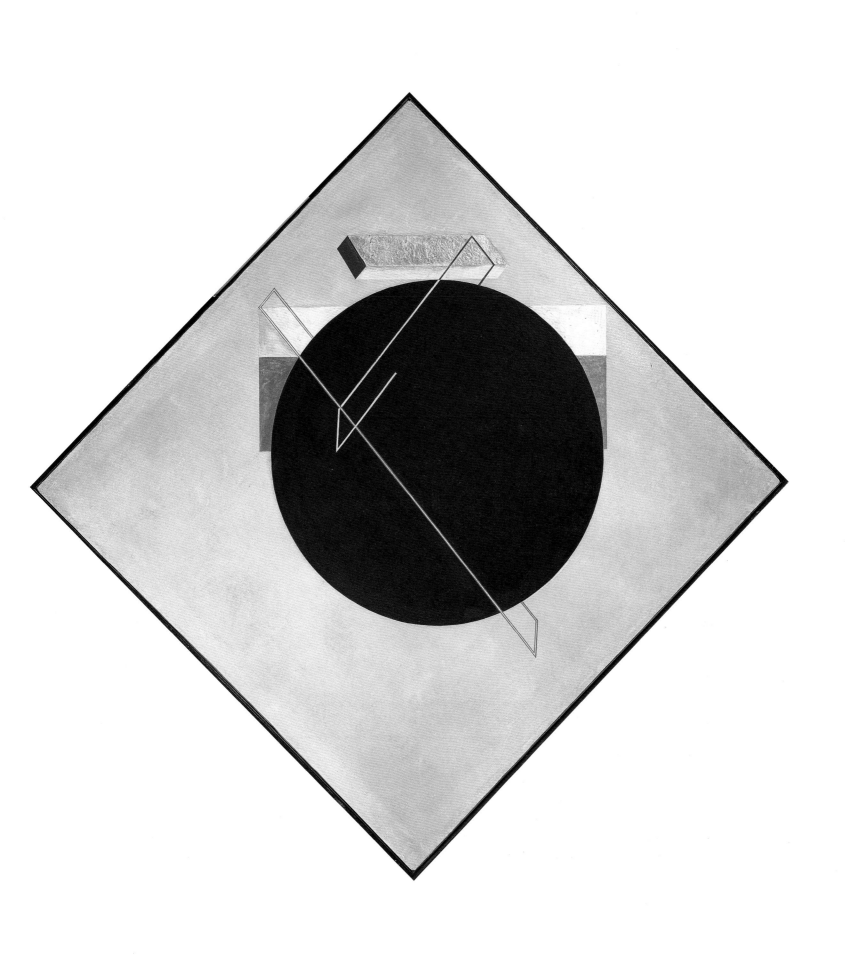

Henri Matisse

French, 1869–1954

Nude on a Yellow Sofa

1926
Oil on canvas, 55.1 × 80.8 cm
Purchased 1958

In 1950 the National Gallery of Canada was seeking to fill an important gap in its collection, for at the time it possessed no painting by Henri Matisse, one of the great French masters of the twentieth century. At Matisse's solo exhibition at the Venice Biennale that year, the Gallery's associate director, Donald Buchanan, had especially admired *Nude on a Yellow Sofa*, which was still in the artist's collection. When Buchanan visited him in the fall and spoke of acquiring the painting, Matisse responded that it was a "solid" work and would be an appropriate choice. However, he later wrote the Gallery to say that he had changed his mind and wanted to keep the work because of its special significance for him. It was not until after the artist's death that the Gallery was able to buy the painting from his son, Pierre Matisse, in New York.

Nude on a Yellow Sofa is one of a number of nudes and odalisques that Matisse painted during his early years in Nice, where he had begun spending the winters in 1916 and where he finally took an apartment in 1921. There he immersed himself in the filtered light of the studio, using patterned fabrics and portable screens to create a highly ornamental artificial space in which to pose his models. The goal of these paintings, with their complex interplay of figure and ground, was the expression of a sublimated sensual pleasure, conveyed not only through the representation of the model's body but also through the overall architecture of the canvas. For Matisse, the tapestry motifs played as active a role as the female nude in the creation of the atmosphere he sought. The relaxed well-being that he felt in Nice, isolated from the demands of the outside world, is evident in the many variations on the theme that he painted during the 1920s. After the near abstraction of the works of the previous decade, the odalisques represented not only a more naturalistic treatment of the figure but also a nostalgic return to the feeling of sensual plenitude he had experienced earlier during a trip to Morocco in 1913.

In pose and setting *Nude on a Yellow Sofa* closely resembles an earlier *Reclining Nude* painted in 1922, now in the Barnes Collection in Pennsylvania. Both are rendered in a high-keyed colour scheme of yellow, pink, green, and red, against which the flesh tones of the model are set off by a white cloth draped over the sofa. But where the Barnes picture emphasizes the graceful lines of the figure, echoing them in the flowing draperies and the arabesques of the flowered screen, the style of *Nude on a Yellow Sofa* is more sculptural, stressing the volumes of the nude and sofa and clearly anchoring them in space. This later treatment may reflect Matisse's renewed interest in sculpture following his return from a trip to Italy in 1925, which marked a turning point in his handling of the theme. Although the model's features are not individualized, she is undoubtedly Henriette Darricarrère, who posed for him from 1920 to 1927. Henriette is portrayed seated in front of the same screen in a work from 1922, *The Pink Blouse*, now in the collection of the Museum of Modern Art in New York. Besides the many paintings, Matisse made three bronze heads of this favourite model, one of which was also acquired by the National Gallery of Canada, in 1958.

D.N.

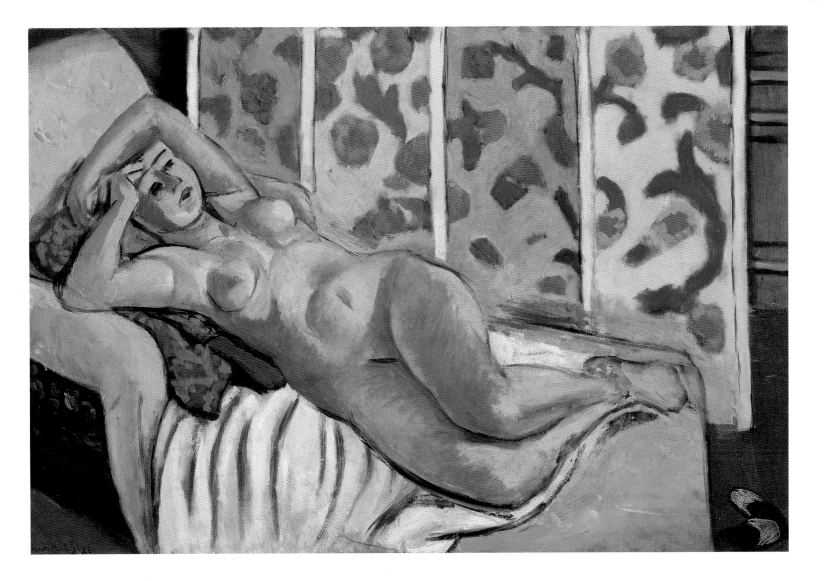

Salvador Dalí

Spanish, 1904–1989

Gala and the Angelus of Millet Immediately Preceding the Arrival of the Conic Anamorphoses

1933
Oil on wood, 24.2 × 19.2 cm
Purchased 1975

This tiny, enigmatic painting is one of several that Dalí made in the early 1930s of his wife, Gala, linking her to Jean-François Millet's *Angelus*. Quite apart from the inclusion of Millet's famous nineteenth-century painting over the doorway, Dalí's work is full of unlikely associations: Gala sits smiling at the back of a brightly lit inner room, faced by a male figure whose bald head and goatee lend him a resemblance to Lenin, a subject Dalí treated in hallucinatory fashion in other contemporaneous works. Among the plaster casts sitting on a high ledge on the wall is a bust with the features of André Breton, the poet and leader of the Surrealist movement, of which Dalí was one of the more controversial members. The casts and the Classical column allude to the humanist traditions of the arts, while the cube and sphere on the table may refer to scientific knowledge. This scene is revealed to us by an unlikely figure with a lobster on his head who holds open the door to the room. He is usually identified as the writer Maxim Gorky, which might link him to Gala, who was of Russian origin, and in fact the rainbow colours of his rather feminine costume echo those of Gala's embroidered jacket. In drawings that Dalí made around the same time, a similar mustachioed figure with an exaggeratedly spherical head is identified as a "conic anamorphosis," but here the distortions are less optical than the result of the surreal juxtaposition of the figure's head and the lobster, one of Dalí's favourite props.

Gala and the *Angelus* were twin obsessions for Dalí. In 1933, after an intense vision of Millet's painting followed by a number of hallucinatory associations in which various unrelated experiences were identified with it, Dalí wrote the first of several texts on the work, in which he developed his "paranoiac-critical" method. Drawing on psychoanalysis, paranoia-criticism was Dalí's way of systematizing his obsessions into an artistic strategy for the expression of spontaneous irrational knowledge. His interpretation of the *Angelus* as a maternal variant on the myth of the devouring father is as much a reflection of his own sexual fears as it is a postulate of Millet's intentions. In Gala, he had met for the first time a woman who understood him and was able to allay his fears. She became both his lover and a dominating mother-figure, and – as Gala-Dalí – his double and alter-ego. Although Dalí produced many other paintings that vividly translate his delirious obsessions with the *Angelus* (and his identification of Gala with the erotic content he discovered therein), here for once he has left Millet's image unaltered as a kind of artistic icon.

If Millet's painting provided the inspiration for Dalí's paranoiac-critical method, a lifelong admiration for the work of the seventeenth-century Dutch painter Jan Vermeer contributed to the realistic style that gave his deliriums the illusion of concrete reality. The composition of *Gala and the Angelus of Millet Immediately Preceding the Arrival of the Conic Anamorphoses* contains echoes of Vermeer, particularly his allegorical *Art of Painting*. The resemblance suggests that the inner room thrown open to our gaze in Dalí's painting is the artist's studio, wherein allusions to Classicism and scientific knowledge, combined with the Surrealist paranoiac-critical method, are placed under the sign of Gala and the *Angelus* of Millet, in an allegory of his art.

D.N.

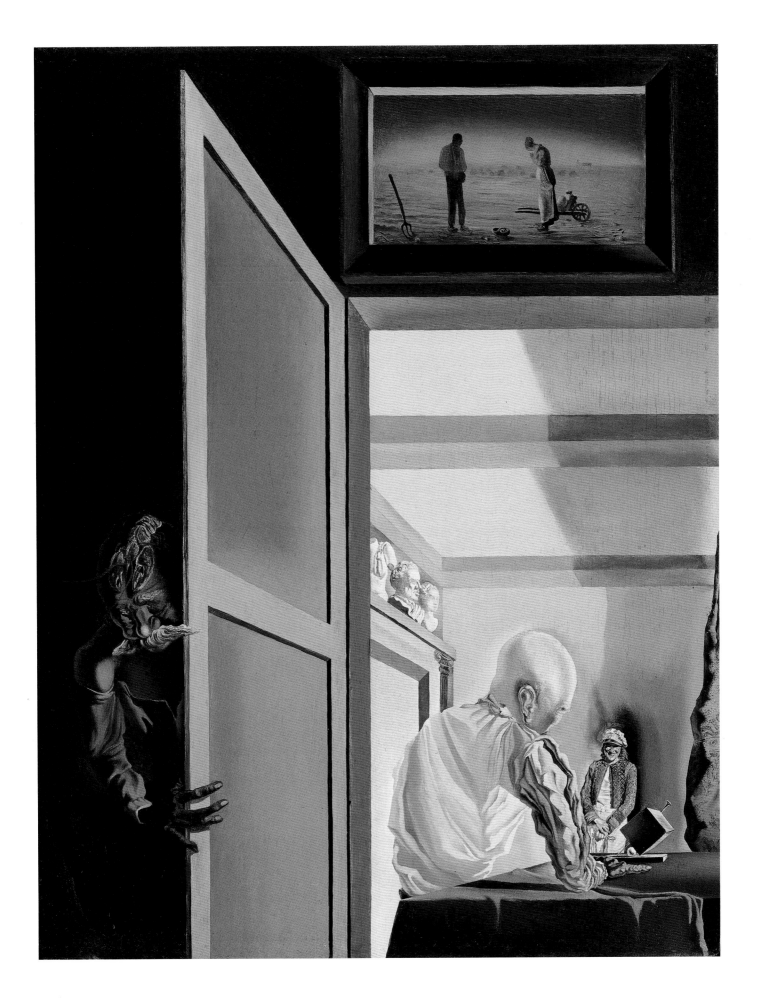

Piet Mondrian
Dutch, 1872–1944

Composition No. 12 with Blue

1936–1942
Oil on canvas, 62 × 60.3 cm
Purchased 1970

Although he was one of the pioneers of abstraction in the twentieth century, Mondrian came late to the uncompromising vision of art that was to guide all his future work. His painting showed little awareness of the modern movement in art until around 1908, when he began to experiment with heightened colour and a pointillist brushstroke. However, it was his encounter with the work of Picasso and the Cubists in Paris, where he lived from 1911 to 1914, that was to be the decisive influence on his future direction. The trees and building facades he painted at the time were analyzed into a network of lines and planes that became increasingly independent of any descriptive relationship to the motif. About the same time, Mondrian's deepening interest in Theosophy, the "spiritual science," led him to see an important relationship between philosophy and art. Rejecting symbolism, he believed that it was only through the general – in other words, through abstraction – that the painter could approach the essential truth of life, and that by avoiding description the work of art could attain both beauty and universality.

Mondrian spent the war years in the Netherlands, returning to Paris in 1919. The interlude was extremely productive. By 1915 he had painted his first fully abstract composition, and in 1917 he published "The New Plastic in Painting," an essay on the new role of art. Mondrian believed that both art and society were in the process of evolving towards absolute principles of unity and harmony. In his mature art he expressed this belief through an equilibrium of opposites created through the purest means possible: straight lines in perpendicular relationship and rectangular planes of primary colour juxtaposed with black, white, or grey. Though he at first equated the equilibrium he sought with a sense of repose and even classical balance, as his art developed it was the dynamic nature of this equilibrium that he emphasized, in compositions of increasing complexity.

One such later work is *Composition No. 12 with Blue*, which consists of a dense lattice of intersecting black lines running from edge to edge, offset by a single blue rectangle. It is one of the group of so-called "transatlantic" paintings that Mondrian began in Paris and London and finished in New York, where he moved to escape the effects of the Second World War. At first glance, the implicitly cruciform central structure conveys an impression of symmetry, but Mondrian has gone to great lengths to counter this effect by subtly decentering the lines on both the vertical and the horizontal axis and by varying the intervals between the lines so that no two are identical. The blue rectangle further weights the painting to the lower right, while short vertical and horizontal lines expand the composition asymmetrically outward.

Although the painting's centralized structure and the pure contrast created by the single primary colour look backward to works Mondrian completed in Paris, the multiplication of the lines – he added the two outer vertical lines that traverse the canvas as well as the short vertical and horizontal lines on the right after he arrived in New York – and the resultant nervous energy anticipate the dynamic movement of his final, vibrant New York works. Constantly evolving, Mondrian's painting depended on no mathematical system but rather on inner intuition – an intuition that sustained the vitality of his work until the end.

D.N.

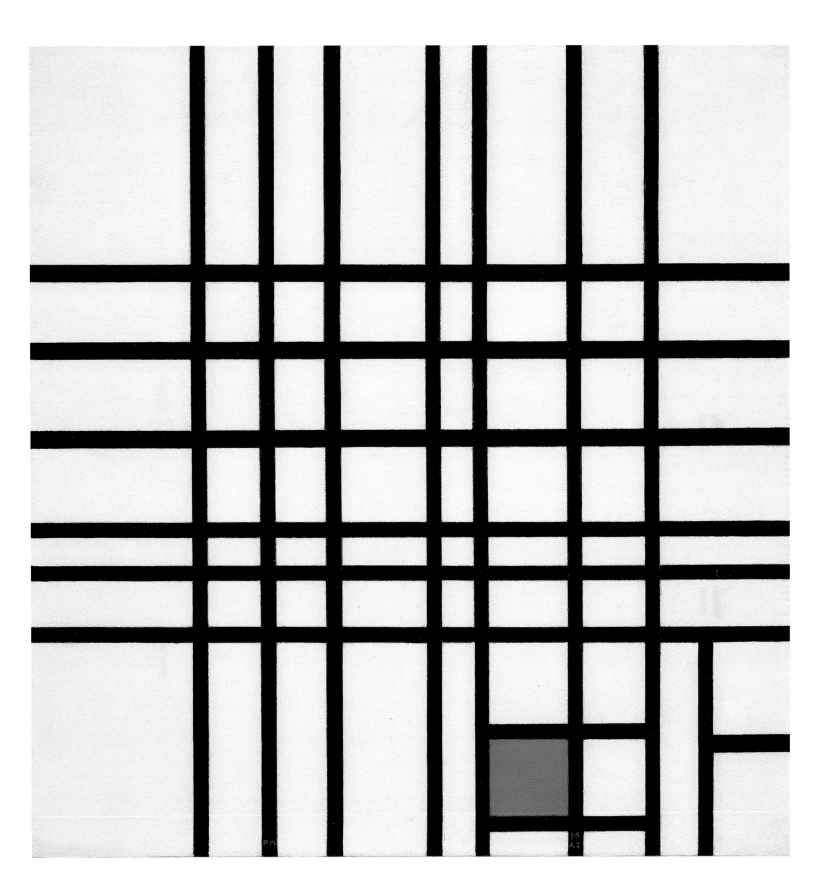

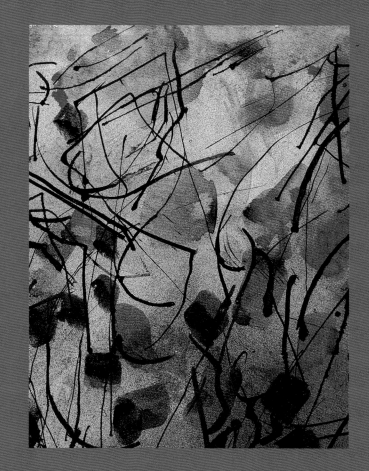

Canadian and
International Art
since 1945

Louise Bourgeois

American, born France 1911

Friendly Evidence

c. 1949
Painted wood, 179 × 15.5 × 6.2 cm
Purchased 1997

Untitled

c. 1950
Painted wood, 167.3 × 11.5 × 13 cm
Purchased 1997

Untitled

c. 1950–1954
Painted wood with stainless steel,
168.5 × 9.2 cm diameter
Purchased 1997

Portrait of C.Y.

c. 1947–1949
Painted wood and nails, 169.5 × 8.3 × 12.5 cm
Purchased 1997

The French-born artist Louise Bourgeois emigrated to the United States with her American husband and their son in 1938. She thus became part of an expatriate community of European artists driven by the threat of war to take refuge abroad, joining her compatriots Fernand Léger and Marcel Duchamp in New York. She was of a younger generation, however, and while her art has formal affinities with the sculpture of such artists as Constantin Brancusi and Alberto Giacometti, it was shaped largely by her experience of her new environment.

These four works belong to a large group of wood sculptures that Bourgeois made between 1946 and 1955, inspired in part by homesickness and a longing for family members she had left behind in France and in part by new acquaintances who aroused strong feelings in her. She called them *personnages* because they stood for individual people. Later, in an unpublished statement, she wrote: "These extremely reduced forms, although apparently abstract because they were uncomplicated, were conceived of and functioned as figures, each given a personality by its shape and articulation, and responding to one another." Although they are capable of standing alone, she meant the figures to be seen in groups. In this way she translated her concern with the relationship between the individual and his surroundings into sculptural terms.

Each of the sculptures here is roughly life-size and carved directly from wood that Bourgeois salvaged from water reservoirs located on the roofs of New York tenement buildings. Their starkly simplified vertical forms suggest standing figures. Of the four, *Friendly Evidence*, with its arms and its slightly inclined head, most strongly evokes a human presence, though the fluted carving of the unarticulated torso also gives it a pillar-like quality. This dialogue between architectural and figural references, common to all of Bourgeois's early works, can be seen as well in the window-like opening that stands for a face in *Portrait of C.Y.* and in the embedded mirror in the black *Untitled* figure. Bourgeois originally meant the sculptures – which by themselves appear fragile and vulnerable – to be planted directly in the floor of the room where they were exhibited, so as to convey the sense of a social gathering. Reviewers of her first exhibitions responded to the psychological tone she had created, commenting that her work expressed human as well as spatial relations.

Bourgeois regards the *personnages* as her earliest mature work. Her move to the United States and the rupture created by the war had isolated her from her family and her origins, giving her the courage to use herself – her memories and fears, her obsessions and antagonisms – as the subject matter of her art. In later works Bourgeois went on to exorcize the demons of her past, developing an eloquent vocabulary of private symbols. Her search for identity – creative and personal – is initiated here, in the dialogues enacted by these rudimentary, almost fetish-like presences.

D.N.

Jackson Pollock

American, 1912–1956

No. 29, 1950

1950
Black and aluminum enamel, expanded steel, string, beads, coloured plastic, and pebbles on glass,
121.9 × 182.9 cm
Purchased 1968

No. 29, 1950 is the only piece Pollock ever painted on glass, and it is certainly the best documented of any of his works. It was made outdoors on a bright autumn day for a film by Hans Namuth, who wanted to show the artist at work, facing the viewer. Namuth, who had already photographed Pollock painting, knew that this would be impossible if Pollock worked as he usually did, dripping fluid paint from a stick or brush or pouring it directly from the can as he moved around a canvas placed on the floor of his studio. He suggested that Pollock work instead on a large sheet of glass laid on two sawhorses, so that Namuth, lying underneath with his camera, could capture the artist's dialogue with his painting.

In the film, Pollock begins a painting, pouring paint onto the glass in an increasingly dense web of lines. After a time he apparently becomes dissatisfied with the result and wipes it out. Because the non-porous surface of the glass, unlike canvas, does not absorb the first layers of paint, he must adapt his approach. He begins a second painting, which will become *No. 29, 1950*. Here collage seems to play an important role, as if Pollock, knowing that he cannot create even a minimal sense of depth, were determined to build the painting outward, into the space in front of the glass plane. He first lays out pieces of steel mesh, curving one outward, then coils of string, strips of coloured plastic, beads, and pebbles to create the initial focal points of his composition. Moving back and forth, he knits these objects together with an exuberant tracery of looping and coiling threads and blobs of black and aluminum enamel, working at first deliberately and then more expansively until he has built up an open, dancing network of lines over the surface of the glass. The result is a work in which drawing and painting are united. From one side, the transparency of the glass support contrasts with the painted and collaged incrustations on its surface; from the other, *No. 29, 1950* is exclusively linear, a drawing in space. Of all the paintings that Pollock completed in 1950, it is the most open, perhaps as a result of his adjustments to the unfamiliar medium.

The question of how *No. 29, 1950* fits into the rest of Pollock's work is an intriguing one. Was it merely an eccentric exception to his usual practice, made to accommodate a friend, or does it play a more integral role? The fact that it was exhibited at the Betty Parsons Gallery along with his other paintings suggests that he and others saw it as an autonomous work, albeit an experimental one. In an interview, Pollock mused about the exciting possibilities of painting on glass in relation to modern architecture, but these thoughts did not result in further experiments. Moreover, it seems that no satisfactory method of displaying the painting was found until Dorothy Miller included it in the exhibition *15 Americans*, which she organized in 1952 for the Museum of Modern Art in New York. It was Miller's idea to build the freestanding frame that allowed the painting to be exhibited away from the wall, out in the space of the room. Shown this way, as it still is today, it inevitably invites comparison with Marcel Duchamp's *The Bride Stripped Bare by Her Bachelors, Even (The Large Glass)*, the twentieth century's most famous painting on glass, which inverted the Renaissance idea of a painting as a window onto the world. Pollock may have seen his painting as a window onto the inner world of the artist, an expression of the energy and motion of inner forces, but to artists of the generation that followed him it stood as proof that a painting was an object *in* space, a material embodiment of thought in the world.

D.N.

Jean-Paul Riopelle

Canadian, 1923–2002

Untitled

1953
Coloured ink on wove paper, 74.5 × 107.4 cm
Purchased 1998

Jean-Paul Riopelle began his career in Montreal as a student of Paul-Émile Borduas and went on to become a founding member of the Automatistes. Following the initial recognition of this new group of artists at the 1946 exhibition of the Contemporary Arts Society, Riopelle left for Paris, returning briefly in 1948 to Montreal, where he signed the *Refus global* – a manifesto promoting freedom of thought that offended both the Roman Catholic Church and the government of Quebec. During these early years, Riopelle made Paris his home, and it was while living there that he became an internationally acclaimed Canadian painter.

By the early 1950s Riopelle was well on the way to establishing himself in the forefront of France's evolving movement of Lyrical Abstraction. Represented by leading avant-garde Parisian dealers, he won the admiration of the respected critic Georges Duthuit, whose brother-in-law, Pierre Matisse, was one of New York's pre-eminent art dealers. In 1953 Matisse offered to act as Riopelle's American agent. *Untitled* was included in the artist's first exhibition at the Pierre Matisse Gallery, in January 1954, along with several other coloured ink drawings and eighteen canvases, including *Knight Watch* and *Tocsin* (both also in the collection of the National Gallery of Canada). The exhibition established Riopelle as one of Canada's most important Abstract Expressionists.

Riopelle's coloured ink drawings are probably the least appreciated of his works, although this seems hard to fathom when one is confronted with a drawing of such beauty and technical brilliance as *Untitled*. It belongs to a series of coloured ink drawings inspired by the artist's admiration for Claude Monet, particularly the water-lily paintings. It is not difficult to see Monet's influence in this work. By spray-painting the ground colours, Riopelle captured the shimmering surface of the water as well as its transparency and seemingly infinite depth. Then, by applying India ink in daubs and dripping lines over the colours, he created the effect of water lilies floating on the surface, their roots penetrating the liquid colour of the pond.

Untitled is a pivotal work in Riopelle's oeuvre. The way the black ink has been applied harks back to his Jackson Pollock–influenced action paintings of 1950 to 1952, where drippings of paint were splattered and dribbled across the canvas. The daubs of black ink also recall the mosaic-like style of the paintings that Riopelle executed in 1952 and 1953, where he applied the paint with a palette knife. In the paintings from the early 1950s, there is a dense layering of pigments, an "all-over" application of the colours that squeezes out light and air. The Monet-inspired coloured ink drawings of 1953, of which *Untitled* is such a fine example, point to a new direction by breaking down the mosaic patterning and decreasing the density of pigments. Air and light are allowed to enter the work – an effect that can be seen in subsequent paintings, such as the 1954 masterpiece *Pavane*, also in the National Gallery of Canada's collection.

R.T.

Paul-Émile Borduas

Canadian, 1905–1960

3 + 4 + 1

1956
Oil on canvas, 199.8 × 250 cm
Purchased 1962

After having been the leader of the Automatiste movement in Montreal in the 1940s, Paul-Émile Borduas left Canada for ideological reasons, determined to pursue his career unhampered. He spent two years in New York before moving to Paris in 1955. In New York, he immediately observed that American artists were experimenting with very large formats and that many were adopting a radically simplified approach to composition. It was during this period that he saw works by the Abstract Expressionist painter Franz Kline, one of the first and most eloquent proponents of the exclusively black-and-white palette. As Borduas later revealed, his own move to black and white happened gradually, through the elimination of colours and intermediary planes and the exploration of heightened contrasts.

While in New York, Borduas rented an all-white studio, where he was able to work for the first time in natural light. It was the American metropolis that prompted him to remark cryptically that "all big cities are black and white." In Paris, too, he worked in a white-walled studio. During the twentieth century, white became *de rigueur* – as, indeed, it still is – for the walls of both artists' studios and contemporary art galleries. Black and white was also, of course, an integral feature of the photography and cinema of the day, and of the Oriental calligraphy that was so popular at the time in international art circles.

In Paris, Borduas discovered the work of Pierre Soulages. He recognized the French artist's black and white paintings as expressions of the primordial duality of night and day – as being ultimately, in fact, about light. Now perceiving space and light as synonymous, Borduas himself became absorbed in the creation of space-light. In this rigorously composed masterpiece in black and white entitled *3+4+1*, he uses powerful contrasts to offer a superb exposition of a new form of unlimited space. With remarkable technical skill, Borduas has exploited the thick creaminess of the paint, created variations in texture, and deftly wielded the palette knife to produce a monumental work. The painting, whose title refers to the disposition of the black forms, was exhibited for the first time in 1956 at New York's prestigious Martha Jackson Gallery. Although executed for the Salon d'Octobre in Paris, it was not presented there.

Borduas had always been fond of using an opulent impasto, and here we have a fine example of this technique. He saw a generous paint layer as somehow symbolizing the soil, the land of his birth, his peasant origins. Living in self-imposed exile on account of his love of painting, he found in the very material of his art a precious link with the place he had left. "Basically," he said, "the element of the world that is for me the most permanent, the only one perhaps, is paint, physical paint, the *matière*, the substance. It is my native soil, my land. Without it, I am rootless. With it – whether in Paris or elsewhere, no matter – I am at home."

D.L.

Claude Tousignant

Canadian, born 1932

Paranoid

1956

Cilux automobile enamel on canvas, 129 × 121.7 × 2 cm

Purchased 1993

The shock effect of this painting by Claude Tousignant, highly innovative for its time, had a number of sources: the extreme simplicity of its composition, the abrupt contrast between its primary colours, and its technique – a flat, roller-applied paint layer, with a sharp contact line defined by masking tape. During the 1950s artists were drawn to the new enamel paints being used in the car industry because of their quick-drying qualities, the glossy surfaces that resulted, and the range of virtually pure colours available. Masking tape quickly became an essential tool in the application of this new medium.

In the dramatic frontality of its planes, *Paranoid* diverges radically from the post-Automatiste painting being practised in Montreal in the early 1950s, which Tousignant, a Plasticien, rejected as a vestigial form of landscape and was determined to escape. Regardless of its possible affinities with the work of painters like Ad Reinhardt and Ellsworth Kelly, who were also interested in pure colour, the power of this work by Tousignant makes it a key contribution to North American painting of the time. It also calls to mind the demanding creations of the American Barnett Newman, whose work Tousignant did not actually discover until 1962, in New York; his subsequent encounters with this artist, whose determination he greatly admired, confirmed in his mind the soundness of the choices he had made a decade earlier. For in his production from this groundbreaking period, Tousignant too was trying to say as much as possible with as little as possible. The essence of his art is to distil colour in order to invoke its full force.

Tousignant is a master colourist, and in *Paranoid* the chromatic intensity is heightened by the juxtaposition of the planes. Through the purity of their pigments, his colours possess a density and energy that often serves to convey a vigorously contained emotion. The binary composition employed frequently during this period would re-emerge later in the form of paired works. The deliberate lack of a frame in most of Tousignant's paintings draws attention to the depth of the stretcher, transforming them into three-dimensional objects. Pursuing this line of reasoning, Tousignant would eventually come to see his painting as a form of sculpture.

It was in 1956, a pivotal year for the artist, that he embarked on his rigorous and uncompromising attempt to define the work of art as an object. This idea – the artwork as a unique object consisting of relations between colours, forms, formats, and supports – originated with the Dutch Neo-plasticist artist Piet Mondrian. It is hardly surprising that there was little sympathy at the time for Tousignant's new direction. But it was nevertheless an eminently logical step in the artist's evolution and one that was more than vindicated a few years later by the rise of American Minimalism.

D.L.

Francis Bacon

British, 1909–1992

Study for Portrait No. 1

1956
Oil on canvas, 197.7 × 142.3 cm
Purchased 1957

Although most of Bacon's portraits were of his contemporaries, the one significant exception was the many variations he painted after Velázquez's masterful *Portrait of Innocent X* of 1650. Bacon had the greatest admiration for Velázquez's ability to combine grandeur and humanity in his portraits, and he was obsessively drawn to this work, as much perhaps for its physical and psychological embodiment of power as for its extraordinary painterliness. The facts of Velázquez's portrait are traced in summary form in Bacon's study – the formal pose, the details of the costume, the oblique gaze of the eyes – yet the sense of direct confrontation is attenuated here. Bacon's pope is watchful but remote, his figure engulfed by the black field of the large canvas. He is further removed by the device of the space frame, which Bacon often employed to isolate his subjects, and by the four parallel strokes of paint at his feet, which read as stairs before his papal throne. Secured by this schematic armature in the ambiguous space of the painting, the pope's spectral figure appears to be a magnificent but lonely specimen of some exotic relative of contemporary humanity.

It is a remarkable but telling fact that during the 1950s and '60s, when Bacon was preoccupied with the subject of Velázquez's portrait, he knew it only from reproductions, and he even chose not to see it when he was in Rome in 1954. He characteristically absorbed a great deal of visual information from photographs, surrounding himself in the studio with news photos, scientific studies, and reproductions of Old Masters. Calling himself a "pulverizing machine," he drew freely from quite disparate sources in his search for images that could reveal some deeper truth about the human subject. Among the most striking examples of Bacon's method are certain of his portraits of the pope with his mouth open in an existential scream, based on the famous image of the screaming nanny in Eisenstein's film *The Battleship Potemkin*. The influence of photography and film on Bacon is subtle but pervasive: it can be felt in the way he reduces the rich reds of Velázquez's portrait to a palette of black, purple, and grey, for example, and also in his use of sequencing in some of the pope portraits to suggest the traces of time. The artist was nevertheless impatient with the literalness of photography, preferring the sort of painterly shorthand that is apparent here, in which the image seems to be conjured out of nothing.

Later in life, Bacon expressed regret over his portraits after Velázquez, calling them obvious and cheap. Yet through them he conveyed an astonishing range of emotions, from reverence to horror to mockery, which suggests that his obsession with the subject had deeper psychological roots. The pope is the ultimate father figure, and Bacon's relationship with his own father had not been an easy one. His portraits divest the pope of his public persona, exposing the private side of the man with humour and sometimes startling savagery. Bacon transforms Velázquez's image of spiritual authority into a hollow man, an ambiguous icon for an age of uncertainty.

D.N.

Mark Rothko
American, 1903–1970

No. 16

1957
Oil on canvas, 265.5 × 293 cm
Purchased 1993

Like many of the American abstract painters of his generation, Mark Rothko was concerned with the subject matter of art. Having moved from subjects in the everyday world to semi-abstract mythical figures influenced by Surrealism before arriving at his mature abstract style in the late 1940s, Rothko saw his development as a process of clarification. Obsessed with being understood, he wanted to eliminate all obstacles standing between the painter and his idea, and between the idea and the observer. Yet despite his relentless quest for the essence of painting, which led to works where colour, light, and space are the only actors, he chafed at being characterized as a colourist, insisting that he was not interested in relationships of colour and form, but in human emotions. Rothko's view of art – and life – was essentially tragic. He saw it in Nietzschean terms, as a struggle between a Dionysian inner state, instinctual and wild, and an exalted Apollonian contemplation that filtered the chaos and made it endurable. In a lecture given at the Pratt Institute in 1958 – a year after painting *No. 16* – he affirmed the necessity of conflict: in art "there must be a clear preoccupation with death," he told his audience, but also, "sensuality … a lustful relationship to things that exist."

By 1950, colour had become the primary carrier of meaning for Rothko, and over the next two decades red was the colour he returned to most often. It was closely associated for him with emotion, and lent itself to endless variations of feeling – now bloody and foreboding, now radiant and sensual, dark or bright. Rothko characteristically preferred subtly nuanced, close-toned juxtapositions of colour areas, but in several paintings of the 1950s he paired red with white, and never so dramatically as in *No. 16* (titled *Two Whites, Two Reds* when it was first exhibited). Here he has used the sensual and poignant qualities of red to contrast with the emptiness of two white fields that seem to mask an immanent darkness. Usually white is identified with light, but here the red areas, wedged between the expanses of white and pushed outward towards the edges of the painting, are the more luminous. This sense of coloured light is the result of Rothko's use of underpainting and thin washes of colour, which he has applied with soft brushstrokes so that his shapes seem to hover ambiguously over or behind the surface of the painting. In *No. 16* he has also emphasized the dramatic contrast of the colours with sharp strokes of the palette knife to scrape away the white on three sides, squaring up the shapes and accentuating the imposition of the white field.

No. 16 was by far the largest painting that Rothko showed at the Sidney Janis Gallery in 1958 and a departure from the close-valued paintings that made up the rest of the show. Critics at the time found it raw and polemical and had difficulty accepting it. For all the sensuality of its warm palette, it is a painting of extreme tensions, and it marks a turning point in Rothko's work. In the dark and deeply spiritual paintings that follow, the preoccupation with death – held at bay by the "lustful relationship" with the world in the struggle that gave life and art its tragic meaning – appears to gain the upper hand. In *No. 16*, light and darkness, body and spirit, still engage in joyous combat.

D.N.

Art McKay

Canadian, 1926–2000

Flat Blue, Flat White, Stove Enamel

1960

Stovepipe enamel and commercial enamel paint on hardboard, 121.6 × 182.5 cm

Gift of Lillian Horeak, Regina, 1994

Art McKay was one of the most talented members of the group known as the Regina Five, which began attracting national attention in the early 1960s. In 1959, at one of the famous workshops he had helped organize at Emma Lake, in northern Saskatchewan, McKay had been shaken by a remark made by the influential American painter Barnett Newman. As a result he decided to abandon his semi-figurative style and adopt a new technique, which involved making small, disconnected marks on white paper with a palette knife dipped in black slate paint. For the first time, he was painting without any preconceived ideas and allowing his subconscious to take over – following, in fact, the principles of automatism.

McKay was aware of the various automatist techniques employed by such painters as Jock Macdonald, Paul-Émile Borduas, and Jackson Pollock. For his part, he took advantage of the approach to express a symbolic battle between the forces of darkness and the forces of light. Applying the methods he had developed on paper, in black and white, to the painting medium, McKay eschewed the brush in favour of a scraper (a technique introduced to Regina by Ronald Bloore) or a palette knife, which he would use to spread enamel and flat commercial paint over his chosen support.

In 1956–1957 McKay went to Merion, Pennsylvania, to attend art history courses at the Barnes Foundation. These courses, which were highly unorthodox for their time, entailed in-depth formal analysis of specific works of art under the firm direction of Violette de Mazia. Hours could be spent discussing a single painting – a Cézanne, for example, or a Matisse – from the marvellous Barnes collection. McKay was profoundly influenced by these sessions, which taught him to see and helped him understand how one could become entranced by a work by truly looking at it. It was what prompted him to encourage viewers to adopt a similarly receptive attitude when looking at his famous mandala paintings from the 1960s.

Drawing on the sum of his artistic experiences, and well aware of the major pictorial issues of the time, McKay was ready at the start of the 1960s to begin producing his most original works. *Flat Blue, Flat White, Stove Enamel*, executed in 1960, is composed of a tornado-like swirl of forms, a veritable maelstrom of emotions. McKay was always fascinated by things that are "moving, flowing, and constantly in process." Among his special interests were Oriental philosophy (particularly Zen Buddhism) and Japanese art. The juxtaposition of blues and whites in this painting recalls, moreover, the chromatic range seen in the famous wood-block prints by Utamaro. The subject matter of *Flat Blue, Flat White, Stove Enamel* is cosmic, for it evokes a primeval state of chaos, the flux that preceded the division of the elements and the creation of the universe. The mandala paintings, which were to follow this work, focus on similar philosophical and spiritual questions.

D.L.

Yves Gaucher

Canadian, 1934–2000

Fugue jaune

1963

Colour relief print on laminated paper, 56.3 × 75.8 cm

Purchased 1964

An artist of remarkable originality and intellectual rigour, Yves Gaucher is considered one of Canada's foremost abstract painters. He began his career as a printmaker in 1958 and was recognized immediately as the unrivalled leader of Quebec's printmaking renaissance of the 1950s and '60s. Initially, his aim was to forge a language in relief printing that would go beyond the two-dimensional imagery of etchings and woodcuts and all their technical variants. An admirer of the prints by Old Masters such as Rembrandt, Gaucher analyzed their aesthetic qualities – the character of line, the texture and colour of the paper, and the rises and recesses created in the paper by the printing process. He first produced a series of relief prints in an Abstract Expressionist style that explored the aesthetics of line, volume, and surface. The increasing technical complexity of each piece had the effect of liberating the design from the flatness of the paper and the tyranny of the rectangular printing block or metal plate.

In 1963, Gaucher's art took a whole new direction. Music and the dynamics of rhythm had always played a role in his work, but that year a musical experience changed his approach utterly: "When I first heard the music of Anton Webern in Paris, it had a tremendous impact on me. I wanted to do in prints what he did in music: to develop a visual rhythmic with counter rhythms established through the percussive effect of colour." Gaucher realized that Webern's spare, atonal music was proof that simplification of technique and imagery could result in greater freedom and enhanced creativity. His response was *En hommage à Webern*, a set of prints that used positive and negative relief, broken lines, and carefully calibrated tones of black and grey on a background of subtly varied laminated papers. *Fugue jaune*, done the same year as the Webern prints, takes Gaucher's art one step further. It testifies to his nascent interest in colour, piqued two years earlier by a Mark Rothko retrospective in New York and a reading of Josef Albers's essay "Interaction of Colour." *Fugue jaune* is the first of Gaucher's prints to explore the kinetic quality of colour in conjunction with a musical form.

A dialogue between printmaking, painting, and (during the latter part of his career) collage was integral to Gaucher's development as an artist. *Fugue jaune*, which successfully combines the artist's admiration for the essence of Rembrandt's etchings, the austere music of Anton Webern, and the colour theories of Josef Albers, was pivotal. It would soon lead Gaucher to apply his synthesis of these complex and varied aesthetic sources to his *Danse carrée* and *Signal/Silence* series, which would establish him as one of Canada's most thoughtful and appealing abstract painters. *Fugue jaune*, like all of Gaucher's best work, is characterized by a refined yet accessible visual language that draws the viewer towards a serene state of contemplation.

R.T.

George Segal

American, 1924–2000

The Gas Station

1963
Plaster figures, Coca Cola machine, glass bottles, wooden crates, metal stand, rubber tires,
tire rack, oil cans, electric clock, concrete blocks, and wood and plate-glass windows,
installation dimensions 259 × 732 × 122 cm
Purchased 1968

Trained as a painter in the years when Abstract Expressionism was at its height in New York, George Segal turned to sculpture in the early 1960s. Like the Abstract Expressionists, he wanted to convey a heightened sense of inner reality, but he was reluctant to separate this from his intensely felt encounters with the tangible world around him. Along with other artists of his generation, like Claes Oldenburg and Allan Kaprow, Segal felt that anything could provide subject matter for the artist: there were no "noble" subjects, and there could be no restrictions on the materials an artist might work with. His breakthrough into sculpture – provoked by his desire for total experience – came in 1961, when he adopted a method of direct casting that involved swathing his models with plaster-soaked bandages. By placing the plaster figures in tableaux composed of carefully selected objects from the everyday world he was able to work in real space, while controlling his figures' environment like a painter.

In looking at the world around him, Segal chose subjects that had vivid personal associations. *The Gas Station* grew out of the familiar experience of stopping for gas while driving on the highway at night. The pale figures of the two men – the vigorous older man absorbed in his work, the younger one slouched on a crate with a Coke in his hand – loom out of the darkness in a shallow space punctuated by a few found objects. In an earlier version of the work, Segal had included much more of the cluttered paraphernalia of a gas station. But after returning from a trip to Europe he stripped the scene down to a few essentials, so that the empty spaces between the figures express a distance that is both physical and emotional. Essentially frontal, like all of Segal's tableaux, *The Gas Station* has a timeless, frozen quality. Partly, this is the result of the ghostly appearance of the plaster figures, whose whiteness gives them the look of disembodied spirits amidst the realistic details of the setting. The feeling of suspension is reinforced by the formal elements of the composition: the rectangular window frames, the pyramid of oil cans, and the line of tires visually arrest the movement of the older man, just as the piled up crates and the Coke machine separate and contain the figure of his companion. Only the functioning clock in the middle – telling real time – interrupts the slow passage of this static geometry, emphasizing the unique combination of realism and abstraction that is characteristic of Segal's work.

Segal's interest in the vernacular of American experience links him to Pop art, although he did not share in the Pop artists' celebration of consumerism or their cultivation of an impersonal-looking style. Casting from life gave his sculptures a convincing realism, but it also left him considerable room for interpretation. In his earlier works, in particular, he used the unrefined exterior of the cast, adding definition where he wanted and blurring what he felt were unnecessary details, much as in drawing or painting. Ultimately, Segal's interest in human experience separates him from Pop art. By combining his cast figures with discarded everyday objects, Segal communicates both the sensual immediacy of the present moment and the detached, objective flow of time that together form the ground of lived experience.

D.N.

David Smith

American, 1906–1965

Wagon I

1963–1964
Steel with black paint, 224.8 × 308.6 × 162.5 cm
Purchased 1968

When David Smith first saw welded iron sculptures by Picasso and Julio González in the pages of *Cahiers d'art* in 1933, he immediately recognized a new way of making art that came out of a tradition in which he himself had roots. Smith had grown up during the industrial transformation of the American Midwest and as a university student had learned to weld steel while working for a summer at the Studebaker automobile plant in South Bend, Indiana. In later notes on his working methods, he made the linkage explicit: "My method of shaping material or arriving at form has been as functional as making a motor car or a locomotive. The equipment I use, my supply of material, come from what I learned in the factory, and duplicate as nearly as possible the production equipment used in making a locomotive." Working mainly in steel – and frequently incorporating manufactured elements with industrial connotations – Smith developed an open style of linear and planar elements that broke with traditional volumetric conceptions of sculpture in the round. Cubism had revealed to him that linear contour could shape space as effectively as mass, and to this insight he added his own understanding of the expressive strength of iron and steel, which led him, towards the end of his career, to develop a monumental sculptural style without precedent in twentieth-century American art.

Wagon I is a powerful example of Smith's later style. When it was exhibited posthumously at the Guggenheim Museum in New York, its abstract but oddly anthropomorphic silhouette was described as "a robot centaur of the machine age," though the artist was more matter-of-fact, calling it "a kind of iron chariot, on four wheels." *Wagon I* combines manufactured and found elements. The head is a solid plate of steel, the elliptical body two boiler-tank tops welded together, and the bowed carriage part of a commercial spring. The wheels were ordered from a steel catalogue, and the axle forgings came from Voltri, in Italy, where Smith had worked in an abandoned steel factory two years earlier. These disparate elements are pulled together by the black-painted surface, which gives Smith's machine-beast a forceful, totemic appearance.

Although Giacometti had made a similar use of wheels in his *Chariot* of 1950, Smith's "Wagons" (he made three of them) have little in common with the Swiss sculptor's attenuated forms. Their source lies, rather, in Voltri, where Smith had found a railway flatcar that he dreamed of incorporating into a monumental sculpture. The dream was never realized. Yet Smith had a profound feeling for the railway – he had hopped freight cars as a boy and later worked in a locomotive plant – and he remained fascinated by the sculptural potential of the load-bearing vehicle. He had placed sculptures on wheeled platforms before, but in *Wagon I* he eliminated the base and integrated the wheels into the body of the sculpture, giving the massive structure a mobility that is both functional and expressive.

Smith said that his sculpture was a statement of his identity, and that his identification was with the working man. Although his sculpture has little precedent in the history of art, its techniques and forms draw upon traditions of forging objects for use that go back to the dawn of history. By unabashedly tapping these traditions he created an art of great formal inventiveness and opened up new sculptural possibilities for artists who followed.

D.N.

Alex Colville

Canadian, born 1920

To Prince Edward Island

1965
Acrylic on hardboard, 61.9 × 92.5 cm
Purchased 1966

This painting by Alex Colville, one of the best-known works in the National Gallery's collection, represented Canada at the 33rd Venice Biennale in 1966. The artist was born in Toronto, but spent most of his teenage years in Amherst, Nova Scotia. In 1938 he began attending Mount Allison University in Sackville, New Brunswick, where he studied principally under Stanley Royle. He graduated in 1942 with a Bachelor of Fine Arts, one of the first degrees of this kind granted in Canada. After enlisting in the army, Colville served from 1944 to 1946 as a war artist. In 1973, he moved to Wolfville, Nova Scotia, where he still lives.

Colville's works all conjure the same powerful impression of suspended time. Focusing on moments of particular significance, he heightens the feelings of disquiet – of anxiety, even – triggered by the many manifestations of strangeness in everyday life. He establishes an order that we sense is precarious, and painfully won, but that enables him nonetheless to achieve effects of great calm and serenity. This order has its source partly in his technique, which consists of a lengthy preparatory phase involving numerous sketches, followed by the meticulous application of paint in countless tiny brushstrokes.

To Prince Edward Island alludes perhaps to the gaze of the mythological figure of Medusa, who had the terrifying power to turn anyone who looked at her to stone. Here, her modern-day sister seems to petrify us, the viewers, punishing us for the voyeurism of which we are all guilty. Colville has often remarked that, consciously or not, he draws inspiration for his scenes from ancient archetypes. In this ferry ride across the Northumberland Strait, between Cape Tormentine in New Brunswick and Borden on Prince Edward Island, the female figure aims her vision-enhancing binoculars directly at us. The art historian David Burnett has described the picture as a metaphorical confirmation of "the self-effacement of the man and the clairvoyance of the woman."

Colville recalls with amusement the angrily macho response of a visitor to the Atlantic Winter Fair in Halifax (where the work was exhibited in 1965) who was incensed that it is the woman who holds the binoculars while the man is relegated to an anonymous position behind her. But this visitor had obviously grasped the picture's significance. Many of Colville's paintings deal with the contrast between the active life, which involves functioning in the world, and the contemplative life, which is the lot of the artist. Here, though, in an ingenious reversal, Colville has depicted observation/contemplation as an active, even aggressive act.

Despite the pitch of the boat as it rides the sea's swell, the artist, in his tireless quest for order, has stabilized the composition by grounding it in the solid equilateral triangle formed by the pose of the central figure and by emphasizing the architectonic qualities of the Abbey-Abegweit's lifeboat. The almost lace-like fall of light on the man's outstretched arms and the many gradations of blue in the background further enhance this exquisitely refined painting. With Colville, order and clarity paradoxically give birth to mystery.

D.L.

Jack Bush

Canadian, 1909–1977

Tall Spread

1966
Acrylic on canvas, 271 × 127.1 cm
Purchased 1966

When Jack Bush produced *Tall Spread*, he had been painting for thirty years and his work had become part of an international movement known under various labels, including colour-field painting and Post-painterly Abstraction. Bush's reputation abroad was already established: he had held his first New York exhibition in 1962, at the Robert Elkon Gallery, had sold fourteen paintings the following year to a Washington collector, Vincent Melzac, and had shown his work at London's Waddington Galleries in 1965.

Always eager to keep abreast of the latest trends in art, Bush had visited New York's liveliest galleries frequently during the 1950s. In Canada, the premature death in 1956 of Oscar Cahén, a distinguished fellow member of Painters Eleven, inspired him to create a series of watercolours composed principally of large black calligraphic signs. This series marked a turning point in his development.

In fact, Bush's work in watercolour would radically alter the direction of his practice as a whole and pave the way towards the large mature works of the 1960s. In June 1957 the famous American formalist critic Clement Greenberg visited him in his studio and expressed considerable enthusiasm for some of the watercolours. As a result, Bush felt encouraged to strive for the same formal simplicity in his oils and to focus his attention on colour. The extent of Greenberg's influence on artists and on the critical discourse of his time is almost unimaginable today; through his opinions and his charisma, Greenberg altered the direction of avant-garde art and defined the prevailing trends. It was only later that his authority would be vigorously challenged.

In the mid-1960s, Bush became interested in different types of acrylic paint and the new ranges of colour available to artists. Drawing inspiration from the experiments conducted a decade or so earlier by Helen Frankenthaler, he began applying paint directly onto raw canvas – a technique that leaves little room for error, since the canvas is actually "stained" rather than painted. A highly skilled colourist – and extremely ambitious – he was determined to surpass even Matisse, whom he fervently admired. In 1962, in Zurich, Bush had observed how Matisse's cutouts give full rein to colour without neglecting motif. Certain defenders of pure abstraction would later criticize the persistence of the motif in Bush's work (among his favourites were the broad central band or "sash," the "tie," the column, and the chevron), but for him it was the route to the appreciation of pure colour.

Around 1965, the broad band gave way to an off-centre striped column. The column in *Tall Spread*, which occupies almost the whole surface of the painting and creates a definite sense of escalation, is finely balanced by the canvas's vertical format and the subtle interaction of the dozen or so colours that form the irregular stripes. This is Jack Bush at his best.

D.L.

Ernest Lindner

Canadian, 1897–1988

Deep in the Woods

1967

Watercolour over graphite on wove paper, 77 × 56.1 cm

Purchased 1968

From his first experience of it in 1935, Ernest Lindner found in Canada's primeval forest a fundamental source for his contemplations on the nature and meaning of existence. "The forest figures in my philosophy that life is a continuous thing, that only forms change … the real life was going on in the close-up, the significant part of life." *Deep in the Woods*, with its rotting, moss-covered tree trunk giving sustenance to a new sapling, is a meditation on the persistence and continuity of life.

Born and raised in Vienna, Lindner emigrated to Canada in 1927 and began working as a farm labourer in Saskatchewan. During the first winters, when there was no work on the farms, he took art classes in Saskatoon. In 1931 he began his career as the art instructor at Saskatoon's Technical Collegiate Institute, where he remained until his retirement in 1962. Lindner also became a major force for the advancement of the visual arts in the province, helping to create an art community and serving as its spokesperson at national conferences and meetings of art societies. As a result of all these activities, time for his own art was limited to the few months of the year that he spent at his island on Emma Lake; he had discovered the place in 1935, and from then on its landscape and forest would dominate his work.

Upon his retirement, Lindner began to read books on science and became fascinated by the idea that microscopic elements could communicate the whole. The significance in this, for him, was that through the details of fungi and leaves or the texture of bark on a rotting tree stump he could comprehend the entire forest. As a consequence, his forest views now shrank from panoramic scenes to highly focused close-ups. Lindner was aided in his new approach by the camera that he used increasingly as age prevented him from sitting or standing for extended periods out of doors. The photographs that he took in the summer enabled him to work with care and concentration in his studio over the long winter months.

As a teacher and practising artist, Lindner had always stressed the craftsman's approach to art, and by the late 1950s the technical dimension of his art had become somewhat stagnant. His retirement happily coincided with the flowering of the Emma Lake artists' workshops, which took place on the shore opposite his cottage. It was the workshops, and particularly the encouragement of Clement Greenberg in 1962 and Jules Olitski in 1964, that helped bring about a new beginning. Greenberg advised Lindner to concentrate on the central image and bring it into the foreground. The result was a series of drawings mostly featuring tree stumps, shown close up and without a background. Olitski encouraged Lindner to consider colour as the structure of the painting, and this concept, combined with his superior draftsmanship, led to his carefully constructed, hyper-realist colour paintings. With *Deep in the Woods*, Lindner reached a new level. The crisp precision of the analytic observer has given way to a softer blending of forms and colour that demonstrates a deeper understanding of the organic totality of this microcosmic natural universe. This work placed Lindner on the national stage, as the leader of High Realism in Canada.

R.T.

Barnett Newman

American, 1905–1970

Voice of Fire

1967
Acrylic on canvas, 543.6 × 243.8 cm
Purchased 1989

Coming of age as an artist in the atmosphere of moral crisis that, in America as elsewhere, pervaded the postwar period, Barnett Newman believed that a completely new art was needed. In his view, Western art – sidetracked by a search for beauty and formal perfection – had lost contact with "man's natural desire for the exalted, for a concern with our relation to the absolute emotions." Newman felt that an art of the sublime was both necessary and possible in his time, but that to achieve it artists would have to free themselves from the past and paint as if painting had never existed. "Instead of making *cathedrals* out of Christ, man, or 'life,'" he wrote, "we are making it out of ourselves, out of our own feelings."

Three essential ideas drawn from his own aesthetic and intellectual experience shaped Newman's artistic response to the revolutionary project he had articulated. The first, derived from the writings of the Russian anarchist Peter Kropotkin, was his belief in the responsibility of the individual to free himself from all dogma, whether of the right or the left. The second, inspired by the Kwakiutl art of the Northwest Coast, was his understanding that the abstract shape had its own reality and could convey ideas and feelings directly, without reference to the visual world. The third, occasioned by his reaction to Indian mounds seen on a visit to Ohio, and later deepened by his insight into the Jewish mystical concept of *makom* – the "place" that God encompasses – was his desire to create a sense of place in his paintings that would have a similar mystery. This feeling of being located was, for Newman, the fundamental spiritual dimension of art; by his attention to place in his paintings he hoped to give the viewer a "feeling of his own totality, of his own separateness, of his own individuality, and at the same time, of his connection to others, who are also separate."

Newman gave expression to the idea of place by dividing his canvases with a narrow, vertical band of colour that he called a "zip," suggesting its ability to activate the surface of the painting. In *Voice of Fire* the "zip" is the red band that is placed exactly in the middle of the blue ground. The painting's title alludes to the "voice out of the fire" in the Bible's description of God's revelation of Himself to Moses and the Israelites at Mount Sinai, and the words direct our attention to the powerful sense of presence that is the painting's subject. The scale of the work, emphasized by the extreme simplicity and symmetry of its composition, contributes to the viewer's sense of awe. If we stand near it, as Newman intended, we are obliged to raise our eyes to take in its soaring height. At the same time, the structure of the painting makes room for us. Its abstract symmetry echoes our own bodily symmetry, while the single red band between the two identical blue bands creates a sense of dialogue between self and other that was fundamental to Newman. Each individual viewer is left to determine the precise nature of this dialogue.

Newman painted *Voice of Fire* for the American pavilion at Montreal's Expo 67, at a time when Americans were confronting the moral dilemmas raised by the war in Vietnam. According to the artist's widow, he was deeply preoccupied by the conflict. The painting does not allude directly to the war, but by making each viewer conscious of where he or she stands, it opens up a moral and spiritual dimension that is profoundly expressive of its place and time.

D.N.

Michael Snow

Canadian, born 1929

Authorization

1969
Black-and-white photographs and cloth tape on mirror in metal frame, 54.6 × 44.4 × 1.4 cm,
with integral frame
Purchased 1969

Michael Snow – painter, sculptor, multimedia artist, filmmaker, and jazz musician – has dedicated his career to an idiosyncratic exploration of human and artificial vision. Renowned for his bold innovations, this exceptionally talented multidisciplinary artist gained fame in the 1960s with his *Walking Woman* series. Borrowing Marcel Duchamp's idea of removing the object from its habitual context, Snow went further by taking art into the street: in her various incarnations, his *Walking Woman* enlivened the downtown core of Toronto and New York and delighted visitors to Montreal's Expo 67.

Starting in the late 1960s a number of creators with backgrounds in the fine arts rather than in photography began making use of the photographic medium, not for aesthetic purposes in the usual sense, but to capture ephemeral situations and events, with an emphasis on concept, idea, and process. Executed in New York, where Snow was living at the time with fellow artist Joyce Wieland, *Authorization* is an extraordinary self-portrait that sucks the viewer into a dizzying vortex of pictures-within-a-picture. By making ingenious use of a mirror, this supremely self-reflective work – in both the literal and figurative sense – uses the photographic medium to further the modernist project of looking at its own inherent processes. Effectively, photography is a continual process of framing, and Snow has underscored this by placing a rectangle of tape in the centre of the mirror, making it the centre of the action.

It has been observed that the title, *Authorization*, is a play on words, conveying not only the usual sense of "permission" or "consent," but also encompassing the word "author." The "author" of this photograph shows himself by means of a series of Polaroid snapshots taken in front of a mirror. Each snapshot is incorporated in the one after it, and the combined results are placed side by side, filling the rectangle marked off by the tape. Image within image within image, they draw the spectator into a relentless spiral, whirling seductively towards infinity. But the mirror does more than simply reflect the artist capturing himself on film – it also reflects the image of the spectator, who thus becomes an integral part of the work. The spectator-accomplice – "my likeness, my brother," to quote Baudelaire – confronts his own gaze and realizes that he can never escape himself.

In 1999 Snow created a work he called *Manifestation (Autourisation of 8 faces)* for the exhibition *Le Temps, vite!*, organized to mark the reopening of the Centre Pompidou in Paris. The title in this case is a play on the French words *autorisation* ("permission") and *autour* ("around"). In this self-portrait, the artist presents simultaneous front and back views of himself. This major work, which has recently been acquired by the Canadian Museum of Contemporary Photography, wittily revisits the theme of *Authorization*.

John Szarkowski, former curator of photography at the Museum of Modern Art in New York, once said that the photographic medium is ambiguous, serving sometimes as a mirror and sometimes as a window on the world. In *Authorization*, the fifth Polaroid stuck in the upper left-hand corner of the mirror, which shows the other four in the series, looks curiously like a multi-paned window. So Michael Snow has brought us full circle: here the mirror has become a window.

D.L.

Greg Curnoe

Canadian, 1936–1992

View of Victoria Hospital, Second Series (February 10, 1969–March 10, 1971)

1969–1971
Oil, rubber stamp and ink, graphite, and wallpaper on plywood, in plexiglas strip frame, 243.8 × 487 cm, with audiotape, tape player, loudspeakers, and eight-page text (photocopied from a rubber-stamped notebook)
Purchased 1971

As someone who was deeply attached to his surroundings, Greg Curnoe always enjoyed looking out the wide windows of his studio in London, Ontario, and seeing Victoria Hospital, where he had been born in 1936. Through a tragic turn of fate, it was the very same hospital to which his body was brought after he was killed in a cycling accident on 14 November 1992. As a literal portrayal of the view the artist saw every day, this large picture may be an indirect comment on one of the oldest metaphors used in describing the art of painting – the one that sees it as a window on the world.

View of Victoria Hospital was exhibited at the Venice Biennale in 1976, where Greg Curnoe, a great colourist in the tradition of the Fauves and Matisse, was representing Canada. The highly simplified forms represent the elements of a landscape seen from afar. The circled numbers (an amusing reference to "paint-by-number" kits) are linked to an explanatory notebook in which, using rubber-stamped letters, the artist recorded a hundred and twenty phenomena observed during the twenty-five months it took him to execute the painting. The language used to describe these phenomena – which include the state of the weather, visits from friends, light effects, sudden puffs of smoke, insects and birds, traffic, the passage of the seasons, and family incidents – is simple, and the descriptions precise. Curnoe was extremely well read. His journal, which he kept regularly, indicates that he was quite aware of the new trend towards conciseness in fiction, manifest in such examples of the *nouveau roman* as Alain Robbe-Grillet's 1955 novel *Le Voyeur*.

By means of an audiotape that accompanies the painting, ambient noises that were recorded during the same period in the studio or through the window are projected from loudspeakers hidden in the work's upper corners. The vertical division that runs down the centre corresponds exactly to the transom dividing the panoramic view of the hospital and its environs. Another important London painter, Jack Chambers (one of Curnoe's comrades-in-arms in the campaign waged by Canadian Artists' Representation to have the status and rights of artists recognized), photographed Victoria Hospital from the roof of his studio on Weston Street and during this same period executed a large painting of much the same scene. Chambers died prematurely a decade or so later of leukemia and, like Curnoe, ended his days at this very hospital.

Curnoe was a politically engaged artist and an energetic defender of ambitious regional art projects. Ideologically, he was vehemently anti-American, and never more so than in the late 1960s. As a young artist he had observed the gradual Americanization of Western society and the insidious commercialization of many areas of life. Canadians, meanwhile, had made their democratic healthcare system a symbol of their identity. The hospital, the place where we are born and where we die, has become a kind of sacred territory. And so, despite its pleasant colours and cartoon-like style, there was, from Curnoe's perspective, nothing trivial about this *View of Victoria Hospital*.

D.L.

Joyce Wieland

Canadian, 1931–1998

Arctic Day

1970–1971
Coloured pencil on cloth cushions stuffed with dacron, 248.6 cm diameter
Purchased 1971

The work of Joyce Wieland, a virtuoso of mixed media and a pioneer in the realm of experimental film, revolves around two main themes: female sexuality and the thorny question of Canada's identity in relation to the United States and Quebec. Whatever her subject, however, she invariably approached it with a blend of irony and passionate lyricism. The sexual revolution of the 1960s had legitimized the expression by women of their own view of sexuality. In her work on Canadian nationalism, Wieland spoke in an original voice that contrasted sharply with the traditional reticence of her compatriots. "All the art I've been doing or will be doing is about Canada," she said. "I may tend to overly identify with Canada."

In 1971, Wieland returned from New York, where she had been living with her husband, the artist Michael Snow, since 1963 and had made a name for herself as a filmmaker. She embarked on research into the flora and fauna of the Arctic – the "occupants" of an apparently barren region that in fact teems with life – and, using the techniques of collage and montage, began transforming a Canadian government publication on the natural sciences. This would become *True Patriot Love*, an artist's book which also served as the catalogue of the solo exhibition of her work mounted by the National Gallery of Canada that same year.

Wieland was already intuiting that among the future's most serious threats were the ecological disasters that would inevitably result from various types of human thoughtlessness. Having published caricatures in *The Canadian Forum*, she was well aware of the preoccupations of the New Left in Canada. In particular, she had read the hard-hitting articles by one of its best-known political commentators, James Laxer, on the issues surrounding the water and energy resources of Canada's far north. Her concern for environmental issues was further reinforced by the Quebec government's announcement in 1971 of the huge James Bay hydroelectric project, which would involve the flooding of over 10,000 square kilometres of land in the north of the province.

Arctic Day, which consists of an assemblage of numerous small cushions bearing drawings in evanescently pastel shades, is a work whose exquisite delicacy mirrors that of the fragile ecosystem that inspired it. Highly innovative in a fine arts context, the piece was made with the assistance of seamstress Joan Stewart and exhibited in an art gallery, which had the effect of placing the traditional women's crafts of sewing, embroidery, and quilting firmly in the artistic spotlight.

Full appreciation of the work requires some concentration, for the eye must be allowed to grow accustomed to its chromatic subtleties. Gradually, we are able to distinguish landscape features, plants, and animals of the far north (among the latter a deer, a snowy owl, a tundra swan, a musk ox, a moose, and a coyote), sometimes accompanied by incisive remarks on their ecological status, such as "decline of the caribou," "almost extinct," and "Jew of the North" – Wieland's description of the mercilessly hunted wolf. The backs of the cushions are in tones of pink, red, blue, yellow, and green that reflect against the ground and bathe the whole work in a soft light. With its form evocatively echoing the Arctic Circle, *Arctic Day* stands as a marvellous tribute to the natural splendour of Canada's far north, of which we remain the guardians.

D.L.

Murray Favro

Canadian, born 1940

Synthetic Lake

1972–1973

16mm colour film loop, projector, wave-machine constructed of wood, canvas, rope, electric motor, and metal fittings, installation dimensions 290 × 610 × 1,220 cm, wave machine 89.5 × 300.9 × 446.4 cm
Purchased 1974

In 1957, Murray Favro moved to London, Ontario, where he attended the H.B. Beal Technical and Commercial High School. The city was undergoing something of an artistic boom at the time, and through the 1960s it would remain home to an extremely active community of painters and sculptors. Southern Ontario, heavily industrialized, is still referred to as the "motor" of the Canadian economy. Such mechanical analogies are not foreign to Favro, for he is a descendant of that noble line of artist-inventors that counts Leonardo da Vinci among its forebears. He recalls that one of his great-uncles was always busy trying to perfect a perpetual motion machine (the dream of inventors since time immemorial), and he in fact made a drawing of it.

In 1969, while working part-time as a projectionist, Favro began experimenting with a movie camera. Recalling how frustrated he had been as an eight-year-old to find himself unable to draw the waves breaking on the shore, he decided to film the beach at Ipperwash, on Lake Huron, and to construct his own wave machine. Rudimentary as it is, *Synthetic Lake* poses a subtle question concerning the nature of artistic representation. By using a mechanical device to reproduce a natural phenomenon, Favro forces us to re-examine reality via its illusion. The means used to create the illusion are obvious, for in reconstructing the ebb and flow of the waves the artist makes viewers aware of the image-projection process.

The wave machine works in conjunction with a beam of light that transmits images of waves onto a moving canvas. The projector, positioned nine metres away, shows a ten-minute film whose rhythm the machine echoes. The machine itself consists of a complex arrangement of cables, pulleys, and hinged wooden frames powered by an electric motor. Reminiscent of an early industrial loom, the device may be an allusion to the Luddite riots of the early nineteenth century, in which English craftsmen, faced with increasing unemployment and proletarianization, destroyed the textile machinery that was replacing them. (Favro, who is also a musician, was a member of a band called the Luddites.) The noise made by the projector and the wave machine is another component of the work. Reality is perceived at successive levels of abstraction: the viewer grasps the real movement of the waves, then their filmic movement, then the movement of the wave machine, and finally the work as a whole.

With this image of endlessly lapping waves projected onto a mechanically undulating canvas, linear time – measurable time – seems to dissolve. Favro has transformed the powerful natural movement of the lake into an original handcrafted machine, a transient perceptual phenomenon into a permanent object.

D.L.

Donald Judd

American, 1928–1994

Untitled

1973
Plywood, 5 elements, 182.9 × 256.5 × 182.9 cm each
Purchased 1973

Like George Segal, Donald Judd turned to sculpture in the early 1960s after having established himself as a painter, convinced that only in three-dimensional works could he avoid the spatial illusionism inherent even in abstract painting. Resistant to both the anthropomorphic tradition of sculpture and the underlying metaphysics of Abstract Expressionist painting, Judd sought to rid his work of all outside references. He gave his constructions no titles, referring to them as "specific objects" in order to distinguish them from painting and sculpture alike. The expression also served as a reminder that he was not interested in pure or ideal forms, or in any notion of universal order associated with earlier geometric art, such as Mondrian's. The quality he looked for was a sense of wholeness in which shape, surface, and colour were separately and clearly articulated. Suspicious of hierarchies of all sorts, he preferred a straightforward ordering of shapes that stressed the distinct identity of each part of the whole, and frequently worked with simple mathematical progressions or serial arrangements that clearly delineated space and volume and made them comprehensible.

Early on, Judd established a limited vocabulary of geometric, mainly rectilinear forms, within which the use of different materials – each with its distinct surface quality and colour – allowed for enormous variation. Although formal progress was relatively unimportant to him, his sculptures showed an increasing openness and formal simplicity. An important change came at the beginning of the 1970s when his work became larger in scale, with a new emphasis on the spatial relationship of the objects to the architecture or site in which they stood. Together with the new scale came new materials. In 1972 he began to use plywood, a cheap, strong, industrial material that permitted multiple variations on a theme at reasonable cost. This series of five six-foot-high parallelepipeds from the following year is one of the first large-scale floor works that Judd made in plywood. Far from being neutral, the lively, organic surface-pattern of the wood offers an interesting contrast to the geometric crispness of the volumes delineated by the rhythmic repetition of open and closed planes. In spite of its formal clarity, the work offers a complex visual experience: looking at the sequence from either end compresses some intervals and opens others, whereas a frontal view emphasizes the contrast between the cubic volume of the room itself and the regular but angled spaces described by the walls of the parallelepipeds. The play of light and shadow also affects the viewer's perception of the work.

Judd's strong predilection for concrete, verifiable experience, reinforced by his study of empirical philosophy at university, led him to be skeptical of any claims to general knowledge that art might make. The meaning of his work does not lie outside the work itself, but is rather to be grasped directly, through an understanding of the visual and physical facts it lays before us. "There is no form," the artist said in a lecture at Yale University in 1983, "that can be form without meaning, quality, and feeling." This statement belies the assumption that so-called Minimal art is impersonal because it does not show the mark of the artist's hand. The unity and openness of Judd's work, his attention to scale and proportion, and his expressive choice of materials lend it a clear and strong intelligibility. It communicates thoughts about the nature of things in the physical world, and about our relationship to those things and to other people, that are distinctly personal.

D.N.

Nancy Spero

American, born 1926

Torture of Women

1976
Gouache, typewritten texts, collage, and handprinting on laid paper, 14 framed panels 60.7 × 292 cm each
Purchased 1993
Panels 1, 2, and 3 illustrated opposite

Nancy Spero has always worked on the margins of the art world, independent of the major movements of her time. Her art is figurative, political, and emphatically feminist, and her rebellious stance towards mainstream art is reflected in her subject matter and in the modesty of her means – sheets of paper, glued end to end to form scroll-like panels, hand-printed and collaged with cut-out painted figures and typed or printed words and sentences. Although she had at first made existential statements about the self in dark, heavily worked paintings, she gradually became dissatisfied with the laboured process of oil painting. Back in the United States in the mid-1960s after five years of relative isolation in Paris, and newly politicized by the war in Vietnam, she turned to drawing, producing rapid-fire gouache-and-ink sketches of giant, insect-like helicopters and anthropomorphic bombs ejaculating and vomiting victims. By the beginning of the 1970s she had found her voice, drawing on ideographic images culled from ancient Egyptian, Sumerian, and Celtic sources. These she combined with wire-service photos and contemporary texts to create a visually spare but morally and psychologically intense narrative style.

Spero saw an analogy between her own efforts to find her voice as an artist and the struggle of all women to be heard in a society that privileges masculine experience. Her feminist convictions found their first, most troubling expression in the fourteen panels of *Torture of Women*. According to Spero, "this series is intended as an ephemeral monument to women political prisoners, addressing the inhuman practices that affect both men and women – but through the depiction of women." The first panel opens with the words "Explicit Explanation," a phrase taken from medieval Spanish commentaries that drew moral lessons from the biblical story of the apocalypse for contemporary readers. The accounts of torture that follow are taken from news stories and Amnesty International reports, typed with a bulletin typewriter or stamped in large wooden letters. Each account is identified with the name of the victim and of the country where the act occurred. They read, as Spero intended, like broadsheets or teletype dispatches, immediate and harrowing, an inescapable indictment. In contrast, the imagery woven around the texts is mythical and non-specific. Dragon-like monsters, ambiguous images from a nightmare world, are interspersed with tiny human heads and dancing figures. Apart from the image of the inquisitor in Classical garb interrogating a naked prisoner, placed alongside a statement about the codified nature of state torture in ancient times, there are no depictions of violence. This Spero leaves to the written word, wherein the voices of the victims themselves are heard.

Extending over thirty-eight metres in length when the panels are laid end to end, *Torture of Women* is a monumental work. Its public scale and open, fragmentary structure, its combination of painterly and mechanical techniques, and its appropriation and repetition of images from many different cultural and historical sources exemplify the transformation of contemporary drawing from the intimate sketch or preparatory study to an independent medium with distinctive expressive possibilities. In *Torture of Women*, Spero hones a narrative form borrowed from codex or frieze into a cry of outrage against acts of violence, an artistic statement worthy of comparison with the great anti-war paintings of Poussin or Goya.

D.N.

EXPLICIT EXPLANATION

"...torture was considered to produce probatio
probatissimi, 'the proof of all proofs', and
its practice was meticulously regulated and
codified... the question was
divided into different degrees:
ordinary, extra- ordinary, preparatory,
and preliminary torture was
administered in a special
chamber by a civil servant who
also served as the public executioner."

Philip Guston

American, 1913–1980

Room

1976
Oil on canvas, 203.2 × 254.1 cm
Purchased 1999

Room belongs to the last, great, figurative period of the American painter Philip Guston, painted four years before his death in 1980. The late paintings are dark in tone, witnesses both to the inner drama of the painter struggling with his personal demons, and to the conflicts being played out on the social and political stage, which outraged Guston and left him feeling helpless.

Guston had been one of the leading abstract painters of his generation, praised for the sensitive brushwork and lyrical colour of his canvases of the 1950s. Gradually, however, abstract painting began to seem to him insufficient. He later described his dilemma eloquently: "When the 1960s came along, I was feeling split, schizophrenic. The war, what was happening in America, the brutality of the world. What kind of man am I, sitting at home, reading magazines, going into a frustrated fury about everything – and then going into my studio to adjust a red to a blue…. I wanted to be complete again, as I was when I was a kid…. Wanted to be whole between what I thought and what I felt."

In his reaction against "pure" painting, Guston sought not only new subjects, but a new, impure, painterly language. The refinement of his abstract paintings gave way to a crude, vigorous, and simplified style that could express his anger and despair. Studio motifs suggestive of the artist's late-night vigils alternate with desolate landscapes peopled with grotesque characters. The sense of menace is ever present – a sign of Guston's constant struggle to respond adequately to daily news stories of cruelty and violence. "We are the witnesses of hell," he wrote.

Room is one of many paintings of the 1970s in which Guston returned, obsessively, to the motif of piled up legs, evoking nightmarish scenes of mob attacks and massacres. A century of successive pogroms in Odessa were part of his family's memory; his parents had fled Russia to start a new life in Canada and later in the United States. Guston was especially haunted by the Russian Jewish writer Isaac Babel's chilling accounts of the rampages of the Cossacks, which he was reading at this time. His paintings of severed hands and legs with their shoes still on distil the fate of a multitude of victims into a few iconic images. On the narrow stage of the canvas the artist lays out the emblems of oppression and suffering: a cartoonish fist wielding a bloody baton, an advancing battalion of skinny, truncated legs. The "room" of the title is an ordinary domestic space, laconically indicated by red floor-boards and a small green rug, as if evil were so banal that it could live anywhere. The claustrophobic darkness of the scene is a long way from the abstract space of an earlier painting of the same title, finished in 1955, where "room" seems to conjure up notions of freedom, signifying the space, opportunity, or occasion for action.

Theatrical without being narrative, Guston's late paintings stage the painter's quest in terms that are both autobiographical and archetypal. Though fraught with uncertainty and doubt, they offer a vigorous response to the question of what it is to be human in difficult times.

D.N.

Jack Shadbolt

Canadian, 1909–1998

Transformations No. 5

1976

Acrylic, commercial latex paint, black ink, pastel, and charcoal on illustration board, 152.7 × 305.1 cm

Gift of Carol M. Jutte, Vancouver, 1995

For Jack Shadbolt, the 1970s were at once an exceptionally productive period and a key stage in his personal evolution. The vertical and horizontal juxtaposition of large pieces of illustration board allowed him to execute much more ambitious compositions than before, where he could give free rein to his talents as a draftsman. Shadbolt had always been a skilful exponent of the various graphic techniques, and even when using acrylic or latex paint he tended to apply it like watercolour or gouache. Now that contemporary art had legitimized large-format drawing and abolished the rigid boundaries between the various artistic disciplines, he felt liberated from the obligation to constantly excel in the strict practice of painting.

Transformations No. 5 is one of a series of works on the metamorphosis of butterflies. Shadbolt had been a keen observer of insects during his childhood, and was especially entranced by the voluptuous splendour of the butterfly, the intricate patterns adorning its wings. As an adult, he saw its fleeting and fragile beauty as a marvellous example of the continual transformation of the natural world. That the concept of metamorphosis played so large a part in his thinking may have been due to the special interest among British Columbia's anthropologists and writers in shamanic ritual, particularly as practised by the Aboriginal peoples of the West Coast. In an effort to vanquish his personal demons, the artist had a short time earlier adopted the guise of a shaman. He was attracted by the strange ritualistic objects used by shamans and by their incantatory and gestural improvisations, perceiving affinities between the extravagant decorative motifs of his own works − the spontaneous outcome of arbitrary juxtapositions − and the paraphernalia and ceremonialism that are central to the shaman's role.

Shadbolt was not the first twentieth-century artist to identify with age-old spiritual beliefs. Picasso actually defined painting as a magical mediation between humanity and the hostile world, a process that imbues the artist − as it once did the shaman − with the power to give shape to our fears and desires. In shamanic practices (such as the symbolic dismemberment of the initiated and their subsequent rebirth) and the inherent instability of forms (illustrated by the transformation masks used for ritual dances), Shadbolt sensed echoes of the metamorphosis theme that had been preoccupying him for decades.

The artist's inspiration was also drawn from a literary source: the work of Vladimir Nabokov, for whom the butterfly's beauty possessed a highly erotic quality. And the choice of the butterfly image was undoubtedly in part a response to formal and decorative questions. Literary reminiscence, symbol of transcendence linked to ancestral spirituality, imaginative flight − the butterfly can embody all this. In *Transformations No. 5*, a more soberly coloured work than others in the series − here the butterfly is on the point of disintegrating − Shadbolt displays his great mastery of the various techniques developed during a long and fertile career.

D.L.

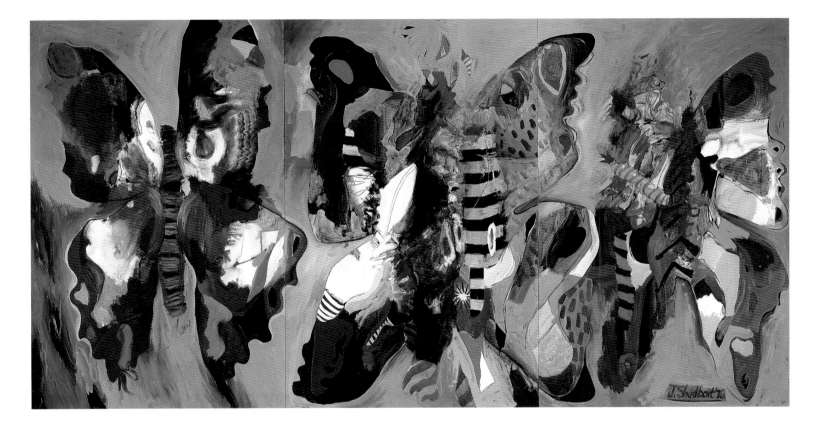

Jeff Wall

Canadian, born 1946

The Destroyed Room

1978
Cibachrome transparency, plexiglas, and fluorescent lights, light box 169 × 258.4 × 7 cm,
image 152.4 × 203.2 cm
Purchased 1979

Based in Vancouver, Jeff Wall originally trained as an art historian. In his work with photography, he has established himself as a social observer whose project is the depiction of modern life. For several decades he has been creating large-scale back-lit colour photographs of carefully staged scenes that are presented in light boxes similar to those used in advertising. Wall's subject matter, however, is a far cry from the world of advertising.

While we typically think of photographs as representations of reality, and paintings as products of the artist's imagination, Wall's images merge both possibilities. Although his works aspire to the high art of painting, Wall is conscious of the fact that in our technologically-based era it is difficult to treat the subject of modern life through that traditional medium. At the same time, he dissociates his work from the photographic aesthetic of spontaneity. In constructing his photographs he works like a cinematographer, developing subjects, scouting locations, casting actors, and setting up scenarios. He then photographs these scenarios, and the resultant large-format colour images are informed by painterly, cinematic, and photographic traditions.

The Destroyed Room is the very first back-lit photograph that Wall produced. The image depicts what appears to be a woman's bedroom, circa late 1970s. While it is ultimately ambiguous, the domestic scene suggests an extremely violent occurence of some kind. A jumble of patterned fabrics and women's clothing and accessories cuts a swath through the foreground. The mattress of an upturned bed has been deeply gouged and its innards are exposed. The dresser drawers have been pulled open, rummaged through, and left askew. Part of the wall has been ripped away, revealing the pink insulation and a supporting beam. A statuette of a woman is visible on top of the dresser, her curtseying gesture seeming to contradict all that has taken place in this room.

The photograph's subject matter, diagonally-structured composition, and dazzling palette refer directly to the scene of lust and carnage in Eugène Delacroix's celebrated 1827 painting *The Death of Sardanapalus*. Delacroix's canvas, inspired by Byron's play, depicts the last moments in the life of the legendary king of Assyria. Reclining on his bed, Sardanapalus contemplates his imminent death and observes all around him the destruction of his court. Sensuous nudes – his concubines – writhe in despair; one is about to have her throat slit. Like Delacroix's masterpiece, Wall's photograph is also erotically charged, even though there is no human present. Showing only the aftermath of violence, Wall employs understatement and economy of means to powerful effect.

K.S.

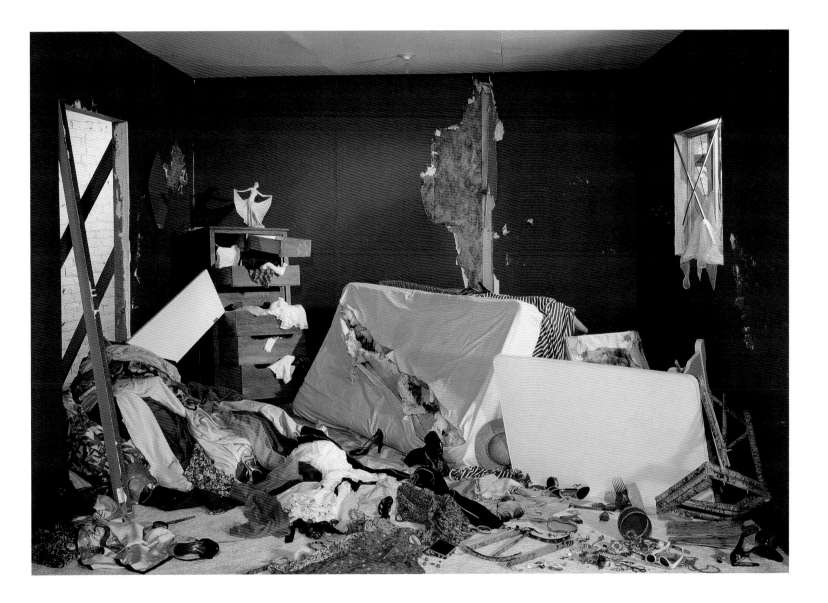

Paterson Ewen

Canadian, 1925–2002

Gibbous Moon

1980
Acrylic on gouged plywood, 228.6 × 243.8 cm
Purchased 1980

Paterson Ewen first became known for the abstract painting he practised when living in Montreal, following studies at the art school of the Montreal Museum of Fine Arts in the late 1940s. Ewen's interests changed, however, and his art took a new direction when he moved to London, Ontario, in the 1960s. The London artists he befriended, like Murray Favro and Greg Curnoe, approached art very differently from the painters of the Montreal avant-garde. They were interested in art as a reflection of lived experience in all its variety. Their work incorporated found objects and images, and gleaned ideas from a wide range of sources, including popular culture, science, mechanics, music, and politics. By 1971, Ewen had embraced representation. He began looking to simple diagrammatic illustrations of natural phenomena – such as cloud formations, thunder, and lightning – found in textbooks and scientific literature, to serve as starting points for his pictures. At the same time, he developed a new approach to painting that involved gouging his compositions into large areas of plywood with a router and then painting on the textured surfaces. Because he would work the router on his hands and knees, he exercised little control over the image as he made it. He took advantage of the accidents that occurred, and would sometimes collage metal and other materials onto the surfaces, with lively results. Compositionally, the paintings were large and spare, betraying the influence of the artist's years of abstract practice.

Gibbous Moon is one of many images of the moon that Ewen produced over the course of his career. It depicts the "humped" phase of the waxing moon, when more than half the surface is illuminated. The moon is traditionally associated with femininity, so this subject might suggest fertility. While only the bright part of the moon is shown and the dark part left unfinished, the complete spherical form is strongly suggested to our imagination by the almost square ground that frames it. Ewen has included details of the moon that would be visible if one were viewing it through a telescope or on a lunar map. The image is rendered in relief, with pits and gouges in the plywood that mimic the moon's mottled surface. This is painted in thin coats of brilliant orange and yellow, as if paint were the reflected light of the sun. Ewen hovers here between the moon's symbolic, poetic associations and scientific observation, between representation and painterly abstraction, between image and materiality. Such ambiguities contribute to the interest and success of this highly original work.

J.S.

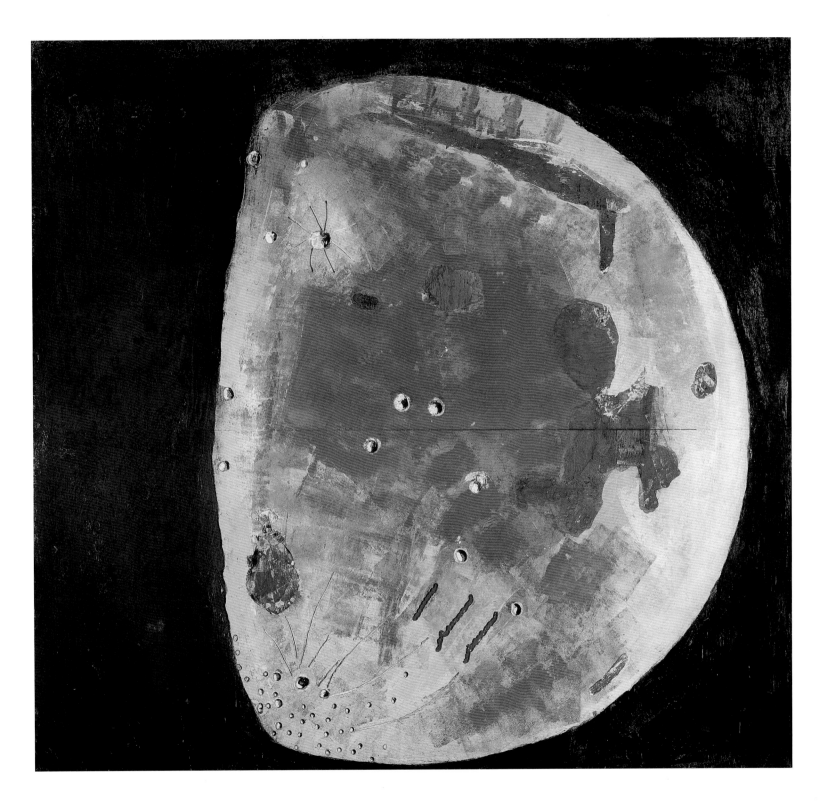

Liz Magor

Canadian, born 1948

Production

1980

Newspaper, wood, and steel, machine 134.6 × 81.3 × 61 cm, paper bricks 5.1 × 10.2 × 20.3 cm each; installed dimensions of brick wall variable

Purchased 1984

The work of Vancouver-based artist Liz Magor has consistently addressed issues of materiality. She questions, for example, how things become what they are, how they contain the evidence of their making, and how the identity of their maker is embedded in them. For Magor, art is part of the continuum of human manufacture. Yet, while she pays close attention to the act of making, the conceptual foundations of her works are crucial to their interpretation. *Production* consists of almost three thousand bricks made from newspaper, accompanied by the simple "brick-making" machine, still caked in paper mash. The paper bricks, whose sheer volume is impressive, have been arranged in different architectural configurations, on occasion covering a whole wall from top to bottom. As we approach the work and examine the bricks closely, we can see that fragments of news stories are still readable on their surfaces.

Production is a monument to labour. Because of the role her own mental and physical energy played in its realization, the artist has referred to the piece as a self-portrait. In thus identifying herself with her product, she reminds us of the effort of all those who perform repetitive tasks, and of the evidence of their spirit all around us. Embracing repetition, materiality, and labour as the conceptual foundation for a work of art, Magor has taken her idea full circle through her own investment in making it.

Production lays bare the processes of its own making – the materials out of which the bricks are made and the machine that served to make them are presented undisguised, and possible uses are suggested in the laying of the bricks and their incorporation into new structures. While Magor has inscribed them with her labour, the bricks retain evidence of their own history as well. The newspapers, with their readable bits of text, hold traces of thousands of real-life stories, and the wood pulp that composes the paper contains the genetic imprint of countless trees. The material excess of *Production* is matched by the extremely broad range of its suggestiveness.

Magor has more recently been concerned with questions of shelter and homelessness, photographing hand-built shelters she has come across in the forests of British Columbia. She has also created shelters as art, including a fully provisioned, though inaccessible, log cabin that she placed in the Toronto Sculpture Garden in 1996, an unlikely oasis of self-sufficiency set down among the legions of urban poor and homeless who inhabit that part of the city. If this piece, *Messenger*, evoked the survival myths that have persisted throughout the history of settlement in the Americas, *Production* stands for community, positing another, perhaps more fragile structure built out of the labour and experience of many.

J.S.

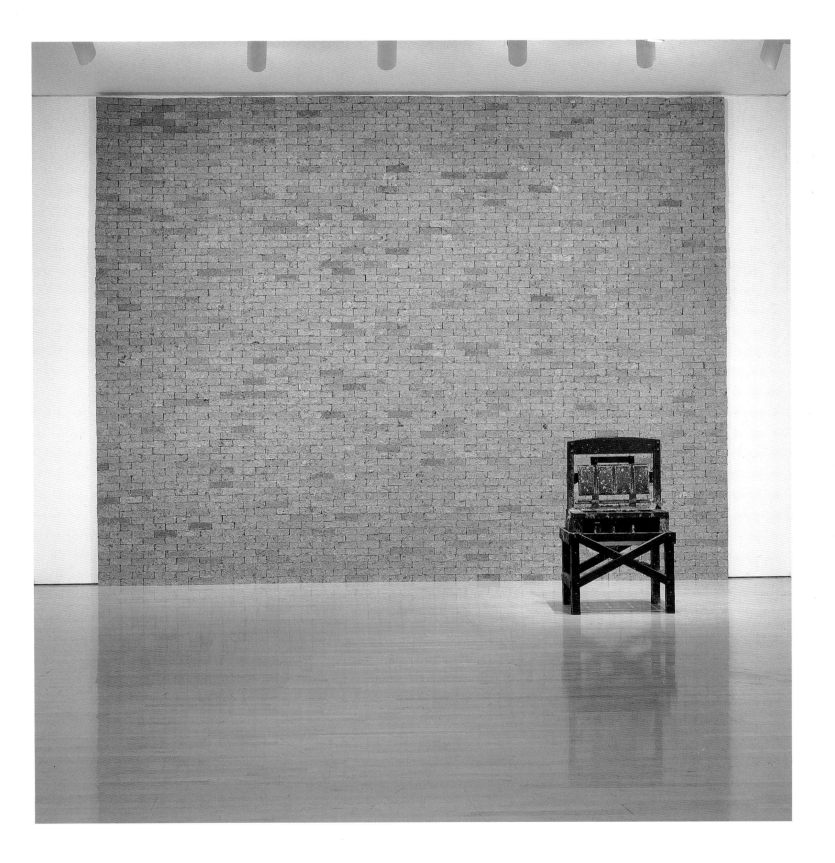

Betty Goodwin

Canadian, born 1923

Swimmer No. 3

1983
Graphite, chalk pastel, oil pastel, and diluted oil paint on wove paper, 2 sheets,
approximately 296 × 108.5 cm each
Purchased 1983

Betty Goodwin's powerful works investigate the human body – its presence and its traces – and the fragility of life. Largely self-taught, Goodwin first gained international attention in the early 1970s with her innovative prints using objects such as parcels and vests. She is perhaps best known for her "Swimmers" series, which she started in 1982, after her husband almost drowned in the river near their cabin in Sainte-Adèle, Quebec. The series evolved slowly over a period of six years, beginning with a sketch of just a head on a small piece of paper and culminating in a number of large-scale drawings, mostly in pastel. In some of the works one or two complete figures are represented, while in others there are only parts of bodies. Looking back on the series, in an interview in 1998, Goodwin commented: "In the Swimmers, there was always the dual side of swimming. How we can't do without water. Water is our life, but it can take you away also."

Swimmer No. 3 shows two figures contained in a brownish-green mass that is itself framed on three sides by the white of the paper. In contrast to the coloured areas representing water, the unworked white areas suggest air being inhaled or exhaled by the figures. On the left the mass of colour extends to the edge of the sheet, giving the impression that the water continues beyond the borders of the drawing. The horizon line is difficult to discern. The two figures, almost life-size, float in an ambiguous pictorial space, helpless and disoriented, caught between moving out of the water and being pulled down into it. They are pointed in opposite directions, the lower one floating on his back, the higher one on his stomach, perhaps struggling to save the other. Only parts of their bodies are distinguishable – arms, torso, head, mouth – the rest blending into the murky fluid.

Goodwin's drawing is on two large sheets of paper that hang side by side, unframed. A contrast is created between the opaque pastels and the translucent oil-stained paper. The large unworked area gives the drawing an unfinished quality, and the absence of a frame highlights the fragility of the paper – appropriately so in a work that speaks so eloquently of the tenuousness of human existence.

J.D.-B.

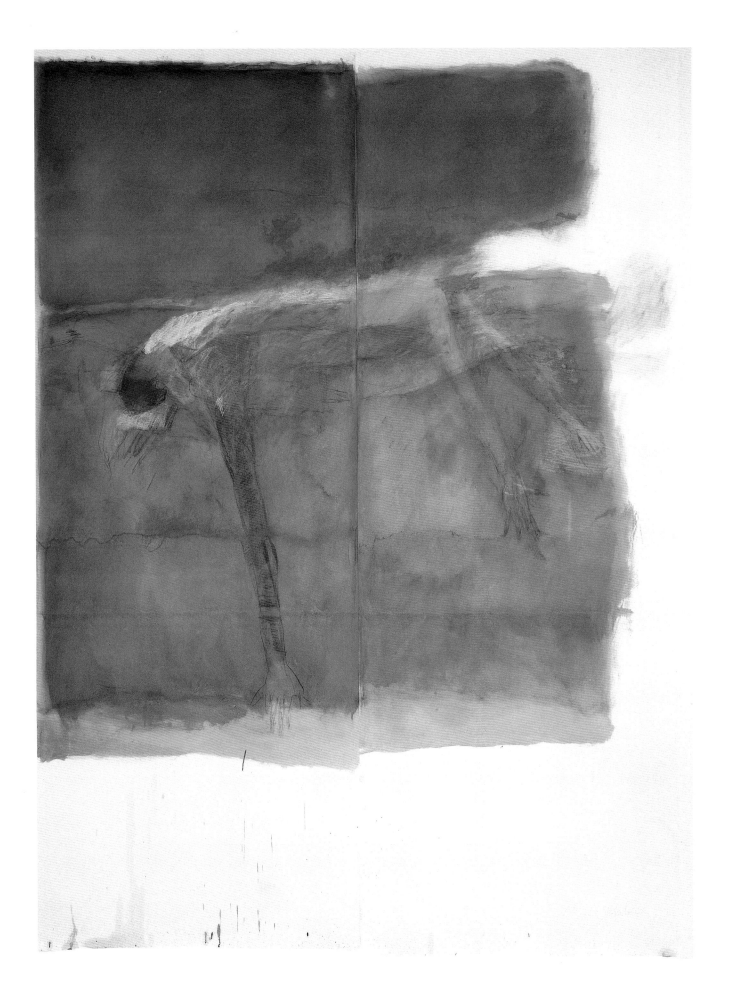

Jana Sterbak

Canadian, born Czechoslovakia 1955

I Want You to Feel the Way I Do… (The Dress)

1984–1985
Live, uninsulated nickel-chrome wire mounted on wire mesh, electrical cord and power, text,
144.8 × 121.9 × 45.7 cm
Purchased 1986

I Want You to Feel the Way I Do… (The Dress) is a work that seems to invite intimacy and an empathetic response, while simultaneously warning the viewer to keep a safe distance. The moment one crosses the threshold of the room where it is displayed, an electronic eye is triggered and heating coils wrapped around the midriff of the dress begin to glow an angry red – their warmth can be felt a few steps away. The dress and another piece, *Corona Laurea*, since destroyed, were inspired by a Martha Graham dance production that Sterbak had seen in Toronto, based on the Greek legend of Medea. On one level, both can be seen as updated versions of the seductive but fatal garments that the sorceress Medea, spurned by Jason in favour of an alliance with Glauce, princess of Corinth, sent as wedding gifts to the princess. When Glauce put on the beautiful dress and diadem, the poisons they concealed burned her to death.

In *I Want You to Feel the Way I Do …* Sterbak has substituted electricity for magic. She has further contemporized her burning dress by means of a short wall text – a monologue reflecting a crisis of identity brought on by a woman's absorption in and subsequent rejection of her lover: "There's barbed wire wrapped all around my head and my skin grates on my flesh from the inside.… It's not that I want to be numb, I want to slip under your skin: I will listen for the sound you hear, feed on your thought, wear your clothes." This state of pathological dependency does not last, and the text ends with a shift in attitude: "I should be grateful but instead … you're beginning to irritate me: I am not going to live with myself inside your body, and I would rather practice being new on someone else." The psychological drama echoes the cycle of love, betrayal, and revenge in the story of Medea and finds its metaphorical enactment in the heating up and cooling off of the electrical wire circling the dress.

This is the first dress that Jana Sterbak made from unorthodox materials – it was followed by *Vanitas: Flesh Dress for an Albino Anorectic*, made entirely out of sewn-together flank steaks, and *Remote Control*, a motorized crinoline. Whether she uses red-hot electrical wiring, meat, or a remote control device, there is nothing arbitrary about the materials: they have been chosen for their analogies with physical or mental processes. Sterbak's "conceptual" use of such substances in fact intensifies the expressive impact of her works, which aggressively invade the sensory space of the viewer. The formal references to clothing as a sort of ready-made stand-in for the body also minimize the distance between the artwork and the everyday world. The idea of the garment as a second skin is a familiar one, and Sterbak exploits this understanding to draw the viewer into the world of her artistic vision. She is concerned with the subject of personal identity, and with how identity is shaped by the perpetual struggle between freedom and constraint in society. Her dresses are both an appeal for empathy – as the title of this work suggests – and a defensive armour, signalling a new girding up in the timeless battle between the self and others.

D.N.

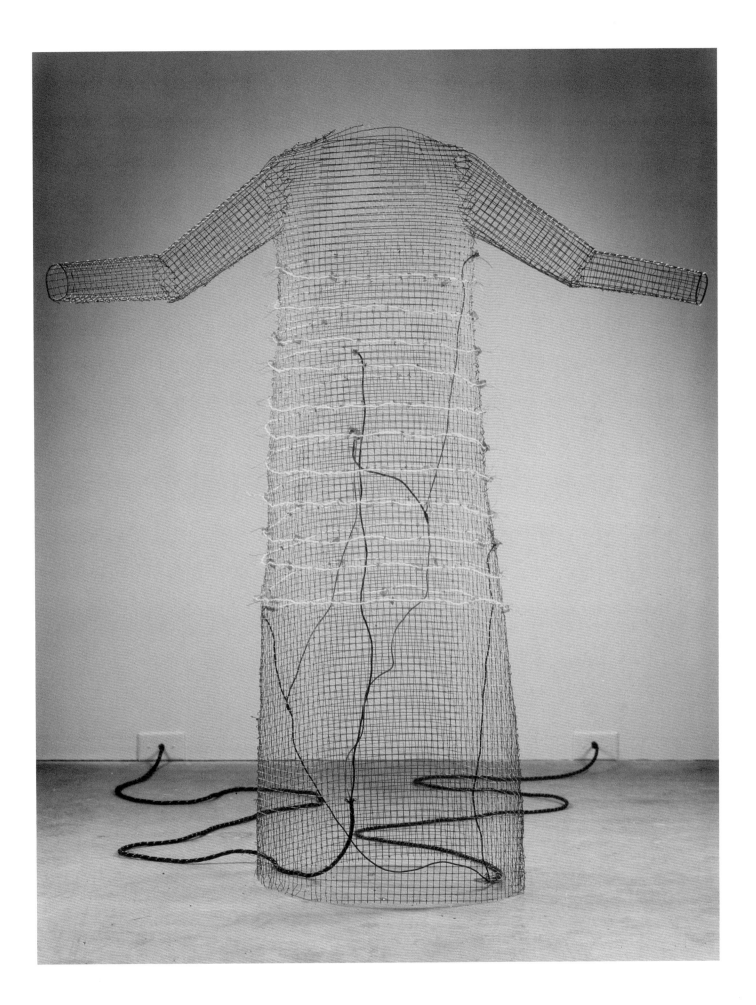

Carl Beam

Canadian, born 1943

The North American Iceberg

1985
Acrylic, photo-serigraph, and graphite on plexiglas, 213.6 × 374.1 cm
Purchased 1986

Carl Beam is one of the leading figures in a creative renaissance among Aboriginal artists that has been in full swing since the 1970s. For many of those involved in this resurgence, art has been a path of healing, of rebuilding personal and cultural identity, of recognizing and repairing the ravages of centuries of colonization and genocide. This art is in essence political expression – sometimes gentle, poetic, and persuasive, sometimes angry, radical, and pointed.

Beam was born in West Bay, an Ojibwa reserve on Manitoulin Island, in Lake Huron. He studied art in British Columbia, completing his formal training at the University of Victoria in 1976. It was there that he first became aware of Aboriginal art from the Northwest Coast and the Woodlands – and there that he began to introduce Aboriginal images into his work. At the time, West Coast artists like Bill Reid and Robert Davidson were reviving traditional art forms and re-using designs that adorned objects both mundane and ceremonial, many of which were to be found only in museum collections. Beam would adopt a different approach. His style owes more to American modernists like Robert Rauschenberg and Jasper Johns than to indigenous traditions, and the content of his art is shaped by a distinctly contemporary sense of cultural cataclysm rather than a desire to tap traditional mythologies.

In *The North American Iceberg* Beam draws together many images from contemporary as well as historical sources. For him, culture is both past and present, encompassing everything we know from oral histories and historical research, everything we have personally experienced, and all the knowledge of the world that comes to us through the media. This particular work includes the artist's self-portrait, in frontal and profile mug shots, juxtaposed with a photograph and encyclopedia entry featuring the Apache leader Geronimo, a historical photograph of American Indians in European dress, and ethnographic photographs of Aboriginal women wearing traditional ornaments. A sequence of images of an eagle in flight seems to relate to the inscription "THE ARTIST FLYING STILL," a proclamation of spiritual survival and self-affirmation against historical odds. News images of a rocket launch and of the assassination of Anwar el-Sadat further anchor the ensemble in the present. A series of regularly spaced numbers and the words "REVOLVING SEQUENTIAL" suggest the cycles of history, repeated at humanity's peril. Beam transforms his photographic sources into painterly images by means of photo-serigraphy and unifies the whole by overlaying images, texts, and applications of red paint (reinforcing the idea that the times he invokes are bathed in blood).

The title, *The North American Iceberg*, merits some explanation. Shortly before the work was made, an enormous exhibition called *The European Iceberg*, heralding new forces in European contemporary art, was held in Toronto. Beam's title is, in effect, a response, announcing another aesthetic force, springing from North American soil. In this respect the artist was prescient, for the acquisition of *The North American Iceberg* by the National Gallery of Canada in 1986 signalled the opening of the institution's collecting practices so as to include in its permanent collection works by contemporary Aboriginal artists.

J.S.

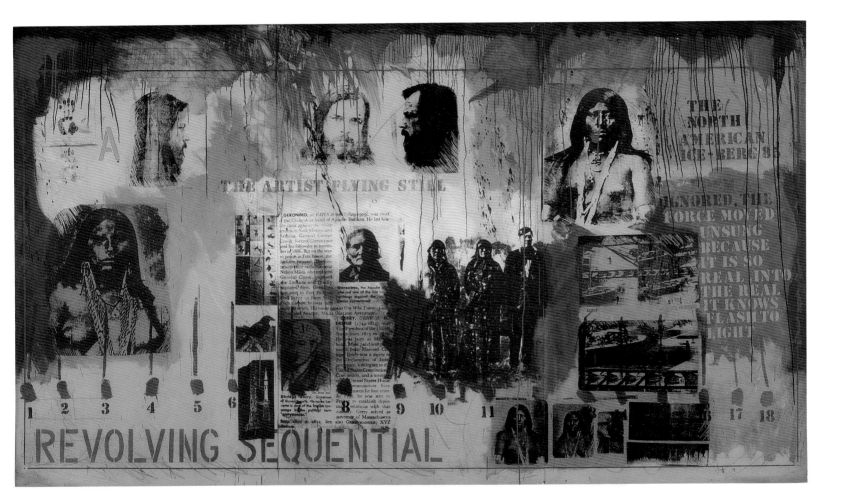

Guido Molinari

Canadian, born 1933

Dance / Sigh

1987
Acrylic on canvas, 4 panels, 274.4 × 366 cm each
Gift of the artist, Montreal, 1992

A key member of the modernist Plasticien movement that burst onto the Montreal art scene in the mid-1950s, Guido Molinari remains a force in the development of abstract painting – a current in art that has seen continual renewal. As a Plasticien, he championed the "hard edge" in painting, eliminating the tonal blending of colour and the trace of the brushstroke so that what remained was an experience of pure colours playing off one another. In the 1960s, Molinari adopted the vertical-stripe motif as an approach to composing colour in series, creating optical rhythms of intensely chromatic, highly differentiated colours. The artist was fascinated by the action of his compositions on the viewer, whose perception of a painting was affected by the rhythmic – and, by extension, temporal – elements within it.

Molinari's "stripe" paintings were a pivotal discovery, and he has continued to use verticality and seriality as vehicles for an intense intellectual investigation of colour. In the 1970s, the frenetic opticality of the stripes gave way to other, slower, more subtle explorations of perception. The stripes became wider, larger colour areas. By the middle of the decade, Molinari was concentrating on colours that were close in tone and hue – slightly varied blacks, reds, or blues, for example. He has since spent years working with a "single" colour. He balances closely-keyed colour areas against each other, sometimes skewing the divisions between them off the vertical, so as to create a dynamic equilibrium rather than a static symmetry. He has explored how colour can form a "fictional space" that our consciousness might inhabit. The idea of colour as light, or absence of light, is present in this work, and one senses a strongly spiritual, poetic dimension to the artist's later thinking about colour.

Dance / Sigh is an extravagant embodiment of colour as space and time, an environment for consciousness. While it remains primarily a painting – four large canvases joined together and set to stand freely on the floor in an open four-sided configuration – it occupies space like an installation, inviting us to enter and move within the area it encircles. Indeed, the experience of this work is enhanced by our movement. As we approach it, it completely saturates our field of vision. The reds appear to change with each point of view: seen from one position, a red may look quite distinct from the reds adjacent to it, but with a change of viewpoint they seem to blend. The varying angles of the canvases mean that the colour areas are differently oriented to the source of light – the work is particularly animated when it is seen in natural light. The irregular widths of the colour areas and the use of diagonal divisions make for a dynamic composition that engages us over time. Our eyes do not rest, and we feel the urge to move from one canvas to the other – we become part of a dance, a somatic experience that is heightened by our immersion in colour. The parallel suggested here between colour and music is impossible to ignore.

J.S.

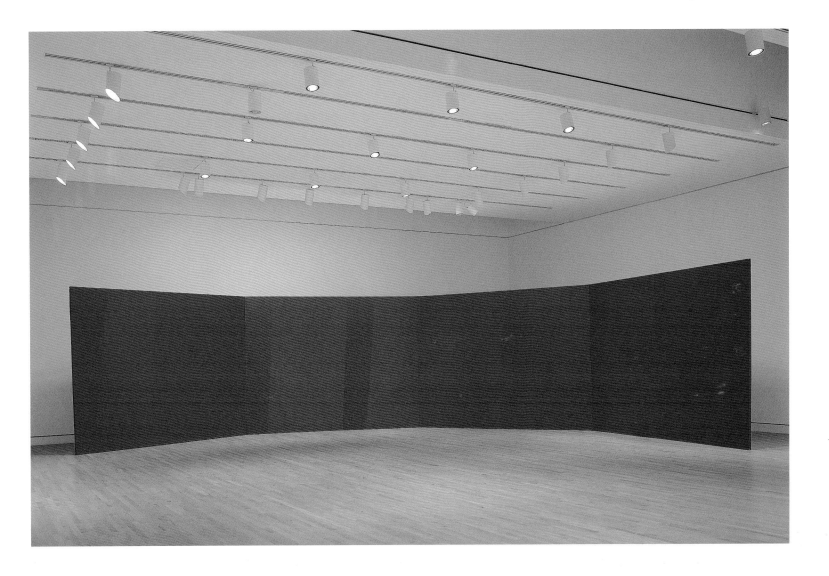

John Greer

Canadian, born 1944

Reconciliation

1989

Marble, bronze, and wood, installation dimensions variable; marble cherry pit 30 × 25 × 26 cm, bronze leaf with wooden post 256 × 183 × 102 cm, marble apricot pit 71 × 53 × 20 cm, marble plum pit 58 × 36 × 19 cm, marble peach pit 54 × 40 × 27 cm, marble almond 75 × 45 × 34 cm
Purchased 1993

John Greer, who lives and works in Nova Scotia, has taught at the Nova Scotia College of Art and Design since 1978. His work has been widely exhibited and collected in Canada. Greer's practice was originally conceptually-based and related to Minimalism, but by the end of the 1970s, like many artists affiliated with NSCAD, he had shifted his attention to traditional sculptural concerns – the shaping of hard substances such as stone, bronze, and steel into representational forms. But while his materials and techniques are traditional, the symbolism of his works is entirely contemporary. In 1985 and 1986 Greer worked in Pietrasanta, Tuscany, where sculpture is an artistic and artisanal tradition. Coming from the Maritimes, where craftsmanship is highly valued, Greer found Italy to be an inexhaustible source of technical information and inspiration. He has since returned many times.

While not abandoning more common stone materials such as granite and sandstone, Greer has grown to love the beauty and variety of marble. Like the diversity of marbles seen in many Italian churches, whose builders often went far afield to obtain different varieties, the marbles of *Reconciliation* come from quarries in Italy, Iran, and Spain. Sensuous as they are, Greer's spare renderings seem to belong more to the realm of the spirit than of material opulence.

Reconciliation is one of a number of works in which Greer has taken objects from nature to serve as his models. He favours the minutiae of the natural world – seeds, thorns, grains of rice, bone fragments – and in the process of rendering them he increases their scale dramatically, magnifying details in order to highlight their shapes and patterns. In so doing, he changes our relationship to them; marvelling at these enlarged natural objects, we may feel as if we had suddenly, like Alice, become small. In *Reconciliation* the huge leaf is propped up in a way that makes it seem at once inviting, like a shelter, and menacing, like a trap. The almond and fruit pits scattered around it are the rejects of the plant and fruit, the detritus that will generate new growth. By enlarging what might seem to us insignificant and ordinary, the work underscores the monumental importance of nature's cycles – sustenance, death, rebirth. The "reconciliation" of the title may refer to the need to acknowledge our place in nature. For Greer, humanity and nature must constantly reconcile – or both be imperilled.

J.S.

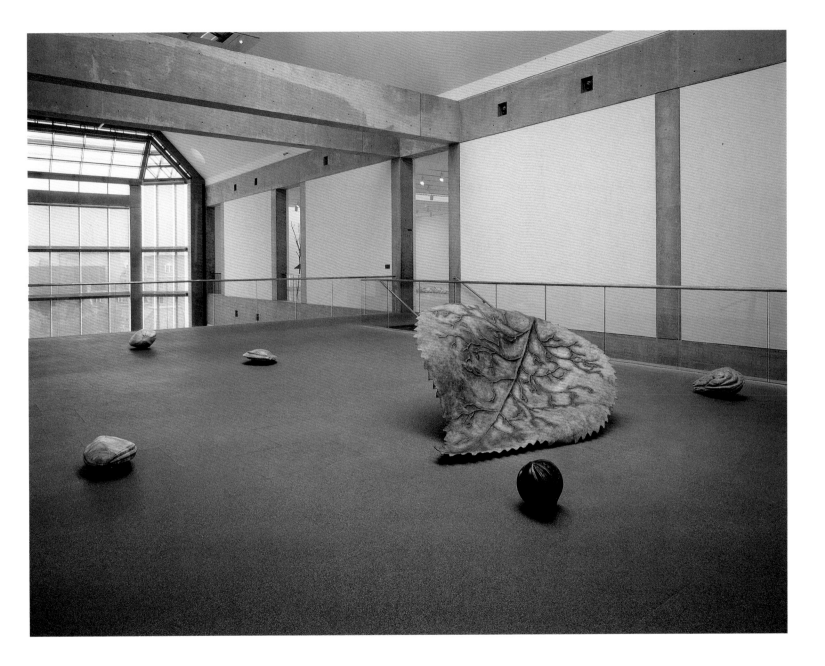

General Idea

AA Bronson (Michael Tims), Canadian, born 1946

Felix Partz (Ron Gabe), Canadian, 1945–1994

Jorge Zontal (Jorge Saia), Canadian, 1944–1994

One Year of AZT / One Day of AZT

1991

1,825 units of vacuum-formed styrene with vinyl, 12.7 × 31.7 × 6.3 cm each /

5 units of fibreglass with enamel paint, 85 × 214 × 85 cm each

Purchased 1995 / Gift of Patsy and Jamie Anderson, Toronto, 2001

One Year of AZT is made up of 1,825 elements of vacuum-formed styrene, representing a year's worth of the daily dosage of five capsules of AZT (the first drug proven to retard the reproduction of the HIV virus) grouped by month around the walls of the exhibition space. The other part of this immense installation, *One Day of AZT*, consists of five grossly enlarged capsules of enamelled fibreglass, lying on the floor of the room. Though physically overwhelming, both in the oversized dimensions of the capsules and in the sheer amount of space it occupies, *One Year of AZT / One Day of AZT* is intentionally understated. General Idea's installation is modelled on a clean, clinical model of wellness, a pharmacological barrier against the assaults of illness – or perhaps more to the point, against the mass hysteria of the media-driven AIDS debate – in the form of neutral, white and blue capsules. Mutely eloquent, the capsules might be containers for the bitter admixture of hype, hope, and despair surrounding AIDS, their impersonal, polished surfaces reflecting and absorbing society's attitudes to the illness.

From the very beginning of their collaboration in 1970, the three artists who made up General Idea – AA Bronson, Felix Partz, and Jorge Zontal – delighted in a broader, media-oriented cultural perspective, which they inverted and adapted to their own ends. Influenced by Roland Barthes's analysis of the "myths" of popular culture, they viewed the art world as a system of signs that they set out to deconstruct. Working collaboratively, they challenged received ideas about artistic identity, and drew upon the discourses of architecture and fashion with nimble irony to construct their own myth of artistic glamour and success. By the end of the 1980s, however, the onslaught of the AIDS epidemic caused their mood to darken. They turned from imagery celebrating their gay sexuality to AIDS-related subjects, borrowing the form and colours of Robert Indiana's painting *LOVE* to produce their first AIDS logo paintings and posters. Subsequently, both Zontal and Partz were diagnosed with the AIDS virus, and General Idea decided that the rest of their work would address this theme. They devoted their energies to developing an iconography that combined cultural readability with a Camp sensibility, allowing their art about AIDS to slip easily between the worlds of high art and popular culture.

Of all their works on the subject, *One Year of AZT / One Day of AZT* is certainly the most elegiac. It is the last major piece completed before the deaths of Partz and Zontal, which marked the dissolution of General Idea. The artists' reduction of the AIDS theme to a single, repeated, mass-produced element, in which all traces of the heroic and the personal are erased, alludes to Minimalism, and specifically to the colourful, industrially fabricated sculptures of Donald Judd. At the same time, their coolly ironical presentation of the subject is probably closer to Marshall McLuhan's notion of mediatized and generalized communicability than to Judd's "specific objects." As this installation demonstrates, General Idea easily bridged such extremes. Their accomplishments rest on their chameleon-like ability to inhabit the available cultural forms, whether on the street or in the museum, and to critique these forms in their own art.

D.N.

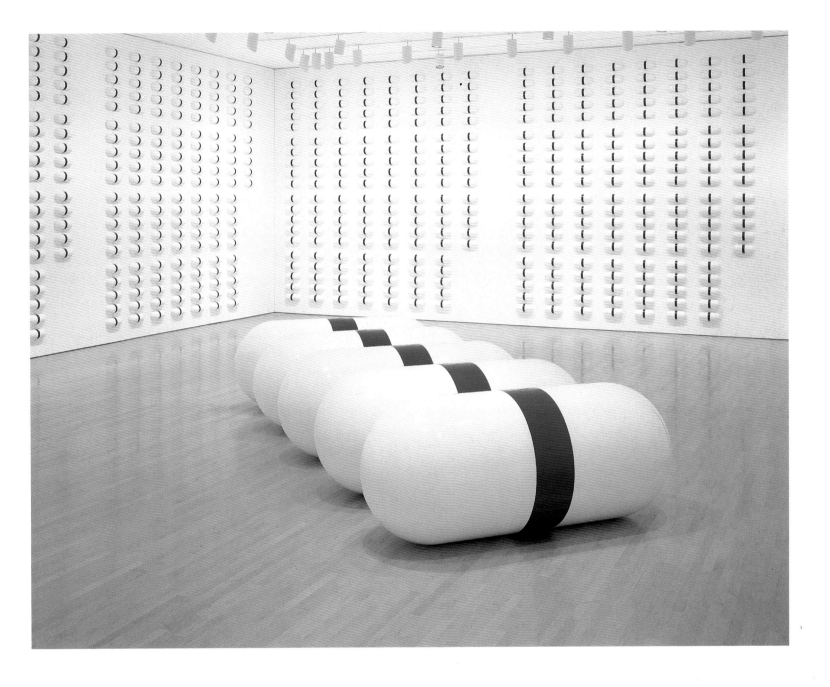

Roland Poulin

Canadian, born 1940

Already, the Night Is upon Us, No. 1

1991
Polychromed wood, 146.4 × 429 × 349 cm
Purchased 1995

Roland Poulin was decisively influenced by his early encounters with Minimalist art. He brought its radical insights to his own work, attempting to rid his sculpture of all outside references and simplifying the formal components. Each piece was intended to be a confirmation of the objective perceptual experience of the viewer. However, as he became increasingly conscious of the ambiguous and subjective nature of perception, he began to question the assumptions behind his earlier work. By the mid-1980s he recognized the presence of an archetypal symbolic language that had emerged in his work. In spite of his doubts about pursuing this new direction, which seemed to run counter to all he had learned from Minimalism, Poulin resolved to explore a symbolism fraught with ambiguity, in which references to the sensual body and its earthly fate are expressed in formal terms midway between figuration and abstraction.

Already, the Night Is upon Us, No. 1 represents an important moment in the evolution of the artist's ideas and sculptural language. In *Sombre* and other sculptures from 1985 and 1986, he had first addressed the subject of death overtly, through the introduction of the bed/tomb allusion. At the same time, he moved from working in cement to building his sculptures out of wood. This change allowed him to intensify the references to sleep and death by working on the scale of the body, while colour offered a newly sensual dimension that gave fulness to the metaphorical meaning of the sculptures, recalling traditional associations between darkness, night, and death.

In the pieces that followed, Poulin introduced a new figurative reference, the table, and explored an increasingly fragmented and dynamic composition of sculptural elements. *Already, the Night Is upon Us, No. 1* is perhaps the most successful of these subsequent sculptures in terms of its metaphorical richness and the dynamic disequilibrium of its composition. It is composed of two main elements: a fragment of a table that is angled so as to appear to be partly submerged in or emerging from the floor plane, and a second, overturned table sinking, as it were, into a large, coffin-like mass. Like the table fragment, this mass seems to be either rising from or sinking into the floor plane. The most gestural of Poulin's works to date, its composition is based entirely on a play of curves and opposing diagonal lines. The result is a spiralling movement that holds the fragmented forms together even as it implies their disintegration.

The combination of table and coffin that figures in this sculpture and others of the same period carries Poulin's meditation on the theme of death a significant step further from the references to sleep and death in *Sombre*. The bed/tomb figure has a long history in Western sculpture, as it does in literature, especially poetry. However, the linking of the table, full of associations with sensual pleasures, and the tomb, is an uncommon and paradoxical connection. Here Poulin's often expressed fascination with contradiction becomes tangible. One suspects that the ambiguity that arises, in part, from the open and complex formal structure of the work is not meant to be resolved. The union of table and tomb is a struggle of two entities that would be incomplete by themselves; each finds its meaning in its opposition to the other.

D.N.

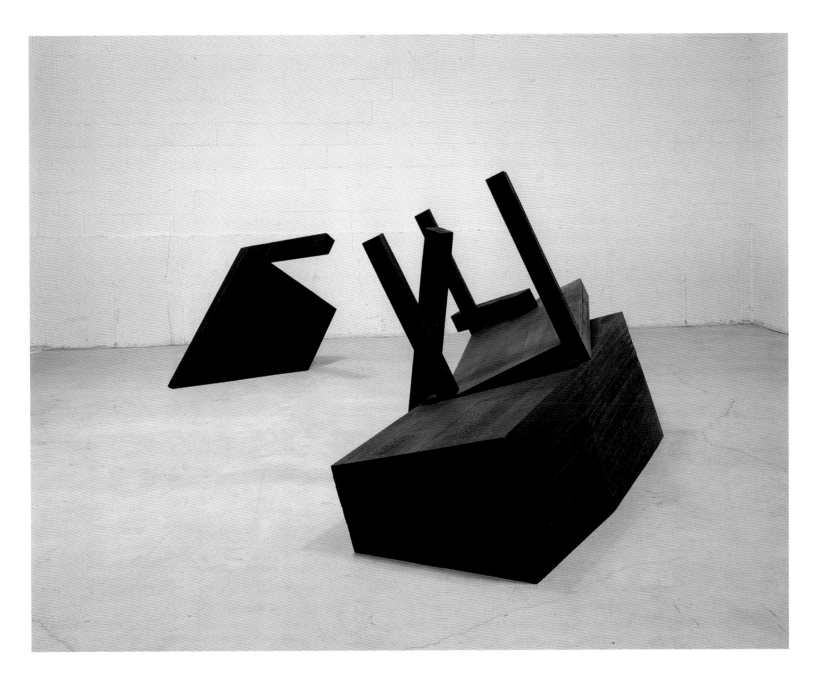

Vera Frenkel

Canadian, born Czechoslovakia 1938

... from the Transit Bar

1992, reconstructed 1994
Six-channel video installation with full working bar, player piano, bar furniture, newspapers, and potted plants, installation dimensions variable
Purchase and partial gift of the artist, Toronto, 1997

Born in Czechoslovakia and raised in England, the Toronto-based multidisciplinary artist Vera Frenkel is one of the pioneers of video art in Canada. Her work introduces narrative into art in the form of story-telling that is a collage of truth, fiction, and memory. Frenkel's stories build upon each other, interweaving, leading into one another, adding characters, places, and situations – some contemporary, some from times past. They embrace unresolved social issues arising from the displacement of people by war, economics, and personal necessity. They also focus on the challenges faced by artists seeking to construct their works on the shifting foundations of contemporary culture.

Frenkel's ... *from the Transit Bar* was originally created for the international exhibition Documenta IX in Kassel, Germany, in 1992. It was subsequently shown at the Power Plant in Toronto and the National Gallery of Canada in Ottawa before being circulated in Scandinavia and Poland by Riksutställningar (Stockholm). The piece, which evokes the atmosphere of a bar in a train station, was conceived as a resting point in the exhibition, a place where people might meet briefly, enjoy the company of new acquaintances or suffer the discomfort of being strangers, and perhaps exchange stories and hear something of the experiences of others. As a work of art that is also a working bar, it operates on a number of levels at once. The bar setting serves as a frame not only for what transpires between the real people who enter it, but also for the presentation of six video narratives. These are shown continuously as drinks are served, the piano plays, and conversations are struck up with other visitors or with the bartender (a role the artist herself sometimes plays). The six narrators are of various ages and ethnicities. Their stories are told as voice-overs in Yiddish and Polish, two languages considered marginal in Germany (where the piece was originally shown) and in Canada, and spoken generally only by those who learn them as children. The narratives are subtitled in English, French, and German, so what the viewer is exposed to are rich, personalized stories distilled through translation and further essentialized as subtitles. Visitors to the Transit Bar are immersed in a babel of languages, to which their own is added.

The idea of travel, and of deeper displacements, is underscored in the work by the moving backgrounds that appear behind some of the speakers, which create the impression that they were filmed while on a train or in proximity to trains. These present-day trains are suggestive of the transports that carried Holocaust victims to their deaths – a memory that is never far from the surface in Frenkel's work. In more recent presentations of the piece, Holocaust stories that were actually overheard earlier by the bartender have been included in some of the newspapers left lying around (each presentation includes newly printed newspapers), linking ... *from the Transit Bar* with the artist's exploration of the Nazi looting of art in her subsequent work, *Body Missing*. Thus Frenkel's work unfolds in an ever-expanding continuum.

Vera Frenkel has created a place for the telling of personal stories upon which new histories can eventually be built. Incorporating political issues, as well as ideas of identity and migration, her work is based on the validation of memory: somewhere, in all the stories, told only once in a bar or shared hundreds of times, the truth might emerge – fragmentary, only partially understood, vitalized by synthesis and imagination.

J.S.

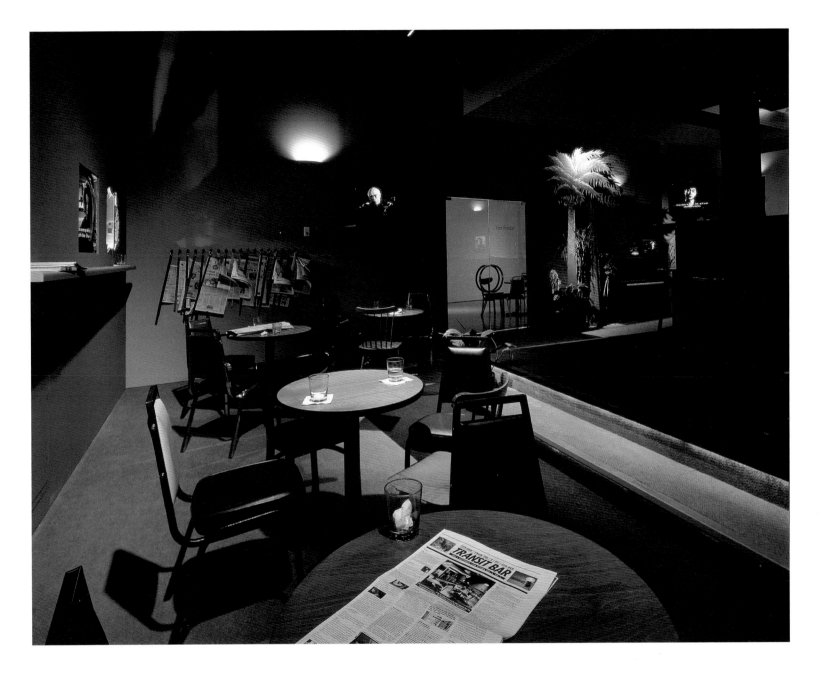

Mona Hatoum

British, born Lebanon 1952

Light Sentence

1992
36 wire-mesh lockers, light bulb, motor, and pulley, 198 × 185 × 490 cm
Purchased 1995

Born in Beirut of Palestinian parents, Mona Hatoum has been based in London since 1975. The outbreak of civil war in Lebanon prevented her from returning home from a trip to England and she remained to study art, establishing herself as an artist there. She first became known in the early 1980s for her performances and videos, which gave expression to the politicization she experienced as a result of her exile in London. Aesthetic and political issues are interwoven in all of Hatoum's work. However, her installations are less overtly tied to particular political situations than were her performances. Influenced by the experiments with materials and space associated with Minimalism and Arte Povera, they offer metaphoric structures for themes that have been present in her work since the beginning: a sense of profound dislocation, and an examination of physical and cultural barriers. While there are certain elements in common among her works in various media – for example, the use of structures that interrupt space without blocking vision – she has moved from using herself as the actor in her performances and videos to giving the spectator that role, in a space subtly transformed so as to draw out a variety of socially and psychologically charged meanings.

Like much of Hatoum's work, *Light Sentence* is inherently ambiguous. Sculptural in means and theatrical in effect, it is about shadow, chaos, and confinement, but also about light, order, and control. Its means are spare, evoking the body without presenting it. It is a menacing yet seductive stage on which we are the actors. The installation consists of tiers of lockers or cages set in two rows, closed off at one end to create a dead-ended corridor. The doors of the cages are open at random. Between the rows, a single light bulb dangles, slowly descending until it touches the floor, and then gradually rising above the cages where it once again begins its slow descent. This mechanical repetition makes the passage of time tangible. The movement of the light bulb is echoed by the rising and falling shadows of the cages, and finally the whole room becomes a transparent cage engulfing the viewer, whose own shadow too is thrown upon the wall.

Hatoum has frequently used grid structures to divide space and act as barriers. Cage-like or fence-like, her grids are far from abstract. They evoke the human body by their carefully calculated scale, and subjective associations of separation and confinement are central to their meaning. Here, the transparency of the lockers and the mechanical movement of the light bulb, which functions like an all-seeing eye, together suggest metaphors of surveillance, calling to mind the Panopticon – a design for a prison developed by the British philosopher Jeremy Bentham. This carceral metaphor is implied, albeit ambivalently, in the title, *Light Sentence*. There are many cages in this installation, some real and others that the light creates, mobile, imaginary, even beautiful, delineated by the shadows on the wall. The viewer remains free to enter, or not enter, the claustrophobic space marked out by the rows of lockers, and ultimately the implied confinement of the physical body is offset by the unfettered play of the imagination.

D.N.

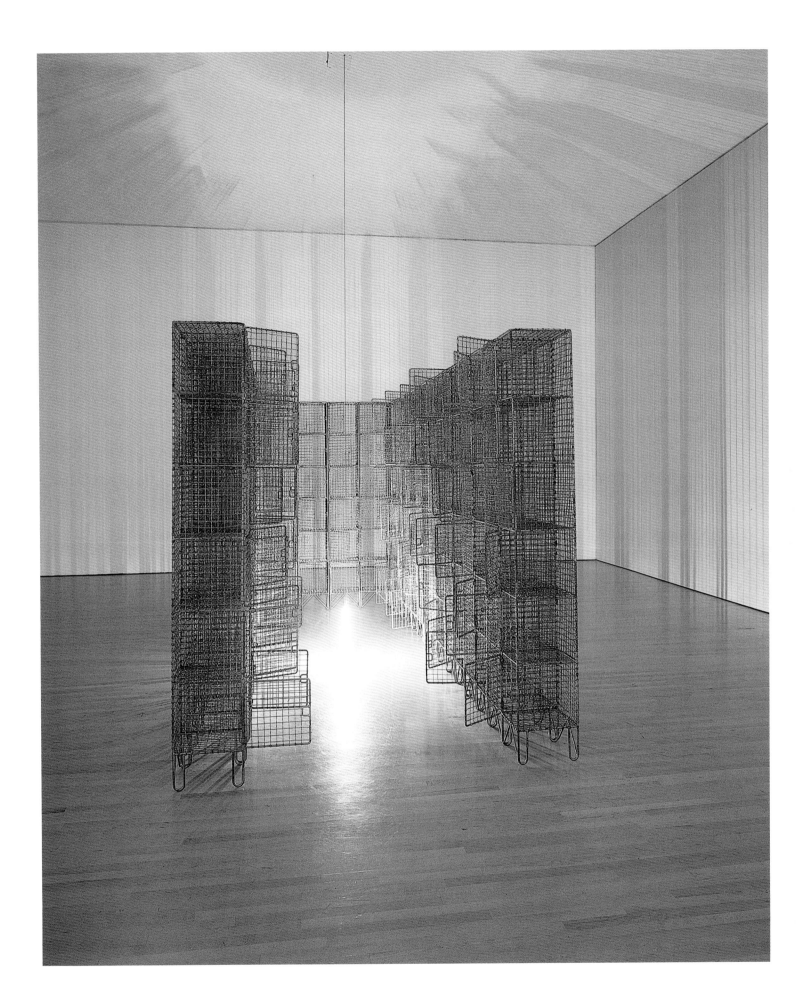

Stan Douglas

Canadian, born 1960

Nu'tka'

1996
Single-channel video installation, duration of one rotation 6 minutes,
installation dimensions 710 × 1,130 cm approx.
Purchased 1997

Stan Douglas's *Nu'tka'* is a Canadian Gothic tale told in a fragmented, circular style. Borrowing from the Gothic novel, a literary form that was popular during the period of North American exploration and colonization, Douglas puts quotations from Cervantes, Poe, de Sade, and others into the mouths of his two interlocutors – the captive English captain of a trading vessel and a Spanish military commander from Fort San Miguel (situated on what is now called Nootka Sound). The moment of first contact with the Mowachat Nation, who traded with the White newcomers to the area, is past. The trading nations and the Aboriginal peoples who have become the object of suspicion and greed are jockeying for supremacy. This is the setting for the tale of haunting and dread that glimmers through the spoken stories told by Douglas's two characters. The Gothic novel put into fantasy form the fear of the unknown that underlay imperialist optimism; in *Nu'tka'* Douglas imbues a distant historical situation set in the sublimely terrifying landscape of Canada's West Coast (an area he knows well) with loathing and desperation.

By the time he made *Nu'tka'* the artist had already produced a number of video, photographic, and projected works that made highly original use of whatever medium he chose as appropriate for his subject. *Nu'tka'* is no exception. The two characters speak on separate soundtracks that the viewer can hear by moving from speaker to speaker within the installation. Several times during the narration the two voices come together and utter the same words. It is as if, despite their mutual enmity and apprehension, the two foreigners shared a common fear of the place and its people. This type of "contrapuntal" soundtrack was pioneered in radio, notably by Glenn Gould in his documentary *The Idea of North*. Here, Douglas marries the sound structure with a video composition that echoes the audio tracks – images that split and come together in tandem with the voices. The basic video image is a 360-degree pan of the landscape surrounding the original site of the Spanish fort. Sequences were shot at different times of day, and consequently when the moving images come together at certain landmarks the light in each is not the same, lending an unsettled, uncanny appearance to the landscape. There is no attempt to disguise this landscape as anything but present-day; it signals the relevance of history to contemporary struggles over land claims and environmental issues that have their roots in the situations described in the Canadian Gothic tale. The artist shows himself here a master at synthesizing different technologies and media, and weaving various historical, literary, and artistic currents into a single, cohesive whole.

J.S.

Gathie Falk

Canadian, born 1928

Dress with Candles

1997
Papier-mâché with acrylic and varnish, 87 × 57.5 × 32 cm
Purchased 1999

Gathie Falk spent her early years in Manitoba, Saskatchewan, and Ontario before settling in Vancouver in 1947. While working as a school teacher in the 1950s she attended summer courses and night classes in painting, drawing, and design. She began exhibiting her paintings in 1960, and in 1965 left teaching to become a full-time artist. It was through her ceramic sculptures and her performance work that Falk initially gained prominence, in the late 1960s. She returned to painting in the late 1970s, and has recently resumed working in sculpture as well.

Dress with Candles is one of a series of six freestanding papier-mâché dresses created by the artist for a 1998 installation called *Traces*. In making each of the dresses, Falk began with a rudimentary pattern cut from newspaper and then "stitched" the sections together with strips of paper and liquid cellulose. Layer upon layer, strips of newspaper were then melded to the surface to give the dress form and definition. Each of the six works in the series features a different object or set of objects – cosmetics, singing birds, a display box of insects, candles, a framed photograph of a boy and another of crossed ankles – installed on a small shelf cut out of the front hem of the skirt. Painted shadows and highlights accentuate the folds and creases on the dress and the protrusions of the imagined body inside it. The entire surface is finally built up with numerous coats of glossy transparent varnish to create a rich effect.

Like many of Falk's sculptural works, *Dress with Candles* is whimsical and playful. Falk's visual language reflects the influence of Pop art and, more significantly, the California Funk movement of the 1960s and '70s. California Funk began as a regional rebellion against the "high" art of the American East Coast; artists such as Robert Arneson, Roy De Forest, and David Gilhooly produced humorous and irreverent ceramic pieces using cartoon-like forms and bright, bold colours. Gilhooly taught at the University of Saskatchewan in Regina in the early 1970s, and as a result a number of Canadian artists, including Joe Fafard and Victor Cicansky, began working in ceramics. Gilhooly encouraged his students to use motifs taken from their own everyday life and immediate environment. It was around this time that Falk created some of her first ceramic sculptures depicting ordinary objects such as shoes and various types of round fruits.

The "Dress" series has also been likened to the religious sculptures of early Quebec wood carvers. Although Falk's sculptures are delicate and lightweight in comparison to those massive representations of saints, angels, and biblical figures, there is a similarity in the hard wood-like finish and in the attention to the folds of the drapery. What is strikingly different, of course, is the Surrealist touch: here, for example, candles with painted flames run in a row along the shelf in front, and two other candles emerge out of the back of the dress, as if clutched by protruding shoulder blades. The candles are at once celebratory and sad. Their flickering flames, combined with the old-fashioned style of the dress, remind us of the passage of time and the brevity of life, making *Dress with Candles* a kind of *memento mori*.

J.D.-B.

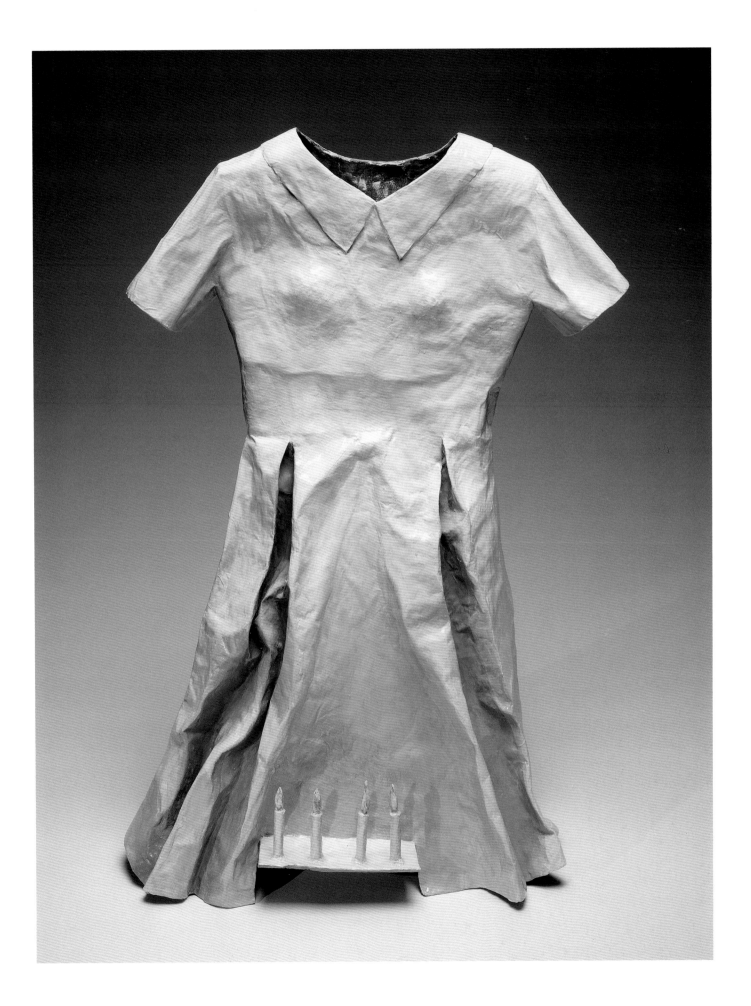

Leon Golub

American, born 1922

Prometheus II

1998
Acrylic on linen, unstretched, 302.3 × 246.4 cm
Purchased 2000

Born into a middle-class Jewish family in Chicago in 1922, Leon Golub belongs to the generation of Americans who grew up in the Depression. During the Second World War he served as an aerial cartographer in Europe. His outlook as an artist and a person was definitively shaped in the late 1940s by his readings in Existentialism and by the Freudian psychoanalysis that he was then undergoing. After studying art history at the University of Chicago and completing an M.F.A. at the Art Institute of Chicago, Golub lived for a time in Italy and Paris, with his wife, the artist Nancy Spero, returning to the United States in 1964.

The earliest artistic influences on Golub's work included cultural artifacts from Africa, Oceania, and the American Northwest Coast that he saw at the Field Museum of Natural History in Chicago, and late Roman and Etruscan sculptures that he saw in Italy. His work until the late 1960s focused on the nude male figure, rendered in a manner that borrowed from both primitivism and late-Classical vocabularies, at first presented singly and later in pairs or warring groups. His treatment of these figures was fully Expressionist, incorporating heavily textured surfaces, distortion, and fragmentation. When the art world turned to neo-Expressionism in the 1980s, interest in his work grew. Golub is distinguishable, however, from his younger contemporaries by his broadly humanist vision and his insistence on addressing the "big" questions about the nature of man and the meaning of moral responsibility.

On his return to the United States, Golub settled in New York. There his work underwent a shift towards a more objective, reportorial content and a simpler, flatter painterly treatment. Powerfully affected by the Vietnam War, he turned to such sources as newspaper and magazine photos, and for the first time he depicted men, and sometimes women, in contemporary dress and situations, with recognizable allusions to contemporary events. In the work for which he became known in the 1970s and '80s, he concentrated his attention on the mercenaries and paramilitary forces who carried out the dirty work of war and oppression in Central America, South Africa, and elsewhere. The violence of these pictures is deeply troubling, the more so because their larger-than-life size and frontal composition cause the spectator to feel directly implicated in the situations they depict.

In *Prometheus II*, a late work, Golub has chosen a subject that is both more personal and more symbolic. Prometheus, the Titan who, for the crime of stealing fire, was condemned by Zeus to the eternal torment of having his liver torn from his body by an eagle, is represented as a pathetic ruffian bemoaning his fate in modern-day language evocative of the world of media sensationalism. When he first came to New York, Golub was looking for subjects with an epic dimension, in reaction to the art world's coolly distanced stance at the time. On one occasion he remarked to the critic Irving Sandler that he was particularly impressed by the magnitude of José Clemente Orozco's Pomona College mural, *The Triumph of Prometheus*. For Golub, Prometheus is more than simply the archetypal anti-hero. Having been employed by Zeus to make men out of mud and water, he stole fire from heaven for them, out of concern for their plight. As a kind of *agent provocateur* and rival of the omnipotent Zeus, he is emblematic of the artist himself, and the pathos with which he is represented here may be Golub's reference, in old age, to his own diminished powers.

D.N.

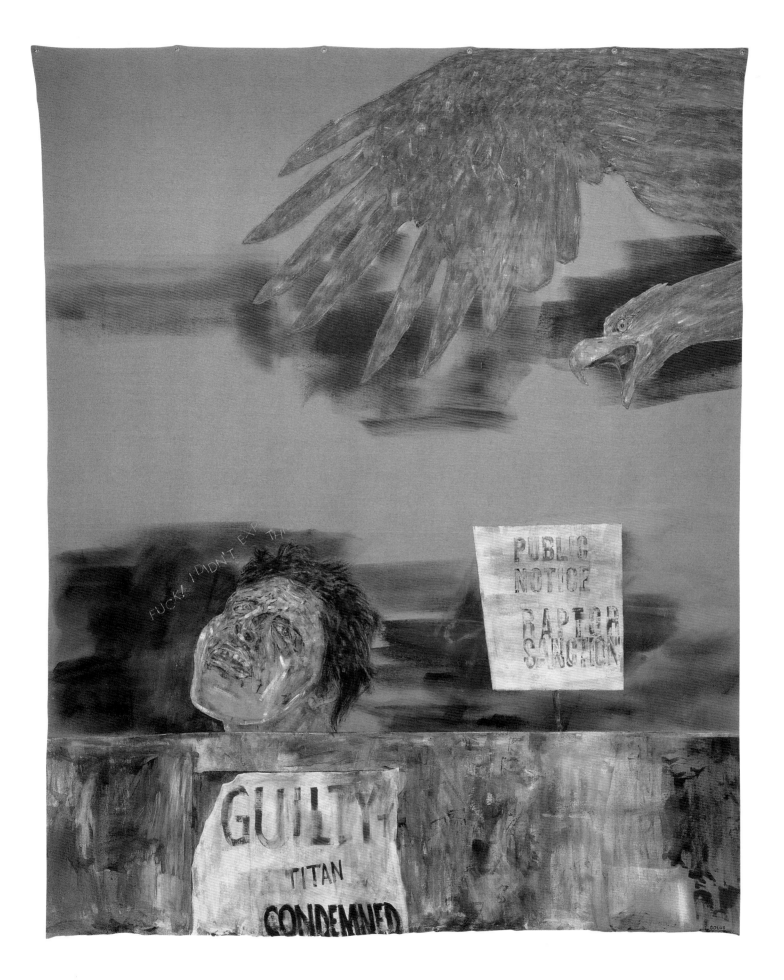

Tony Cragg

British, born 1949

A Place in My Heart

1998

Thermoplastic dice over fibreglass, left element 228 × 190 × 109 cm, right element 172 × 90 × 92 cm
Purchased 1999

Tony Cragg is a prominent member of the generation of British sculptors who emerged on the international scene in the late 1970s. Unlike their immediate predecessors, such as Henry Moore and Anthony Caro, these younger sculptors found their inspiration not in traditional materials but in manufactured objects and in the detritus of everyday life. Cragg's imagination was also nourished by a particular interest in how modern science has extended the boundaries of knowledge, opening up hidden realms and blurring the distinction between the natural and the artificial.

In the mid-1980s Cragg turned to traditional sculptural techniques, such as casting, and to an exploration of volumetric forms. To some observers at the time, this move seemed to be going in a conservative direction. In retrospect, however, it is clear that the drive to enlarge his sculptural vocabulary stemmed from Cragg's determination to explore certain themes. One of the artist's ongoing ambitions is to communicate the invisible information that has accumulated around things in the world, including ourselves, through an autonomous visual language with its own syntax. The attempt to create such a language is what has spurred the unusual diversity of his sculptural works. His method, which is not without its quirky humour, often involves estranging the familiar through a substitution of materials and a manipulation of forms, combined with changes of scale, from the very small to the very large.

A Place in My Heart is typical of the formally inventive sculptures that constitute Cragg's recent work. The title, which has overtones that are both emotional and physical, prompts us to see in the bulging and hollowed shapes a suggestion of the muscular chambers and ventricles of the heart. Yet the sculpture does not literally represent anything. It essentially demonstrates Cragg's ability to analyze, deconstruct, and recombine the forms of things existing in the world in order to create new and unfamiliar objects that tease us with their resemblance to things we already know. The dazzling skin of dice that clads the forms and visually knits them together seems to take us, metaphorically, from the inner world of the body, where regulated function dominates, to the outer world of daily experience, where chance holds equal sway. The incongruity of such juxtapositions has led some to view Cragg as a latter-day Surrealist, but it is hard to believe that the unscientific dogmas of Surrealism could hold any interest for him. More likely, it is the incongruity here of scale and form – the small geometrically-shaped dice as opposed to the organic volumes they embody – that especially pleased him.

K.S.

Gerhard Richter

German, born 1932

Lilies

2000
Oil on canvas, 68 × 80 cm
Purchased 2002

Gerhard Richter began his career as a muralist in East Germany during the post-war years. In 1961 he moved to West Germany and became active in the contemporary art world centred around Cologne and Düsseldorf. Using published images and family photographs, he began making the first of his many celebrated photo-realist paintings, recognizable by their distinctive blurred look. Over the years his work has reflected – or at least has seemed to reflect – a wide range of influences, including Pop art, Minimalism, abstraction, neo-Expressionism, and Conceptualism. Austerely critical of himself and of the practice of art in general, Richter has in fact consistently eluded all "isms."

In his photo-realist paintings Richter has frequently turned to traditional subjects: portraits and self-portraits, landscapes, and still-lifes. *Lilies* is a still-life depicting a bouquet of white lilies in a glass vase placed on a table. The image is devoid of clear outlines and verges on the abstract. A strong light source outside the picture illuminates the flowers from above, casting a broken pattern of shadows on the surface of the table. The canvas is divided into an upper field and a lower field. The space above the line of the table may be seen as representing the material world, where things possess measurable volume. Below the line, in the immaterial realm of shadows, the vase, flowers, and leaves are transformed, seeming almost to disintegrate and merge into the creamy yellow surface of the table. Viewed within the context of the *vanitas* tradition, which has exerted a strong hold on Richter's imagination, *Lilies* is symbolic of the fragility of life and the vanity of worldly desires in the face of death's inevitability. While the artist seeks to capture the fleeting beauty of the flowers, the blurring of the image makes visible the passage of time.

The candidum lily, also known as the Madonna lily, is a traditional Christian symbol of purity, chastity, and virginity, often associated with the Virgin Mary and included in depictions of the Annunciation. It is significant, in this regard, that the palette of *Lilies* resembles that of Richter's 1973 series of paintings titled *Annunciation after Titian*, all based on Titian's *Annunciation* in the Scuola di San Rocco in Venice. Out of his great admiration for Titian's masterpiece and his fascination with its subject, Richter wished to somehow possess it by copying it. In *Lilies* he seems to be returning to the challenge of possessing the Titian. This time, however, he has extracted only a detail from it and recast it as a still-life, in order to express what would be, in his terms, the "beautiful truth" within it. Although he is not religious himself, Richter believes that religious images "still speak to us. We continue to love them, to use them, to have need of them."

K.S.

Brian Jungen

Canadian, born 1970

Shapeshifter

2000
Plastic chairs, 145 × 660 × 132 cm
Purchased 2001

Brian Jungen's Swiss and Aboriginal ancestry has made him keenly aware of the ironies inherent in cultural transformation. Jungen was raised in the northeastern interior of British Columbia, near Fort St. John, and is a member of the Doig River band of the Dunne-za Nation. He graduated from the Emily Carr Institute of Art and Design in 1992 and has lived and worked in Montreal, New York, and Vancouver.

Beginning with the exhibition of his 1999 series of Northwest Coast–style masks created out of chic brand-name running shoes, Jungen has been questioning the idea of what constitutes Aboriginal art while making radical use of the commercial "ready-mades" of the international mass market. *Shapeshifter*, whose title alludes to tales of metamorphosis, continues and develops these lines of inquiry. Hung from the ceiling, it appears at first glance to be some sort of dinosaur skeleton, of the kind found in natural history museums. On closer examination, it becomes clear that the work is actually made of pieces cut out of plastic patio chairs and bolted together.

The whale skeleton in *Shapeshifter* is not an anatomically correct one, but is an amalgam based on photographs of different species. Jungen has, in effect, taken the "whale bones" that he found within the patio chairs and restored them to the whale. His way of working can be thought of as a kind of reverse archaeology: beginning with a new, whole object, he has mined it to find skeletal fragments, which he has then pieced together to form the remains of a creature that looks as if it might once have existed.

Jungen first started using plastic chairs in 2000, when he was making his *Bush Capsule*, a work conceived as a temporary seasonal shelter, similar to the kind that would have been familiar to his Dunne-za family. He was initially attracted to the chairs for their ordinariness as much as for their beautifully sculpted lines, and it occurred to him that he could construct a kind of geodesic dome using pieces of them as modular support elements, not unlike the whale bones used by the ancestral Inuit for the walls and rafters of their winter houses. At about the same time that he was making *Bush Capsule*, he developed an interest in the displays of whales at both the Vancouver Aquarium and the University of British Columbia's Museum of Anthropology. Thinking about how contemporary cultural institutions present the endangered species as educational exhibits and as tourist attractions, he began to see the plight of the whale as symbolic of the plight of Aboriginal people and their culture, simultaneously fetishized and marginalized. *Shapeshifter* intriguingly combines these troubling social themes with an exuberant deconstruction of the material surface of our throwaway culture.

K.S.

Inuit Art

Jessie Oonark

Canadian, 1906–1985

When the Days Are Long and the Sun Shines into the Night

1966–1969

Felt pen and graphite on wove paper, 126.8 × 317.8 cm, trimmed irregular at left and right

Gift of Boris and Elizabeth Kotelewetz, Baker Lake, Northwest Territories, 1991

Jessie Oonark's panoramic drawing *When the Days Are Long and the Sun Shines into the Night* teems with activity. From left to right and top to bottom, men, women, and children work and play – hunting caribou with bows and arrows, travelling by dog team, fishing through the ice, gathering for a drum dance, shovelling snow, playing ball, cooking bannock, fixing a sled. As Oonark explained, her subject is Inuit life during those intense Arctic spring and summer months when there are close to twenty-four hours of daylight, the air warms up, game becomes more plentiful, life is renewed, and not a moment is to be wasted. Oonark signals the time of year in the drawing by means of the ring of suns surrounding the group of figures assembled inside the circular form of a snow house.

A member of the Utkusiksalingmiut (one of the "people of the place where there is stone for making pots") from the Back River area of the central Arctic, Oonark moved into the Baker Lake settlement in 1958. Encouraged by a visiting biologist who shared his art materials with her, she began to draw. The end result was an active twenty-five-year career and a body of work – prints, drawings, and appliquéd wall hangings – that earned her a reputation as a major contributor to Inuit art. An ambitious piece, *When the Days Are Long and the Sun Shines into the Night* shows the crisp, angular lines that became a hallmark of her style. Equally evident is her passion for clothing and design; Oonark not only captures regional variations in parka forms and decoration, but uses them as a point of departure for her contemporary expression, a mix of rich cultural information and abstraction.

Prior to the creation of the Sanavik Co-operative and the artistic flourishing of Baker Lake in the 1970s, Oonark's nascent talent was supported by a variety of individuals and programs (her first prints were published in Cape Dorset in 1961). When Boris Kotelewetz arrived in Baker Lake in 1966 as an arts and crafts officer, he made sure that Oonark received a variety of new art materials and a studio space of her own. The artist experimented widely. A desire to work on a larger scale than was possible with standard drawing paper manifested itself in a mural that she painted on the side of a local building in 1968. The following year, she presented Kotelewetz with a large roll of paper that had been among the art supplies she had acquired some time earlier. Instead of cutting it up, Oonark had used the whole surface to create *When the Days Are Long and the Sun Shines into the Night.* The experience gave Oonark an opportunity to draw on a grand scale and to test her powers of visual orchestration. As the drawing shows, she responded to the challenge with aplomb. And now, with hindsight, it is possible to appreciate how she carried this mastery of complex spaces and shapes through the rest of her career.

M.R.

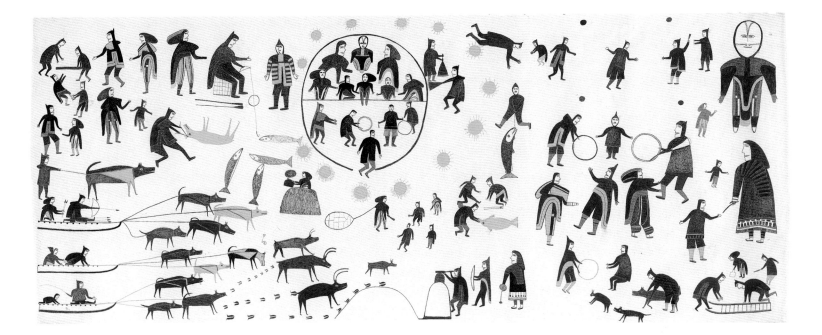

Pitseolak Ashoona

Canadian, c. 1904–1983

Joyful Woman with Water Pail

c. 1967

Felt pen on wove paper, 41.5 × 35 cm

Gift of the Department of Indian Affairs and Northern Development, 1989

Her arm raised in a gesture that seems to simultaneously greet the viewer and invite admiration, the figure in *Joyful Woman with Water Pail* delights us with her spontaneity and charm. The drawing calls to mind a remark in the artist's 1971 oral autobiography, *Pitseolak: Pictures Out of My Life*: "All through my married life, because Ashoona was such a good hunter, he brought me beautiful skins – all kinds of seal and caribou. Many women used to be jealous of me because I had such lovely clothes." Even with all the challenges of camp life, Pitseolak took an interest in fashion. She appreciated the quality of skins her husband provided, and she developed considerable expertise as a seamstress, cutting and sewing the skins into fine garments and decorating them with ornaments. In *Joyful Woman with Water Pail*, the trim hanging from the edges of the woman's parka seems to be more than just the usual caribou skin fringe; it is probably meant to depict the prized beads or perhaps British penny coins that became part of clothing adornment in the era of trade goods and changing lifestyles.

Widowed in the late 1940s, Pitseolak moved her family from Ashoona's remote Nettilling Lake camp to live with relatives in the vicinity of Cape Dorset. By the mid-1950s she was helping to support the family by sewing parkas and socks for the new arts and crafts programs that James and Alma Houston were establishing in the community. Inspired by her cousin Kiakshuk, who had become involved in the fledgling print studio, she acquired some paper and pencils. As soon as her first drawings were sold, her art began to flourish. During what proved to be a thirty-year career, she produced some seven thousand drawings and more than two hundred prints – works that not only capture the seasonal rhythms and details of traditional Inuit life on the land but also display a marvellously assured, energetic drawing style all her own. For Pitseolak, drawing was at first simply a tool of survival; in the end it launched her on a personal creative journey that gave full expression to her determination, humour, and enthusiasm for life.

Joyful Woman with Water Pail was executed at a time when Pitseolak had already been drawing for about eight years. One of the things in it that is new, for her, is the use of the red felt pen. In support of its artists, the West Baffin Eskimo Co-operative has over the years sought to provide access to a variety of different materials and techniques, and early in 1967 the first supply of coloured pens was received. Pitseolak took to them quickly, finding their fluidity and the addition of colour especially appealing. The bold red used for *Joyful Woman with Water Pail* is an essential component of the drawing's lively attractiveness.

M.R.

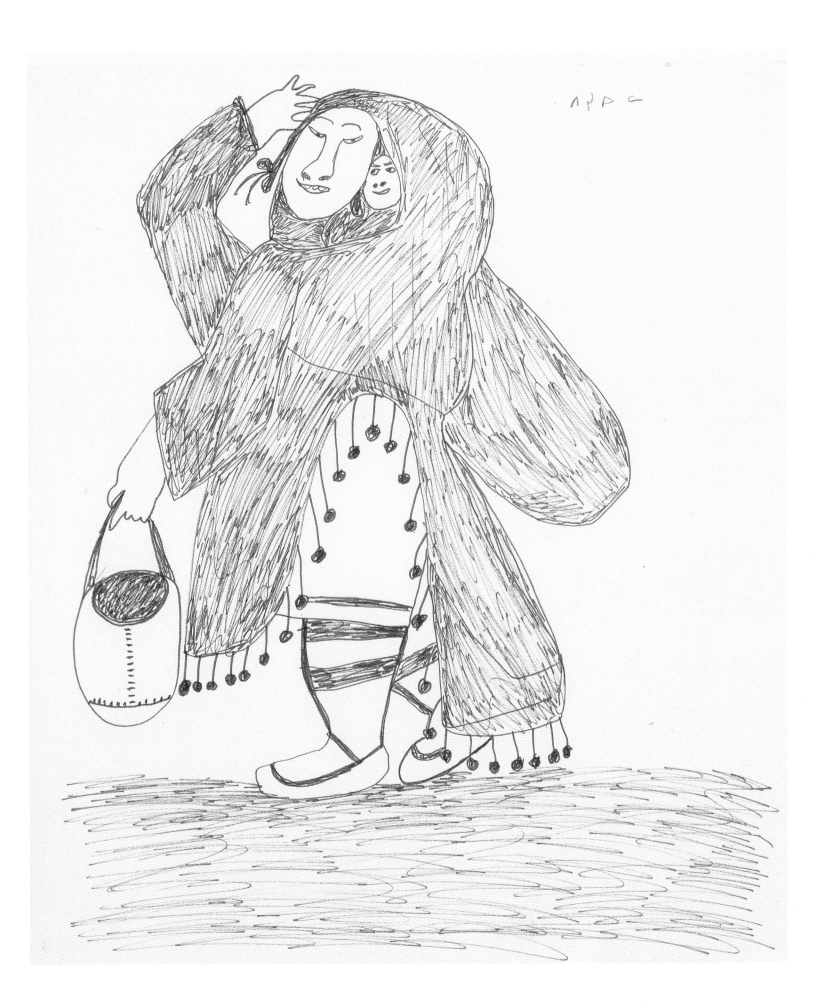

Karoo Ashevak

Canadian, 1940–1974

Figure

1974
Whale bone, 41 × 44.2 × 10.5 cm
Gift of the Department of Indian Affairs and Northern Development, 1989 (Gift of John and
Judy McGrath, 1984)

> Sometimes I make figures with funny faces or scary faces that I see in my dreams. Sometimes I carve faces
> of spirits from old Eskimo stories. They scare me too.
>
> <div align="right">KAROO ASHEVAK, 1973</div>

Karoo Ashevak's meteoric rise to prominence began in 1970, when two of his earliest sculptures received awards in a competition organized to mark the centennial of the Northwest Territories. The artist quickly gained a reputation for his imaginative figures, conceived in ancient, weathered pieces of whale bone, that present an alternately playful and serious vision of both the human world and the spirit world. While grounded specifically in the culture of the Netsilingmiut, the "people of the seal," Ashevak's work seems to have touched a universal chord. In his home region of Kitikmeot, in the central Arctic, he was a major force in articulating a distinctive expressionistic style of Inuit sculpture. Reviewers sometimes compared his work with that of Picasso because of the similarity in the treatment of the face. Solo exhibitions in Toronto, New York, Montreal, and Washington were among the highlights of four intensely productive years that ended tragically with his death in a house fire in 1974.

Part of the character of Ashevak's art is its ambiguity. Something of an eccentric and a keen practical joker, the artist frequently introduced humour into his work. At the same time, visual clues in many of his works point to a spiritual dimension. Speaking, for example, of his 1973 sculpture *The Coming and Going of the Shaman* (also in the National Gallery's collection), he commented that it represents "a transferring of shaman power or the shaman spirit from one shaman to another." The iconography of *Figure* may be examined in a similar light. According to his sister, Ashevak was strongly affected by physiognomy, and was particularly struck by the unusually mismatched eyes of an elderly man in the community who was said to have been a shaman. The literature on Inuit spiritual life tells us that this feature – having eyes of different sizes and shapes – is one of the attributes of a person with special powers, an outward manifestation of their ability to see what others cannot. Some sources cite the need for the shaman to be wearing mittens during certain practices and rituals. In the end, the interpretation of *Figure* as a representation of a shaman remains plausible but inconclusive – which is probably just as the artist intended it.

Ashevak's method was to use a series of sculptures to explore variations on an idea or visual motif that intrigued him. A late work, *Figure* comes near the end of a group that focuses on the relationship between face and arms. Comparison with two similarly titled versions from 1971 and 1973 (both also in the National Gallery) shows a clear progression towards a flattening and simplification of forms. The distorted facial features – eyes of different shapes, flattened nose, gaping mouth – and the stylized body emerging from the natural form of the whale shoulder-bone epitomize the inventive capacity that makes this artist's production unique. Elegant, evocative, and elusive, *Figure* is classic Ashevak in both content and conception.

<div align="right">M.R.</div>

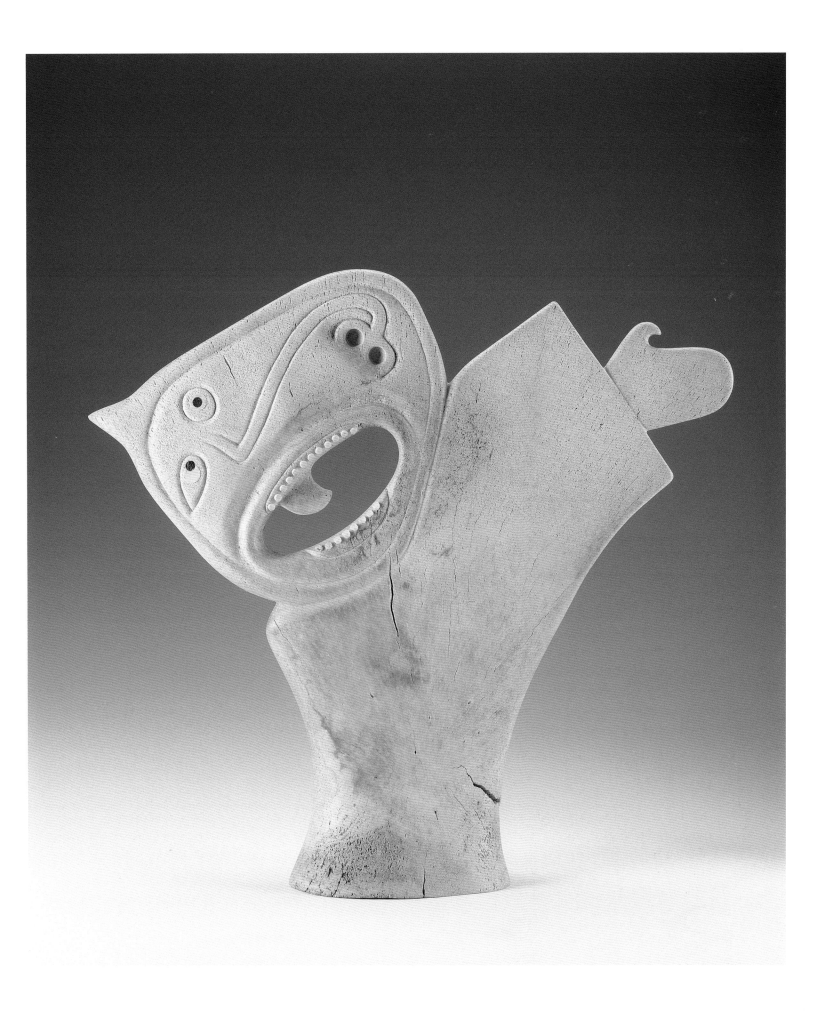

Pudlo Pudlat

Canadian, 1916–1992

Ship of Loons

1982–1983
Coloured pencil and black felt pen on wove paper, 56.6 × 76.6 cm
Purchased 1993

Birds, water, canoe – the elements of Pudlo Pudlat's *Ship of Loons* are familiar enough; one would expect to find them in an Arctic landscape. Here, though, the unexpected has happened. Instead of bobbing on the waves in their customary, solitary manner, these loons – a handsomely decorated trio – have become passengers and travelling companions aboard the boat.

Trading the tools of an Inuit hunter for pencil and paper, Pudlo began his artistic career in earnest around 1960, when he started making drawings for Cape Dorset's burgeoning printmaking studio. In an era of accelerated change, with Inuit moving into settlements, and airplanes and televisions becoming commonplace in the Arctic, Pudlo turned drawing into a means of "thinking on paper," displaying an indefatigable curiosity about everything that he ever experienced. A fascination with local wildlife, traditional everyday objects, and modern technological marvels, combined with a profound awareness of the freedom and contradictions arising from the act of drawing itself, provided the content of his acutely observed and brilliantly extrapolated images. At his death in 1992, Pudlo left behind an oeuvre of over four thousand drawings and two hundred prints, many of which daringly brought the modern-day world into the realm of Inuit art.

Ship of Loons was produced at a period in Pudlo's career – around 1982 to 1984 – when he was preoccupied with transforming large-scale figures of animals and birds into bold compositional motifs. Earlier, in the 1960s, Pudlo had worked mainly with individual figures isolated in the centre of the sheet. In the 1970s, however, new experiences with acrylic paint and lithography seem to have prompted him to move towards a use of the entire page, including the edges, as a means of structuring an image. In his *Blue Musk Ox* of 1978–1979, for example, the animal's snout is cropped as if it were literally walking off the paper and out of sight. In *Ship of Loons*, Pudlo has solved the problem of representing motion by animating the composition with a simple yet highly effective shift in the placement of the subject. The tilting of the canoe not only conveys the impression that it is riding up the side of a wave, but also gives the drawing an energetic diagonal thrust. With its snapshot-like framing, confident lines, and stylized decoration of both canoe and birds, *Ship of Loons* blends "thoughts" on how to compose and execute a drawing with the artist's ongoing exploration of transportation. As the work so clearly shows, surprising juxtapositions and gentle humour are defining qualities of Pudlo's art.

M.R.

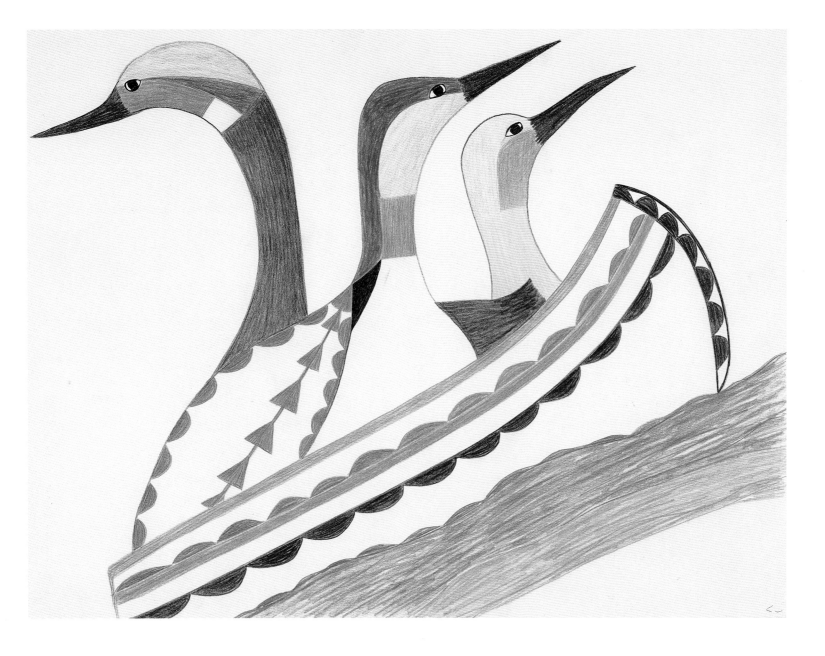

Kiawak Ashoona

Canadian, born 1933

Bird Creature

1990
Light-green stone (serpentine), 49 × 45 × 22 cm
Purchased 1991

Kiawak Ashoona dates his first sculpture to about 1947. While living at a hunting camp on southwestern Baffin Island, he incised and decorated a walrus tusk, which his elder brother, Qaqaq, later took to the Baffin Trading Company to exchange for supplies. Kiawak explained in a 1979 interview: "I started carving by myself. I had a talent for it … I was one of the first to carve." Soon after, in the early 1950s, he found a creative outlet in the activities of the art programs launched in Cape Dorset. In 1953 his work was included in the "coronation exhibition" *Eskimo Carvings*, held at Gimpel Fils in London, England. By the 1960s, when Kiawak settled permanently in Cape Dorset, carving in stone had clearly become a central part of his life and livelihood. Over the years, he has come to be recognized as one of the leading members of the now-famous West Baffin Eskimo Co-operative. His 1962 *Howling Spirit (Tornaq) and Young* was featured on the cover of the catalogue for *Sculpture/Inuit*, the landmark exhibition that brought Inuit sculpture to international attention in the early 1970s. More recently, Kiawak was awarded the 1999 Molson Prize by the Canada Council for the Arts, in recognition of his outstanding lifetime contribution to the nation.

Kiawak's sculpture most often focuses on images of people engaged in the domestic and hunting activities that commonly occupied the Inuit before the transition to the modern settlement. Two fine examples can be found in the collections of the Canadian Museum of Civilization and the West Baffin Eskimo Co-operative: the small 1960 *Woman's Head*, noteworthy in particular for its beautifully executed braided hair, and the 1978 *Woman Holding Fish*, where a change in the colour of the stone is deftly exploited to articulate differences between the woman's skin and her caribou hide parka. These works also reveal Kiawak's concern for psychological nuance. As he himself once observed, it is the expressiveness of the subject's face that determines the success of a sculpture.

A powerful, brooding presence, *Bird Creature* is one of Kiawak's most ambitious works, perhaps his finest. Here, the artist's concern with the delineation of personality is combined with his interest in the spirit world. Inuit stories tell of a time when there was no separation between the human, animal, and spiritual realms: not only could the inhabitants of these worlds communicate with one another – transformations of bodily form were also possible. In the early 1960s, fantastic creatures – some legendary, some newly imagined – became an important subject for many Cape Dorset sculptors, including Kiawak. The extraordinary nature of his strange beasts is accentuated by his precise and elegant rendering of their physical details. The National Gallery's *Bird Creature*, made nearly thirty years after the *Howling Spirit* mentioned above, affirms both the continuing power of the subject and the artist's remarkable ability to find new ways of manipulating the beautiful green serpentine stone he uses, of truly making it come alive. With its jutting knees and elbows, beady-eyed stare, and spiny back, *Bird Creature* bristles with authority, as if defying the viewer to enter its space. Whatever it represents – transformed human or bird of prey – this sculpture is a masterful study in psychological expressiveness.

M.R.

Photographs

David Octavius Hill and Robert Adamson

British, 1802–1870 / 1821–1848

The Reverend Dr. Abraham Capadose (1795–1874), Physician and Calvinist Writer of The Hague

c. 1843–1847

Salted paper print, 20.3 × 15.6 cm

Purchased 1977

When the Scottish landscape painter David Octavius Hill announced that he was planning to produce a painting commemorating the founding of the Free Church of Scotland, he was advised by Sir David Brewster, a physicist and the principal of Edinburgh University, to engage a young man by the name of Robert Adamson to assist him. Together, with the aid of the newly invented art of photography, they would undertake the onerous task of representing each of the 474 delegates who were to be included in the final painting. It is believed that Adamson provided the technical support, stood behind the camera, and actually printed the photographs, while Hill arranged the poses and the overall composition of the images. The collaboration between Hill and Adamson resulted in a body of photographs that set the standard for nineteenth-century photographic portraiture and provided a unique record of some of the famous and influential people of their day.

The subject of this photographic portrait by Hill and Adamson is the Reverend Dr. Abraham Capadose (1795–1874), a physician and Calvinist writer from the Hague. Capadose had been one of the delegates to the historically important Disruption meeting, held on 18 May 1843, that resulted in the formulation of the Deed of Demission and the founding of the Free Church of Scotland. Born into a Sephardic Jewish family and baptized at the age of twenty-seven, Capadose was a central figure in the nineteenth-century "Jewish Awakening" movement in the Netherlands and actively promoted outreach efforts and prayer services for the "salvation" of Jews. He helped found the "Friends of Israel in the Hague" in 1846 and the "Netherland Society for Israel" in 1861.

In this portrait, Capadose is shown with a Bible, an allusion to his prominence within the church hierarchy and his status as a devout thinker and writer. Depicted in three-quarter-length profile, he clasps the spine of the large book with both hands. Because of the constraints of the calotype process used by the photographer, the print was made outdoors; the strong sunlight causes the sitter's forehead and hands to stand out dramatically from the swag of dark brocade in the background and pulls the eye to the brilliant white of his high-collared shirt. Capadose stares intently at something outside the frame of the image, and his expression is serious – seeming to suggest the solemnity and nobility of his reasons for being in Scotland. At least one other portrait of Capadose was made during this sitting, and it shows him in a slightly more relaxed pose, with his left hand resting on his thigh. The bold shadows and the simple, straightforward composition of Hill and Adamson's photographs link their work to the long tradition of British portraiture in the manner of Sir Henry Raeburn and Sir Joshua Reynolds.

L.P.

William Henry Fox Talbot

British, 1800–1877

A Fruit Piece

before June 1845
Salted paper print, 18.4 × 22.4 cm
Purchased 1994

As the inventor of the negative-positive process – the basic principle of photography, according to which a "negative" image is used to produce a "positive" print – William Henry Fox Talbot holds a crucial place in the history of photography. He was a man of many interests, including physics, mathematics, botany, and Assyriology. Between 1844 and 1846 he published (in instalments) *The Pencil of Nature*, the world's first book to illustrate the potential of the new medium of photography, and this picture, *A Fruit Piece*, was included as the final illustration. In the text accompanying the image, Talbot makes no reference to the still-life itself but discusses rather the number of photographic prints that can be made from one negative and the way in which a negative should be washed.

The rich, velvety brown tonality of this print is only rarely seen in salted prints of this period, and it superbly demonstrates Talbot's mastery of the chemical and technical aspects of the crafting of salted paper prints from his new invention of paper negatives. These paper negatives, which Talbot referred to as "calotypes," could be used to make multiple prints and were therefore well suited to the production of illustrated books.

Two baskets – one porcelain and one wicker – overflow with fruits, among them a pineapple, apples, and what appear to be pomegranates and peaches. In painting, the fruit basket is traditionally the attribute of Pomona, the Roman goddess of fruits and fruit trees. The inclusion of the pineapple – something of a status symbol in the nineteenth century, often serving as an exotic gift with which to impress people – is no doubt a reflection of Talbot's fascination with botany, and it has actually been suggested that this example may have been grown in the photographer's own greenhouse.

The Scottish tartan that covers the table beneath the still-life in *A Fruit Piece* appears again in another photograph made by Talbot, titled *Flowers on a Check Table Cloth*, and is most likely an allusion to the photographer's interest in all things Scottish. Talbot's careful alignment of the white stripe of the tartan's pattern along the right edge of the table separates the dark areas of the tablecloth from the dark recesses of the background and gives the photograph depth. This attention to the aesthetic properties of the photograph indicates that Talbot's intentions in using the medium were as much artistic as scientific.

L.P.

Hermann Carl Eduard Biewend

German, 1814–1888

Helene at My Father's Farm in Rothehütte
(Outside the Administrator's Quarters)

September 1849
Daguerreotype, 16.6 × 11 cm (half-plate)
Gift of Phyllis Lambert, Montreal, 1988

Characterized by its ability to capture minute detail in sharp definition, and to produce delicate tones upon a mirror-like surface, the daguerreotype process marked the dawn of a new era in the history of image making. For the first time, a technique existed that could, with the aid of chemistry and optical technology, leave a permanent and accurate impression of the visible world upon a two-dimensional surface. Invented by the French painter Louis-Jacques-Mandé Daguerre and presented free to the world in 1839, the daguerreotype became the first commercially viable photographic process.

Trained as a chemist, Hermann Biewend was one of the few German daguerreotypists to make landscapes and architectural views as well as portraits. Here, only nine years after the first daguerreotype was made in Germany, he has employed the new process to create a full-length portrait of his wife – one of a number of daguerreotypes he made of his family. Intimate, informal, and tender, these images contrast sharply with the more common portraits made by commercial daguerreotypists of the day, where the poses struck by the sitters are formal, the surrounding décor comprised predominantly of stock-in-trade props, and the sitter's reserved expression an indication of the distant relationship with the photographer.

Helene at My Father's Farm in Rothehütte admits the viewer into a private exchange between two people whose lives are closely linked. Leaning against the wall of her in-laws' farmhouse, her arms folded in a slightly defensive attitude, and holding a cloth in her left hand, Helene gives the impression that she has had to interrupt a task in order to accommodate her husband's wish to take her photograph. Her expression, nearly as enigmatic as that of the Mona Lisa, is a combination of impatience, affection, and shyness. It suggests that even though it would have taken only from one to four seconds to make a daguerreotype in full sunshine, her husband may have had to coax her to act as his model.

Records show that Helene, who was born Feodore Meyer, converted from Judaism to Christianity, probably at the time of her marriage to Biewend. Perhaps the fierce intensity with which Biewend turned to the camera to record his joy in his family reflected a love that had prevailed in spite of social constraints. As a scientist, he undoubtedly saw the professional potential to which photography could be directed. It is therefore all the more remarkable that he chose instead to use it to express his feelings about his private world. The daguerreotypes he left of his wife and children are remarkable for their ability to communicate the emotional bonds that gave rise to them over one hundred and fifty years ago.

A.T.

Charles Nègre

French, 1820–1880

Chimney Sweeps Walking

September–November 1851
Salted paper print, 15.2 × 19.8 cm
Purchased 1968

Charles Nègre was born in Grasse, in the south of France. He came to photography by way of painting, entering the Paris studio of Paul Delaroche in 1839 and completing his training under Ingres. Awarded a gold medal for painting at the Salon of 1851, he began taking photographs in earnest that same year.

Chimney Sweeps Walking was shown in May 1852 at an exhibition held by the Société Héliographique in Paris, where it was seen by the critic Charles Bauchal. Writing in *La Lumière*, he described the work as "a pearl." "Nothing," he remarked, "could be more ravishing than this little sketch, which brings to mind Rembrandt's drawings." Bauchal was clearly moved by the way in which the photograph monumentalizes an ordinary moment in everyday life, blending a poetic, painterly quality with photographic realism. But the blurry, informal, snapshot-like appearance of the image belies its meticulous creation. With his training as a painter, Nègre was quick to understand that although the medium of photography could readily and accurately capture the plethora of detail in any given scene, artistic judgment regarding subject, viewpoint, and pictorial effect was essential if the photograph was to succeed as a work of art.

Nègre photographed these young chimney sweeps at dawn, on the Quai de Bourbon in front of his apartment building. In a series of at least four images, he captured them in various positions – sitting, standing, and walking – possibly with the purpose of making a painting later. According to James Borcoman, Curator Emeritus of the National Gallery's collection of photographs and a Charles Nègre scholar, Nègre worked hardest on this particular image, suggesting that he considered it the most successful of the series.

Made the year after the 1850 Salon, where Gustave Courbet had exhibited his monumental realist works *The Stone Breakers* and *Burial at Ornans*, Nègre's *Chimney Sweeps Walking* is not only a superb example of the application of artistic judgment but also an expression of a contemporary interest in scenes drawn from everyday life. In contrast to Courbet's paintings, however, which paid homage to the existence of rural peasants, Nègre's photographs of chimney sweeps, organ-grinders, and market vendors captured scenes from the contemporary urban world, anticipating what we call today "street photography." Although Nègre was not the first to photograph scenes of the everyday, he explored the genre more fully than any other photographer working at the time. By using a combination of lenses to arrest movement, he was able to imbue his pictures with a sense of immediacy, conveying what one contemporary critic described as an impression of "life itself."

A.T.

Eugène Atget

French, 1857–1927

Boulevard de Strasbourg, 10th Arrondissement, Paris

1912
Gelatin silver print, 22.5 × 17.7 cm
Purchased 1980

It may be said that Eugène Atget's decision to become a photographer arose out of his failure to sustain a career in the theatre, for it was due to his limited success as an actor and his forced retirement from the stage that, around 1890, he turned to photography for a living. As the advertisement he placed in the February 1892 issue of *La Revue des Beaux-Arts* makes clear, his plan was to produce photographs for use by artists, and the sign on his door on Rue Campagne-Première actually read "Documents pour artistes." His principal clients nevertheless included a number of France's major institutions. In 1899, for example, the Bibliothèque Nationale purchased about a hundred photographs of Old Paris for the very reasonable sum of one franc twenty-five centimes each – the price of a meal in a modest restaurant.

Atget's range of subject matter was extraordinarily wide, and his work as a whole constitutes a veritable catalogue of urban life. He photographed back lanes, gardens and squares, boulevards, signs, facades, doors, kiosks, fountains, public sculptures, urban "furniture" of various kinds, and architectural details. His repertoire also included small-time tradespeople, such as flower and basket sellers, café waiters, street musicians, porters, and prostitutes. His city was a theatre full of unpretentious actors playing secondary roles – not the exciting, modern city that was the Paris of Baudelaire. Atget had little in common with Constantin Guys, the poet's "painter of modern life." His approach was essentially nostalgic, for his goal was to record for posterity the minor street professions, whose very existence was threatened by industrialization, and the buildings dating back to the Ancien Régime that had managed to survive Baron Haussmann's enormous public works program. What Atget captured on film was the disappearance of pre-modern Paris. His images themselves, however, are resolutely modern and had a profound influence on twentieth-century art, from Surrealism on. Atget's work is more than simply a record of the surviving traces of an obsolete world: it is a meditation on the representation of time. *Boulevard de Strasbourg, 10th Arrondissement, Paris* illustrates this perfectly. The immobility of the mannequins, and the corsets, which the 1920s would relegate to history, serve as metaphors of a bygone age. In contrast, another article of female underwear, the slip hanging near the store entrance, embodies the present moment. The blurred effect of the garment suggests a kind of resistance to the fixedness of the photograph – a happy accident that foreshadows Man Ray's famous *Explosante-fixe*, one of the iconic images of the Surrealist movement.

V.L.

Gustave Le Gray

French, 1820–1882

Wave – Sète

1857
Albumen silver print, 34.2 × 41.4 cm
Purchased 1967

The wave photographed by Gustave Le Gray, although quite modest in comparison to some of the magnificent examples painted by the Romantics a few decades earlier, is nevertheless remarkable on several counts. Its realism, the way the camera has interrupted its progress, and the clarity and whiteness of its crest all combine to make it something of a feat. Quite apart from any associations with the painting tradition, and particularly with the seascape genre, what we are witnessing here is actually the birth of the snapshot.

At the time, the capturing of the movement of a wave photographically was proof of both technical virtuosity and artistic daring. In 1857, Marc Antoine Gaudin, critic for the weekly newspaper *La Lumière*, praised the ingenuity of Le Gray's process and described his work as "the event of the year." The details of the incoming tide, the clarity of the rocks upon which the previous wave has just broken, and the dark mass formed by the jetty all bear Le Gray's unmistakable stamp. The sky, with the almost infinitely modulated tones of its clouds, adds a wide spectrum of shades to the image. Yet the photographic plates of the period were not sufficiently sensitive to simultaneously record waves in motion and the full tonal range of a cloudy sky. Le Gray met the challenge of uniting the beauties of heaven and ocean in the same image by joining two negatives, one of the sky and the other of the sea, which he combined to create the illusion of a perfectly homogenous whole. The horizon-line marks the place where the two original images meet. *Wave – Sète* is thus a montage of disparate elements that were in fact interchangeable, as witness a series of works executed between 1856 and 1859 where the same sky appears in a number of different views.

Le Gray's trick proved that documentary truth is far from absolute – an important enough demonstration in light of the refusal by his contemporaries to accord photography any higher status than (in Baudelaire's famous words) that of very humble servant of the sciences and arts. Furthermore, as a comment on the photographic aesthetic itself, Le Gray was asserting the principle that technique, especially when it is innovative, is as much an expression of the poetic imagination as of the scientific mind.

<div align="right">V.L.</div>

Man Ray

American, 1890–1976

Rayograph

1922
Gelatin silver print, 23.9 × 17.8 cm
Purchased 1982

Serendipity has always played as important a role in art as in other areas of human investigation and creativity, but to Man Ray and his fellow Dadaists and Surrealists it was almost a credo. Man Ray's entire oeuvre is a chronicle of his search for new ways to make art, both technically and conceptually. He claimed to have produced his first photograms, or "Rayographs," in his Paris darkroom purely by accident. Finding an unexposed sheet of paper in the developing tray, he placed on top of it several darkroom objects: a thermometer, a glass funnel, and a beaker. He then turned on the overhead light, and "before [his] eyes an image began to form" – he had created his first cameraless photograph. Man Ray's account of this chance discovery is in fact slightly disingenuous: as a child he had made images with the simpler technique of placing fern leaves on printing-out paper and exposing them to sunlight, and he was familiar with another early photographic technique, the cliché-verre, where an image is scratched onto a glass plate negative and then printed on emulsion paper.

Man Ray was enamoured of photography. Overcoming his initial hesitancy, he began using a camera in 1915, in order to document his paintings for an exhibition. His newly acquired skill soon enabled him to earn a living through fashion and portrait photography, and at the same time it broadened his range of creativity. "I have freed myself from the sticky medium of paint," he wrote, "and am working directly with light." In cameraless photography, he saw a way to realize his goal of making automatic images. Ironically, however, the Rayograph technique led him into a period of very intense creative work in which the hand and mind of the maker are altogether evident. Man Ray's darkroom became a sort of cave where he created dream images out of moving shadows and bursts of light, with objects of differing degrees of opacity and translucency.

Included among the various sorts of objects that Man Ray tried using in his "paintings with light" were crystals and prisms. In this *Rayograph*, the prisms, with their sharp-edged geometric forms and brilliant luminosity, are set off against the soft-edged organic-looking shapes in the upper part of the composition. The tight bundles of hair – or are they dustballs? – appear to float in the space, their highlights giving them an airy, mobile, almost playful presence. As one writer has observed, the Rayographs show a "total lack of gravity."

This image is closely related to a less complex one included in *Les champs délicieux*, Man Ray's portfolio of Rayographs published in 1922. The same prisms and hair-like substances appear, suggesting that the two were made on the same occasion. In its abstract exploration of the movement of light and the translucency and three-dimensionality of a variety of objects, the work is typical of the Rayographs created in 1921 and 1922.

A.T.

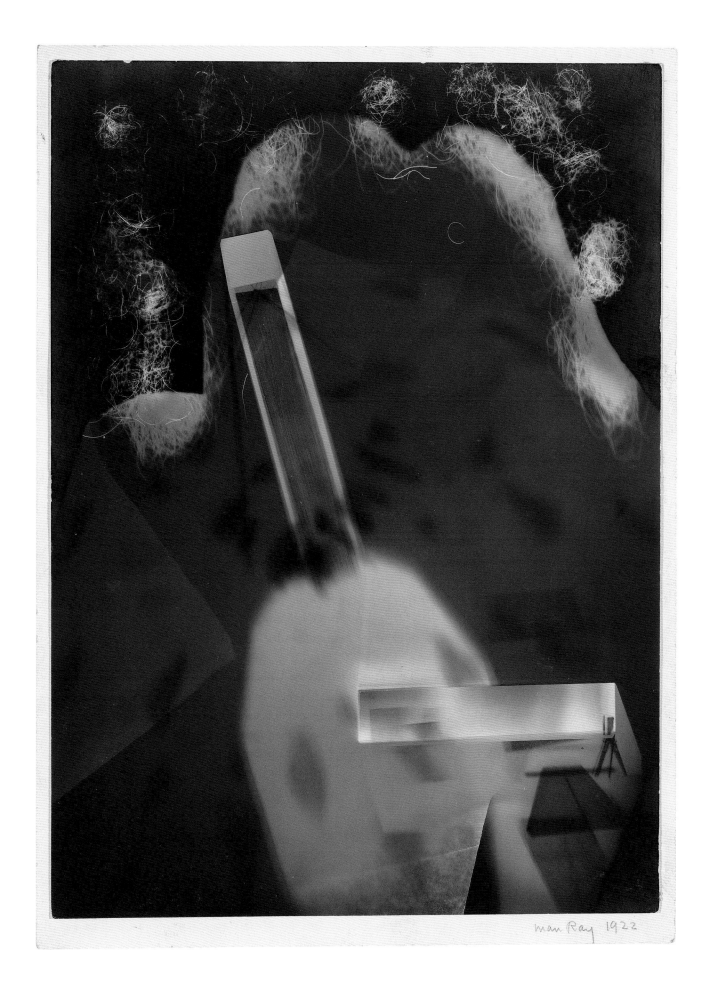

man Ray 1922

Edward Steichen

American, 1879–1973

Sunburn, New York

1925
Gelatin silver print, toned, 25 × 20 cm
Purchased 1999

Sunburn, New York stands out from the generally more conventional portraits of socialites and celebrities that Edward Steichen was making in the 1920s. This closely cropped study of the face of a young woman staring unflinchingly into the camera lens conveys a rare emotional intensity. Many years after it was made, in the early 1960s, Steichen observed that "a portrait must get beyond the almost universal self-consciousness people have before the camera…. The essential thing [is] to awaken a genuine response."

Here, the woman's head appears in the centre of the picture space as a disembodied element, elegantly balanced, like a Brancusi sculpture. The dark hair and sombre background frame the oval of the face, accentuating its finely formed features. The sitter who posed for *Sunburn, New York* is unidentified, but she is believed to have been either an assistant of Steichen's or a visitor to his studio.

Steichen's motive in making this photograph may simply have been his fascination with the subject's dark tan – such, at least, was the claim advanced by his widow, Joanna Steichen. However, in the mid-1920s Steichen was occupied principally with making commercial portraits for the readers of *Vogue* and *Vanity Fair*, in a much more impersonal style, and so his creation of this dramatically composed portrait, with its intense and seemingly intimate overtones, remains intriguing.

From the very accomplished pictorialist photography he produced in the first decade of the twentieth century, which included experimentation with colour photographs using the Autochrome process, Steichen turned in the 1920s to "straight" photography and to making fashion photographs. His use of photography for commercial ends created a rift between him and Alfred Stieglitz, the doyen of early twentieth-century American photography. Nevertheless Steichen continued to be unstinting in his praise of the many portraits Stieglitz made of his wife Georgia O'Keeffe over a twenty-seven-year period, beginning in 1917. The relationship between *Sunburn, New York* and this extraordinary Stieglitz series is striking, and an indication perhaps that Steichen had taken Stieglitz's criticisms to heart.

Born in Luxembourg, Steichen emigrated with his family to the United States in 1881. He began to make photographs in 1895 while studying under Richard Lorenz and Robert Schode at the Milwaukee Art Students League. From 1947 to 1962, Steichen was curator of photographs and director of the department of photography at the Museum of Modern Art in New York. As both a photographer and a curator, he exercised enormous influence over the direction taken by photography in the first half of the twentieth century.

A.T.

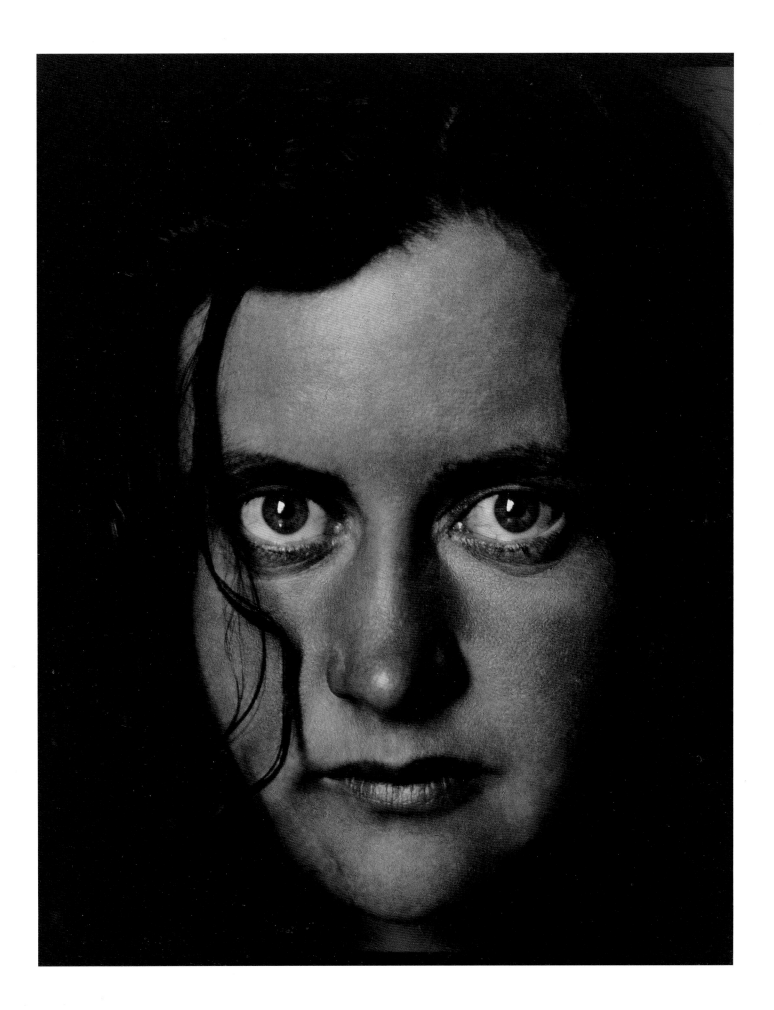

Edward Weston

American, 1886–1958

Christel, Glendale

1927
Gelatin silver print, 24 × 18.5 cm
Purchased from the Phyllis Lambert Fund, 1979

Edward Weston's great passion for life, combined with his disciplined approach to the craft of photography, resulted in the creation of some of the most famous images of the twentieth century. His belief in the interconnectedness of life and art, his strong feelings about photography as an artistic medium, and his consummate technical and printmaking skills are but a part of his legacy. Weston's photographs are now generally considered to be among the finest examples of the modernist aesthetic.

Christel Gang, the model in this photograph, was born in Kiel, Germany, in 1892. She arrived in San Francisco with her mother in 1906. After her mother's sudden death the following year, she went to live with another German family. She eventually settled in Los Angeles, learned to work as a stenographer, and started her own secretarial company. Gang first met Weston in the summer of 1925 at the Japanese Club in Los Angeles, where she had gone to see an exhibition of his photographs. Already an ardent admirer of his work, Gang asked Weston if he would photograph her. The two soon became lovers, and were to remain lifelong friends. For a time, Weston hired her to take dictation and transcribe his daybooks. A lively and intelligent woman, Gang moved in circles that included many of Weston's own friends, among them the filmmaker Sergei Eisenstein, the critic and poet Sadakichi Hartmann, the dancer and writer Ramiel McGehee, and the Japanese-American photographer Tazio Kato. She read widely and was constantly interested in new developments in literature, painting, cinema, and photography. In her letters to Weston she often referred to an "inner nearness" or "spiritual communion" that linked their souls. Weston acknowledged this spiritual connection, and expressed gratitude to her for having introduced him to "vistas of the metaphysical."

Gang modelled for Weston on several occasions between 1925 and 1929. Two photographs of her back that he made in 1927 were especially prized by Weston himself. While working on them, he wrote in one of his daybooks: "A start has been made. C. has a body of exaggerated proportions. To overstate her curves became my preoccupation. The ground glass registered sweeping volumes which I shall yet record more surely." The strangely elongated back seen in this photograph indicates something of those "exaggerated proportions." The torso is almost rectangular in form. By instructing Gang to drop her head forward, and then by tightly cropping the image, Weston was able to concentrate on the back alone. It was his belief that each part of the body could be photographed in such a way as to reveal its "quintessence." Unlike the romantic and often sentimental nude studies made by Pictorialist photographers around the same time, this stark and radically modern image is an excellent example of how Weston strove to transform objects and even the human body through the use of unconventional vantage points and sharp focus. In Weston's hands, light was a tool that could carve forms in space while at the same time revealing their sensual and tactile qualities. In photographs such as this portrait of Christel Gang, with its strong sense of presence, he altered our way of looking at the world.

L.P.

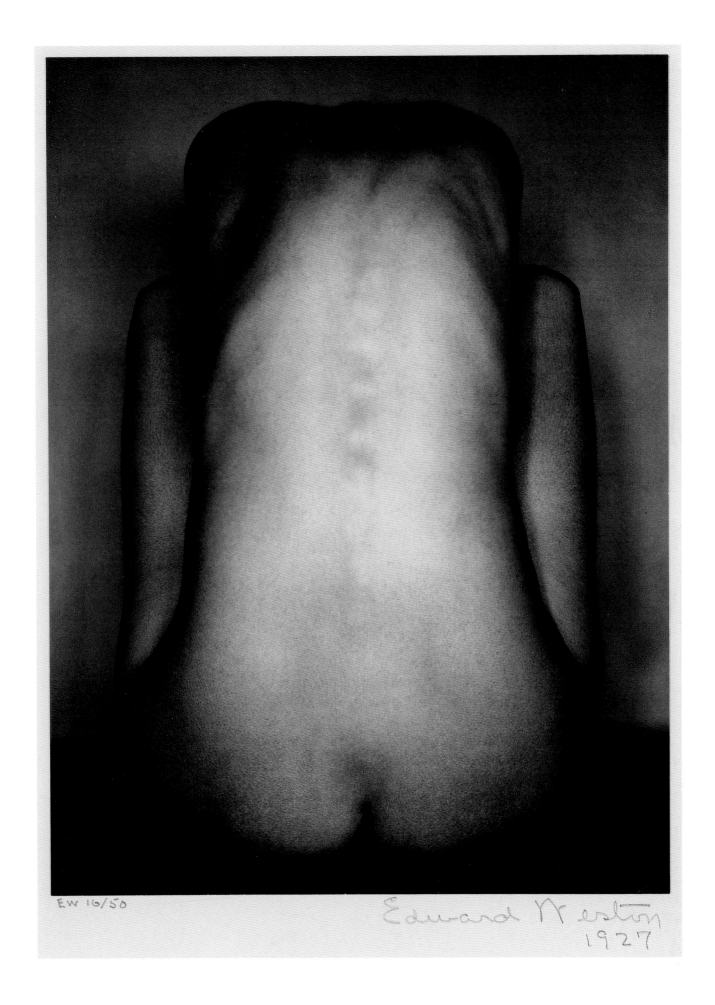

EW 16/50

Edward Weston
1927

Walker Evans
American, 1903–1975

Manhattan

c. 1928–1929
Gelatin silver print, 8.6 × 12.4 cm
Purchased 1990

"Stare," Walker Evans once said. "It is the way to educate your eye. Stare, pry, listen, eavesdrop. Die knowing something." Evans brought to photography a penetrating, complex, and subtle visual intelligence. He left behind a powerful body of photographs that range from precisely seen abstractions like *Manhattan*, through stirring portraits of sharecropper families and subway passengers, to images of vernacular architecture and objects. *Manhattan* may at first be startling, for it seems radically different from the more familiar documentary works by which this artist has come to be known. It represents a three-year period in the late 1920s and early 1930s when Evans was introducing strongly angled views and abstraction into his images, experimenting with an approach to seeing and recording the world that was more European modernist than American.

In *Manhattan*, Evans has taken an ordinary urban view of elevated railroad tracks and iron girders seen against a background of pavement and transformed it into a complex and dynamic lattice of lines and textures. He has achieved this by holding his camera in a strongly angled position and rejecting the traditional perspective of the viewer who stands upright before a lateral horizon. Photographing this elaborate interplay of lines and surfaces under an even light, Evans has also captured the important details of rivets and sprockets that punctuate the diagonal beams and attach the rods to the vertical bars on the right-hand side. The repetition of these circular forms sets up a rhythm within an otherwise planar and static arrangement.

Although Evans would soon reject the more formalist vision of European modernist photography, seeing it as a distortion of the world rather than a clarification of it, he always remained sensitive to how the slightest shift in a photographer's viewpoint alters the sense and structure of the image. He is best known for his photographs of vernacular American architecture and for the images of rural poverty that he produced in the 1930s for the Farm Security Administration, and his work is generally associated with the documenting of urban and small town America.

Manhattan is therefore an unusual work for Evans, undoubtedly inspired by his 1926–1927 stay in Europe, an experience that was reinforced by his acquaintance with two young Germans, the painter Hanns Skolle and the architect Paul Grotz. Grotz, an advocate of the new unadorned modernist style in architecture, apparently lent Evans his Leica camera, and he later recalled that Evans was attracted to the cultural life of Berlin, in particular German film and architecture. The sharply angled perspective and the emphasis on dynamic geometrical shapes that we see in *Manhattan* are certainly reminiscent of the experiments made by German photographers, particularly those associated with the Bauhaus.

We cherish this photograph not only because it is a rare example of Evans working in the style that has come to be labelled the "New Vision," but also because it encourages us to look with renewed interest at the simple objects that make up our everyday environment. A daring, lucid, and intelligent example of Evans exploring the limits of his vision, it occupies a special place in the National Gallery's collection of almost four hundred of his works.

A.T.

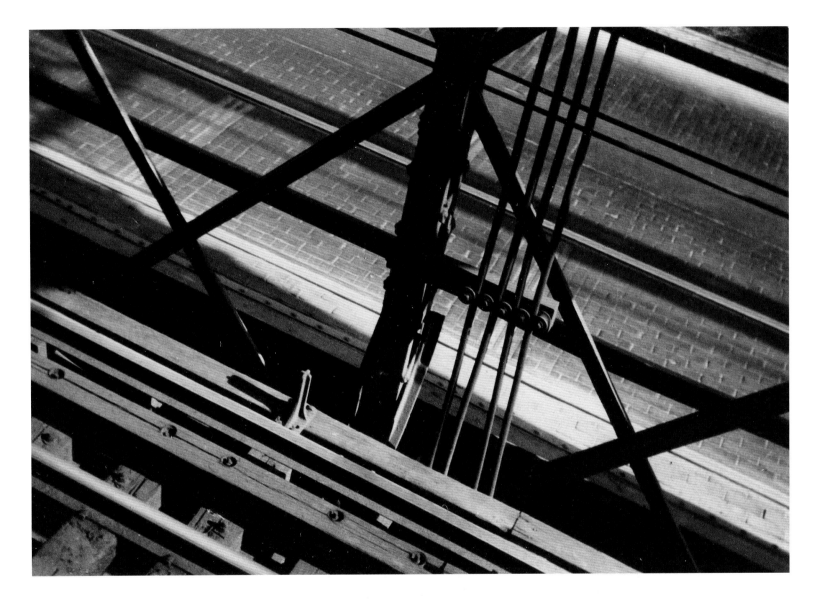

August Sander

German, 1876–1964

Bricklayer's Mate, Cologne

1929, printed posthumously before 1971
Gelatin silver print, 30.4 × 24 cm
Purchased 1977

August Sander produced thousands of portraits of his contemporaries. His ambitious goal was to put together a record of his era by photographing German people of all professions, trades, classes, and social milieus, thereby creating an immense visual encyclopedia, or rather a huge family album of the entire nation. To Sander, a person's portrait was really a reflection of the group, community, or occupation to which he or she belonged. It was not the identity of the individual that fascinated him so much as that of the group.

By 1910, when Sander opened a studio in Cologne, he had adopted an approach unhampered by the legacy of painting and the fine arts tradition. His publicity stated clearly that his intention was to make "simple, natural portraits, showing the subjects in a setting that reflects their personality." By photographing people in their own surroundings – their home or workplace – rather than in the conventional space of the studio, Sander was trying to capture their social affiliation, their culture, their values. He actually asked his mostly anonymous models to act the part of their own life, to project an image that corresponded to the way they saw themselves. Out of this technique, which Sander called "self-projection," was born a strange alliance between the aspirations of model and photographer. Here, for example, while the facial expression and determined pose of the bricklayer's mate express a sense of basic pride in manual labour, his attitude also evokes the mythology, culture, and ideology of the revolutionary worker, something Sander was particularly interested in. Moreover, the artist has deliberately enhanced the figure's heroic character by retouching the photograph so that he appears to be emerging from darkness – a rarity, for Sander did not normally sanction this kind of manipulation.

In this work, then, as well as making a portrait of the young man Sander was also striving to represent the universal worker. In fact, the image's remarkable power derives from this fusion of individual and collective identity. The photograph was among the sixty-one portraits comprising the collection titled *Antlitz der Zeit* ("Face of Our Time"), published in 1929. In his preface to it, the novelist Alfred Döblin wrote:

> Are we seeing individuals here? It's strange. We think we are seeing individuals, but suddenly we realize that we are not seeing individuals at all … Something else is going on here – and what is it? The thing we are about to witness is the astonishing way in which society overlays faces and images with the strata of its class and education systems …

V.L.

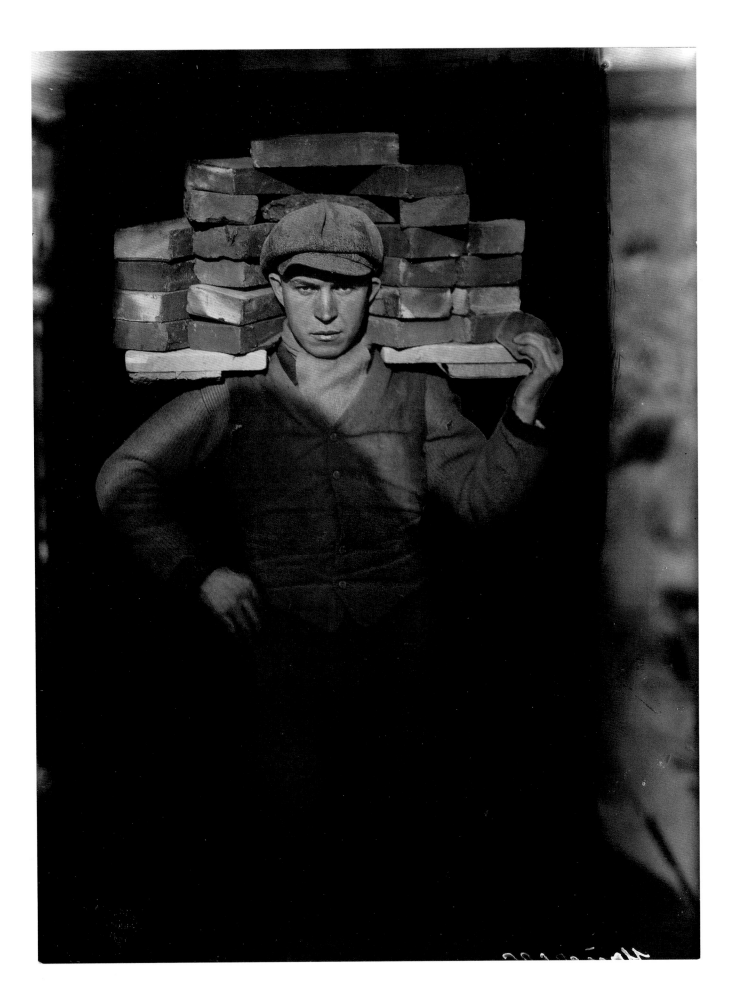

Brassaï

Hungarian/French, 1899–1984

Bijou at the Bar de la Lune, Montmartre, Paris

1932
Gelatin silver print, 50.4 × 39.6 cm
Purchased 1993

The lady in this photograph, a familiar figure in the bohemian Paris of the 1930s, was known to all as "La Môme Bijou." The story was that she had actually been a member of the upper classes and had fallen on hard times. Dressed here in fin-de-siècle style, she is the perfect embodiment of colourful, eccentric Montmartre – then the uncontested domain of artistic modernity, and even now a symbol of Paris's golden days. Brassaï was immediately fascinated by this celebrated lady of the evening, from the moment he first spotted her sitting on a banquette in the Bar de la Lune, smothered in rings, costume jewelry, and fake pearls. In that initial session he took three photographs of her. The former *cocotte* posed enthusiastically for him, parading her finery, flirting, and revelling in her rediscovered glory. In spite of her efforts, however, Brassaï's images mercilessly reveal the poverty to which this demimondaine has been reduced. *Bijou at the Bar de la Lune* shows us a face bloated with alcohol, a glassy stare, clown-like makeup, and ravaged hands. The other two photographs are scarcely more flattering, for beneath the table we catch a glimpse of lumpy legs in torn stockings. It is not hard to see how Bijou would have provided the inspiration for the leading character in one of Jean Giraudoux's best-known plays, *The Madwoman of Chaillot* (1943).

Brassaï had been photographing Paris's nightlife since 1926, recording the seamier side of the ostensibly genteel City of Light. "In those days," he said, "nobody thought of photographing sewer workers and homosexuals, and squalid dives like opium dens, bal-musettes, and brothels, along with the people who frequented them." *Paris la nuit*, a collection of sixty-four of his photographs published in 1932, laid bare this secret world. Most of the images in it picture the city's streets, bridges, squares, and urban "furniture" (the famous street urinals, for example) – the "sets," in fact, that served as the backdrop for all sorts of illicit activities. The photographs with the most criminal subject matter did not come to light until 1984, with the discovery of negatives by Brassaï that had been considered lost for over fifty years. One of the portraits of La Môme Bijou was featured in *Paris la nuit*. The caption that accompanies it aroused the model's indignation, however, for she is described as a character straight out of the most nightmarish pages of Baudelaire.

V.L.

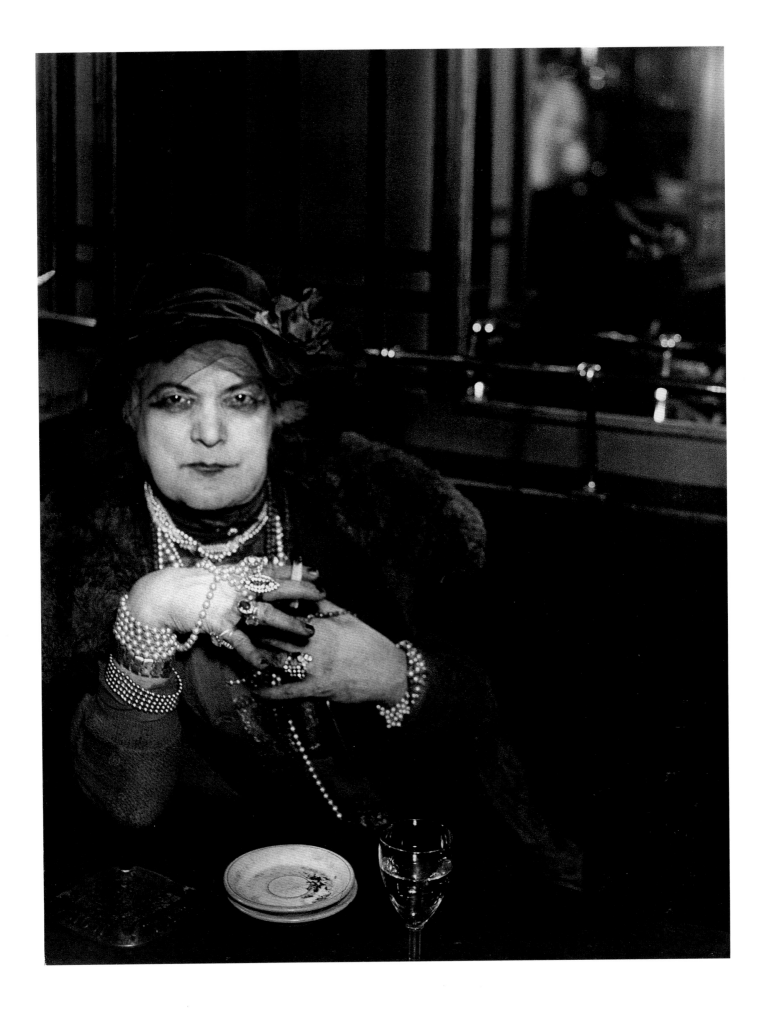

Dorothea Lange

American, 1895–1965

Migrant Mother

March 1936, printed 1950–1959
Gelatin silver print, 33.1 × 26 cm
Purchased 1995

Dorothea Lange's *Migrant Mother* is sometimes referred to as "Migrant Madonna," in part because of its content, but also because the image has been composed with the same exacting and expressive attention to formal construction evident in the work of many Renaissance painters of religious subjects.

As a member of the photographic unit of the Farm Security Administration – one of several American government agencies established to assist farmers during the Great Depression – Lange photographed rural people in twenty-two states between 1935 and 1942. In March 1936 she discovered a recently widowed mother living with her seven children in a pea-picker's camp outside San Francisco. Returning from a photographic assignment in Los Angeles, Lange was drawn to the camp by a crudely lettered sign on the side of the highway. She later recalled her encounter with the woman and her family:

> I saw and approached the hungry and desperate mother, as if drawn by a magnet. I do not remember how I explained my presence or my camera to her, but I do remember she asked me no questions. I made five exposures, working closer and closer from the same direction. I did not ask her name or her history. She told me her age, that she was 32. She said that they had been living on frozen vegetables from the surrounding fields, and birds that the children killed. She had just sold the tires from her car to buy food … The pea crop at Nipomo had frozen and there was no work for anybody. But I did not approach the tents and shelters of other stranded pea-pickers. It was not necessary; I knew I had recorded the essence of my assignment …

It seems clear that Lange's intention was not simply to record what she saw, but to tell a story that might move politicians and citizens to act on behalf of the poor.

Every element in this picture, from the framing of the portrait in the camera's viewfinder to the manipulation of the tones in the print, suggests a series of deeply considered decisions about its composition and realization. The last in a sequence of negatives that Lange made on a cold, wet afternoon, *Migrant Mother* presents the subject and her three youngest daughters – one an infant in arms – as a pyramid of connected bodies. Filling the space, their arms and hands forming a rhythmic tableau of linking gestures, they seem to present, symbolically at least, an indestructible defence against the outside world.

An icon in American art of the Depression era, Lange's *Migrant Mother* makes a very powerful impression, and it has consequently been analyzed at great length, plagiarized and reworked as a symbol for social causes, and adopted as the object of deconstruction in at least one contemporary artwork. A number of photographic historians were curious enough to finally uncover the identity of the woman, Florence Owens Thompson, and to investigate the details of her life. Beyond all this, however, the photograph stands out as an intensely beautiful image, very much of its time and place, and yet, to each new generation that sees it, timelessly universal.

A.T.

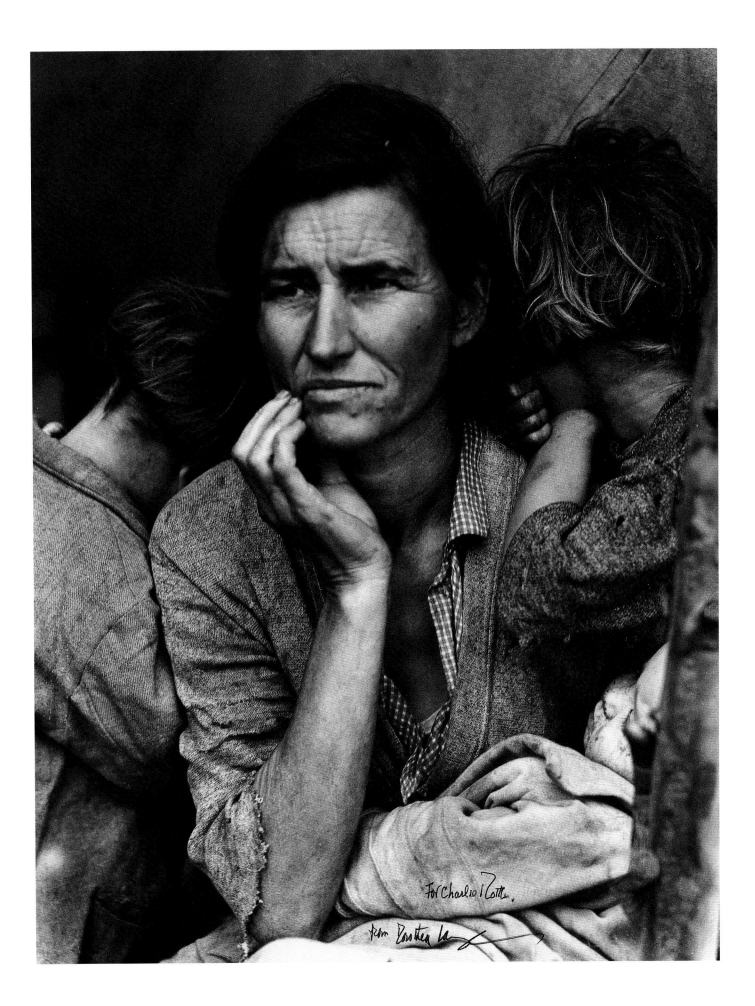

For Charlie Potts.

from Dorothea Lange

Lisette Model

Austrian/American, 1901–1983

Coney Island Bather, New York

c. 1939–July 1941
Gelatin silver print, 34.5 × 27.2 cm
Purchased 1985

Born in Vienna, Lisette Model began her career as a photographer in Paris in the early 1930s. *Coney Island Bather* was made several years after she and her husband, the painter Evsa Model, had emigrated to the United States and settled in New York.

By unabashedly manipulating her negatives and her prints, Model adopted an approach to photography that ran counter to the indiscriminate, fact-collecting aspect of the medium. She not only cropped the negative to exercise maximum control over the composition of the figure within the space, but also practised "burning and dodging," techniques that enabled her to highlight certain areas of the image and to suppress others. She felt no compunction about using other darkroom tricks, such as tilting the printing easel that held the paper in order to accentuate foreshortening and thus emphasize the monumentality and the dramatic potential of her final image.

Coney Island Bather was Model's first assignment for the American fashion magazine *Harper's Bazaar*, part of a commission offered her by Alexey Brodovitch, the legendary Russian emigré editor, designer, and photographer who in the 1930s and '40s shaped the look of *Harper's Bazaar* and *Vogue*. Brodovitch had seen Model's bold, witty photographs of the habitués of Nice's Promenade des Anglais, made in 1934 and 1935, and he wanted her to explore Coney Island with the same unforgiving eye. Appearing in the July 1941 issue, *Coney Island Bather* was accompanied by a caption filled with vaudevillian hyperbole: "Coney Island Today, the Bathing Paradise of Billions ... where Fun is Still on a Gigantic Scale." The constant emphasis in *Harper's Bazaar* on the virtues of looking svelte served to invest *Coney Island Bather* with an added outrageousness.

In this image, Model celebrates the Rubenesque bulk of the bather, planting her plumb in the centre of the space and allowing her generous volume to edge out any extraneous details. This archetypal earth goddess stands by the sea with a defiant voluptuousness, her face radiant, indeed triumphant. With what one senses to be a combination of attraction and repulsion, Model stresses the tactile fleshiness of her subject and the sensual contact of her feet with the mud and ebbing water.

Model's images were not limited to the topical themes and ephemeral life of fashion and news magazines. While working as a photojournalist she was simultaneously being exhibited and collected by museums and building a career as one of the most noted teachers of photography in the United States. It was at the Museum of Modern Art in New York that Model's most celebrated student, the American photographer Diane Arbus, first saw another version of *Coney Island Bather*, in which the model is recumbent. "What a beautiful photograph that is," she wrote to Model in a postcard. Arbus was struck by the extent to which her mentor's vision was shaped by a sense of wonder inspired by the commonplace, something that existed in reality; this she found convincing and moving. For Model, the portrait was not the place for polite evasion; it had to be a recognition of the whole person.

A.T.

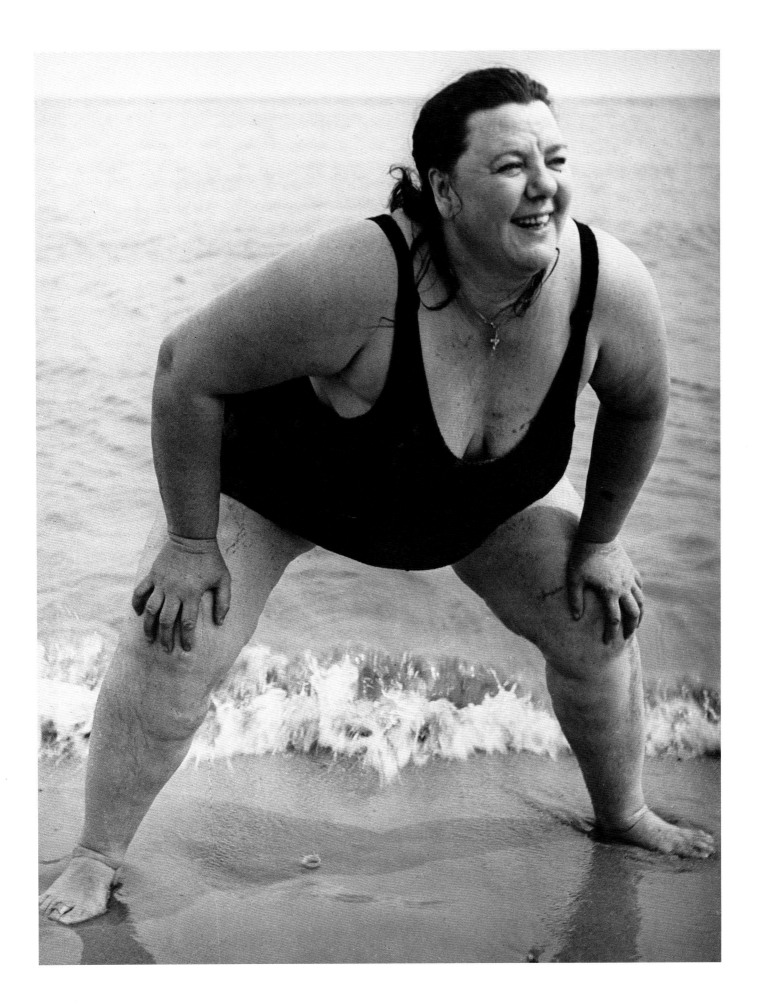

Manuel Álvarez Bravo

Mexican, 1902–2002

The Threshold

1947
Gelatin silver print, 24.4 × 19.4 cm
Purchased 1999

Manuel Álvarez Bravo was the most important modernist photographer in Mexico. He began his career in 1924, the same year that the Surrealist movement was launched in Europe with the publication of André Breton's *Manifeste du surréalisme*. Throughout the following decade, he created his photographs in complete unawareness of the movement that would later adopt his work as emblematic of all it stood for. For Breton, Álvarez Bravo's photographs presented Mexico as "an inexhaustible register of sensations, from the most benign to the most insidious."

Born into a family where painting and photography were familiar activities – his father was an amateur painter and a photographer, while his grandfather had been a professional portrait painter – Álvarez Bravo came to maturity during a time of political and social revolution in his country. Forced to leave school at the age of thirteen because of his family's financial difficulties, he worked as a clerk in the Mexican Treasury Department until 1931. He managed to further his interest in the arts, however, by enrolling in 1918 in music and painting studies at the Academia Nacional de Bellas Artes.

Álvarez Bravo's initiation into photography occurred during the flowering of Mexico's artistic renaissance, and at a time when the medium was undergoing a burst of creative renewal throughout the world. His work, along with that of Tina Modotti, Águstin Jiménez, Emilio Amero, and Lola Álvarez Bravo (his first wife), reflects the new aesthetic concerns that were to shape both iconographical and formalist innovation during the period of Mexican modernism. Deeply influenced by the epic imagery of the muralists José David Alfaro Siqueiros, Diego Rivera, and José Clemente Orozco, and by the paintings of Rufino Tamayo, Álvarez Bravo ultimately aspired to create photographs that would express both his Mexicanness and his modernity. His first works, however, embody a vision that is defined by a unique sense of what is mysterious in the everyday world. Light and darkness are the visual tools he uses to transform the banal by spotlighting or obscuring the most common objects and mundane moments.

The Threshold is a dark, disturbing, and cryptic image that illustrates Álvarez Bravo's preoccupation with the sensual and the earthy. All we see of the woman in this photograph is her lower legs as she stands at the threshold of a room. Her bare feet rest on a paved floor, where large puddles spill into each other. In an eloquent gesture of avoidance, almost in a kind of dance, the woman's toes are curled upward and away from the puddles. While light strikes the topmost puddle with a bright downward band that draws the viewer's eye to the threshold, the successive pools are merely etched in a luminous outline. What are these puddles? Álvarez Bravo relishes the mysteriousness of black and white photography, and the viewer is left to speculate on the meaning of the scene.

A.T.

Canadian Museum
of Contemporary
Photography

Lutz Dille

Canadian, born Germany 1922

Coney Island, New York, U.S.A.

1962
Gelatin silver print, 50.6 × 40.7 cm
Purchased 1966

As a body of work, Lutz Dille's photographs reveal a love of life and of people. Often imbued with humour, they present a visual chronicle of society. Photography was widely popular in Germany prior to the Second World War, and its creative use by Bauhaus artists and vanguard photographers – as well as the picture press, so lavishly illustrated with photojournalism's candid images – must certainly have informed Dille's approach to the medium. Like his father before him, Dille was a passionate amateur photographer, and after the war, during which he had worked as a reconnaissance photographer, he formalized his photographic education at Hamburg's art college.

When Dille emigrated to Toronto in the early 1950s, his interest in photography meshed well with the prevailing artistic trends in his adopted land. His sequential and humanist photographic style attracted the attention of a television producer, who animated a series of photographs Dille had taken in Paris into a short film. He was also hired by the National Film Board as the still photographer for a 1959 film, *The Back-Breaking Leaf.* Numerous other assignments followed, and in 1968 the National Film Board of Canada's Still Photography Division – the predecessor of today's Canadian Museum of Contemporary Photography – recognized Dille's artistic contribution in an exhibition and publication entitled *The Many Worlds of Lutz Dille.* This was the first solo exhibition to be presented in the National Film Board's Photo Gallery, which had opened the previous year. *Coney Island, New York, U.S.A.* was included in the exhibition, along with other photographs Dille had taken during his travels working on commercial and self-assigned projects.

Dille's prime focus has always been people. Unlike the work of the photographer Henri Cartier-Bresson, whose dramatic halting of action defined "decisive moments," Dille's images concentrate on characterizing the people he photographs. His subjects are often portrayed as types, distinguished by their dress, demeanour, vocation, or activity. Like a journalist looking for a story, Dille frequents public places where human drama and interaction are likely to occur – a downtown street, a market, a racetrack – and he has often been rewarded by compelling subject matter. Dille's creative moments emerge over time; he focuses on a subject that offers potential and then records the unfolding situation in a rapid burst of successive shots as the elements of the scene coalesce pictorially. The resulting photographs are lively, animated through composition, gesture or expression, and tonality.

Coney Island was at one time a popular attraction for photographers of the social scene. Lisette Model and Robert Frank both photographed there. In contrast to Frank's more sombre views, Dille's *Coney Island, New York* is characteristically humorous and light-hearted. In its succinctness, it is a kind of caricature. The bather's statuesque form, which is the central focus of Dille's picture, fills the vertical height of the frame, the proportions of his muscular physique measured against the backdrop of surf and sand. Alone, the figure would present a simply comic portrait. But with perceptive wit, Dille has juxtaposed this epitome of manhood with the man-child, vulnerable and forever susceptible to emotion.

M.H.

Pierre Boogaerts

Canadian, born Belgium 1946

"Synthesization" of the Sky
Second Part: Making the shape of the clouds geometrical, No. 3, Montreal

1975
Chromogenic print, 35.7 × 27.7 cm
Purchased 1984

Pierre Boogaerts was born in Brussels in 1946 and studied fine arts at the city's Institut Supérieur Saint-Luc. He moved to Canada in 1971. His highly personal oeuvre, more or less unique in contemporary Canadian art, is fascinating for the depth and consistency of the discourse that is reiterated in each cycle and for its preoccupation with photography as a medium that both arises from and engenders visions of the world.

In 1971, Boogaerts began exploring the power of photography to create analogies of reality – whence the introduction and affirmation of the concept of reference, which became so crucial to the development of his work. In the early pieces, although the kinship with Earth art and Pop art is very clear, photography is still linked to the traditional disciplines of serigraphy and drawing. Like a number of other artists of his generation, Boogaerts was influenced by Warhol's conviction that the personality of the artist should recede into the background and the painter's craft be subordinated to a mechanically detached and slick vision of everyday reality. According to this view, the camera is used simply as a tool to translate literally what it is directed at, and the photographic image becomes a shortcut from nature to its representation.

Rooted in these principles, Boogaerts's purely photographic work began with a series entitled *"Synthesization" of the Sky* (1973–1975). In this succession of variations on the configuration of sky and cloud, Boogaerts demonstrates how photography can transform reality (in this case a natural phenomenon) by structuring and organizing it through framing, sequencing, and colour – techniques that are integral to the medium.

Boogaerts's starting point is very simple: "the use of the 36-frame strip of film in the form of the contact sheet made after the film is developed." His subject is clouds silhouetted against a blue sky. The framing of each shot links it to the next. The gaze is a moving frame that pans across reality in directions determined by the artist in accordance with the limitations of his medium. Photographic framing reproduces this movement and in so doing cuts into reality and extracts a fragment that includes and excludes certain elements, creating an overlap between inside and outside, interior and exterior.

The organization of the frames, which was planned by the artist before the shots were taken, results in a number of geometric forms. The juxtaposed images are presented within a grid, in an order that offers a multidimensional reading. The arrangement of the geometric forms on the contact sheet superimposes a kind of structure on the fluidity of a naturally-occurring phenomenon. What we experience is a picture-within-a-picture effect in which each frame, each fragment, is integral to a whole that, while related to each of its parts, uses the sum of those parts to amplify reality.

P.D.

Evergon

Canadian, born 1946

The Caravaggio

1984
Polaroid print, 244.1 × 113.1 cm
Purchased 1986

The Caravaggio was one of Evergon's first Polaroid prints on a life-size scale, and to achieve it he employed considerable skill. Because a Polaroid print is a direct exposure on paper rather than an enlargement from a negative, the photographer had to use a room-sized camera to create the shot, affording him only a very shallow depth of field within which to compose his real-life collage. The work is noteworthy for another reason: it resolves a number of concerns that have preoccupied the artist throughout his career, in particular the relation of technique to subject matter.

Previous works by Evergon had also involved subjects that appear confined or compressed in the pictorial space. During the 1970s, in a series of colour Xerox prints exploring notions of repressed sexuality, he created collages that combined pictures of friends with images of various animals symbolizing the spirit of each person. To reinforce the idea of entrapment he wrapped the pictures with thread, visually binding each figure in place in the composition. Through the photocopy process, the materials were further compressed onto an entirely planar surface. In subsequent works, Evergon placed his model and related objects on top of a large suspended sheet of plexiglas. Using a Polaroid SX-70 camera, he then made several exposures of the assemblage from underneath, mimicking the viewpoint and lighting of a photocopy machine, and finally pieced the prints together to reflect the whole view. In the interlocked prints that resulted, the figures appeared trapped in an ethereal space, their bodies pressed by gravity against the invisible sheet of plastic.

For *The Caravaggio,* Evergon's use of the large-format Polaroid camera required him to deal with a vertical picture plane rather than the horizontal surface to which he was accustomed. Although the spatial depth appears greater than in the earlier works, the stage for the models and props was little more than half a metre deep. The camera imposed a further compression by limiting the depth of field to a few centimetres. As before, Evergon orchestrated the space using collage, allowing him to play on the contrasts between real and illusory space to create conflicting impressions of expansiveness and restriction. In order to emphasize three-dimensional form Evergon employed high-contrast lighting, creating shadows that indicate successive layers of depth. A photograph of the sky inserted as the backdrop also helps give an illusion of expanded space. In contrast to these devices, which convey a sense of perspective, a sheet of plastic placed between the camera and the figure reinforces the picture plane and provides clues to actual spatial relationships. Smears and spatters of paint on the plastic focus attention on its surface and add an expressionistic accent to the scene. The white painted border around the plexiglas frames and unites the various components of the composition.

The work's title reveals its prime source to be the Italian Baroque painter Caravaggio, whose influence is evident in the richness and sensuality of the colour and in the dramatic lighting. The presentation of a young man holding a platter of fruit pays direct homage to Caravaggio's famous *Boy with a Basket of Fruit.* For Evergon, as for many other homosexual artists working during the 1980s, the Baroque master was an important source of inspiration. Certain aspects of the image are indisputably camp: the artificiality of the props, the leopard-skin loincloth worn by the model, and the unnatural look resulting from the formal construction all combine to accentuate the theatricality of the photograph. The work is exemplary of Evergon's preoccupation with identity and sexuality, but also of his layered imagery, in which the real and the imaginary co-exist.

M.H.

Donigan Cumming

Canadian, born United States 1947

Untitled, June 4, 1985

From the series "Reality and Motive in Documentary Photography: Part 2"
1985
Gelatin silver print, 50.4 × 40.4 cm
Gift of the artist, Montreal, 1986

The launch in 1986 of Donigan Cumming's three-part exhibition *Reality and Motive in Documentary Photography* sent shockwaves through the photographic community. Much of the reaction was hostile: the artist was found guilty of parody, contempt, and abuse of power. The subjects of the 131 photographs – the poor, the young, the old, the handicapped, the marginal, the middle-class – clearly belong to the documentary tradition. And they are all presented in their own everyday surroundings: the living rooms of suburban bungalows, boarding-house rooms, cluttered kitchens, apartments in chaotic disarray.

The unsettling thing about this theatre of excess, where the characters either give full rein to their obsessions or display the scars from the blows life has dealt them, is Cumming's dismantling of the old illusion that photographic representation is transparent and of the myth about the purity of the photographer's intentions. Without any qualms, and with no false modesty, these anti-heroes of an endlessly humdrum world embody and even help stage projections of themselves and their desires, submitting to the merciless glare of the camera's flash, which tends to exaggerate features and draw out stereotypes. Although these images appear to be genuine examples of documentary representation, each is actually a *mise en scène* that undermines and challenges the sacrosanct notion of "naturalness" and its inevitable corollary, "truth." In the mass of discordant elements and confused styles that go far beyond the comfortable boundaries of good taste, it is quite impossible to distinguish between fact and fiction. The mask cannot be removed from the face, clothing cannot be differentiated from costume, home cannot be singled out from décor. Normality and abnormality are here simply the two faces of existence.

Cumming recruited over two hundred individuals for the creation of his portrait gallery. One of them, seen here, was Nettie Harris (1912–1993), a journalist, actress, and model who worked with him from 1983 until her death. After serving as a bit player in *Reality and Motive in Documentary Photography* and *The Mirror, the Hammer, and the Stage*, she took on the leading role in *Pretty Ribbons*. In this last project, Cumming used Nettie's expressively withered flesh to offer a graphic picture of the struggle against aging, the decline of vitality, and the ultimate confrontation with death. Nettie comes across not just as a model or an actress, but as an intelligent woman who, unreservedly and with the evident encouragement of the photographer, undermines the spectator's own taboos. Photography, stripped by Cumming of its traditional function as a conscience-assuaging window on the world, becomes here a mirror, one that unceremoniously presents viewers with an image of their own most shameful prejudices, deeply buried fears, and secret fantasies.

P.D.

Jin-me Yoon

Canadian, born South Korea 1960

Souvenirs of the Self (Lake Louise)

1991, printed 1996
Chromogenic print transmounted on plexiglas, 192.7 × 232.8 cm
Purchased 1996

Jin-me Yoon's experience as an Asian woman living in Canada informs many of her inquiries into the icons of Canadian identity. Born in Seoul, South Korea, Yoon emigrated to Canada in 1968 – a move she believes has made her an outsider with respect to both countries. Her Korean ancestry contrasts with that of Canada's predominantly White, Caucasian populace. Yet, since much of her development took place in Canada, she is regarded as a foreigner in her country of origin. Yoon's dual identity thus gives rise to a sense of displacement. As she is neither exclusively Canadian nor exclusively Korean, she cannot authentically lay claim to either identity. Rather, she occupies a position somewhere "between" these two nationalities, and from her special vantage point she examines how ideas of nationhood are constructed and how such concerns relate to broader issues of identity and gender.

For Yoon, a powerful symbol of Canadian identity is the land. In order to investigate its enduring significance, she places herself within certain settings that have become quintessential icons of Canadian landscape. In *Souvenirs of the Self (Lake Louise)*, Yoon stands on the shore of Lake Louise in Banff National Park, her head precisely positioned at the photograph's vanishing point. Her presence in this landscape draws attention to a number of issues. Landscape photography is traditionally associated with heroic male activity, such as that undertaken by nineteenth-century explorer-surveyors. Historically, few women have been connected with the wilderness landscape, and those of Asian descent practically not at all. Yoon's work also calls attention to the complicity of the camera in the process of colonization: photography has been instrumental in depicting the land as a vast empty area awaiting settlement and development, and therefore in allowing the presence of Aboriginal peoples on the land – and their displacement from it – to be ignored.

As evidenced by its very title, *Souvenirs of the Self* investigates the relation between issues of personal and cultural identity and those of tourism and nationalism. Posed as if for a tourist snapshot, Yoon looks directly at the camera with an enigmatic expression. As her intentions and thoughts are difficult to discern, her presence in the photograph is somewhat disconcerting. She appears out of place, and indeed Yoon was often treated as a foreigner while working on the series that includes this image. Her photograph raises the question of who inhabits areas deemed symbolic of Canada, and whether such spaces allow for the equal representation of all.

In an elegant and somewhat understated manner, *Souvenirs of the Self* explores the complex intersections of nationality and history, gender and visibility. Yoon structures her work so as to provide viewers with insight into these difficult matters, in the hope of guiding them to a deeper understanding of her position and their own, and of the many subtle connections that link the two.

A.K.

Authors

A.K. Andrea Kunard, Assistant Curator, Canadian Museum of Contemporary Photography

A.T. Ann Thomas, Curator, Photographs, National Gallery of Canada

C.H. Charles Hill, Curator, Canadian Art, National Gallery of Canada

C.J. Catherine Johnston, Curator, European and American Art, National Gallery of Canada

C.L. Christine Lalonde, Assistant Curator, Prints and Drawings, National Gallery of Canada

D.F. David Franklin, Deputy Director and Chief Curator, National Gallery of Canada

D.L. Denise Leclerc, Associate Curator, Canadian Art, National Gallery of Canada

D.N. Diana Nemiroff, Curator, Modern Art, National Gallery of Canada

J.C. John Collins, Assistant Curator, European and American Art, National Gallery of Canada

J.D.-B. Josée Drouin-Brisebois, Assistant Curator, Contemporary Art, National Gallery of Canada

J.S. Janice Seline, Management Consultant, Oklahoma City Museum of Art

K.S. Kitty Scott, Curator, Contemporary Art, National Gallery of Canada

L.P. Lori Pauli, Assistant Curator, Photographs, National Gallery of Canada

M.H. Martha Hanna, Director, Canadian Museum of Contemporary Photography

M.P. Michael Pantazzi, Curator, European and American Art, National Gallery of Canada

M.R. Marie Routledge, Associate Curator, Inuit Art, National Gallery of Canada

P.D. Pierre Dessureault, Associate Curator, Canadian Museum of Contemporary Photography

P.P. Pratapaditya Pal, General Editor, Marg Publications, Mumbai, India

R.T. Rosemarie Tovell, Curator, Prints and Drawings, National Gallery of Canada

R.V. René Villeneuve, Associate Curator, Canadian Art, National Gallery of Canada

S.B. Stephen Borys, Curator, Western Art, Allen Memorial Art Museum, Oberlin College

V.L. Vincent Lavoie, Research Associate, Notman Photographic Archives, McCord Museum of Canadian History

Index of Artists

Copyright Notices